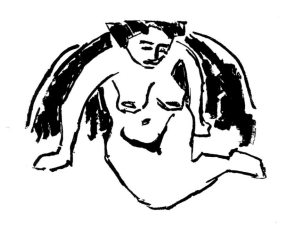

EXPRESSIONISM

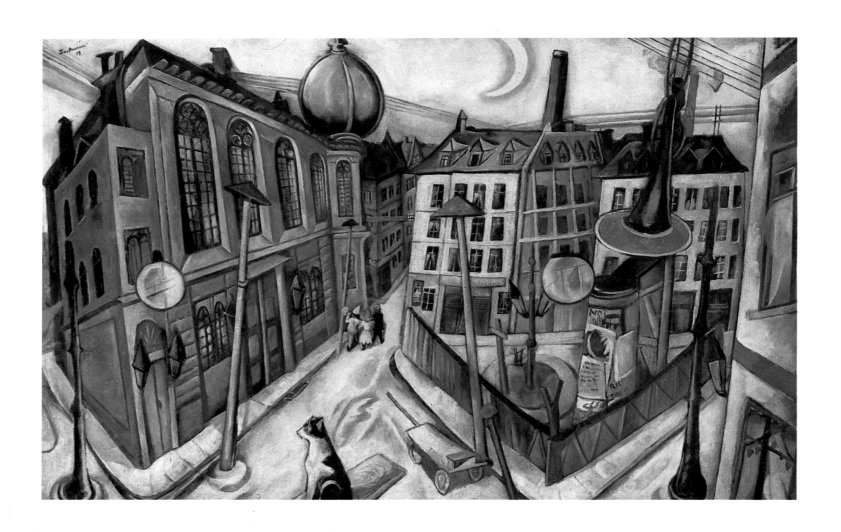

Dietmar Elger

EXPRESSIONISM

A Revolution in German Art

Benedikt Taschen

FRONT COVER:
Alexei von Jawlensky:
Still Life with Vase and Jug (detail), 1909
Stilleben mit Vase und Krug
Oil on hardboard, 49.5 x 43.5 cm
Museum Ludwig, Cologne
Photo: Rheinisches Bildarchiv, Cologne

ILLUSTRATION PAGE 1:
Karl Schmidt-Rottluff:
Seated Nude, 1911
Hockender Akt
Lithograph, 35.5 x 39.8 cm

ILLUSTRATION PAGE 2:
Max Beckmann:
Synagogue, 1919
Synagoge
Oil on canvas, 90 x 140 cm
Städelsches Kunstinstitut und Städtische Galerie,
Frankfurt am Main

BACK COVER:
Franz Marc:
The Little Blue Horses, 1911
Die kleinen blauen Pferde
Oil on canvas, 61 x 101 cm
Staatsgalerie Stuttgart, Collection Lütze,
Stuttgart

**This book was printed on 100 % chlorine-free bleached
paper in accordance with the TCF standard.**

© 1994 Benedikt Taschen Verlag GmbH
Hohenzollernring 53, D–50672 Köln
© for the illustrations: VG Bild-Kunst, Bonn 1994: Beckmann, Campendonk,
Delaunay, Ensor, Feininger, Grosz, Jawlensky, Kandinsky, Kokoschka, Matisse,
Mueller, Schmidt-Rottluff. Otto Dix Foundation, Vaduz 1988: Dix. Conrad Felixmüller,
Hamburg 1988: Felixmüller. Siddi M. Heckel, Gaienhofen 1988: Heckel. Dr. Wolfgang
and Ingeborg Henze-Ketterer, Wichtrach/Berne 1988: Kirchner. Magistrate of the City
of Darmstadt, Darmstadt 1988: Meidner. Executors of the Morgner Estate, Soest 1988:
Morgner. Munch Museet, Oslo 1988: Munch. Gabriele Münter and Johannes Eichner
Foundation, Munich 1988: Münter. Seebüll Foundation, Ada and Emil Nolde, Neukir-
chen-Seebüll 1988: Nolde. Max Pechstein Archive, Hamburg 1988: Pechstein. Helene
Rohlfs Foundation, Essen 1988: Rohlfs. Fondazione Werefkin, Ascona 1988: Werefkin.
Edited and produced by Ingo F. Walther
Appendix: Dietmar Elger and Ingo F. Walther
English translation: Hugh Beyer
Cover: Angelika Muthesius, Cologne

Printed in Germany
ISBN 3–8228–0274–3
GB

Contents

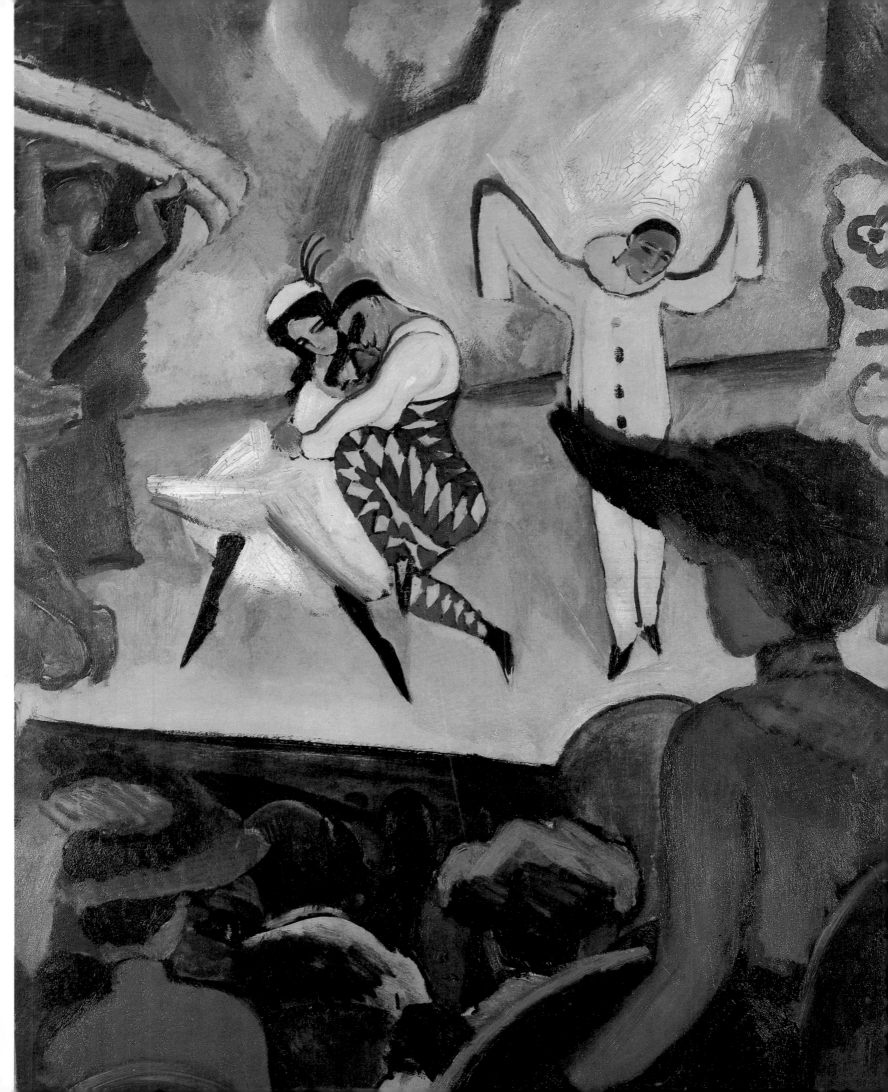

Expressionism – A Revolution in German Art

There is a certain vagueness and open-endedness about the term Expressionism. It can be understood on a variety of different levels and has eluded all attempts to give it a precise definition. What is more, coinage of the word itself has been ascribed to various people. Tradition has it that the Berlin art dealer Paul Cassirer explicitly characterized Edvard Munch's works as *Expressionist*, to emphasize their difference from *Impressionist* art. However, it is equally possible that Lovis Corinth's words were influential, commenting on the *22nd Secession Exhibition* of French Cubists and Fauvists in 1911: "Furthermore, we also exhibited a number of works by younger French painters – the Expressionists. We believed that we should not deny them to the public, because the Secession has always regarded it as its duty to show what interesting things are being created outside Germany." At least for Corinth's contemporaries, Expressionism continued to be a handy label and a synonym of modern art in general. Thus a book called *Expressionismus und Film*, published in 1926, also devoted a considerable amount of space to artists such as Piet Mondrian, Vladimir Tatlin, Kasimir Malevich, Man Ray and Kurt Schwitters.

Nowadays, of course, these artists have become history, and we no longer find it difficult to distinguish between their many different styles. Nevertheless, there continues to be a certain amount of confusion as to which artists can be regarded as typical representatives of Expressionism. In fact, a number of literary and art historians have become so suspicious of the term Expressionism that they have stopped using it altogether. Also, for many of the artists in this book, Expressionism was only a limited period – and often a very short one – within their overall artistic development. Wassily Kandinsky was probably the most radical example, because his Expressionism just before 1914 led to abstract art in a series of consistent steps. On the other hand, there was Walter Gropius's Bauhaus manifesto, which started off a school of art that was unparalleled in its demand for functionality and clarity of form, while at the same time still totally permeated by an Expressionist language.

Expressionism, however, was by no means limited to fine art, even though its significance and influence in other areas should not be over-

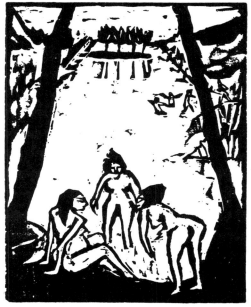

Erich Heckel:
Nudes by the Forest Pond, 1910
Akte am Waldteich
Woodcut, 19.4 × 15.1 cm

August Macke:
Russian Ballet, 1912
Russisches Ballett
Oil on hardboard, 103 × 81 cm
Kunsthalle Bremen, Bremen

estimated. The desire to follow an Expressionist style was equally wide-spread in literature, drama, stage design, dance, film and architecture. If there is any consensus at all, then it can be found with regard to the temporal limits of the phenomenon. The foundation of the artists' group *Die Brücke* (The Bridge) in Dresden in 1905 is generally regarded as the first cornerstone of Expressionism, and the revolutionary post-war unrest of 1920 is seen as the end of the movement in Germany, thus forming the second cornerstone. There are some who would prefer to pre- or post-date the period by up to five years. However, this certainly does not mean that after 1920 Expressionism ceased abruptly in art, literature and architecture. The period of 1905 – 1920 merely defines the years when political events and the social climate found their appropriate artistic expression in this particular style, a period – as we would put it nowadays – when Expressionism left its mark on the current mental climate, on the *zeitgeist*. Similarly, Henri de Toulouse-Lautrec's paintings and lithographs, for instance, reflected the hedonistic society of the Belle Epoque in Paris, while at the same time influencing the spirit of the time.

Nevertheless, it is completely wrong to speak of a uniform Expressionist style, determined by a number of typical features. One only has to consider the formal differences between art, literature and cinema, but this lack of uniformity is also in evidence when we compare the various artists with each other. Take, for instance, Kirchner, Kandinsky, Kokoschka and Dix, and there are far more differences than signs of stylistic kinship. Apparently we seem to be dealing with an expression of

James Ensor:
Masks Arguing about a Hanged Man,
1891
Oil on canvas, 59 × 74 cm
Koninklijk Museum voor Schone
Kunsten, Antwerp

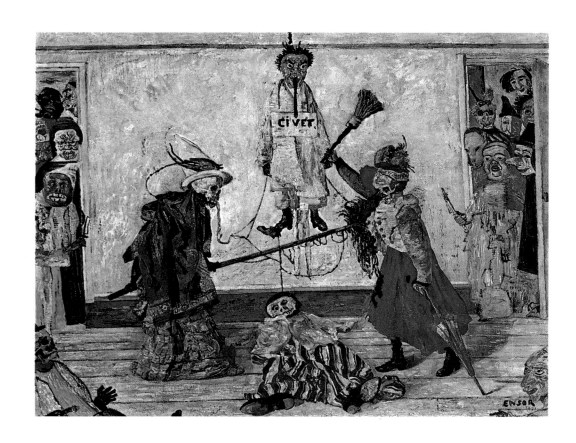

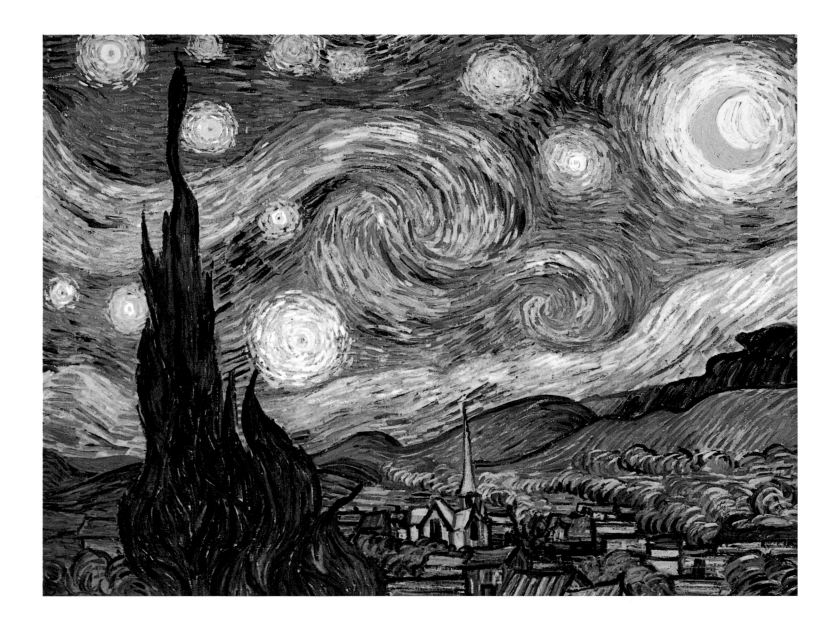

a certain awareness of life among the younger generation, whose common bond was no more than their rejection of dominant social and political structures.

What the Expressionists depicted was a simple, organic symbiosis, based on the rhythm of nature alone. They created a utopian counterworld that was the exact opposite of a society determined by the alienating processes of industry and governed by the political system of Kaiser Wilhelm II – the German equivalent of Victorianism. This process of coming to terms with the world was nearly always accompanied by the painter's personal emancipation. Most of the younger Expressionists came from respectable, upper middle class backgrounds, the kind of families in which the current political system had found its most faithful adherents.

The art scene towards the end of the Wilhelmine Empire was determined by the Impressionists of the *Berlin Secession*. Under the presidency of Max Liebermann, in particular, and as late as 1914, they claimed to be

Vincent van Gogh:
Starry Night (Cypresses and Village), 1889
Oil on canvas, 73 × 92 cm
Metropolitan Museum of Art, New York

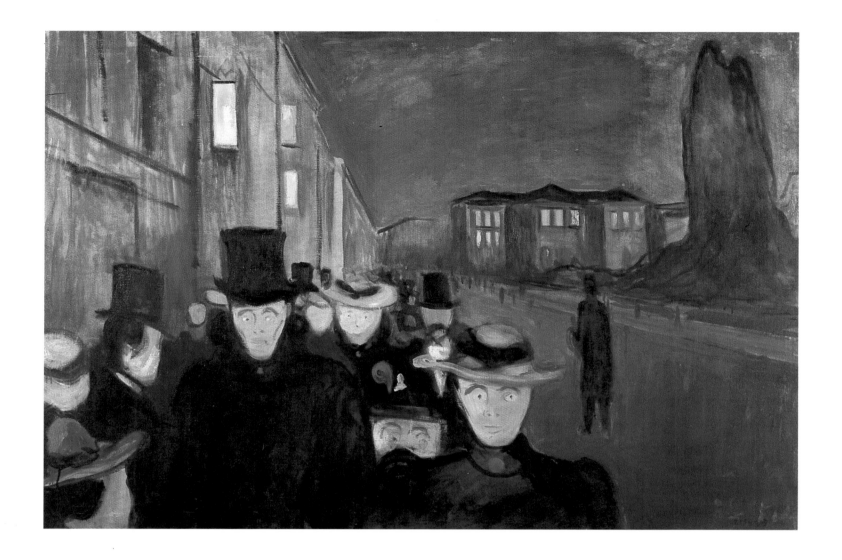

the sole representatives of modern art in Germany. The young generation of Expressionists, however, felt rather more reluctant to emulate this German variant of French Impressionism. "On the whole," said August Macke contemptuously, "there are far too many 'nice paintings' in the Secessions." On the other hand, the Expressionists did allow themselves to be influenced quite considerably by the works of Vincent van Gogh (p.9), Paul Gauguin (p.11), Robert Delaunay (p.12), James Ensor (p.8) and Edvard Munch (above). Van Gogh's attempt to share his life and work with Gauguin – even though it failed – as well as Gauguin's later trips to Tahiti were seen by the Expressionists as ideal patterns for their own lives and communities. It was through van Gogh that they gained access to modern French art. In fact nearly all of them were so much under his influence at first that Emil Nolde advised his artist friends to call themselves *Van Goghiana*, rather than *Die Brücke*. However, while the *Blaue Reiter* and the Rhenish artists enthusiastically seized upon Delaunay's mystic colour theory, the *Brücke* painters also emulated Munch and Ensor, artists who endeavoured to go beyond a mere perception of reality and who aimed at a psychological rendering of the impressions they perceived. Seen within this context, it is probably understand-

Edvard Munch:
Evening on Karl Johan, 1892
Oil on canvas, 84.5 × 121 cm
Rasmus Meyer Collection, Bergen

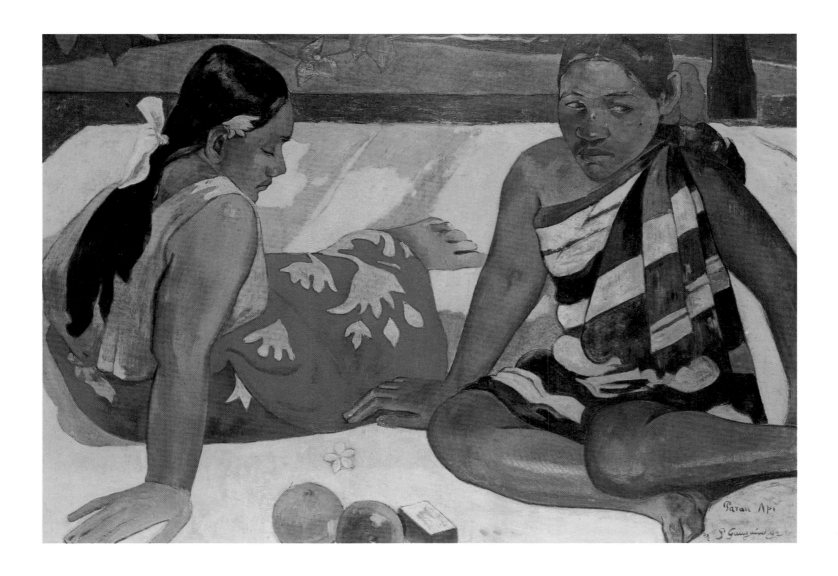

Paul Gauguin:
What's New?, 1892
Oil on canvas, 67 × 91 cm
State Collection of Art
Gemäldegalerie Neue Meister,
Dresden

able that the *Brücke* painters denied having any links with the Fauve artists or Munch, because they were trying to define their own autonomous position in art. However, we can find similar evaluations in German art history as late as the sixties – a result of a false desire to assert themselves against French art.

In fact, this very enthusiasm for modern French art was one of the few features that united the various Expressionist artists' groupings and individual painters in Germany. On the other hand, a comparison between the *Brücke* circle in Dresden and the *Blaue Reiter* artists in Munich can also serve as an example of the vast varieties of style that Expressionism was able to cover. Only the *Brücke* artists can be regarded as a group of artists who actually worked together and even lived together for a while. The *Blaue Reiter*, on the other hand, was a name that had never been chosen as a group name by the artists themselves. Rather, it was the title – though a programmatic one – of the almanac edited by Wassily Kandinsky and Franz Marc in 1912. Indeed, the very origin of the word is indicative of Southern German Expressionism, which was far more intellectual and determined by manifestos and written statements. The *Brücke* artists, on the other hand, spent considerably less time reflecting

upon their own activities and artistic aims, but tried to capture their sensory experiences and visual impressions as directly as possible in the form of paintings.

Although Erich Heckel and Franz Marc tried several times to establish a common ground between all the artists, there were too many differences to allow any closer links or even shared activities. Although *Die Brücke* was allowed to take part in the second *Blaue Reiter* exhibition, and works of Berlin artists were printed in the almanacs, Kandinsky did have his doubts about the *Brücke* people and only allowed small formats to be included. In a letter to Marc, he said, "Of course, one has to exhibit this sort of thing. However, I believe that it is wrong to immortalize them in a documentary of contemporary art (which is what our book is intended to be) and to regard them as a decisive force that gives direction. And so I, at any rate, would be against large-scale reproductions ... Small reproductions mean that this is one way of doing it. Large ones: this is how it is done."

Robert Delaunay:
Window into Town, 1912
Oil on canvas, painted pine frame,
46 × 40 cm
Kunsthalle, Hamburg

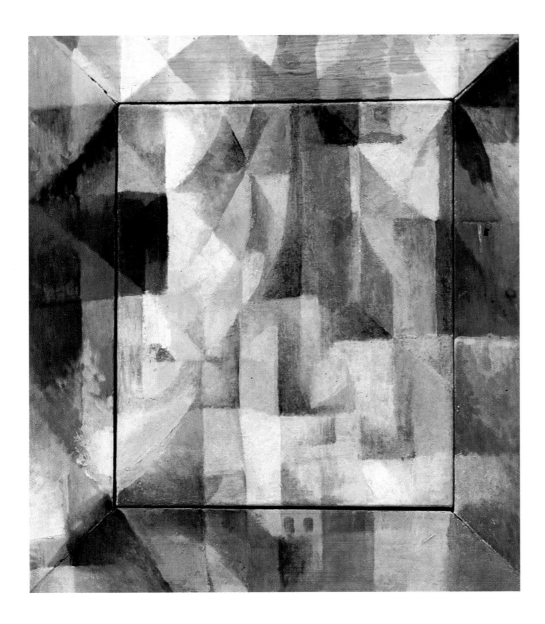

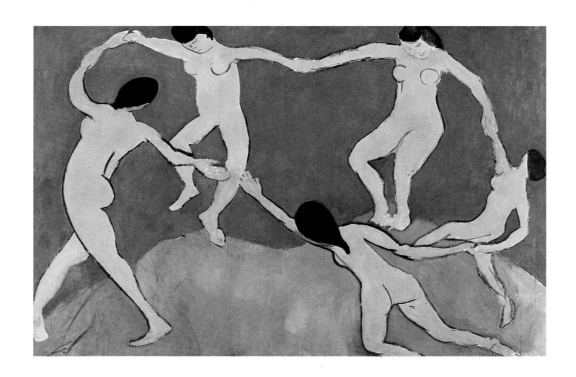

Henri Matisse:
The Dance, 1909
Oil on canvas, 259.7 × 390 cm
Museum of Modern Art, New York

The events of the First World War had a far-reaching effect on the Expressionist movement. The war, which was welcomed with nationalist enthusiasm in the whole of Germany, was regarded by the Expressionists as a powerful catharsis. They believed that it would destroy the ancient order, which they had felt to be so oppressive, and that a better society would arise from its ruins. As soldiers fighting in the trenches, they were looking for a great experience of community and youth that would transcend the traditional class barriers of bourgeois society. Beckmann, Kirchner, Heckel, Macke, Marc, Kokoschka, Dix and many others enlisted as volunteers, united by the common hope that they would gain fresh impressions for their art. "Outside there was that wonderful, magnificent noise of battle. I went outside, through large groups of injured and worn-out soldiers coming back from the battlefield, and I could hear this strange, weirdly magnificent music … I wish I could paint this noise," Beckmann enthused in a letter to his wife in 1914. Only a few Expressionist artists, such as Max Pechstein, George Grosz, Ludwig Meidner and Conrad Felixmüller, did not share the prevailing euphoria. However, the longer the trench war dragged on, the more there was a change of attitude among the other artists, too: Dix's paintings changed into an accusation of militarism and the bourgeoisie. Kirchner, Beckmann and Kokoschka could not bear the horrors of trench warfare, but had physical and psychological breakdowns and were discharged. Many other Expressionists – Marc, Macke, Morgner – died in action at an early age.

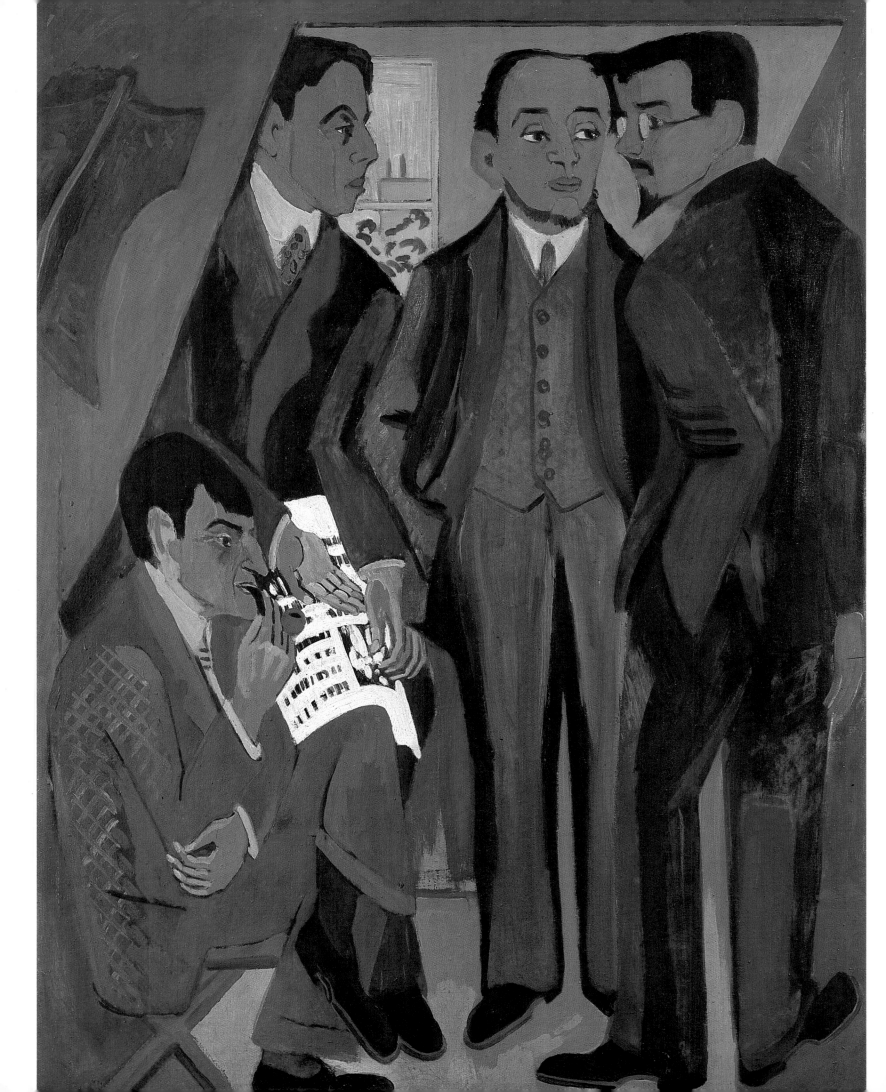

On 7 June 1905, four students of architecture at Dresden formed a group of artists called *Die Brücke* (The Bridge). They were Fritz Bleyl, Ernst Ludwig Kirchner, Erich Heckel and Karl Schmidt-Rottluff, and some of them had already been friends for quite a few years. Kirchner and Bleyl had been studying at the Saxon Institute of Technology, while at the same time trying their hands at painting and drawing. Heckel and Schmidt-Rottluff had known each other since their days at school in Chemnitz, and they had both been students at the Institute since 1904. It was Heckel's elder brother, a former school friend of Kirchner's, who introduced the two pairs of friends to one another.

The formation of this group may well have been favoured by the isolated position of its members at the Institute. All four shared an

The Brücke Group of Artists

enthusiasm for art, and the only reason why they were studying such a practical subject was to please their parents on whose monthly contributions they depended. On the other hand, however, it is likely that all of them were quite consciously seeking contacts with the artists' circles of German Romanticism. The *Brücke* artists shared with them a desire for recognition and fellowship, and they were hoping to find this in working and living together with like-minded people. And as they were still quite young and without formal academic qualifications, they were aware that what they were seeking could never be provided by ordinary middle class society.

It was Kirchner who took the initiative to form the artists' circle and Schmidt-Rottluff who chose the name, *Die Brücke* (The Bridge). He may have been inspired by the numerous bridges in Dresden – the "Florence on the river Elbe". But he may also have thought of it as a step towards new shores in the world of art. Neither of these interpretations are certain, and the only record we have is of a conversation with Heckel in 1958: "We did, of course, discuss how we might approach the public. One night, on our way home, we were talking about this again. Schmidt-Rottluff suggested the name 'Brücke', because it was a word with a number of meanings that did not suggest a particular programme, but would link one side with the other."

Bleyl, who had taken his degree in architecture together with Kirchner shortly before 1905, left the group again in 1907 and moved to Freiberg, Silesia, where he became a teacher at the local School of Architecture. Later, other artists joined the group, though sometimes only for a very short time. Nolde was an active member of the circle from 1906 to the end of 1907, and even a number of foreign painters came to be regarded as *Brücke* painters, probably to emphasize the international character of the circle, though they did not take any active part. They were Cuno Amiet

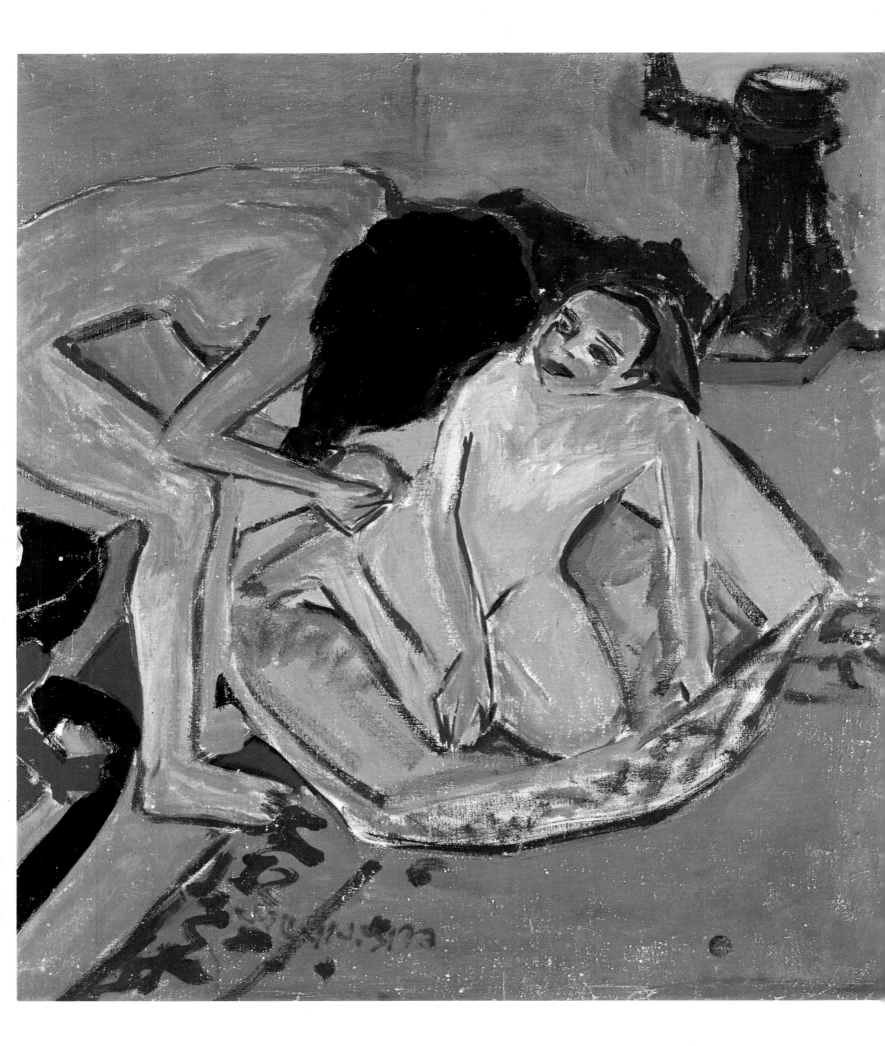

(Swiss, from 1906), Axel Gallin-Kallela (Finnish, 1907), Kees van Dongen (Dutch, 1908) and Bohumil Kubišta (Czech, 1911). When the *Brücke* was dissolved, it also had 75 associate members, so-called 'passive members'. Apart from the three founder members Kirchner, Heckel and Schmidt-Rottluff, only two other artists played a decisive role in the development of the circle and contributed to the formation of a distinctive *Brücke* style. They were Max Pechstein, who joined in 1906, and Otto Mueller, who did not become a member until 1910.

Nothing reflects the difference between *Die Brücke* and the *Blaue Reiter* more clearly than the artists' essays and manifestos. Whereas Kandinsky made quite a number of extensive statements, the Dresden group summed up its entire programme in only sentences. In 1906, Kirchner had made a wood cut of the text and the title vignette – the stylized motif of a bridge: "We believe in development and in a generation of people who are both creative and appreciative; we call together all young people, and – as young people who bear the future – we want to acquire freedom for our hands and lives, against the well-established older forces. Everyone belongs to us who renders in an immediate and unfalsified way everything that compels him to be creative." This is a very general statement. But it clearly shows the generation conflict of the artists who were aged between 21 and 25, as well as their desire to find fellow combatants in their isolated situation. However, their revolutionary zeal for social change and for the freedom of their "hands and lives" vis-à-vis the establishment did not go beyond aesthetics. The artists were searching for an indirect and, if possible, direct way of translating reality into artistic shorthand. One of their favourite themes was that of man in a natural environment, unspoilt by any form of industrialization. Another theme was nudes, because the artists saw their unclothed models as creatures carried off into a state of unspoilt arcadia.

The *Brücke* painters tried to adapt their style to this theory, though their thick application of paint, with layers of impressionist brushwork, limited their scope for speed and spontaneity. It was not until they added petroleum to their paint that they achieved a mixture which enabled them to spread the paint more broadly, thinly and smoothly with a bristle brush or a palette knife. The visual impact of these paintings was now determined by the contrast and tension between complementary coloured surfaces.

When the *Brücke* artists formed their group, they were seeking to share not only their work but also their lives. In September 1906, Heckel took over the organization of the circle and became its manager. In an old cobbler's workshop at 65, Berliner Strasse – in the middle of Dresden's working class area around the Friedrichstadt railway station – the *Brücke* studio started one of the most significant developments in 20th century art. Even the furnishing of this shared room was a demonstration that the artists did not distinguish between work and life. Both were seen as inseparable. The furniture was home-made and painted with exotic themes. The tapestries were decorated with their own batik prints. This

PAGE 14:

Ernst Ludwig Kirchner:
The Painters of Die Brücke,
around 1926/27
Oil on canvas, 168 × 126 cm
Museum Ludwig, Cologne

Ernst Ludwig Kirchner:
Two Nudes with Bath Tub and Stove,
1911
Zwei Akte mit Badetub und Ofen
Oil on canvas, size unknown
Burda Collection, Offenburg

is where they painted together, discussed the results, read poetry and Nietzsche and generally inspired and influenced each other. The friends met nearly every day to work together, which led to a unified style within their group and showed itself most clearly in the paintings they brought home from their trips to the Moritzburg Lakes from 1909 to 1911. Indeed, there are a number of works where even experts find it difficult to determine who painted them. We do, however, know that the common themes of the *Brücke* artists were above all due to Kirchner's ideas, while Heckel introduced the formal innovations. That this collective style was a conscious aim of the artists' joint endeavours can be seen in the catalogue of their 1910 exhibition at the Arnold Gallery in Dresden. It shows reproductions of several paintings in the form of woodcuts which they had made of each other's paintings.

Pechstein was the first member of the group who moved to Berlin as early as 1908. The other *Brücke* painters did not visit it until 1910. A year later, they settled down there. The spiritual climate in Berlin was quite different from the peaceful tranquility of Dresden. Hoping to receive new impulses, the *Brücke* artists decided to expose themselves to the impressions of the big city , with its anonymity, its vast differences between social classes, its pulsating night life and the activities of numerous artistic circles.

By now they had formed a very clear collective style, and they were hoping that this would enable them to hold their own in the tough competitive struggle with other Berlin artists. In this climate, however, a painter had to develop his own personal style. And so it was almost inevitable that the *Brücke* artists soon began to detach themselves again from their collective style. Kirchner, Heckel, Schmidt-Rottluff, Pechstein and Mueller certainly reacted rather differently to the city. In the same way, each one of them – though differing in intensity – kept trying to achieve a balance with the chaos and anonymity of Berlin. Each artist now spent the summer months on his own or just with one friend, but no longer together as a group, on the Moritzburg Lakes near Dresden, in Dangast (near Oldenburg) on the North Sea, in Nidden (East Prussia) or on the Baltic island of Fehmarn.

Kirchner's account of the development of the group in his *Chronik der KG Brücke* (Chronicle of the Brücke Artists' Circle) in 1913 (p. 21) led to the final breach between the painters. Heckel, Schmidt-Rottluff and Mueller accused Kirchner of presenting a biased view of the group, without due consideration of the facts and over-emphasizing his own achievements. On 27 May 1913, the *Brücke* sent a letter to its associate members, explaining that the circle had been dissolved. Kirchner's name was already missing from the signatures. When one reads the Chronicle today, it is difficult to follow the other artists' criticism of Kirchner. Rather, it gives rise to the suspicion that the former friends had become so alienated from each other – both as artists and as people – that the Chronicle merely served as an opportunity to take the formal consequences of these internal antagonisms and to separate.

Ernst Ludwig Kirchner:
Negro Dance, around 1911
Negertanz
Oil on canvas, 151.5 × 120 cm
Kunstsammlung Nordrhein-Westfalen, Düsseldorf

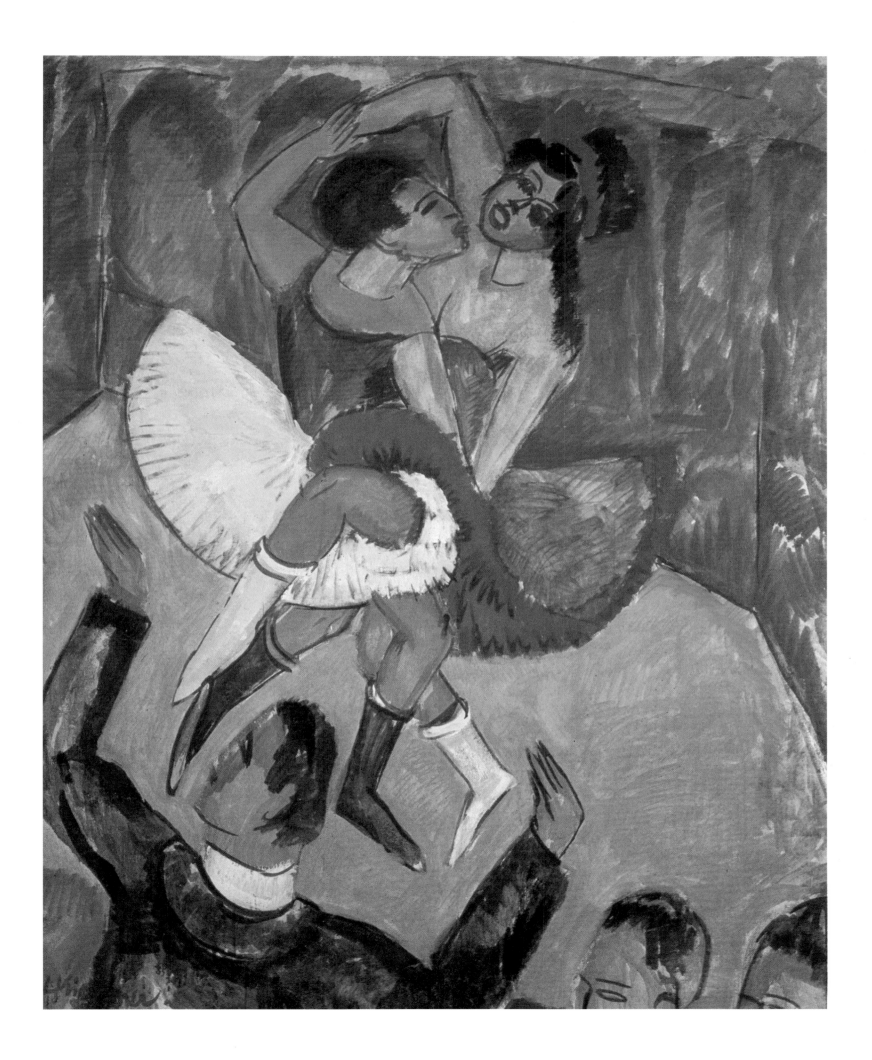

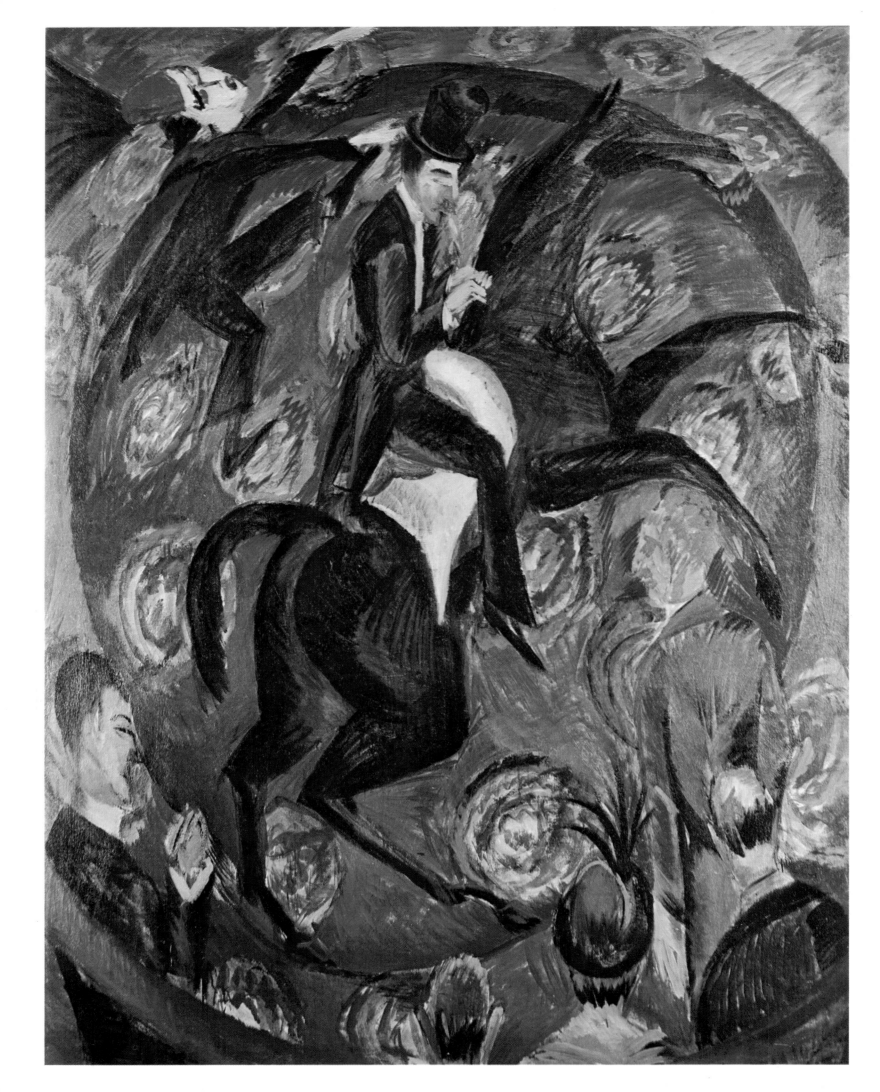

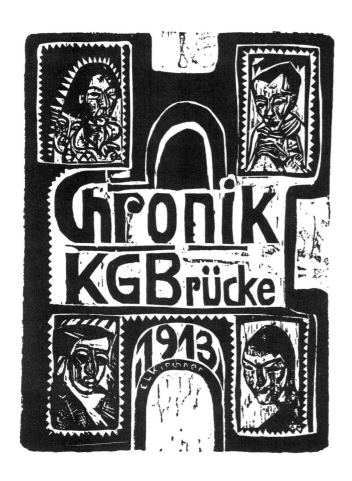

The *Chronicle of the Brücke Group of Artists*, 1913. The text, which was written by Kirchner, led to the break-up of the circle. The woodcut on the front page with four portraits of members as well as the two woodcuts on page 1 are by Kirchner. Size of each sheet: 67 × 51 cm

Ernst Ludwig Kirchner:
Circus Rider, 1914
Zirkusreiter
Oil on canvas, 200 × 150 cm
Morton D. May Collection, St. Louis (Mo.)

In 1902 the painters Bleyl and Kirchner met in Dresden. They were joined by Heckel, whose brother was a friend of Kirchner's, and Heckel brought along Schmidt-Rottluff whom he knew from Chemnitz. The artists met to work in Kirchner's studio where they could study nudes, the basis of all fine art, in their free and natural simplicity. By producing these drawings, they had the common feeling of being inspired by life itself and of submitting to their own experiences. In a book called Odi profanum *each artist expressed his own ideas in drawing and prose, enabling others to compare their individual styles within one publication. In this way a group called* Brücke *was formed quite automatically, with each person inspiring the other. Kirchner introduced the woodcutting technique from Southern Germany, having taken it up again after he had been inspired by old woodcuts in Nuremburg. Heckel started carving wooden figures again; Kirchner enhanced this technique by painting his own woodcuts, while trying to find the rhythm of self-contained figures in tin casts and stone. Schmidt-Rottluff produced the first lithographs on stone. The first exhibition of the group took place on their premises in Dresden; it did not receive any recognition. However, a lot of inspiration came from Dresden itself, because of its scenic beauty and its ancient culture. This is also where the* Brücke *group first found their foundation in art history with the works of Cranach, Beham and other mediaeval German masters. On the occasion of an exhibition by Amiet in Dresden, …*

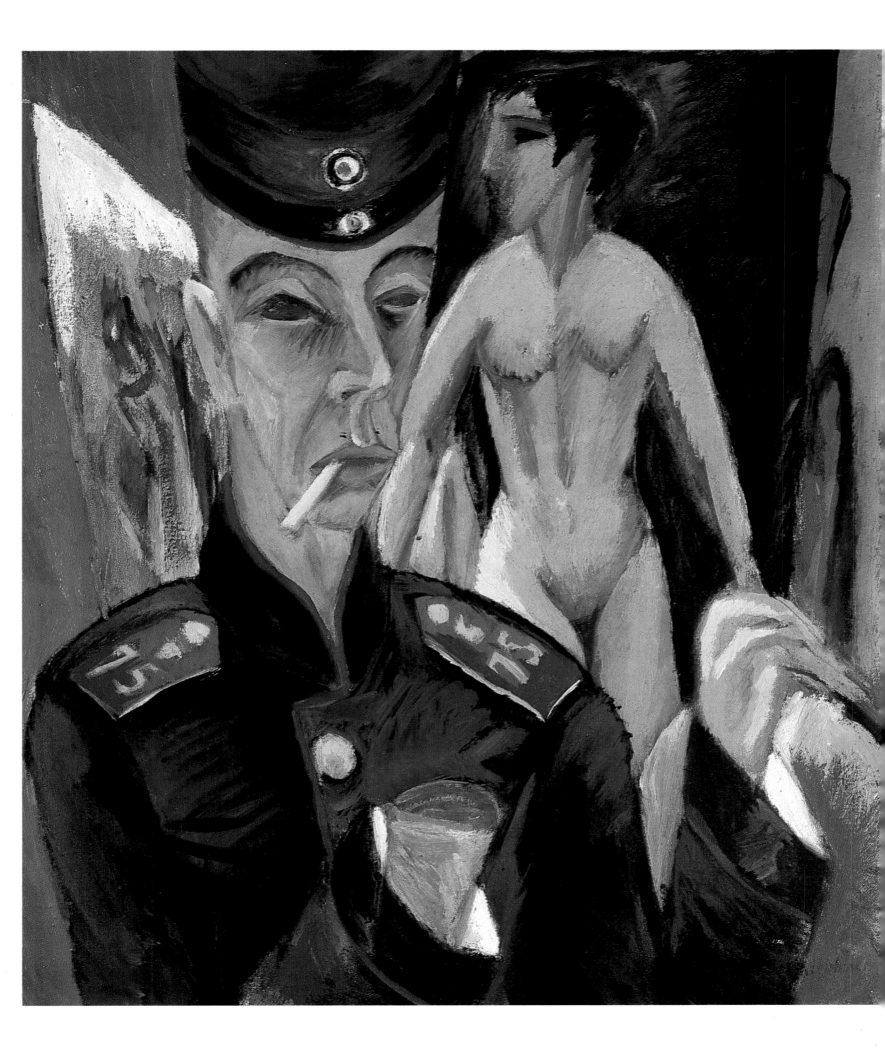

Ernst Ludwig Kirchner

Kirchner is regarded as the leading personality among the *Brücke* artists. He was the one to suggest the formation of the circle in 1905, and it was his Chronicle, written in 1913, that caused the break-up of the group after eight fruitful years. Unlike his companions, he made several written statements about his art, and fragments of his later Davos diaries (1918 – 1938) still exist. Reading these comments, however, one begins to wonder how Kirchner could possibly have managed to fit in with a group of painters on the same level and for such a long time. Although Kirchner's work is nowadays undisputedly regarded as the most significant and influential contribution to the *Brücke*, he developed an almost obsessive urge in later years to emphasize the uniqueness of his own work and his own dominant position. In retrospect, the early *Brücke* years were seen quite differently by Kirchner. He believed that during that time, when the artists had developed their own style mainly by working together and influencing each other, they merely benefitted from his own ideas, which they then managed to market in a profitable way. In his Davos diaries and letters he attempted to play down the significance of the *Brücke* years for his own artistic development and even to deny it. In 1924, after reading and correcting the manuscript of Will Grohmann's book (*Das Werk E.L. Kirchners*), he added a note: "That *Brücke* episode must be taken out again. I don't want to have anything to do with it. After all, it's not even related to my work." Claiming to be the sole inventor of the characteristic *Brücke* style, he pre-dated numerous paintings of his, going back as far as 1902.

Kirchner, who was born in Aschaffenburg on 6 May 1880, had a typical middle-class background. His father, Ernst Kirchner, was an engineer working at a paper factory. In 1887 the family moved to Perlen, near Lucerne, and in 1890 they finally settled down in Chemnitz, where his father had been given a lecturership in paper research at the local Academy of Trade and Industry. Kirchner started to draw at quite an early age and even developed some talent in this area, though after leaving grammar school in spring 1901, he followed his father's wish and took up architecture at the Saxon Institute of Technology in Dresden. It was during his first term that he met Bleyl, who became his friend and

Ernst Ludwig Kirchner:
Head of Ludwig Schames, 1917
Kopf Ludwig Schames
Woodcut, 55 × 23.5 cm

Ernst Ludwig Kirchner:
Self-Portrait as a Soldier, 1915
Selbstbildnis als Soldat
Oil on canvas, 69.2 × 61 cm
Allen Memorial Art Museum
Oberlin College, Oberlin (Ohio)

shared his passionate interest in liberal art. Although both of them passed their degree in engineering in 1905, they had spent most of their time painting and drawing.

Kirchner spent the autumn and spring terms of 1903/4 in Munich, where he attended classes in composition and life drawing at a private school of art, run by Wilhelm von Debschitz and Hermann Obrist. The school was called the *Educational and Experimental Studio for Applied and Liberal Art*. So far as his further artistic development was concerned, his time in Munich was significant mainly because of the numerous impressions and new ideas which he gained. Not only did he become acquainted with Art Nouveau, which was to influence his early prints, but in his numerous visits to art galleries he also saw works by Toulouse-Lautrec, Georges Seurat, Camille Pisarro and van Gogh. Later, in 1905, he was to encounter Van Gogh's works at the Arnold Gallery in Dresden again. And although he found his paintings rather too "nervous and tattered", this was the artist who influenced him more than any others during his first *Brücke* years. On the other hand, he rather disliked the disciplined, almost academic pointillism of Seurat, Signac and Pissarro. Van Gogh's ecstatic insistence on form was much more to his taste. The small painting *Woman's Head with Sunflowers* (p. 29) must have been painted in 1906 at the earliest, because it already shows Kirchner's chosen partner Doris Grosse (called Dodo), whom he had met that year and with whom he stayed until he moved to Berlin. Dodo – who was 25 at the time – is shown in profile and before a window. On the window sill there is a narrow vase with three sunflowers. This theme may well have been Kirchner's way of paying tribute to van Gogh, and the choice of colour and the relief-like application of short dynamic brush-strokes are also reminiscent of him. There are flat, unbroken colour surfaces, without any shades that might lend dimension to the different hues of the body. These areas are further emphasized by the red contour, running from the petals of the flowers and along the girl's head and body and making them appear to belong together. This is a stylistic element which can be seen again and again in Kirchner's paintings, including his later ones. It is only the directions of the short brush-strokes, side by side with one another, which give substance to the shapes.

In 1908, together with the French Fauve artists, the *Brücke* exhibited their art at Emil Richter's showroom, though without Matisse. And indeed, it was not long before the influence of several French painters appeared in Kirchner's work. They were André Derain, Raoul Dufy, Georges Braque (who later became a Cubist) and van Dongens (who is said to have joined the *Brücke* himself for a while). At the time, his style was no longer determined by naturalism, but by the expressive options inherent in the use of pure, unadulterated colours. From now on, however, Kirchner no longer applied thick layers of paint, but thinned it down with petroleum and spread it over the canvas thinly and broadly.

Kirchner's painting *Two Nudes with Bath Tub and Stove* (p.16) of 1911 clearly shows his stylistic progress compared with his work of 1906. Both

Ernst Ludwig Kirchner:
The Red Tower in Halle, 1915
Der rote Turm in Halle
Oil on canvas, 120 × 91 cm
Folkwang Museum, Essen

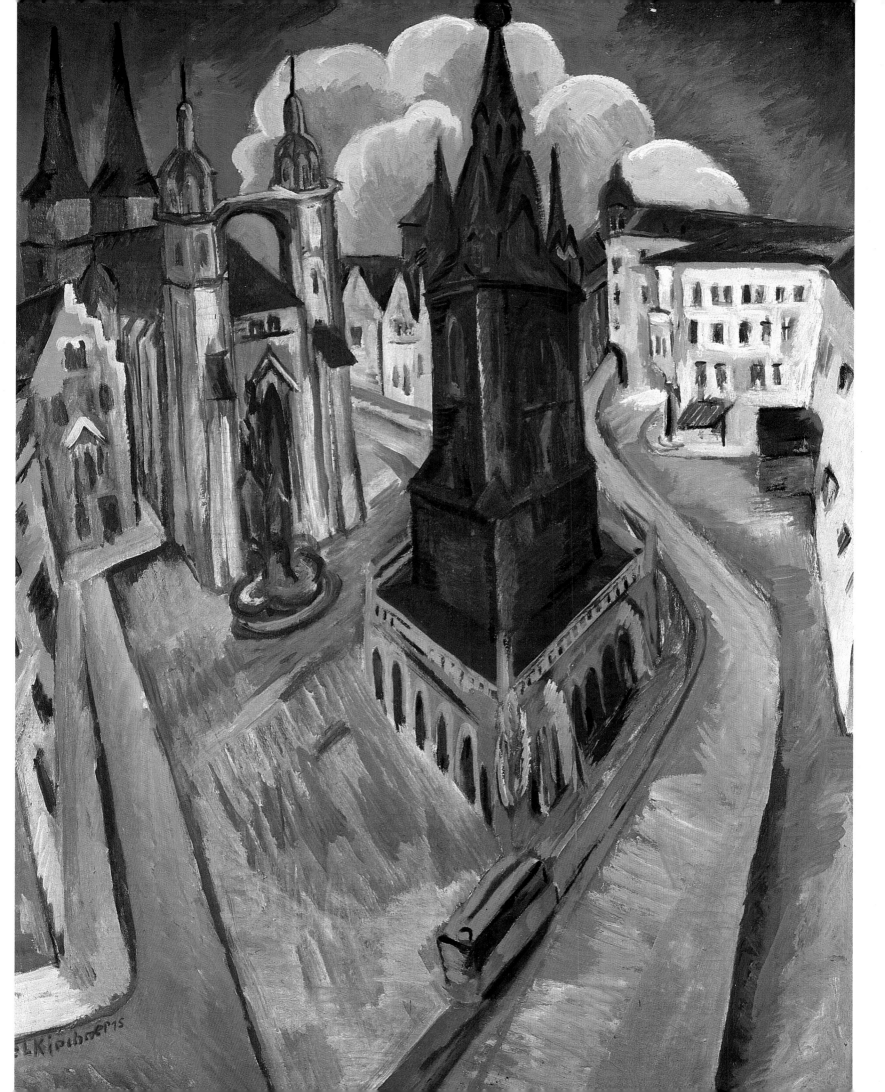

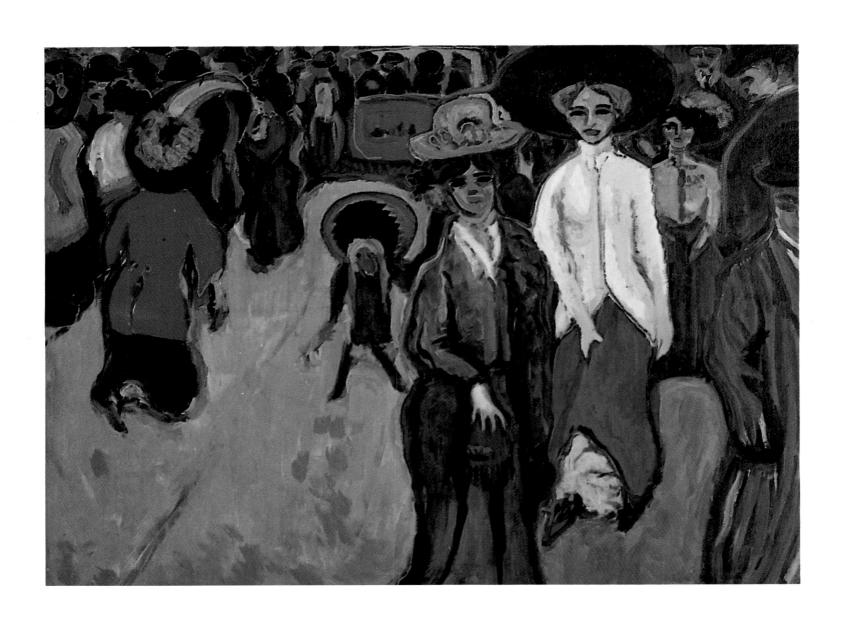

paintings are dominated by the same strongly contrastive areas of green vs. orange, but the conspicuousness of his brush strokes has been replaced by unmodelled areas surrounded by contours. Again, Kirchner employed the technique of contours encircling, as it were, the various figures and objects. These contours disrupt the compositional hierarchy imposed by perspective, and emphasize instead the parallel coloured surfaces within the picture. In this particular painting, Kirchner observed a rather private and intimate scene involving two naked young girls. He made one of them the central character by placing her in a small bath tub filled with water, while the other girl is bending down to her on the left. The stove on the right proves that the scene is actually inside – something which the large green surfaces do not suggest at all. By painting nudes in his studio and – even more so – in the open air, the artist tried to approach his ideal of a life that was free from inhibitions and in harmony with nature. On numerous occasions he took his models to the Moritzburg Lakes, with artistic results that most fruitfully reflected his attempts to live a life shared with others and free from all the fetters of civilization. For Gauguin, this ideal seemed to have found its fulfilment in his trip to Tahiti. In 1910, to advertise Gauguin's exhibition at the Dresden Art Gallery, Kirchner had made a woodcut, and he and the other *Brücke* artists tried to imitate the Frenchman.

Unlike Pechstein and Nolde, Kirchner did not feel any urge whatever to travel to the South Sea himself. According to his own words – which are somewhat unreliable – he had already discovered African and Pacific art as early as 1902, at the ethnographical museum in Dresden. However, this did not begin to influence his own art until about 1909. Photographic evidence from his studio at 65, Berliner Strasse – which he had taken over from Heckel in 1906 – suggests that he began to decorate it with exotic motifs in 1910. These photographs show that Kirchner had decorated his studio with murals and curtains which he had designed himself. Using the reduced symbolic language of batik, he depicted exotic animals, figures, loving couples in various positions, and floral themes.

It was not until 1911, when Kirchner moved to Berlin, that he began to turn his attention to life in the city as one of his major artistic themes. Although he had already depicted circus and music hall scenes during his Dresden years, he had been mainly searching for the foreign and exotic element in those motifs. This can be seen quite clearly in the titles: *Negro Dance* (p.19), *Csardas Dancers, Hungarian Dance, Romanian Artistes, Japanese Theatre* and *Panama Dancers*. However, his famous Berlin street scenes were anticipated – at least thematically – by his painting *The Street* (also known as *Street in Dresden*, p.26) of 1908, which he reworked in 1919. Kirchner is also known to have painted several townscapes during those years, but they are no more than isolated instances in a period when he concentrated mainly on human figures. Again, there are broad contours, encompassing all the individuals and merging them into a solid mass of people. This portion is mainly black, with dark shades of blue, and it contrasts sharply with the pavement

PAGE 26:
Ernst Ludwig Kirchner:
The Street (also: Street in Dresden), 1908
Die Strasse (auch: Strasse in Dresden)
Oil on canvas, 150 × 200.4 cm
Museum of Modern Art, New York

PAGE 27:
Ernst Ludwig Kirchner:
Dodo and Her Brother, around 1908
Dodo und ihr Bruder
Oil on canvas, 170.5 × 95 cm
Museum of Art
Smith College, Northampton (Mass.)

Ernst Ludwig Kirchner:
Woman's Head with Sunflowers, 1906
Frauenkopf mit Sonnenblumen
Oil on hardboard, 70 × 50 cm
Burda Collection, Offenburg

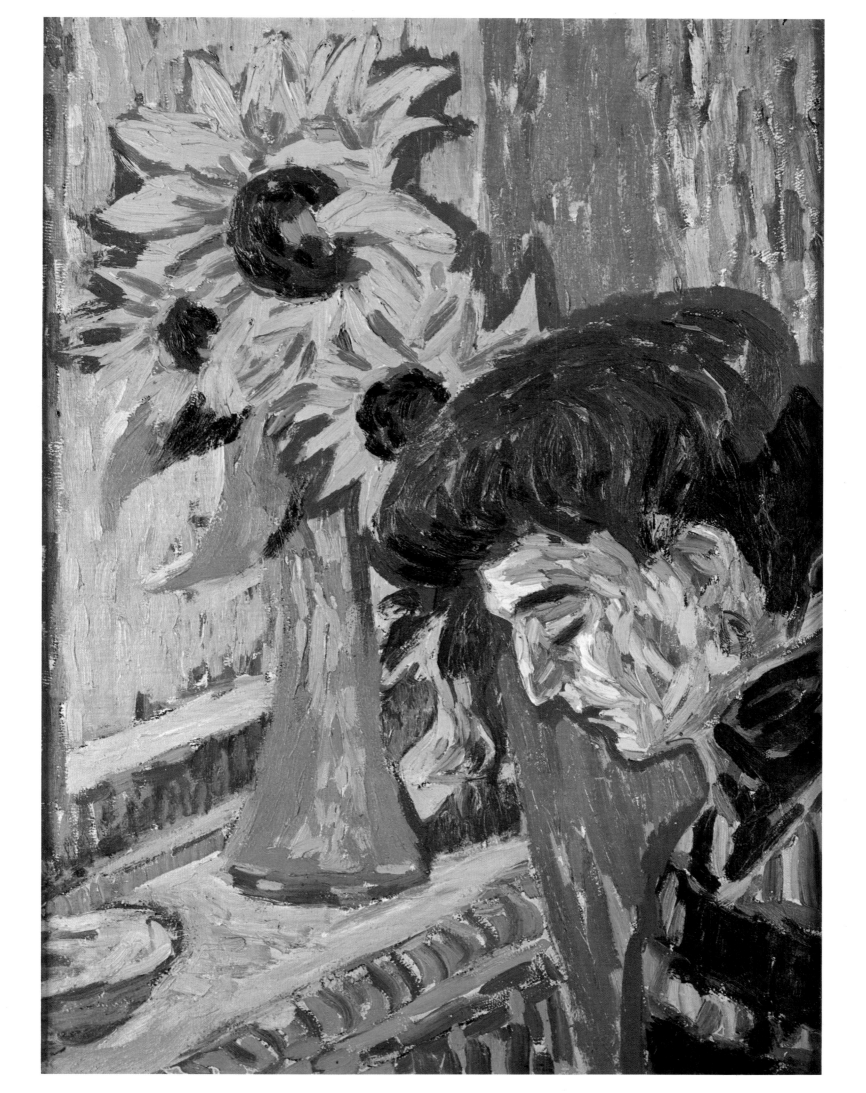

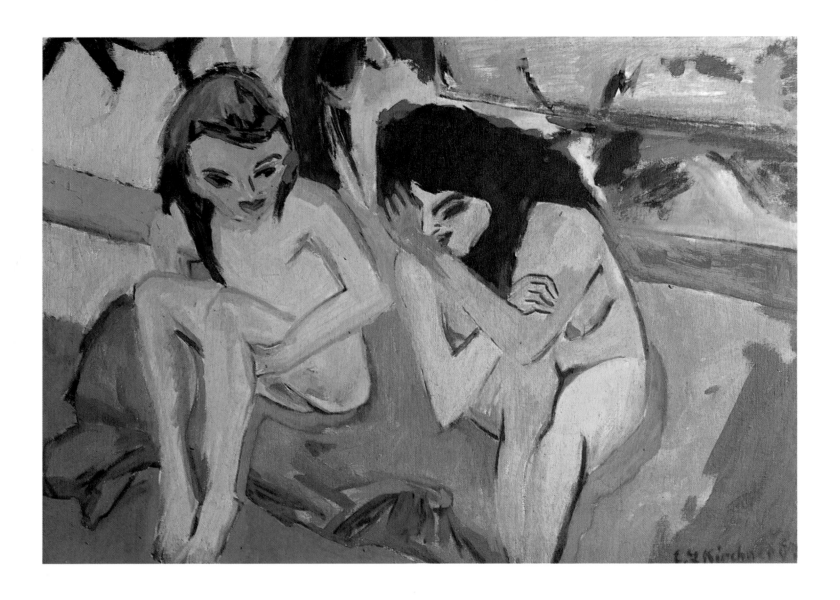

which is almost equally large, but structured more delicately and painted in light shades of pink. Only two female figures – facing the viewer – stand out from the anonymous crowd with any individuality at all. They are typical, well-to-do middle-class women of the time. With her brightly coloured blouse, the younger woman is quite conspicuous against her dark surroundings and immediately attracts the eyes of the viewer. But in spite of her broad-rimmed hat, she does not in the least appear a woman of the chic world of fashion. Nor is she a precursor of those metropolitan prostitutes whom Kirchner painted in Berlin between 1913 and 1915. And the soft, round brushwork put *The Street* even more firmly into Kirchner's early creative phase.

There must have been a reason, of course, why Kirchner anticipated the theme of the city which he did not take up again until five years later,

Ernst Ludwig Kirchner:
Two Girls, around 1910
Zwei Mädchen
Oil on canvas, 75 × 100 cm
Kunstmuseum, Düsseldorf

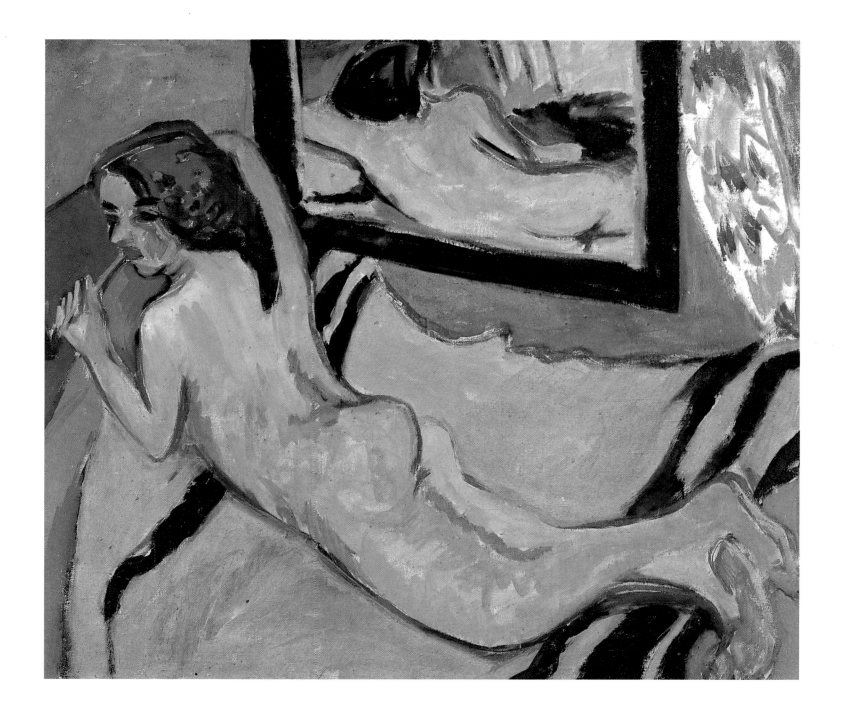

Ernst Ludwig Kirchner:
Reclining Nude with Mirror, 1910
Liegender Akt vor Spiegel
Oil on canvas, 83.3 × 95.5 cm
Brücke Museum, West Berlin

when he painted some magnificently impressive paintings on the subject. From 1902 onwards, the Norwegian painter Munch had exhibited his art several times in Dresden. The last occasion had been 1906, when 20 of his paintings were displayed at the spring exhibition of the Saxon Art Society. It is impossible to determine nowadays whether Munch's *Evening on Karl Johan* of 1892 (p.10) was among them or whether Kirchner had seen the picture elsewhere. Today it seems indisputable that Munch had some influence on his art, even though Kirchner always vehemently denied such a possibility and even tried to assert the exact opposite. Even as late as 1926, Kirchner wrote in his diary: "I know that Munch has long been taking an interest in what I'm doing and that he has imitated me quite a lot. So far as the public is concerned, however, it's all the other way round and people say that I stole his ideas."

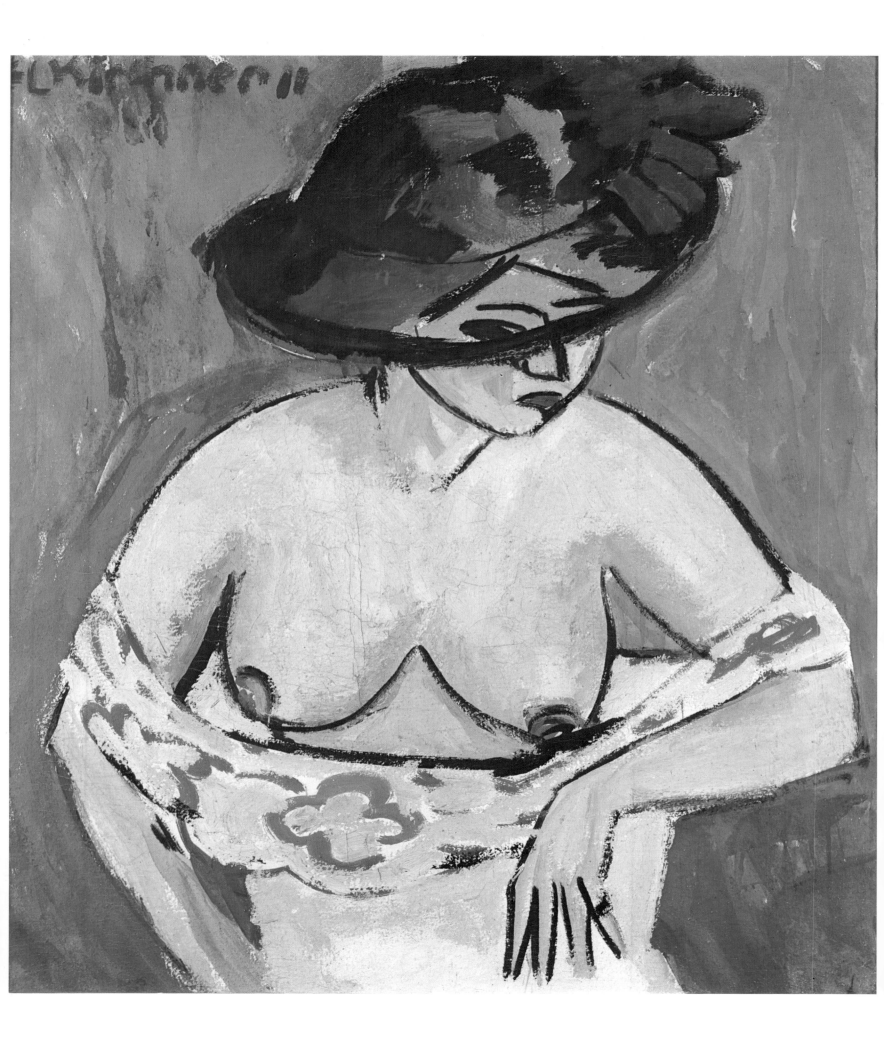

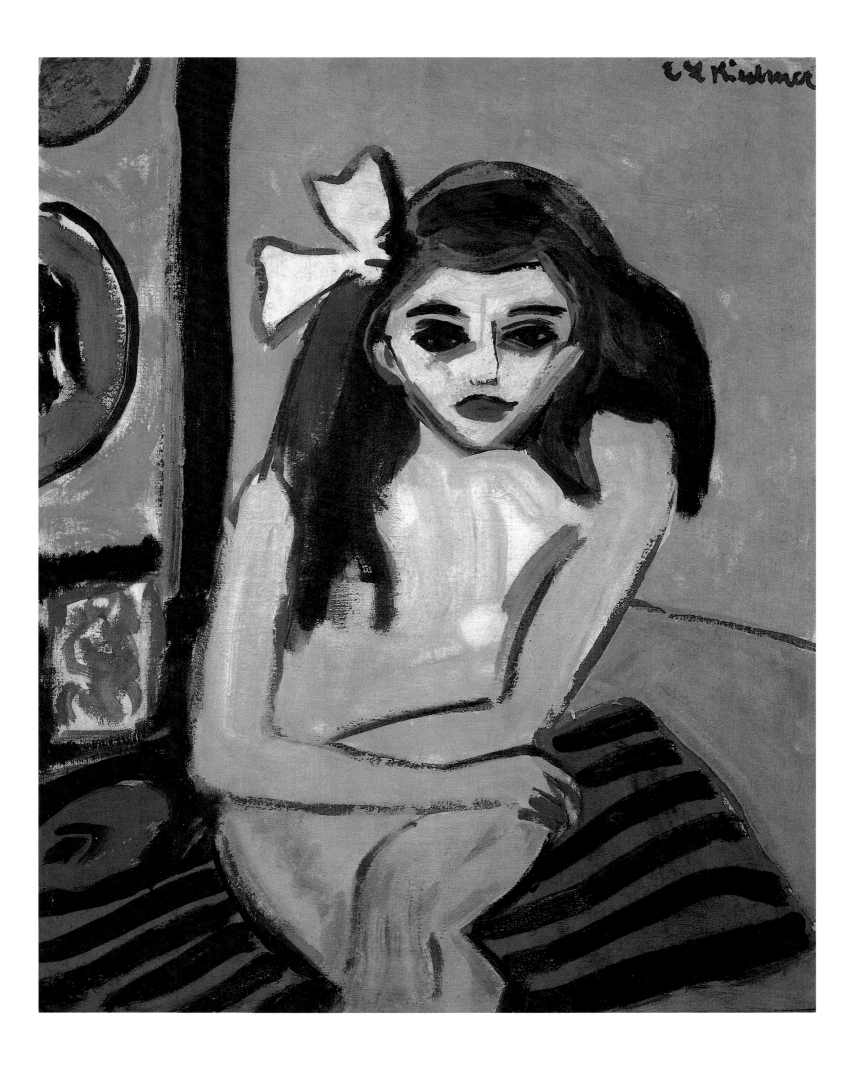

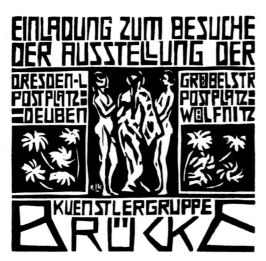

Ernst Ludwig Kirchner:
Invitation to the *Brücke* exhibition in the exhibition room of Seifert's lamp factory in Dresden-Löbtau, October 1906
Woodcut, 10.1 × 10.1 cm

Ernst Ludwig Kirchner:
Red Elizabeth Bank in Berlin, 1912
Rotes Elisabethufer in Berlin
Oil on canvas, 101 × 113 cm
Staatsgalerie moderner Kunst, Munich

PAGE 32:
Ernst Ludwig Kirchner:
Female Nude with Hat, 1911
Weiblicher Akt mit Hut
Oil on canvas, 76 × 70 cm
Museum Ludwig, Cologne

PAGE 33:
Ernst Ludwig Kirchner:
Marcella, 1909/10
Oil on canvas, 76 × 60 cm
Moderna Museet, Stockholm

In 1909, Kirchner first visited Berlin on two short occasions. In 1910, he went to stay for a longer time and painted his first views of the city. But it was not until 1911 that he actually settled down in a part of Berlin called Wilmersdorf. Pechstein, who had been living in the capital since 1908, drove it home to the other *Brücke* artists that artistic recognition and financial success were far more likely in Berlin than in Dresden.

The change of abode from provincial Dresden to the hectic life of a big city had a far more noticeable effect on Kirchner's art than on that of the other *Brücke* artists. His sensitive spirit responded to the new environment more intensively and with a far more lasting effect. And even though he continued to concentrate on the themes of the music hall and studio, he nevertheless changed the quality of his style. Until then, Kirchner had still beeen under the influence of Art Nouveau, but his rounded brushwork now turned into nervously angular series of little strokes. The colours are no longer side by side, in thinly painted surfaces, but penetrate and merge into each other. The fact that Kirchner called his views of Dresden "town*scapes*" says a lot about the character of these works. Following the example of harmonious landscapes, he merges walking people into one unit, together with lines of streets and house fronts.

This is impressively emphasized by Kirchner's powerfully rhythmic brush-strokes in his *Red Elizabeth Bank*, painted in Berlin in 1912 (p.35). It is a painting of the Luisen Canal with its two banks linked by a bridge in the background. The trees, planted on either side of the canal, draw the viewer's gaze into the depths of space and guide him towards the church at the back, the Melanchtonkirche. Against the wan, greenish grey paleness of the painting, its red brick façade shines forth like a beacon. This red colour recurs only in the two bridge piers and another building at the back. Together, they form the corners of an imaginary square that seems to have been written into the composition. The streets, the banks of the canal and the bridge appear to be totally empty of people. The viewer has to look twice before he notices two figures in the right-hand corner. In contrast to his Dresden paintings, Kirchner often showed the city of Berlin as something that excluded man and was isolated, unreal and threatening. This tendency became even more noticeable in later paintings, such as *The Red Tower in Halle* (1915, p.25). The city's architecture was shown as the exact opposite of nature. In Berlin, the harmonious townscapes of Dresden were supplanted by the architecture of the big city.

The sort of person who actually inhabits the city found his way into Kirchner's art in quite a different way. The artist isolated him from his architectural environment. Topographical landmarks in Kirchner's famous street scenes between 1913 and 1915 were reduced to an absolute minimum and he concentrated entirely on psychological depictions of human being. It was with these works that Kirchner's art developed his full maturity. He painted nine large paintings on this topic (cf. also p.39), of which the last was *Women in the Street* (1915, p.40). He also produced numerous drawings and printed graphics of similar scenes pp.38 and 42.

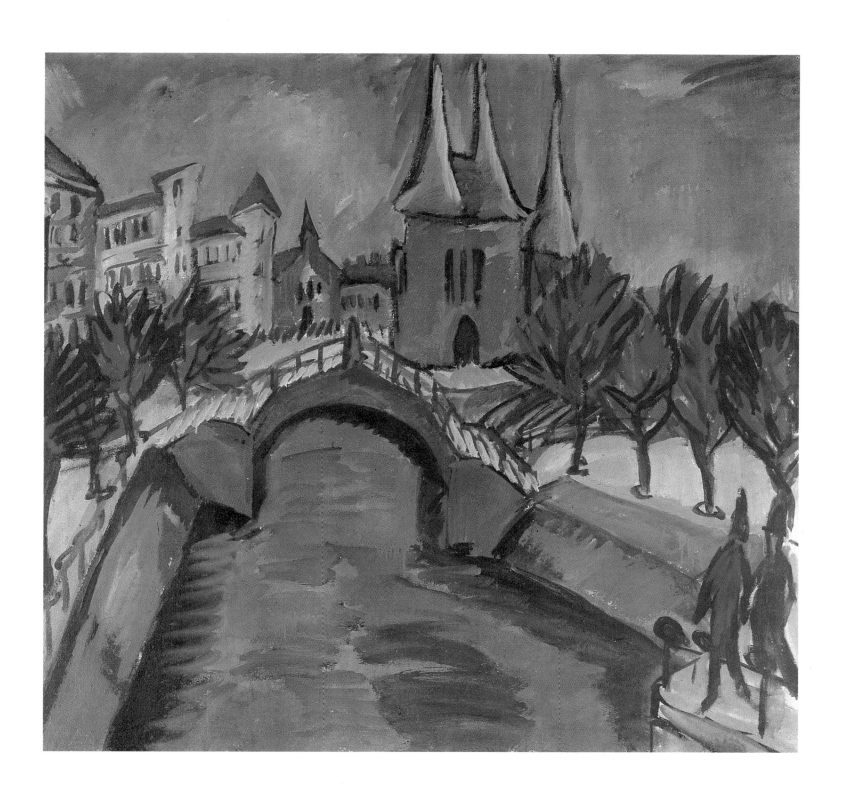

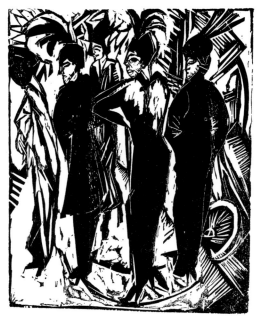

Ernst Ludwig Kirchner:
Five Prostitutes, 1914
Fünf Kokotten
Woodcut, 49.5 × 37.8 cm

PAGE 36:
Ernst Ludwig Kirchner:
The Judgment of Paris, 1912
Das Urteil des Paris
Oil on canvas, 111.5 × 88.5 cm
Wilhelm Hack Museum, Ludwigshafen

PAGE 37:
Ernst Ludwig Kirchner:
Stepping Gingerly into the Sea, 1912
Ins Meer Schreitende
Oil on canvas, 146.5 × 200 cm
Staatsgalerie, Stuttgart

Ernst Ludwig Kirchner:
Street Scene in Berlin, 1913
Berliner Strassenszene
Oil on canvas, 121 × 95 cm
Brücke Museum, West Berlin

A line of several couples is coming towards the viewer from the depth of the painting with energetic steps. The first couple has advanced right to the front, and their elongated, angular bodies occupy the whole length of the picture. The woman of the world, self-confidently erect, has been placed right at the centre of the composition, where she dominates the entire painting. The gentleman beside her has been assigned a secondary position, simply by virtue of his quiet, grey clothes and his dejected expression. The setting is difficult to make out, except that some architecture is indicated in the background – an arched bridge on the left and a building on the right. The people in the painting are devoid of any individual portrait-like traits. Instead, Kirchner's models are a certain type of city person, characterized by a particular posture as well as elegant, fashionable clothes. The artist, who found quite a few of his motifs in nightclub districts and the appropriate establishments, was fascinated by the coquettish behaviour of Berlin's prostitutes.

The entire theme of *Women in the Street* has been immersed in a venomously unreal sheen of green and yellow – colours with an aggressive luminosity that stresses the angularity of the women's bodies even more. The calm coloured surfaces with the clear contours which prevailed in Kirchner's earlier paintings have been replaced with hectic brush hatchings, which create overlaps between different areas. The artist's psychological sensitivity, unrest and nervousness are dynamically expressed in the harsh graphic quality. Indeed, lines have become visible reflections of the artist's state of mind. Kirchner himself very aptly described his rhythmic brushwork as "power lines", thus showing that he must have had some knowledge of Futurist works and ideas. And when we consider the couples moving from the background towards the front, we may even want to see them as a simultaneous sequence of movements in a Futurist sense.

In his unstable, over-excited state of mind, Kirchner became increasingly isolated, both privately and as an artist. It was in Berlin's prostitutes, who were equally ostracized by society, that he found his match. The time when artists and models could simply enjoy each other's company at the Moritzburg Lakes was definitely over. In Berlin, the individual was lost in the anonymity of respectable middle class society and the demimonde. This can be seen very clearly when we compare his Moritzburg nudes of 1910 and – a theme along similar lines – *Stepping Gingerly into the Sea* (p.37), painted on the Isle of Fehmarn in 1912. There can be no doubt that his move to Berlin had resulted in a change of expression and style.

The soft, rounded bodies of Kirchner's Dresden models had been replaced by tectonically elongated nudes. Kirchner had a private explanation for this development. In 1911, he and Dodo – his Dresden companion – separated, and he met Erna Schilling. She represented a completely new type of woman for him, and he felt that she was responsible for the change of style that was taking place in his art at the time: "The way in which I depicted people was now influenced very strongly by my third

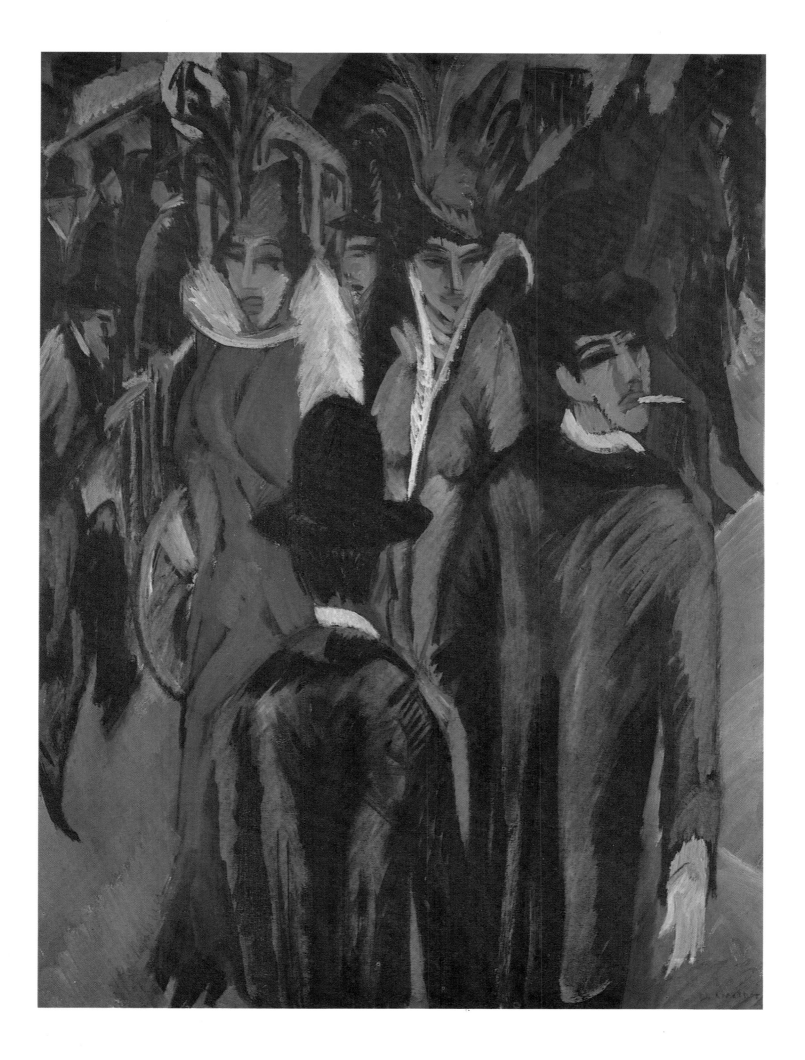

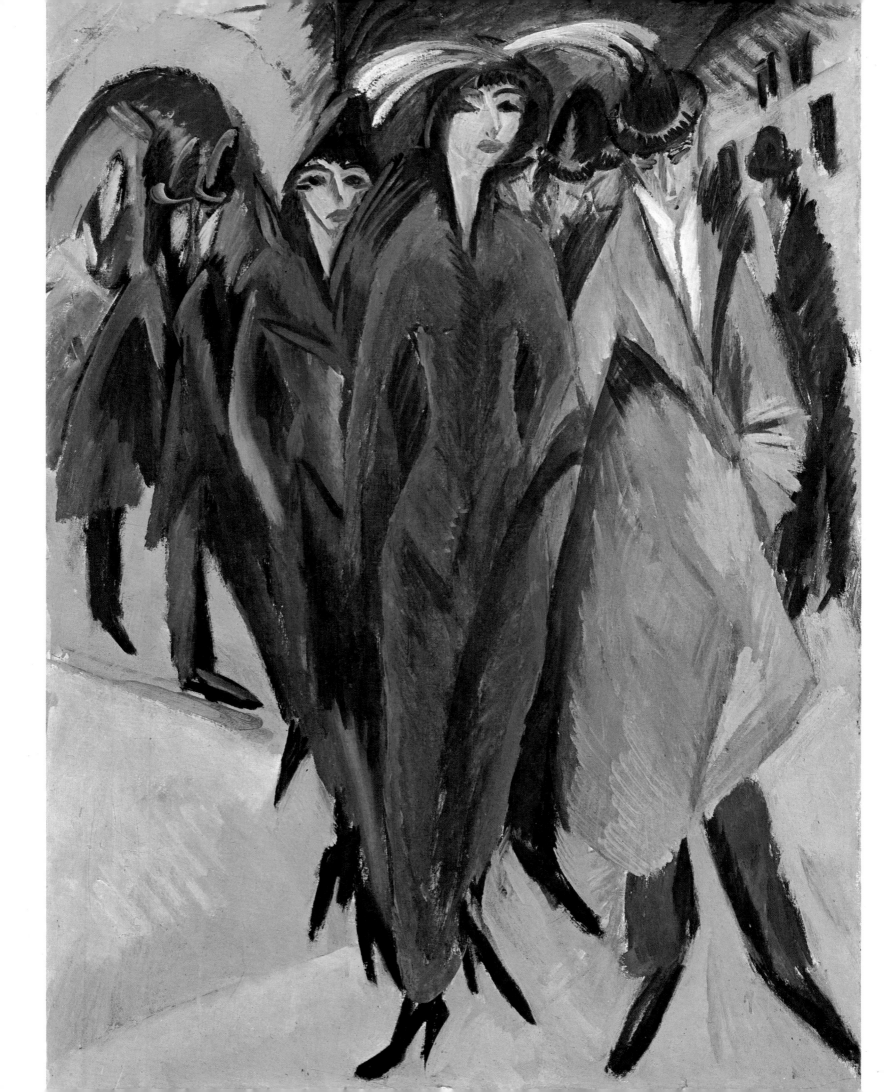

wife, a Berlin woman, who shared my life from this point on, and her sister. The beautiful, shapely, architectonically structured bodies of these two girls replaced the soft Saxon bodies."

Eventually, though, Kirchner did find the recognition as an artist which he had been hoping for. In spring 1912, the *Brücke* artists mounted their first large-scale exhibition at Fritz Gurlitt's gallery. This was soon followed by Kirchner's first solo exhibitions – at the Folkwang Museum in Hagen and then again at Gurlitt's. In April 1914, he was able to move into a new, larger studio in a part of Berlin called Friedenau, which he again decorated with his own painted murals.

In August 1914 the First World War broke out, and Kirchner enlisted as an "involuntary volunteer", as he described himself years later. However, being of rather a sensitive disposition, the artist was unable to bear either the uniformity of the military forces, which stifled all individuality, or the constant fear for his own life. In September 1915, after only a few months, he suffered a physical and psychological breakdown and was discharged until further notice. It was in the same year that Kirchner painted his two most powerful and convincing self-portraits, *The Drunkard* (Germanisches Nationalmuseum, Nuremberg) and *Self-Portrait as a Soldier* (p.22 and front cover).

Kirchner's *Self-Portrait as a Soldier* was an expression of his psychological and physical suffering as well as his inability to continue his work as an artist under those conditions. In a letter to Karl Ernst Osthaus, he confessed that he could only work at night. The portrait shows Kirchner in the uniform of his field artillery regiment. He has turned away from the nude in the background – one of his typical motifs – and is looking towards us. However, he cannot establish any eye contact, because his eyes are empty, hollow and dead. As a symbol of his dead creativity, he stretches forth the bloody stump of his right arm, while at the same time trying to keep his balance by clutching at the back of a chair. The painting is dominated by glowing red colours, whose aggressive impact is further enhanced by their contrast with the black uniform.

Kirchner's poor state of health meant that, from December 1915 onwards, he frequently spent some time in a sanatorium – first in Königstein in the Taunus region, then in Charlottenburg (Berlin) and finally, in 1917, in Switzerland. While under medical supervision, he suffered from symptoms of paralysis, a persecution complex and the intense anxiety that he might be healed and would then have to serve in the army again. He secretly refused to eat, and it was not until his doctor reassured him that he was too weak ever to be a soldier again that Kirchner ceased to resist the healing process. In July 1918, he was discharged from the sanatorium in Kreuzlingen, even though he was still not completely well.

Instead of returning to Germany, Kirchner then rented a farm on the *Längmatte*, near Frauenkirch in Switzerland. Far away from the big cities, with the simple farming people of Davos as his neighbours, he rediscovered that natural, spontaneous community spirit, which he had been trying so hard to find on his trips to the Moritzburg Lakes. Gradually

Ernst Ludwig Kirchner:
Women in the Street, 1915
Frauen auf der Strasse
Oil on canvas, 126 × 90 cm
Von der Heydt Museum, Wuppertal

41

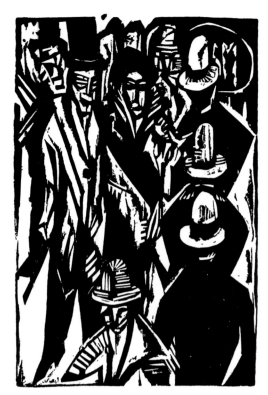

Ernst Ludwig Kirchner:
Public Strolling in the Street, 1914
Flanierendes Publikum auf der
Strasse
Woodcut, 29.2 × 18.2 cm

he overcame his illness, though he was too sensitive ever to be completely healthy again. In numerous works he reflected upon his own situation: *Self-Portrait as a Sick Man* (1917/29; Staatsgalerie moderner Kunst, Munich), *The Sick Man's Head, Self-Portrait* (1917; woodcut), *Self-Portrait with Dancing Death* (1918; woodcut).

Kirchner was fascinated by the mountains and the people whose lives were completely subject to the forces of nature, the changes of day and night and the rhythm of the seasons. It seems that in his painting *Alpine Pageant* (Kunstmuseum St. Gallen) he was trying to conjure up this harmony of man and animal, as it were. In other works, however, we can feel the meaninglessness and futility of man in relation to the gigantic world of the mountains. This theme can also be found in *Moonlit Alpine Pasture* of 1919 (p.44). It was in such a pasture that Kirchner inhabited a simple mountain refuge. There are no longer any people in this painting, and their presence can merely be deduced from the line of little Alpine houses, huddling against the ascending mountain slope as if seeking protection, which divides the composition diagonally. The bright moon, visible above the nocturnal scenery, only illuminates the high mountains in the background. The furthest optical point – though placed at the centre of the viewer's attention – is the prominent silhouette of the Tinzenhorn, a mountain at the southern end of the Davos valley, towering above it as its symbolic landmark. At that time, Kirchner almost obsessively used to depict the Tinzenhorn again and again in his graphic prints, drawings and paintings. Painted with powerfully angular clusters of brush-strokes, the *Moonlit Alpine Pasture* is full of movement, with its focal point in the bottom right-hand corner and spreading eruptively over the entire theme. This may well have been the last time that Kirchner's brushwork approached the expressiveness of his Berlin street scenes. The colour scheme, consisting of green, purple, pink and yellow, creates a mood which seems solemn and unreal.

Kirchner, who had never found it particularly easy to socialize, became more and more eccentric, fearful and suspicious towards other people. This was partly due to his illness, from which he never managed to recover completely, and partly to his isolated life in the remote Swiss mountains, far away from Berlin and without any contact with either his artist friends, or with collectors or gallery owners. As early as 1919, Erna sent several consignments of his works to Switzerland, works which had previously been stored in his Berlin studio. Kirchner immediately began to re-work quite a few of them – including his early Dresden *Street* of 1908 – and also to change their dates. There are a number of paintings and drawings among his works which were originally created in about 1909, but which Kirchner had decided to pre-date between 1902 and 1904. Thus, he wanted to cement his claim to leadership among the *Brücke* artists, while proving at the same time to other artists, such as Munch, that he alone had initiated and developed all the important stylistic developments of the group. And to make sure that his art was treated with the appropriate respect by art historians, he insisted that all

authors who wrote about him submitted their texts for him to edit. Grohmann's publications of 1925 and 1926 must therefore be regarded, in part, as Kirchner's own words. On other occasions, Kirchner wrote the articles himself, under the pseudonym of a certain French doctor, called Louis de Marsalle, with titles such as "Zeichnungen von E.L. Kirchner" (Drawings by E.L. Kirchner) and "Über die Schweizer Arbeiten von E.L. Kirchner" ("On the Swiss Works of E.L. Kirchner). In a letter to the collector Gustav Schiefler, Kirchner even praised Marsalle's excellent interpretations of his work: "Incidentally, I am sending you this essay which will be of interest to you. It was written by my local friend de Marsalle, who had, I think, simply an ideal way of writing."

His diary, in particular, is full of malicious, mostly untenable, accusations against gallery owners who tried to cheat him, and against former *Brücke* companions who had supposedly stolen his ideas and were trying to harm him wherever they could. After a visit to an exhibition in Zurich, he wrote the following note on 19 September 1925: "Heckel looks really bad. And there's nothing left of that former forcefulness, his pictures look fake and ugly, he imitates everything, especially me ... Well, Heckel has always imitated others, he has just been very crafty so that nobody has ever noticed." Indeed, Kirchner rather preferred to forget all about his former *Brücke* membership. This is why it was all the more surprising when, in 1926/27, he painted a large-format picture of human figures called *The Painters of Die Brücke* (p.14) as a supposedly programmatic homage to the *Brücke* group.

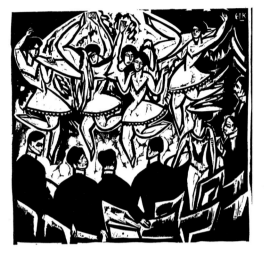

Ernst Ludwig Kirchner:
Dances on the Skating Rink,
between 1909 and 1912
Eispalasttänze
Woodcut, 23.7 × 23.5 cm

It was in December 1925 that Kirchner first returned to Germany for several months, going to Frankfurt and Chemnitz and then spending more time in Dresden and Berlin. His return to the old places where the *Brücke* artists had been active must have re-awakened sentimental reminiscences in the artist's mind of the years when they had worked together. And so it seems as if, for a short while, he managed to forget the distance between himself and his former friends. However, this impression is deceptive. The people who are depicted full length in a small room are Mueller, Kirchner, Heckel and Schmidt-Rottluff. Except for the Swiss painter Amiet, who did not take any active part in the life of the group, these were the four members of the group when it was dissolved in 1913. The independent-minded Mueller is sitting in the left-hand corner, slightly apart from the others, on a small stool. The other three painters are standing closely together. Schmidt-Rottluff – in the foreground, on the right – occupies the entire length of the painting. Next to him, at the centre of the composition, stands Heckel, the confident manager and driving organizational force of the group. However, not Heckel but Kirchner himself seems to be the central figure in this painting, bowing down to Heckel and Schmidt-Rottluff from the background, with a large document in his left hand. Its layout – a text with two illustrations in the top left and bottom right-hand corners – points to the fact that it is a double page from Kirchner's *Chronik der KG Brücke* (Chronicle of the Brücke Artists' Circle) of that year. The argument about this Chronicle is the real topic of

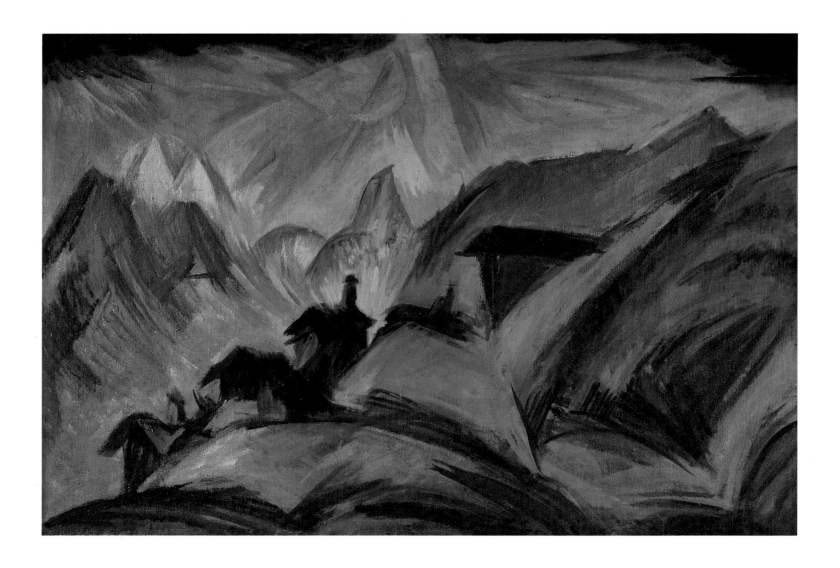

the painting. Kirchner's *The Painters of Die Brücke* is therefore by no means a sentimental reminiscence, but an artistic attempt to justify, in retrospect, his own position and to protest his own innocence in the breakdown of the *Brücke* . After the quarrel about the Chronicle, Kirchner depicts himself in this painting as willing to be reconciled again.

Kirchner's choice of the pseudonym Louis de Marsalle shows that he also wanted his art to be successful in France. In 1925, the formal achievements of Cubism, which had started in Paris, began to influence his own work. They continued to do so quite considerably for about a decade and brought about a conspicuous change of style. 1925 was the year of the *Great International Art Exhibition* in Zurich , and Kirchner subsequently noted down his impressions in his diary. Hardly any of the exhibiting artists was at all adequate in his view. Picasso alone prompted a measure or approval: "The strangest and best one is undoubtedly Picasso." From then onwards, as he expressed himself under his pseudonym, de Marsalle, Kirchner began to "try and establish a link between today's German art and modern stylistic ideas." The typical

Ernst Ludwig Kirchner:
Moonlit Alpine Pasture, 1919
Staffelalp bei Mondschein
Oil on canvas, 138 × 200 cm
Museum am Ostwall, Dortmund

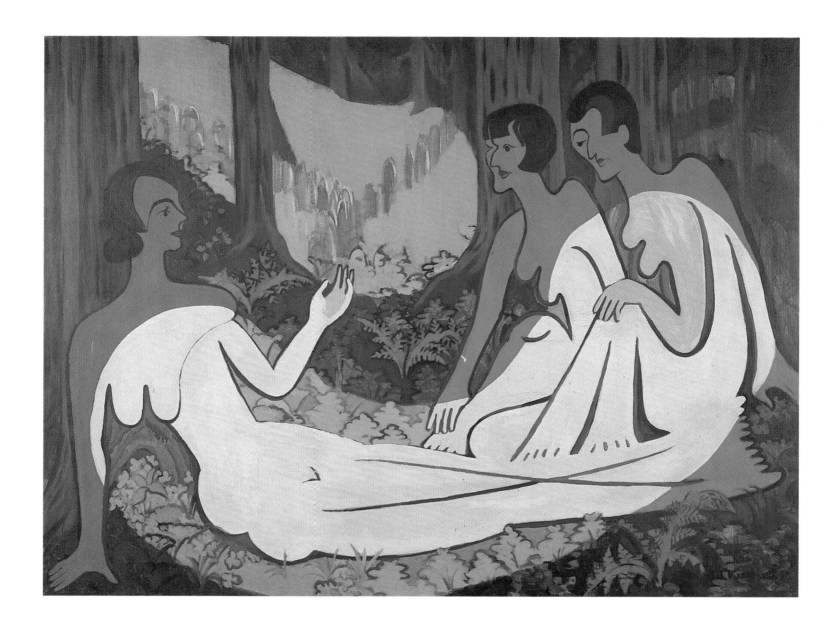

Ernst Ludwig Kirchner:
Three Nudes in the Woods, 1934/35
Drei Akte im Wald
Oil on canvas, 149 × 195 cm
Wilhelm Hack Museum, Ludwigs-
hafen

vividness of his brushwork now turned into a thin, particularly effective application of paint. Surfaces and decorative lines assumed independent proportions and detached themselves from the subject-matter. His painting *Three Nudes in the Woods* (above) is a typical example of this phase in Kirchner's oeuvre, which is generally regarded as his "abstract" style.

From the distance of the Swiss mountains, Kirchner observed with great interest and at the same time increasing concern the new cultural activities in Nazi Germany. The illness, from which he never quite managed to recover, as well as the defamation of his art as "degenerate" were undoubtedly factors which contributed to his suicide on 15 June 1938.

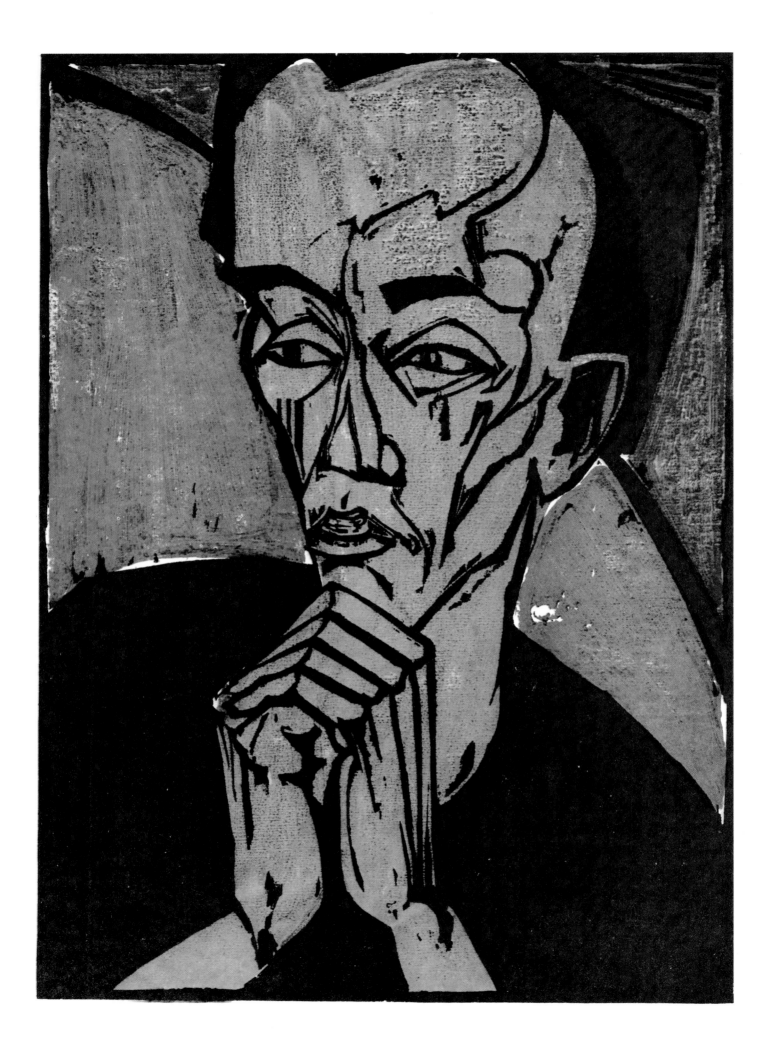

Erich Heckel

Erich Heckel had the central role of mediator in the *Brücke* circle. He had a good deal of organizational talent and therefore took it upon himself to look after the circle's correspondence and its rapidly increasing activities. If Kirchner, in his Chronicle of 1913, was able to enumerate joint exhibitions in most major German cities as well as foreign ones, it was mainly due to Heckel's commitment and his skill in negotiating. It was partly because of his endeavour to seek contacts with the new Munich artists, especially Marc, that the *Brücke* was mentioned in the almanac of the *Blaue Reiter* in 1912. And in 1906 Heckel rented the small empty shop in Berliner Strasse, Friedrichstadt (a part of Dresden), where the artists spent most of their time sitting together, painting and discussing their pictures.

Heckel was born in Döbeln, Saxony, in 1883. His father was a railway engineer, and it was in the nature of his job that the whole family had to move around quite a lot. In 1897, they finally moved to Chemnitz, where Heckel went to the local grammar school and met Karl Schmidt – who came from a place called Rottluff – in 1901. Later, Heckel recalled his early interest in drawing, and his list of graphic prints shows that he had made woodcuts as early as 1903. Nevertheless, when he left school in 1904, he decided to study architecture at the Institute of Technology in Dresden. Both Heckel and the other founder members of the *Brücke* regarded architecture as a compromise with their respectable middle class parents who would never have supported them if they had wanted to study art. Although architecture was mainly geared towards practical and technical skills, it left a certain amount of space for creativity. However, when Wilhelm Julius Heckel finally changed his mind and decided to sponsor his son for a course in art, Heckel rejected this proposal because he was worried that it might spoil his unadulterated approach to art.

Heckel only stayed at the Institute for eighteen months, and after the founding of the *Brücke* in June 1905, he gave up his course and accepted a job as a draughtsman at Wilhelm Kreis's architectural studio. Although the purpose of this job was merely to earn money, he managed to use it for the benefit of the *Brücke*. When the architectural firm was asked to

Erich Heckel:
Portrait of a Man (Self-Portrait), 1919
Männerbildnis (Selbstbildnis)
Coloured woodcut, 46 × 33 cm
Private collection

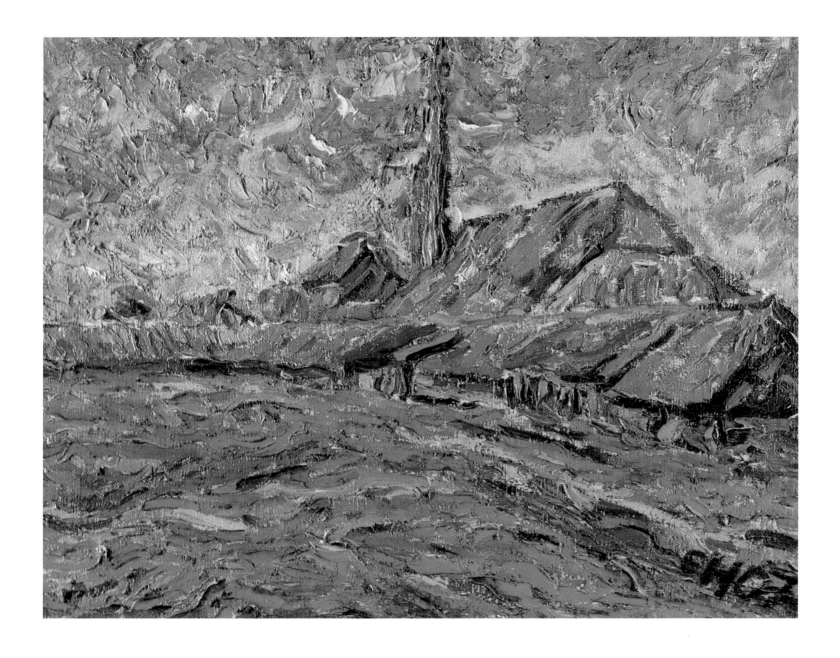

design an exhibition room for the lamp manufacturer Max Seifert, Heckel was able to persuade the industrialist that it was worth while giving wall space and display cases to the *Brücke* for an exhibition on his premises on the occasion of the inauguration.

Heckel's *Brücke* paintings up to 1913 can only be tentatively assessed nowadays. Too many of his paintings did not survive the terrors of the Nazi attacks on art – or a bomb which hit his studio in 1944. His oeuvre catalogue lists nearly four hundred paintings for the years 1905 to 1913, and more than half of them seem to have been destroyed or lost.

Heckel's early oil paintings display the same opaque Impressionist style that was so typical of all the other *Brücke* painters. At that time, Heckel still took the paint straight from the tube, without thinning it down, before applying it in short lines. Also, the early works were still painted on hard board, and the change to canvas did not come until 1907 that Heckel changed to canvas. Heckel then began to apply the paint

Erich Heckel:
The Brickyard (Dangast), 1907
Die Ziegelei (Dangast)
Oil on canvas, 68 × 86 cm
Thyssen-Bornemisza Collection,
Castagnola

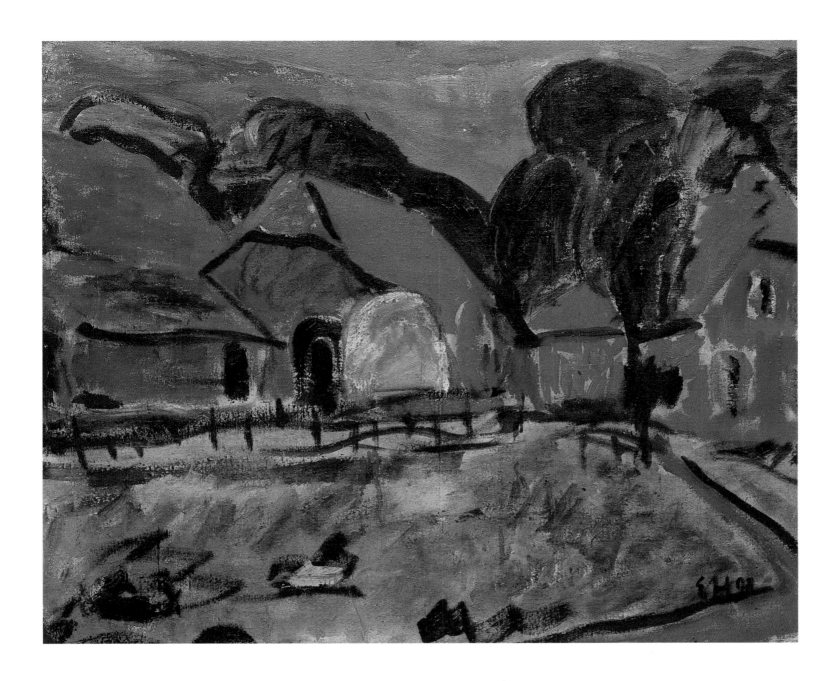

Erich Heckel:
Red Houses, 1908
Rote Häuser
Oil on canvas, 65.5 × 79.5 cm
Kunsthalle, Bielefeld

more generously, leaving the individual colour values next to one another so that, again and again, the surface was visible underneath. Thus, Heckel already emphasized the expressive value of each colour, and – unlike in Impressionism – it was not his aim that the viewer himself should have to mix the colours in his mind. His method of applying the paint set the entire composition flickering and shimmering – particularly the sky. A year later, when Heckel first saw paintings by van Gogh, he saw that he had been on the right lines.

In 1907, Heckel gave up his job at the architect's studio, and – in the autumn – went on a painting expedition to Dangast, together with Schmidt-Rottluff. There he painted *The Brickyard (Dangast)* (left), which is generally regarded as a key to his oeuvre. So far his touch had been loosely Impressionist, but now it became considerably firmer, with a broader division of the surface. It was at this time, too, that the contrasts between various colours became extremely important to him, and the

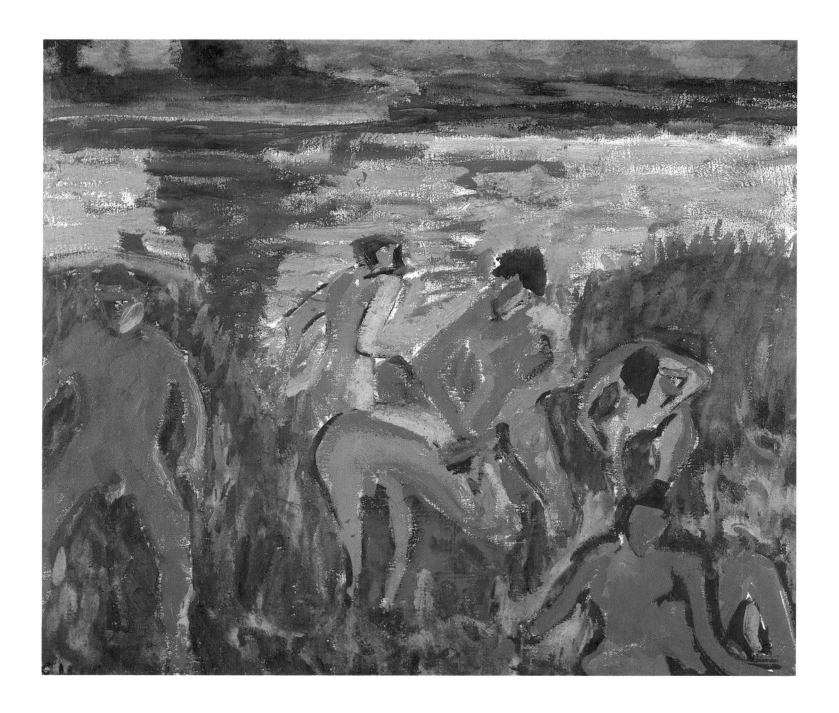

theme is dominated by the strong complementary contrast between the red brick roofs and the green meadows in the foreground.

Until 1908, Heckel's paintings were dominated mainly by landscapes, and especially by solitary farmyards around Dangast, where – until 1910 – the artist withdrew every year in order to paint on his own. His landscapes are therefore good examples of how he moved towards Expressionism and the typical *Brücke* style. In 1908, with *Red Houses* (p.49), Heckel reached his Expressionist stage. It is a painting which lends itself very nicely to a comparison, because its theme and colours are so similar to the *Brickyard* of the previous year. At the same time, however, we can see the stylistic differences even more clearly. The *Brücke* painters were aiming to record their immediate impressions as directly as possible and with swift brush strokes. Heckel therefore experimented quite exten-

Erich Heckel:
Bathers in the Reeds, 1909
Badende im Schild
Oil on canvas, 71 × 81 cm
Kunstmuseum, Düsseldorf

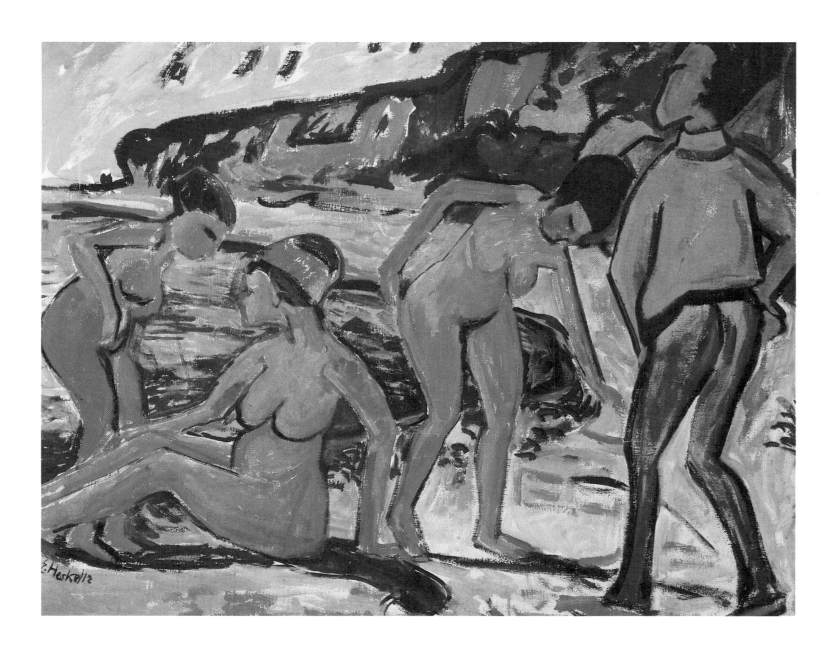

Erich Heckel:
Seaside Scene (Bathing Women),
1912
Szene am Meer (Badende Frauen)
Oil on canvas, 96 × 121 cm
Von der Heydt Museum, Wuppertal

sively with different thinners, including petroleum, so that the paint could be spread more smoothly. Only now did he manage to achieve the desired degree of genuine flatness when applying the paint, a technique which emphasized the expressiveness of pure colour values. Again, he made use of the complementary contrast between red and green, which served to enhance the luminosity of each colour. In *Red Houses* a narrow path leads from the front edge of the painting through some large green meadows to several buildings grouped round a farmyard. Like a red ribbon, the path spreads horizontally across the entire width of the picture. Some thick red trees protrude from behind the houses so that only a small area of blue sky is visible at the top of the picture. It is only in a few details – such as the window façade of the building on the right – that we can still clearly discern the hastiness of Heckel's brushwork.

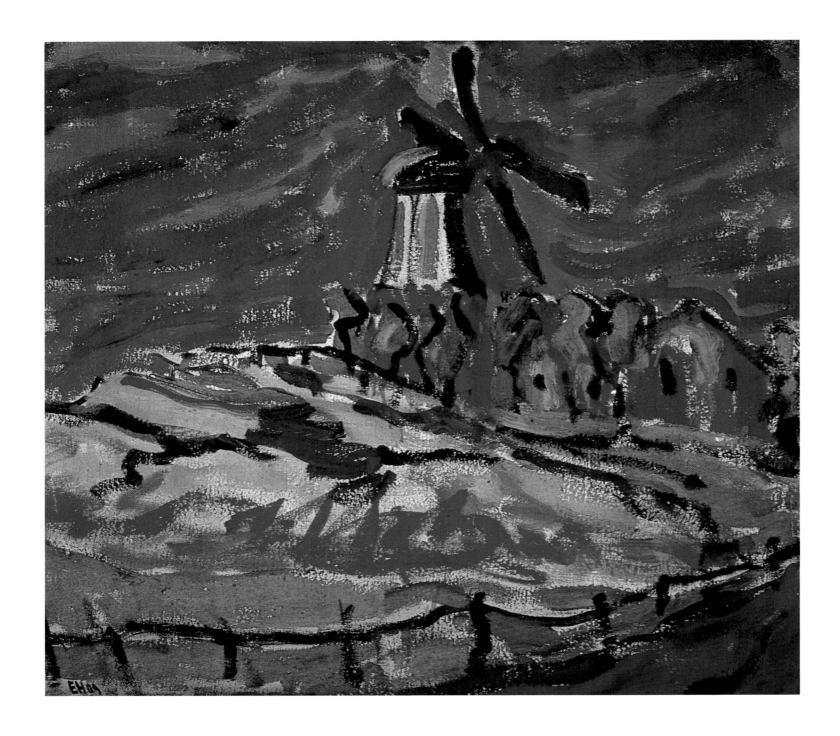

Otherwise, the colours combine to form large segments of the picture which are only separated from one another very sketchily and even incompletely, by means of black contours.

When the *Brücke* artists rebelled and turned away from traditional art as it was taught at the academies, they also rejected the idea of depth perspective. It is true, of course, that our visual experience leads us to discern a perspective hierarchy in the various elements in Heckel's *Red Houses* partly because we know that that there is a shape further back which is covered by other objects. Heckel, however, applied the paint in such a way that this visual experience was counteracted as far as possible. In doing so, he also detached the colours from the objects to which they belonged, thus emphasizing the artistic qualities of each of them

Erich Heckel:
Windmill near Dangast, 1909
Windmühle bei Dangast
Oil on canvas, 70.7 × 80.5 cm
Wilhelm Lehmbruck Museum,
Duisburg

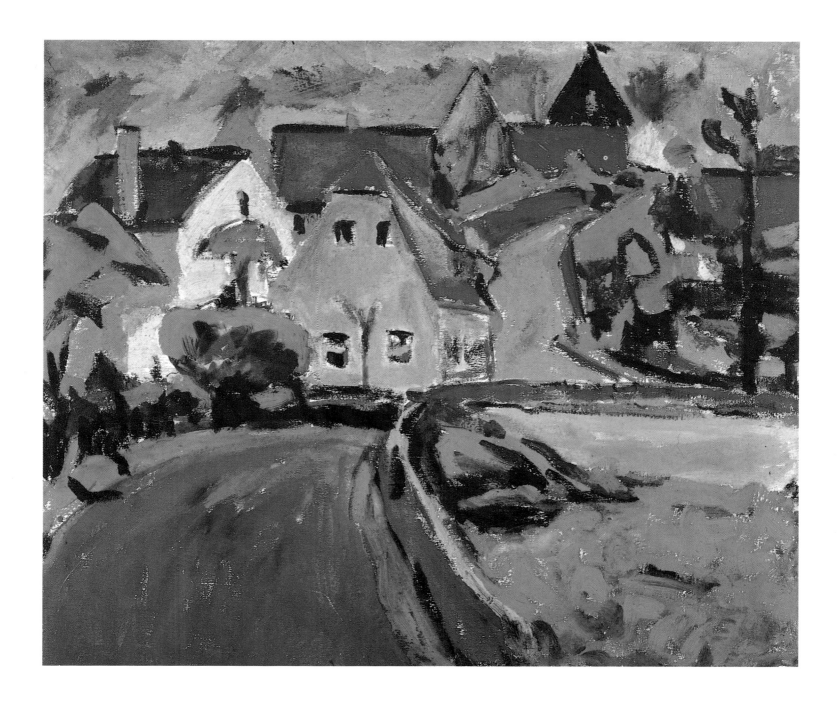

Erich Heckel:
Saxon Village, 1910
Sächsisches Dorf
Oil on canvas, 70 × 82 cm
Von der Heydt Museum, Wuppertal

within the composition. In a similar way, this also applies to his *Saxon Village* (p.53), painted two years later.

All the *Brücke* members, of course, regularly tried to balance their urban environment in Dresden – and later Berlin – with trips into nature. In the summer they would escape to the Moritzburg Lakes or the Baltic coast. It was Heckel, more than any of the others, who always found new ideas and themes for his art whenever he went to stay in the country for longer periods. Between 1907 and 1910 he spent quite a long time in Dangast each year. In 1909 he travelled to Italy for four months, visiting – among other places - Verona, Padua, Florence and Venice on his way to Rome. In 1910 and 1911 Heckel joined the other *Brücke* artists on the Moritzburg Lakes. And in addition, he travelled to Prerow on the Baltic in

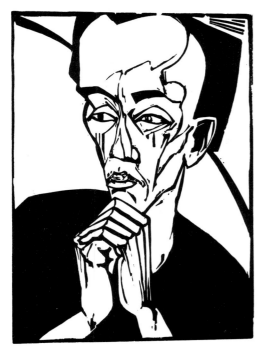

Erich Heckel:
Portrait of a Man (Self-Portrait), 1919
Männerbildnis (Selbstbildnis)
Woodcut, 36.5 × 27.5 cm

Erich Heckel:
Railway in Berlin between Gleis-
dreieck and Görlitz Station, 191
Stadtbahn in Berlin zwischen Gleis-
dreieck und Görlitzer Bahnhof
Oil on canvas, 60.5 × 77.4 cm
Städtisches Museum
Abteiberg, Mönchengladbach

1911, to Stralsund and Fehmarn in 1912, to Caputh in 1913 and, for the first time in his life, to Osterholz, near Flensburg. This may be why the cities made very little impact on his art – neither the leisurely atmosphere of Dresden nor the metropolis of Berlin. There are of course some isolated townscapes and paintings of cafés, music halls and circuses in his oeuvre catalogue of 1908 to 1913, but these are indeed exceptions and – unlike in Kirchner's works – did not signal any new stylistic directions in his art. One of these rare townscapes was painted in 1911, probably in the autumn, shortly after Heckel had moved to the capital and taken over Mueller's former studio in Steglitz. *Railway in Berlin* (p.55) is almost the exact counter-image of the harmonious Dangast landscapes with their closeness to nature. His picture of Berlin shows high-rise blocks of flats on either side of the road, converging centrally in the very depths of the painting. However, the vanishing point itself is covered by a raised railway line running horizontally across the picture, in front of the houses. Instead of the sketchy, colourful areas of his landscapes, Heckel used compact, geometrical blocks for his composition, as well as broad black contours. The human figures seem tiny, as if they had been pushed to the edge of the painting by the dominant architectural constructions. Although – like his *Red Houses* of 1908 – this picture is also dominated by the contrast between two colours, they are no longer cheerful colours. Red and green have been replaced by a menacingly unreal contrast between the yellowish brown sky, reflected by the colours of the façades, and the blue road.

Heckel's second major theme, after landscapes, was not so much the depiction of streets, but of human beings. During his Dresden years (until 1910), he produced almost exclusively paintings of nudes, mainly in his studio, but occasionally also on location, at the Moritzburg Lakes. *Bathers in the Reeds* (p.50) of 1909 is an excellent example. A group of naked figures are seen turning towards each other, except for a male figure who is standing apart from the others, on the left, and facing the viewer. However, this figure is separated from the rest of the group – who are more active – not only with regard to his position, but also the red colour of his body. Furthermore, he is engulfed by the green reeds, as if by an impenetrable wall. Even more than his Dangast landscapes, which were painted at the same time, Heckel's touch consists of swift and lively brush strokes which give coherence to all the shapes in the painting. This is particularly true of the figures, who are characterized exclusively by their contours, while their internal structures – including the faces – are concealed by the way in which the paint has been applied. Thus, though depriving each person of his individual character, Heckel managed to emphasize his artistic message even more clearly and unambiguously. *Bathers in the Reeds* is Heckel's contribution to the attempt of the *Brücke* artists to reconcile man and nature and to re-establish harmony between them.

And yet despite this rather summary method of depiction, we can in fact identify at least some of the people in the painting. Heckel spent the

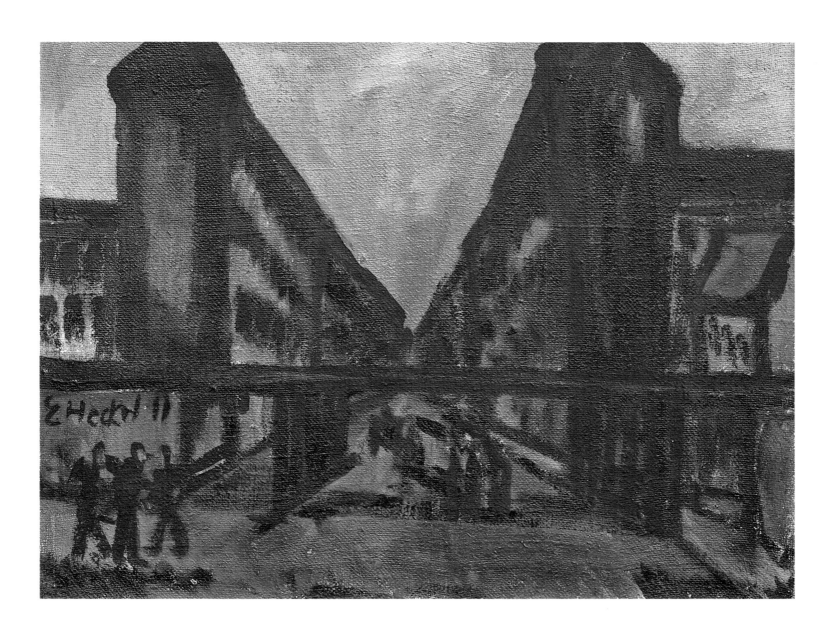

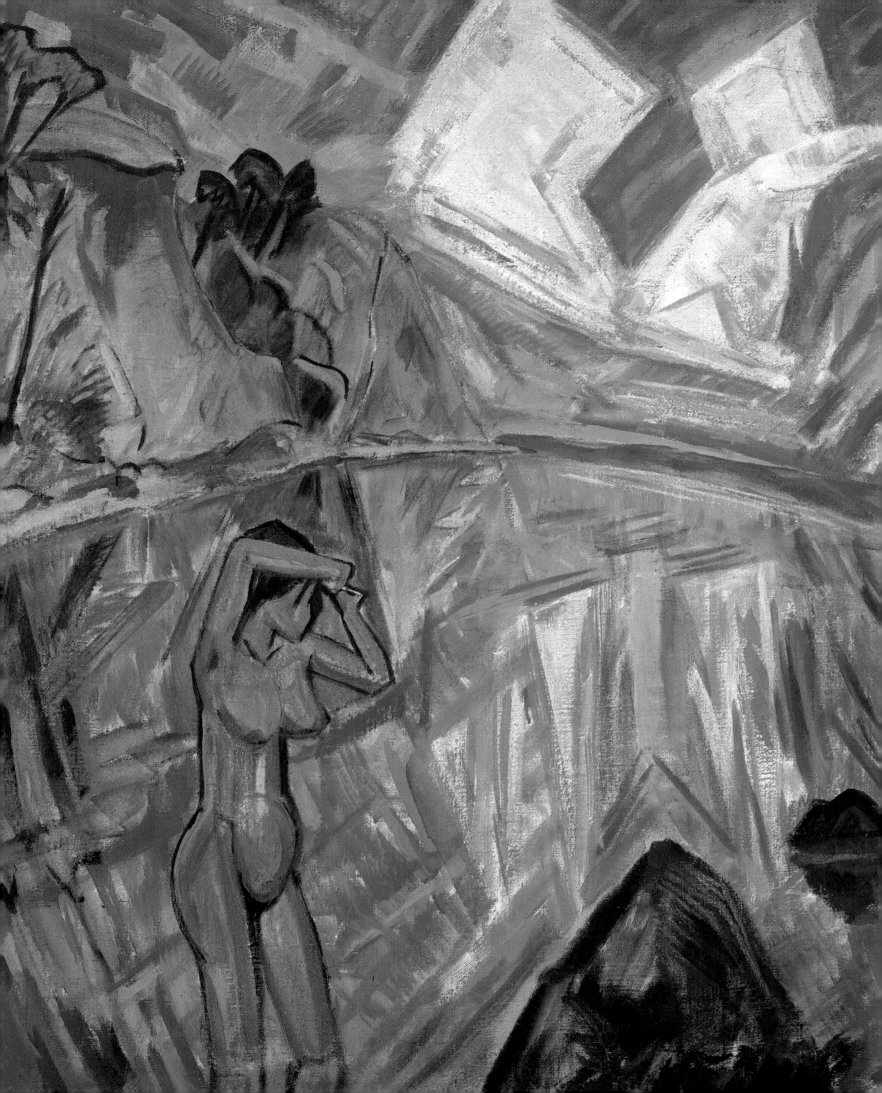

summer of that year at the Moritzburg Lakes, together with Kirchner and several models who accompanied them. It follows that the six figures in the painting were probably the two artists together with four models. The one at the centre, surrounded by four female nudes, can be identified as Kirchner. The thinness of his face seems to suggest this. This would mean that Heckel saw himself as the person who is standing apart. Although it may seem unusual in this particular case, the separate figure has a function which is quite traditional in art, that of establishing contact between the viewer and the subject of the painting.

When Heckel moved to Berlin in autumn 1911, he gathered quite a number of new impressions and made new contacts. Gradually he gained public recognition. In 1913 he gave his first solo exhibition at the Gurlitt Gallery. But although female nudes – in the studio or outside – remained a central topic in his art, the general tenor of his paintings began to change. The brightly colourful bathing scenes of the Moritzburg Lakes began to take on a different aspect, and his *The Glass Day* (1913, left) may well be a key painting in this respect. While the theme is again that of a bathing nude, it shows particularly clearly Heckel's changing use of form and colour. On the one hand, he did not achieve any simultaneity of perspective and movement, and the painting therefore remains typical of Expressionism. On the other hand, however, one cannot deny the influence of Cubism and Futurism. Heckel had seen such paintings in Berlin.

The picture was painted very thinly in oils. The soft, decorative lines, which used to enfold all shapes, have become straight and angular so that the entire theme seems to consist of interlocking crystal shapes. The whole composition is dominated by the translucent, blue brightness of the water and the sky, which also seems to penetrate the other elements – the female nude in the foreground and the steep coast at the back. There is a frozen iciness about the colours, the shapes are crystallized, and the theme of reflection – which is also present in the title of the painting – describes not so much the actual theme itself as the formal stylistic method. Thus, Heckel no longer used colours as his main medium of expression, but proceeded to depict light and non-material space, penetrated by coloured surfaces. *The Glass Day* was painted in 1913, and Heckel's discovery of new subjects undoubtedly went hand in hand with the final breakup of the *Brücke* circle that year.

As for his portraits, Heckel's years in Berlin brought about some important changes, both with regard to his formal methods and also the use of colour in his themes. He no longer applied the paint very lightly and the bright, almost cheerful colours, became more sombre. From now on his figures had dark contours round them, placed very firmly and angularly. The expressively complementary colours of his paintings were replaced by more restrained hues of black, brown and green. From a purely technical point of view, Heckel's firmer use of form can be traced back to woodcuts. During this time Heckel began to cut the themes for his paintings in wood, and he sometimes also made etchings of them. It is by

Erich Heckel:
The Glass Day, 1913
Der gläserne Tag
Oil on canvas, 138 × 114 cm
Staatsgalerie moderner Kunst,
Munich

no means the case that Heckel's graphic prints always followed his paintings. And occasionally he started with a woodcut which then served as the model for a painting. In fact, a large number of his later works – and nearly all of the more important ones, including the *Glass Day* - were produced in both forms, as paintings and as prints.

The formal development of his pictorial idiom was accompanied – and possibly triggered off – by the discovery of a new subject for his depiction of people. It was a topic which had been totally unknown during his years of carefree bathing scenes. In the years 1912 – 1914, the cheerfulness of his paintings was increasingly replaced by the motifs of suffering, anxiety, sickness and death. Heckel began to read Dostoyevsky again, whose works he had already come across as a schoolboy in Chemnitz. In 1910 he met Sidi Riha, whom he married in 1915, and her illness was documented by Heckel with some impressively intimate paintings.

When war broke out in 1914, Heckel volunteered for military service. The commander of his regiment was Walter Kaesbach, an art historian who had managed to gather together a number of young artists in his unit. Thus Heckel was actually able to continue his artistic activities throughout the war. Not only did he paint portraits of his comrades and a small number of scenes from his life as a soldier, but also many views of the broad expanses of the Flemish countryside, as in his *Flemish Plain* (p.60). The style of Heckel's *The Glass Day* had started off as an innovation and continued to prevail in all his other landscapes until about 1919. It seems as if the real theme of these paintings is the light, although Heckel was unfamiliar with Delaunay's experiments in Orphism. Broken at times, as if seen through a prism, the entire theme is shot through by light, which is indeterminate and without any identifiable source. There is no trace in Heckel's paintings of the ruined, churned-up earth of the battlefields. His Flemish landscapes are anti-worlds in relation to the horrible reality that surrounded him as soldier every day. They are permeated by light, as if by a shimmer of hope for a future world in which there will be peace. This is the impression one gains from paintings like *Spring* (p.61), a landscape with a lake in the bright light of the spring sun.

After 1918, Heckel did not return to the powerfully Expressionist style of his pre-war paintings. Although he continued to paint the same well-known themes – landscapes, portraits and bathing scenes – and added numerous still lifes of flowers, his colours had lost their ecstatic expressiveness. Instead, Heckel now used more restrained, harmonious colours for a naturalist depiction of reality that lacked force.

PAGE 60:
Erich Heckel:
Flemish Plain, 1916
Flandrische Ebene
Oil on canvas, 83 × 96 cm
Städtisches Museum
Abteiberg, Mönchengladbach

PAGE 61:
Erich Heckel:
Spring, 1918
Frühling
Tempera on canvas, 91 × 92.5 cm
Nationalgalerie SMPK, West Berlin

Erich Heckel:
Corpus Christi in Bruges, 1914
Fronleichnamstag in Brügge
Oil on canvas, 94 × 82 cm
Städtisches Museum, Mülheim an der Ruhr

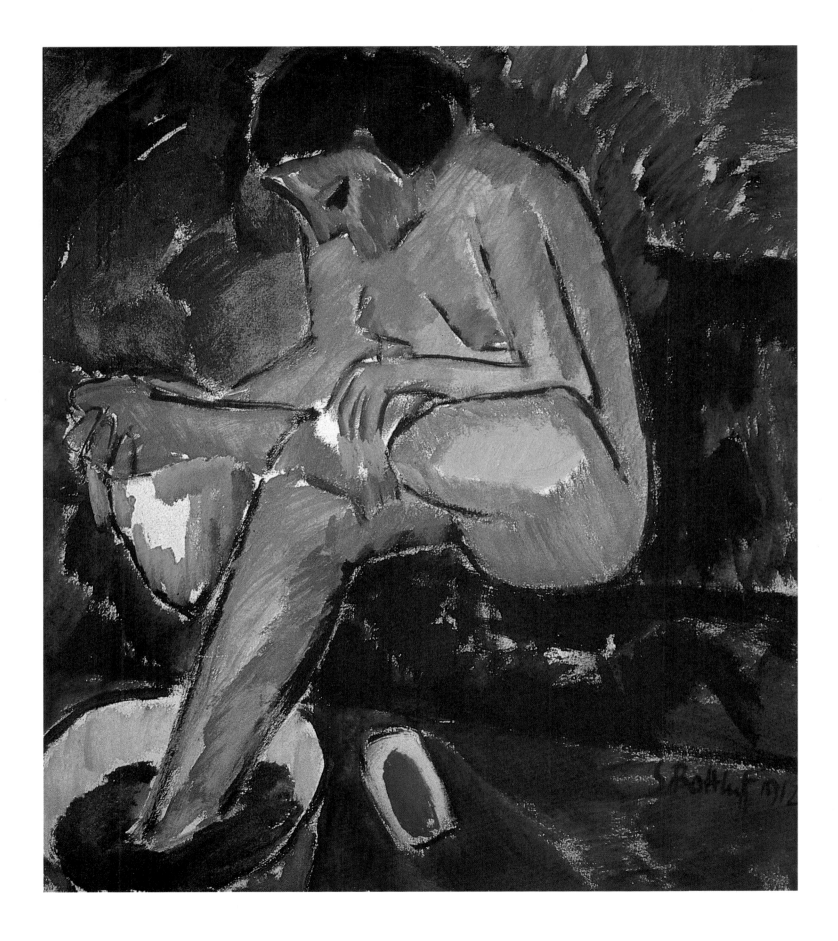

Karl Schmidt-Rottluff

Among the *Brücke* artists, Karl Schmidt-Rottluff played the least active role in the life of the group. He hardly ever put in an appearance at their artistic sessions in the shared Dresden studio. Rather, he preferred to withdraw to his own little room and paint in solitude. He never took part in their famous trips to the Moritzburg Lakes from 1909 to 1911, and so he had no part in the development of their artistic style, nor in the expression of their ideas about possible social reforms, ideas which they tried to live out in practice. Like the others, he started off in Dresden. In 1910 he installed himself in a little studio in Hamburg, and although he moved to Berlin in 1911, the life of the city never became a topic for him. Paintings such as *Houses by Night* (p.75) of 1912 remained outstanding exceptions in his art. Instead, he found his motifs – above all landscapes with solitary farms and bathing scenes – on his extensive summer holidays, and these provided him with enough material for the rest of the year. In 1907, he went to Dangast for the first time. Heckel joined him a few weeks later, and he returned there every year until 1912. We can understand the significance of these summer trips for his artistic development much better if we recall that, in 1908, Schmidt-Rottluff stayed there – with a few short breaks - from April to November, and in the following two years until October. It was not until 1911 that he began to concentrate on portraits, which he had done only occasionally until then.

Karl Schmidt was born in Rottluff on December 1st, 1884. His father was a miller, and he was the youngest of the *Brücke* artists. From 1897 to 1905, he went to the grammar school in Chemnitz, where he also met Heckel. The two young men shared an interest in museums and exhibitions as well as the events of the *Literarische Klub* (Literary Club), where they met the Scandinavian authors Henrik Ibsen and August Strindberg. They also came across Nietzsche's writings for the first time, ideas they later discussed in the *Brücke*.

In his choice of a profession, Schmidt went against the wishes of his father, who would have liked him to study theology, and in April 1905 he started a course in architecture at the Saxon Institute of Technology in Dresden. There he met Heckel again, who introduced him to Kirchner. Schmidt did not continue his course beyond the first year, when he finally

Karl Schmidt-Rottluff:
Self-Portrait, 1914
Selbstbildnis
Woodcut, 36.5 × 29.8 cm

Karl Schmidt-Rottluff:
Girl Doing Her Toilet, 1912
Mädchen bei der Toilette
Oil on canvas, 84.5 × 76 cm
Brücke Museum, West Berlin

yielded to his desire to devote himself entirely to art. On 7 June 1905, he became one of the founding members of the *Brücke*, whose name was chosen at his suggestion. From this time onwards Schmidt added his birthplace to his name, signing all works as Schmidt-Rottluff.

Although Schmidt-Rottluff is known to have made some early attempts at painting while he was still at school, he did not produce any serious artistic endeavours until he joined. However, although he had emulated the same artists as the other members, even his first works only fitted into the *Brücke* pattern of development on a very superficial level.

During these first years, Schmidt-Rottluff's subjects were rather difficult to make out in the densely packed colour schemes that he used, especially since he did not draw any contours whatever. After all - said Schmidt-Rottluff – nature did not have such contours either. Using short, swift brush-strokes as well as some longer, wave-shaped areas, he managed to introduce a vibrant effect into the entire painting. This was similarly true of Kirchner's art at that time and also Heckel's earlier paintings, but their colours had a certain lightness about them which was missing from Schmidt-Rottluff's. There is an opaque quality about his brushwork which makes it seem unusually heavy and self-contained. In a number of Dangast paintings of 1907, Schmidt-Rottluff increased the thickness of his colours even further by using a spatula instead of a paintbrush.

What was no more than a slight tendency in Schmidt-Rottluff's early paintings became a decisive factor in the further development of his art. His aloofness from the *Brücke* as a community where people shared their life and work was reflected in the stylistic development of his art. His oeuvre was never without an unmistakable degree of independence. He was totally unaffected by that typical *Brücke* style which emerged around the year 1910, a style that was partly due to their time together at the Moritzburg Lakes and which even makes it difficult for today's art historians to determine who painted what. Schmidt-Rottluff never took part in these trips. Throughout this crucial *Brücke* year, he chose Dangast, near Oldenburg, as his place for artistic inspiration and not Dresden or Berlin. And so it hardly seems surprising but perfectly logical that an exhibition poster of 1911 referred to him as a Dangast artist.

Gradually, however, Schmidt-Rottluff began to abandon this "monumental" style of Impressionism. In fact, in some of his Dangast landscapes, a change began to take place as early as 1909, and it eventually became dominant when he returned there the year after. In paintings such as *Landscape in Dangast* (p.67) of 1910, he thinned down his paint, which enabled him to apply it more gently and smoothly. The opaque, Impressionist hotch-potch of his earlier paintings disappeared, and his motifs also increased in firmness. The bright colourfulness of his paintings was reduced, and he made increasing use of less conspicuous contrasts of blue, yellow and the secondary colour, green. However, he still composed his paintings of individual, rhythmic brush-strokes, which made for a certain restlessness within the picture as can be seen here.

Karl Schmidt-Rottluff:
Boats in the Bay, 1914
Boote in der Bucht
Woodcut, 29.6 × 36.2 cm

Karl Schmidt-Rottluff:
Dyke Breach, 1910
Deichdurchbruch
Oil on canvas, 76 × 84 cm
Brücke Museum, West Berlin

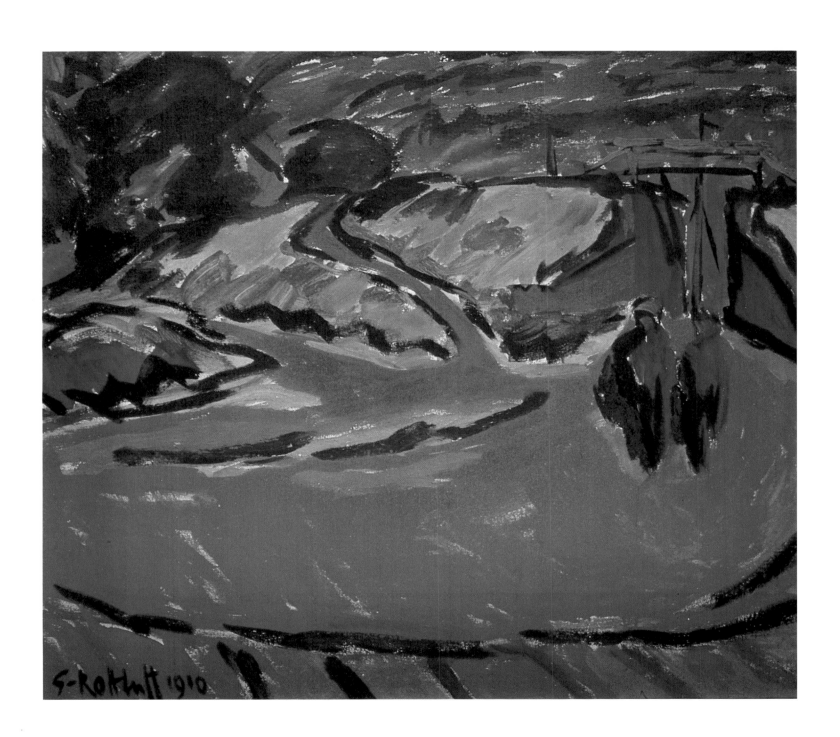

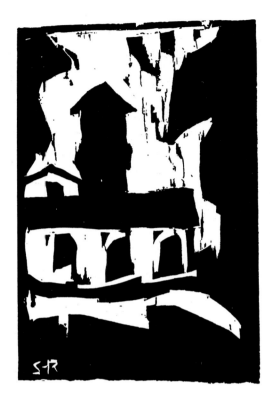

Karl Schmidt-Rottluff:
Villa with Tower, 1909
Villa mit Turm
Woodcut, 39 × 29.6 cm

Karl Schmidt-Rottluff:
Landscape in Dangast, 1910
Landschaft in Dangast
Oil on canvas, 76 × 84 cm
Stedelijk Museum, Amsterdam

One of Schmidt-Rottluff's frequent motifs in his Dangast paintings was that of a solitary farm building, embedded in the landscape. He shared this interest with Heckel, from whom he must have benefitted, because both painters had spent that summer in Dangast. Similar stylistic innovations had begun to dominate Heckel's art as early as 1908, for example in his *Red Houses*. 1910 proved the decisive year for Schmidt-Rottluff's artistic development. During his months in Dangast he succeeded in turning his brushwork, which was very light at first, into large areas of colour. It was an important step in increasing the expressiveness of his style, which can be seen very clearly when we compare his painting *Dyke Breach (p.65)* with his *Landscape in Dangast* (p.67), painted in the same year, though slightly earlier. *Dike Breach* is dominated by the expressiveness of pure colours, spreading across the entire painting in broad areas so that all the shapes are treated in a very summary manner. The lack of detail makes for a further simplification of the theme. The adjoining colour surfaces are partly surrounded by spontaneous, imprecisely positioned black lines. But these lines, like a skeletal structure, lend firmness and stability to the composition. The painting is dominated by the aggressive colourfulness of a large, shapeless area of red, which is in sharp contrast with an intensive blue. The third primary colour, yellow, only serves as an accompanying chord of green and orange. The actual motif remains almost irrelevant and is no more than an occasion for the unrestrained flow of colours.

The combination of dominant red and ultramarine blue can be found in numerous other paintings by Schmidt-Rottluff of that period. However, his total disregard for the natural colours of the actual locality itself also led to misunderstandings, bringing him negative feedback and the criticism that his pictures were "screamingly garish" in their colourfulness (Hans Hildebrandt, 1924). With these paintings Schmidt-Rottluff had reached the most mature stage in his development, and he subsequently painted many of his most impressive works, with all the Expressionist features that were so typical of the *Brücke*. This was indeed quite an achievement, when we consider that the artist had only just turned 25 that summer.

Hamburg was particularly important for the *Brücke* artists, because it was there – and not in Dresden or Berlin – that the circle had its largest number of supporters, i.e. associate members. Schmidt-Rottluff benefitted especially from the support of Hamburg collectors. The first list of associate members, in the form of a woodcut by Kirchner in 1906, only mentions one Hamburg contributor, a lawyer called Schiefler, who was an enthusiastic collector of contemporary prints and who later edited the print catalogues of Munch, Nolde and Kirchner. When Schmidt-Rottluff paid a brief visit to Hamburg in 1906, he introduced him to the art historian Rosa Schapire, who then visited him in Dangast that year. Schapire became an enthusiastic support of the *Brücke* circle. As a collector, she acquired works by Schmidt-Rottluff, who in turn painted four portraits of her in the years 1911 – 1919. Each of them is quite different in

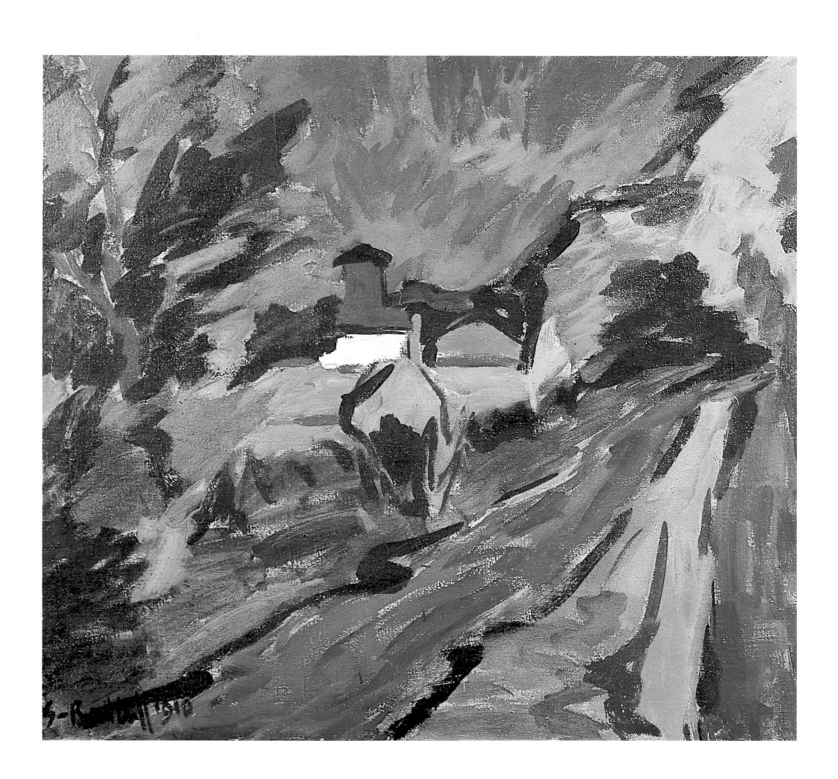

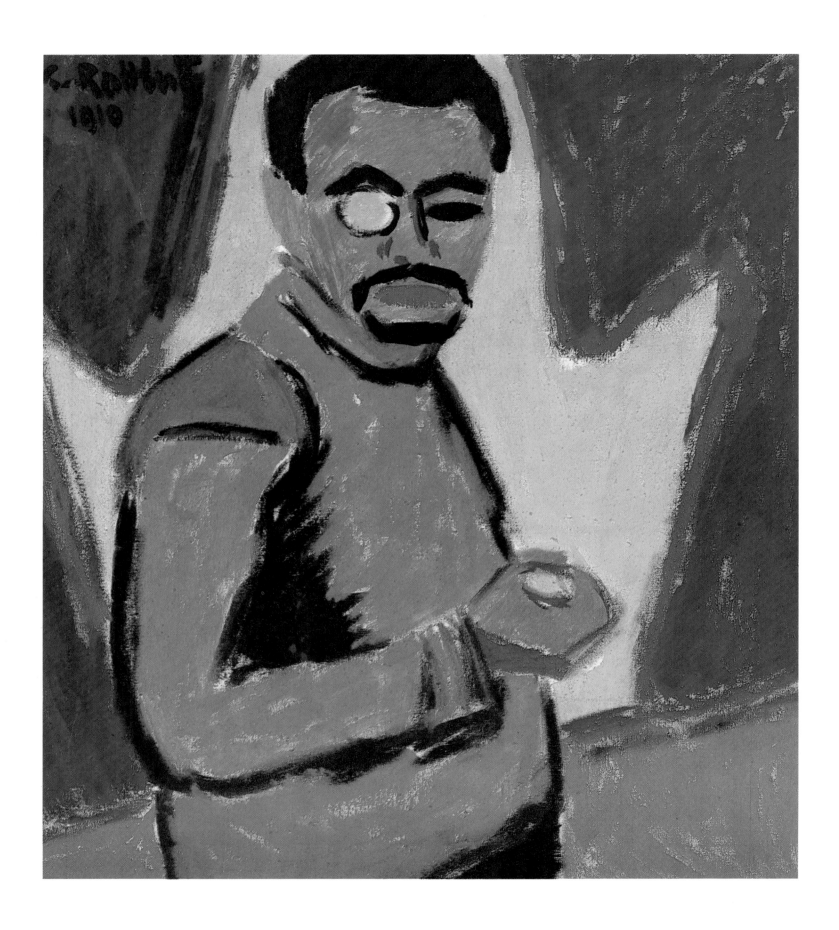

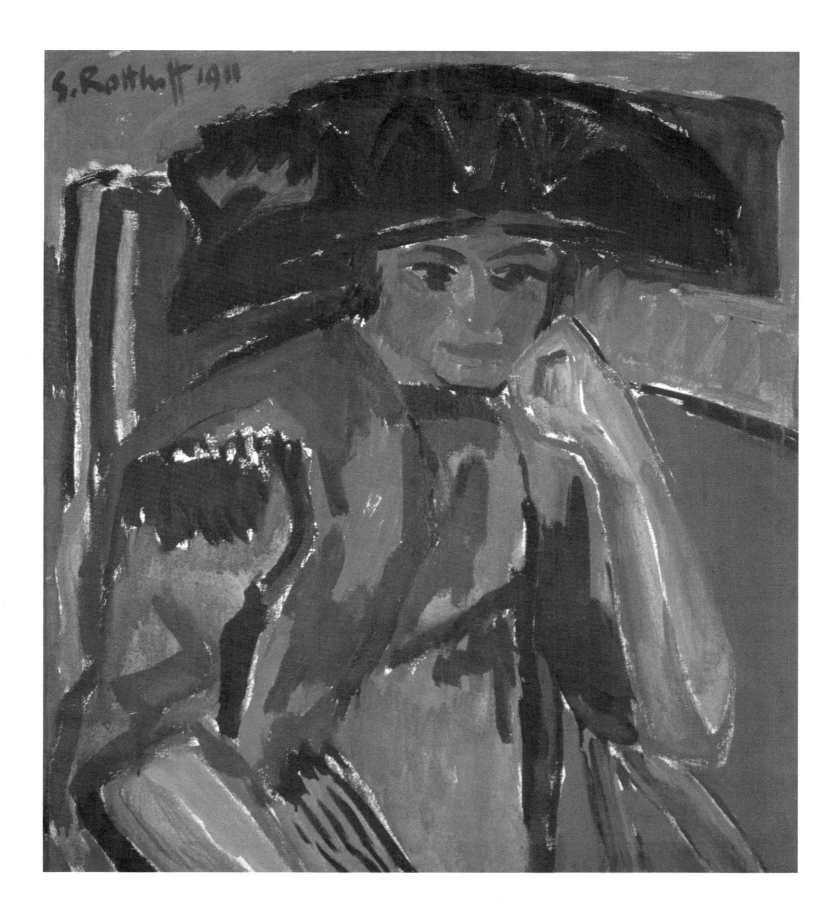

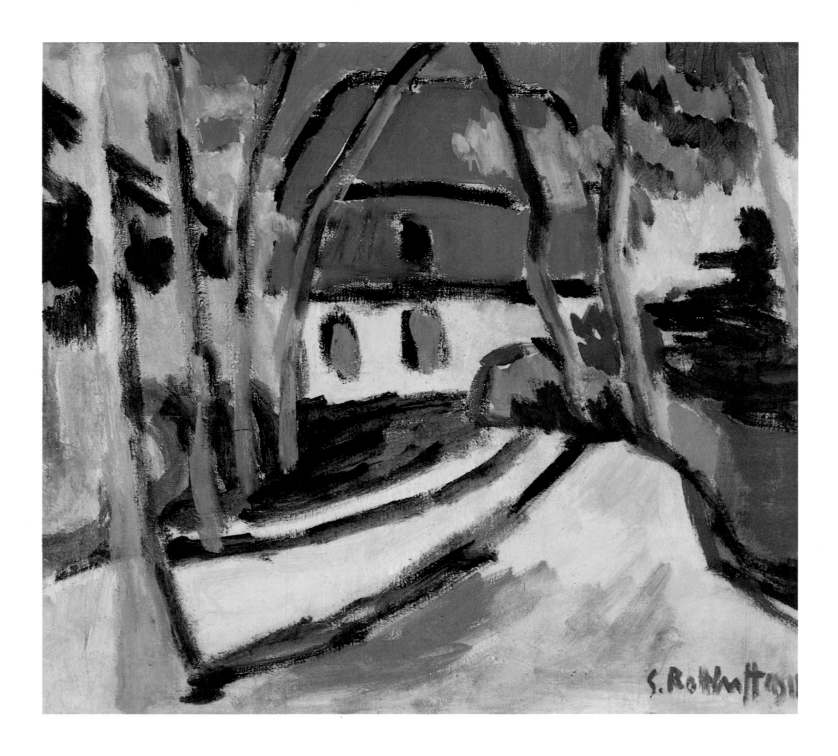

style and therefore characteristic of the artist's various stages of develop-
ment and experiments with form. The first of these portraits, which can
now be seen at the Brücke Museum in Berlin, became particularly fam-
ous. Painted in 1911, it was one of his very first portraits, for he had
neglected this particular area almost entirely in favour of landscapes.

Schmidt-Rottluff spent the first three months of 1911 working in his
Hamburg studio. It is likely that this was the time when he painted his
Portrait of Rosa Schapire (p.69) – a half-length portrait of his chosen
partner sitting in an armchair. Her posture is calm and pensive, with her
left arm supporting her head. The colours, however, seem to be in sharp
contrast with the subject. Another element that stands out is his strong

Karl Schmidt-Rottluff:
Early Spring, 1911
Vorfrühling
Oil on canvas, 76.3 × 84 cm
Museum am Ostwall, Dortmund

PAGE 68:

Karl Schmidt-Rottluff:
Self-Portrait with Monocle, 1910
Selbstbildnis mit Einglas
Oil on canvas, 84 × 76.5 cm
Nationalgalerie SMPK, West Berlin

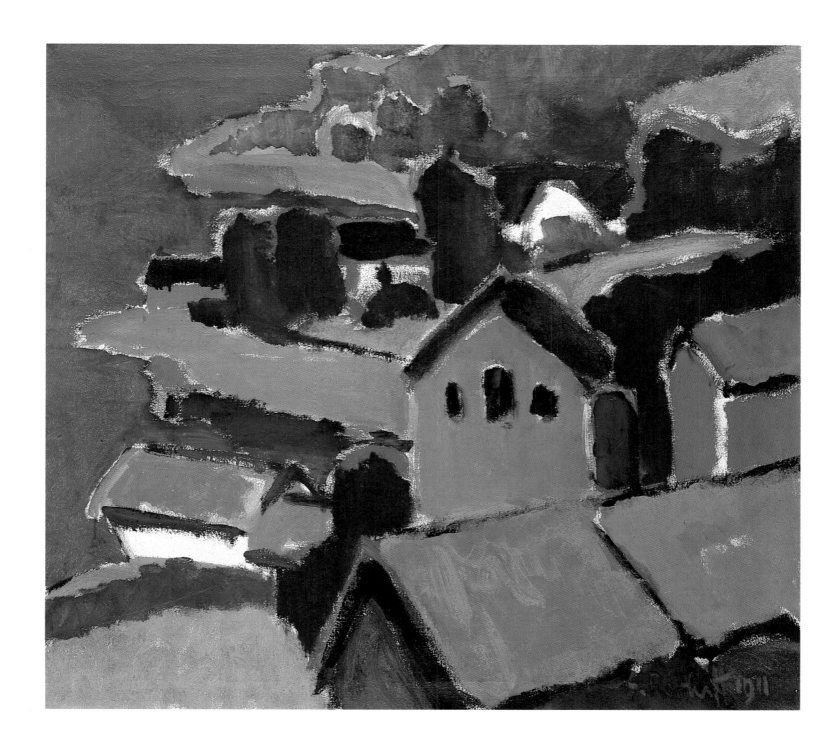

Karl Schmidt-Rottluff:
Lofthus, 1911
Oil on canvas, 87 × 95 cm
Kunsthalle, Hamburg

PAGE 69:

Karl Schmidt-Rottluff:
Portrait of Rosa Schapire, 1911
Bildnis Rosa Schapire
Oil on canvas, 84 × 76 cm
Brücke Museum, West Berlin

brush strokes, which give the painting a large, solid structure. Although most of the painting is dominated by shades of brown and Rosa's green skirt, this complementary contrast only serves to emphasize the luminosity of the bright red. The arm which protrudes into the red area in the bottom right-hand corner seems to be moving upwards, towards the woman's face. Her face is the focal point of the painting, towards which Schmidt-Rottluff draws our eyes. The red face with its blue eyes is brightly radiant against the dark green background which surrounds it.

Schmidt-Rottluff spent the summer of that year with the associate member Gustav Rohlson and his wife, at their country residence in Norway. There he painted his unusual view of the village *Lofthus* (p.71).

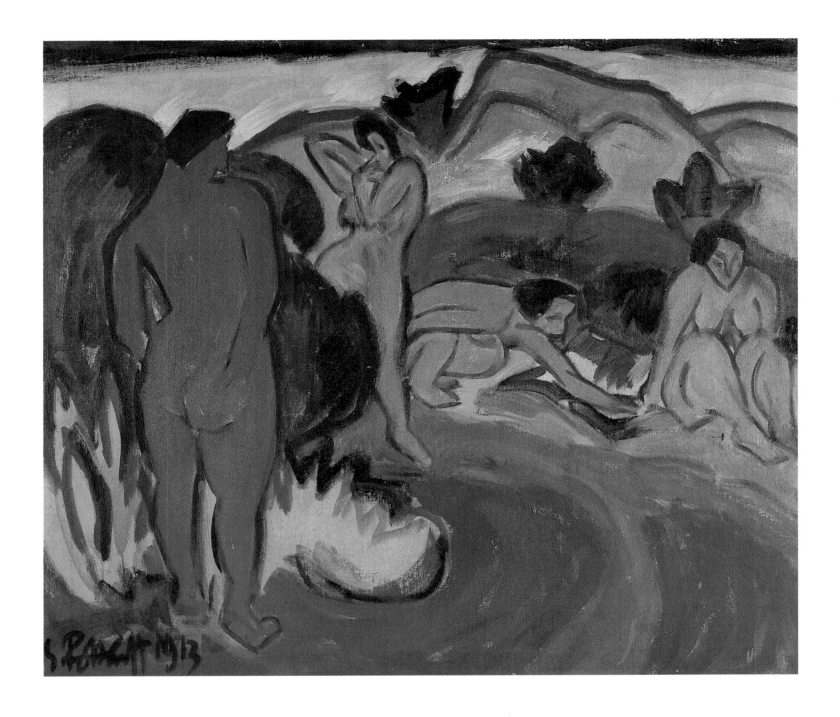

No human figures are to be seen in this painting. We are afforded a view from a point a little above the buildings. However, Schmidt-Rottluff's style rather seems to counteract this thrust towards spatial depth. He radically simplified all shapes, arranging them two-dimensionally and side by side with one another, so that the painting almost seems like a tapestry. There is a cheerfulness about the picture which was unusual for the painters of the time. Schmidt-Rottluff deliberately avoided aggressive colour contrasts. Instead, he used mixed colours and shades brightened up with white. However, it was the last time that the artist opted for such a radical reduction of volume and perspective.

Only a year later, in 1912, Schmidt-Rottluff embarked upon a significant stylistic innovation. In September he went to the *Sonderbund* exhibi-

Karl Schmidt-Rottluff:
Four Bathers on the Beach, 1913
Vier Badende am Strand
Oil on canvas, 88 × 101 cm
Sprengel Museum, Hanover

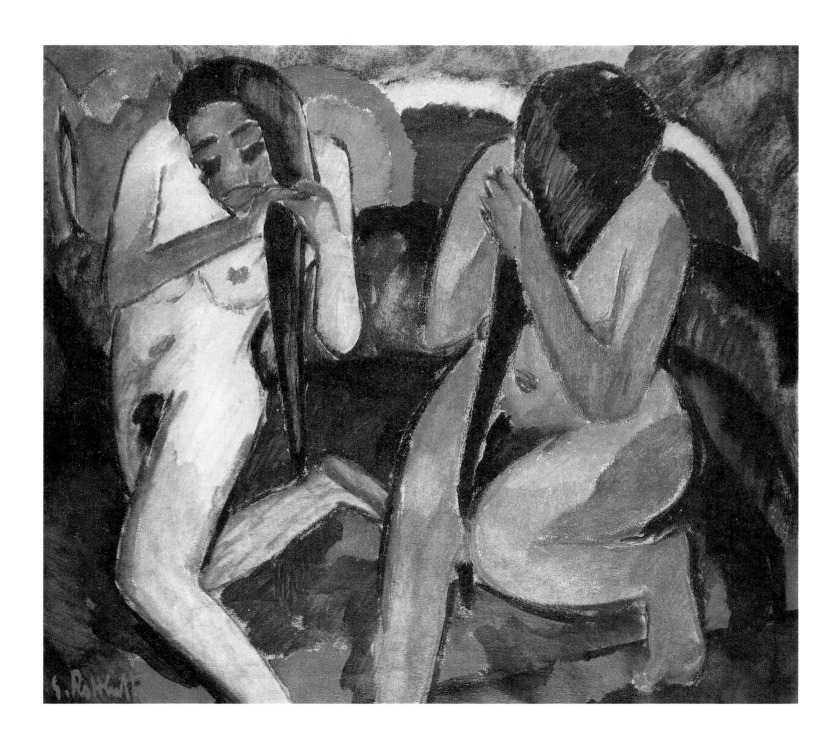

Karl Schmidt-Rottluff:
After the Bath, 1912
Nach dem Bade
Oil on canvas, 87 × 95 cm
Gemäldegalerie Neue Meister
Staatliche Kunstsammlungen,
Dresden

tion in Cologne, where he encountered the French Cubists and their experiments with form. These paintings prompted him to try more daring pictures himself, in which he disected human figures into semi-abstract Cubist shapes. In this way he was influenced by the same art that also stimulated Kirchner to paint his magnificent Berlin street scenes and which made Heckel create works such as *The Glass Day*.

These "Cubist" experiments, however, were really only a short phase in the development of Schmidt-Rottluff's paintings. But what remained was a new hierarchy within the picture, where the formerly dominant angular areas of colour became secondary to shapes. His double portrait *After the Bath* (above) – also painted in Hamburg in 1912 – shows these stylistic criteria very clearly. The contours of the two women are no

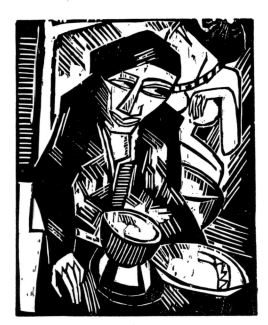

Karl Schmidt-Rottluff:
Melancholy, 1914
Melancholie
Woodcut, 50 × 39 cm

Karl Schmidt-Rottluff:
Houses by Night, 1912
Häuser bei Nacht
Oil on canvas, 94 × 86 cm
Museum of Modern Art, New York

longer soft and smooth: the artist stresses the angularity of their bodies as well as their plasticity by using shades of ochre. This change is even more apparent when we look at his views of houses, which seem to be mere cubes, and mostly without windows.

In 1913, after the final breakup of the *Brücke*, Schmidt-Rottluff went to Nidden, East Prussia, between the Courland Lagoon and the Baltic Sea. Again, he painted a number of excellent nudes in the open air, with a dominant red that outshines all the other colours, such as in his *Four Bathers on the Beach* (above). These paintings always consist of several figures, each person being preoccupied with themselves. There is no interaction between them, nor even eye contact. Painted with broad, sweeping brush strokes, their large, upright bodies stand out against the horizontal sweep of the landscape.

Again, he was considerably influenced by Cubism, though this time also by his interest in African sculptures. This is apparent in his portrait style. Earlier, when Schmidt-Rottluff had visited the ethnographic museum in Dresden, he had been fascinated by exotic wooden sculptures from Gabon and Cameroon. And when he produced his own block-like, wooden sculptures in 1909/10, he seems to have prepared the ground for further use of these sources of inspiration. However, it was not until 1914 that he used these ideas for his paintings. The bodies of the people consist of simple cubic shapes, which gives them an obviously sculptural effect. The contours of people's faces in paintings such as *June Evening* of 1919 and *Double Portrait S. and L.* (p.77) of 1925 are dark and angular. With these paintings, Schmidt-Rottluff achieved a firmly fixed repertoire of shapes which makes the individual features of his models seem abstract, typifying and – in this case – africanizing them. Nevertheless, even these paintings have a portrait-like quality about them.

Unlike the cheerful colour contrasts of his earlier works, the paintings immediately before and during the first months of the war took on a more sombre aspect. This may of course be a formal device, because in the years 1907 to 1910 there had already been a shift in emphasis within Analytic Cubism from colour to form. However, it is far more likely that the earthy heaviness of brown and grey shades, which give the subjects an air of melancholy poignancy, was a reflection of Schmidt-Rottluff's personal mood in view of the political situation. While many of his fellow-artists enthusiastically volunteered for military service, he was filled with forebodings about the impending disaster. It was a direct reflection of contemporary events that the artist's colour range generally became darker, and even his nudes – which were to be his last for several decades – had thin, haggard bodies and elongated, distorted limbs.

In spring 1915 Schmidt-Rottluff was drafted into the army, where he served in an infantry regiment. During these years, until he was de-mobbed in December 1918, he did not paint any new pictures. He did, however, create a number of wooden sculptures, and his artistic activities now lay primarily in the areas of drawings and woodcuts – two techniques which were far more intimate and easier to handle for a

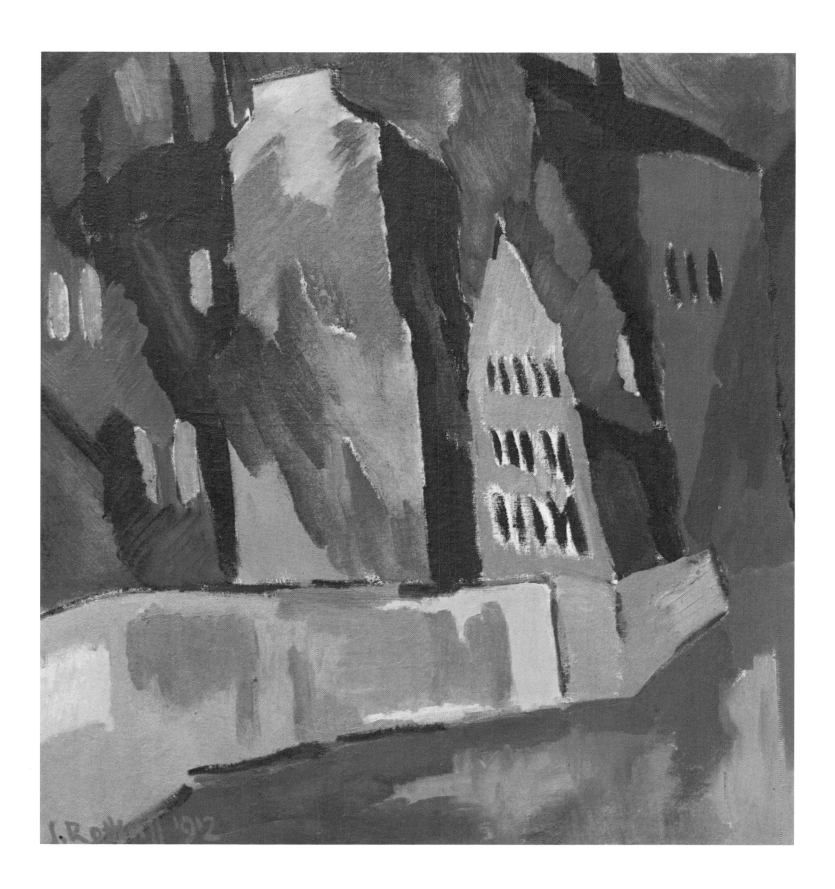

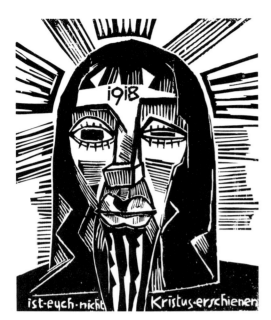

Karl Schmidt-Rottluff:
"Did not Christ Appear to You", 1918
"Ist euch nicht Kristus erschienen"
Woodcut, 50.1 × 39.1 cm
Museum am Ostwall, Dortmund

Karl Schmidt-Rottluff:
Double Portrait S. and L., around 1925
Doppelbildnis S. und L.
Oil on canvas, 65.5 × 73 cm
Museum am Ostwall, Dortmund

soldier. His artistic development now proceeded along similar lines to that of Marc, Rohlfs and Morgner, in that he also began to take an interest in religious themes. The most remarkable of these works were created in 1918, when Schmidt-Rottluff produced a portfolio containing eight prints on New Testament themes (cf. illus. left). In turning to biblical motifs, the artists were searching for something that would sustain them spiritually in view of the disastrous breakdown of the old order and the immediate threat to their own lives. Christ's Passion became symbolic of their own anxieties and hopes as well as of the suffering of entire nations at that time. When Schmidt-Rottluff used woodcuts as a medium, he did so quite deliberately, as he was fully aware of their historic function in political pamphlets. In two of them he established a direct link with the current situation in 1918. On the second plate he depicted Christ with the date on His forehead. And plate number three, the *Road to Emmaus* contains a cannonball in the background, flying from the left straight across the scene.

After he was demobbed, Schmidt-Rottluff's life stabilized very quickly. Gradually, his paintings also began to make an impact on the art market and were bought by museums. He mainly used the improvement in his financial situation for renewed travel. Not only did he spend long periods of the summer on the Baltic coast again, but he also travelled abroad. In 1923 and 1930 he went to Italy, in 1924 to France, and in 1928 and 1929 he visited Switzerland.

Schmidt-Rottluff took an active part in the *Arbeitsrat für Kunst* (Co-Operative Council for Art) founded in 1919, though this political commitment was not reflected in his paintings. In the post-war years, he simply continued where he left off before the war, painting landscapes, bathing scenes with several figures, portraits and still lifes. He even used the same bright colours again, although they were subtler in their tonality and less contrastive. Nevertheless, unlike Heckel, he managed to preserve the Expressionist vein of the *Brücke* style in his art.

When Schmidt-Rottluff died on 10 August 1976, he was the last survivor of the *Brücke* artists.

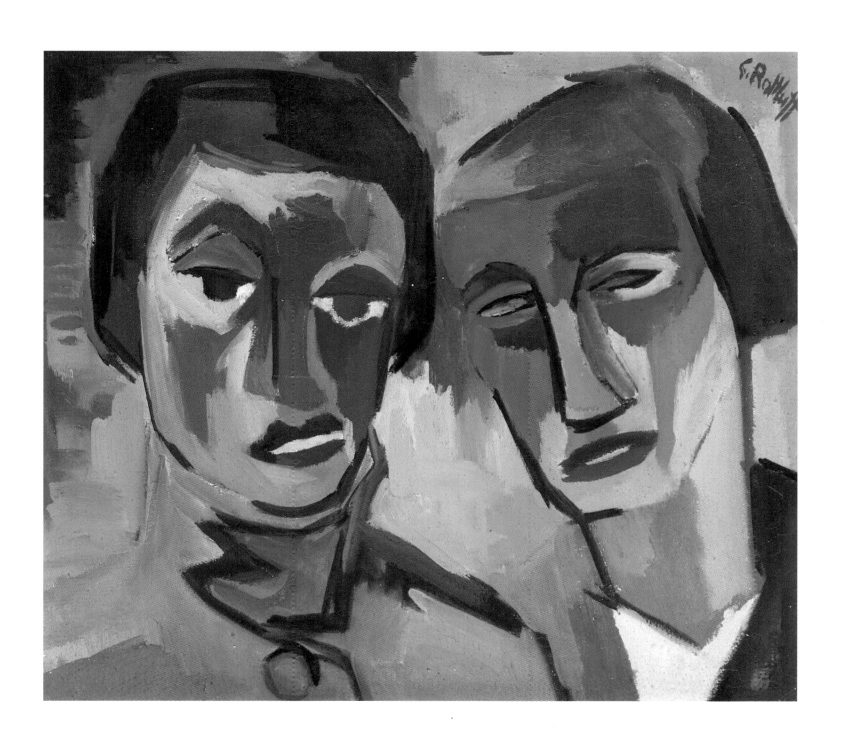

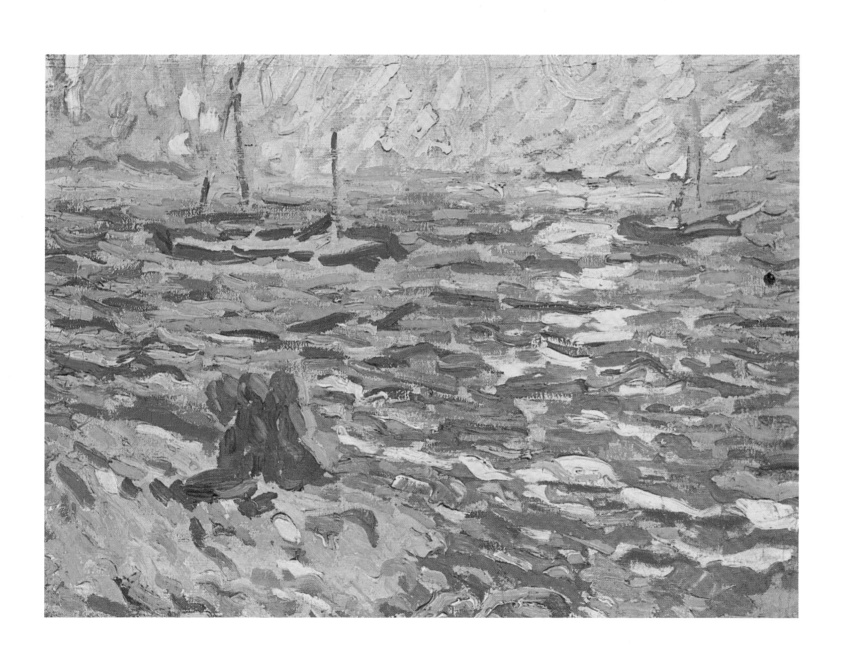

Max Pechstein

In many ways, Max Pechstein's art occupies a special position within the *Brücke* group. Unlike Kirchner, Heckel and Schmidt-Rottluff, he was not one of the founding members of the circle, and he was the only one whose art was based on academic training. His firm craftsmanship, confident technique and mastery of perspective can be seen in nearly all the phases of his artistic development. Indeed, it was even a problem for him to break away from his academic background and to find a fresh approach to art which was comparable to that of the other *Brücke* artists, who were complete amateurs. The only time he succeeded in doing so was during the summer months of 1910, when he shared his life and work with Kirchner and Heckel at the Moritzburg Lakes.

On the other hand, however, it was precisely because of his thorough training that Pechstein could sell his works at a very early stage and live on his work as a painter. In fact, his art was already recognized on an official level as early as 1907, when he was awarded the State Prize of Saxony. In 1912, he was the only *Brücke* artist who was asked to participate in the annual exhibition of the Berlin Secession. And no sooner had he agreed than he was excluded from the *Brücke* circle. When Paul Fechter published the first monograph on *Expressionism*, he paid tribute, above all, to Pechstein's achievements, while the other *Brücke* members were merely said to have followed him: "Understandably, he was the head of the *Brücke* group in Dresden ... Erich Heckel, E.L. Kirchner and Schmidt-Roffluff, who were going along with him at the time, really only produced the same things, though with their own quiet, personal variations." After numerous positive articles and essays by various authors, three monographs were written about Pechstein between 1916 and 1922 – one by Walther Heymann, who even exalted him to the heights of "a Giotto of our time", another by Wilhelm Hausenstein and a third by Max Osborn.

This unusual recognition by collectors, museums and art critics, which continued until 1933, contrasted sharply with the response to his art after the Second World War. The late fifties and sixties saw the publication of large, academically well-founded volumes on Kirchner, Heckel, Schmidt-Rottluff and Mueller, and not a single one of them has so far been matched even remotely by any book on Pechstein. Even the cente-

Max Pechstein:
Self-Portrait (Detail), 1909
Selbstbildnis (Detail)
Lithograph, 45 × 43 cm

Max Pechstein:
Landscape with River, around 1907
Flusslandschaft
Oil on canvas, 53 × 68 cm
Folkwang Museum, Essen

Max Pechstein:
Nude on a Carpet, 1909
Akt auf Teppich
Lithograph, 43.2 × 32 cm

Max Pechstein:
Open Air (Bathers in Moritzburg),
1910
Freilicht (Badende in Moritzburg)
Oil on canvas, 70 × 80 cm
Wilhelm Lehmbruck Museum,
Duisburg

PAGE 80:
Max Pechstein:
Still Life with Winter Cherry and Red
Peppers, 1906
Stilleben mit Judenkirsche und Pfef-
ferschote
Oil on canvas, 65.5 × 70 cm
Sprengel Museum, Hanover

PAGE 81:
Max Pechstein:
Girl in Red with a Parasol, 1909
Mädchen in Rot unter Sonnenschirm
Oil on canvas, 98 × 98 cm
Hessisches Landesmuseum, Darm-
stadt

nary of his birth – 1981 – passed relatively unnoticed and without any retrospective exhibitions, which are normally organized with great enthusiasm on such occasions. When the Royal Academy of Arts held its retrospective called *German Art in the Twentieth Century* in 1985, Pechstein was the only *Brücke* artist whose works were missing.

Obviously, the over-emphasis on Pechstein's achievements until 1933 was totally unjustified and showed a lack of discernment. However, it was equally unjust when, after 1945, people went right to the other extreme and completely underestimated his artistic significance for the movement.

Pechstein was born in Zwickau on 31 December 1881. His later position as an outsider within the *Brücke* was already reflected in his social background. His father was a clothmaker, and so, unlike Kirchner, Heckel or Schmidt-Rottluff, he did not come from a well-to-do middle-class family, but from the working classes. Nor was he able to go to grammar school. Instead, he went to an ordinary state school in Chemnitz, which he left at the age of 15, to train as a house painter. However, when his father saw how talented his son was, he was prepared to encourage and support him, and so in 1900 he enabled him to attend the School of Applied Arts in Dresden. In 1902 Pechstein transferred to the School of Fine Arts, also in Dresden. Pechstein tried his hand at decorative and monumental designs for murals and turned out to be an outstandingly good craftsman. To earn his keep, he produced commercial art, designing lamps, chairs, wallpaper and cigarette packets. This tendency towards the decorative left its mark on his paintings and drawings.

It was due to one of his murals that Pechstein was accepted into the *Brücke* circle in 1906. He had painted a glowingly red tulip field, and when he realized that construction workers had toned it down to people's "ordinary taste" by spraying grey onto it, he protested loudly. "Suddenly somebody was standing beside me who was supporting me in my indignation. It was Heckel, who was still working for Kreis's at the time. Full of joy, we discovered that we were totally of one mind in our urge for freedom and for an art that could thunder ahead, unfettered by convention. And so I joined Heckel, Ernst Ludwig Kirchner and Schmidt-Rottluff in their circle, the *Brücke* group."

Pechstein benefitted greatly from the other *Brücke* artists in his attempt to free his art from the academic conventions he had learnt. Being self-taught, they displayed a complete lack of concern for the traditional rules of composition and the use of colour, and this carefree attitude influenced Pechstein for a short while. He, in turn, was able to serve the group with his thorough knowledge of painting technique. His *Still Life with Winter Cherry and Red Peppers* (p.80) was painted in 1906, marking precisely that point in his stylistic development, where he was when he joined the *Brücke*. His brilliant colours and loose pointillism show that he was looking for a certain expressiveness of style, while the classic composition of the still life and his naturalist attention to detail show that he was still firmly rooted in his academic training. The vase is

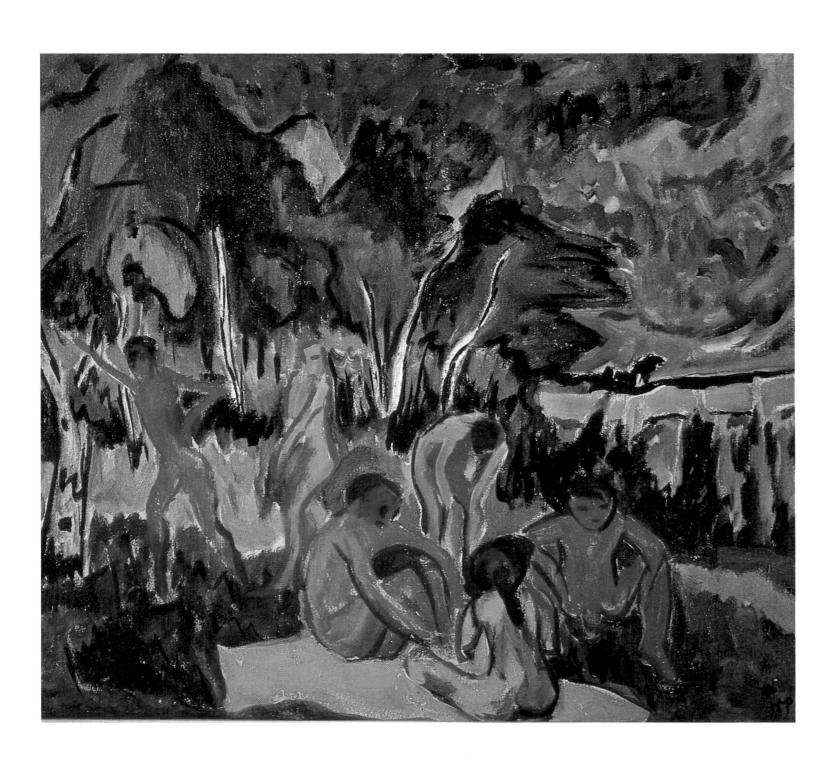

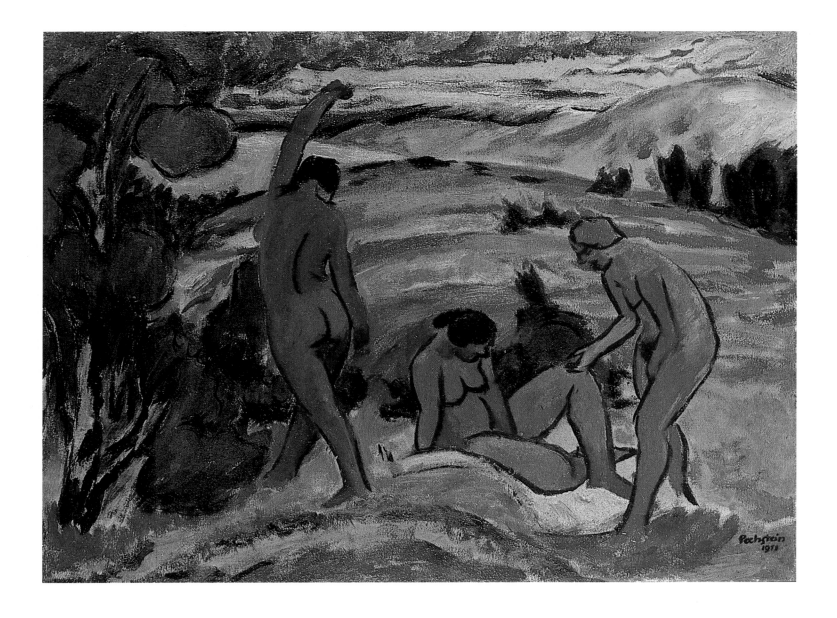

depicted with precision, and the shadows and reflections of light are modelled with great meticulousness.

Although Pechstein painted the same themes as the other *Brücke* artists – nudes, portraits, bathing scenes and landscapes – he neverthe-less applied the paint rather differently and also used different colour contrasts. This can be seen particularly clearly in his portraits, where he rendered his models with naturalistic fidelity, and there are only very few paintings where he abandoned the anatomic correctness of the body or the idea of perspective within the painting. As if wanting to prove his expertise at drawing, he sometimes even shortened the perspective of his paintings or drawings by depicting the subject from far above or far below, without distorting the body.

On a study trip to Italy in autumn 1907, Pechstein was given new ideas for his use of colour. It was his first encounter with Giotto's works, and he became enthusiastic about Roman and Etruscan frescos. He returned to Germany via Paris, where he saw the art of the Fauves and recruited van Dongen as a new *Brücke* member. However, it was his new Italian

Max Pechstein:
Three Nudes in a Landscape, 1911
Drei Akte in einer Landschaft
Oil on canvas, 75 × 100 cm
Musée National d'Art Moderne
Centre Georges Pompidou, Paris

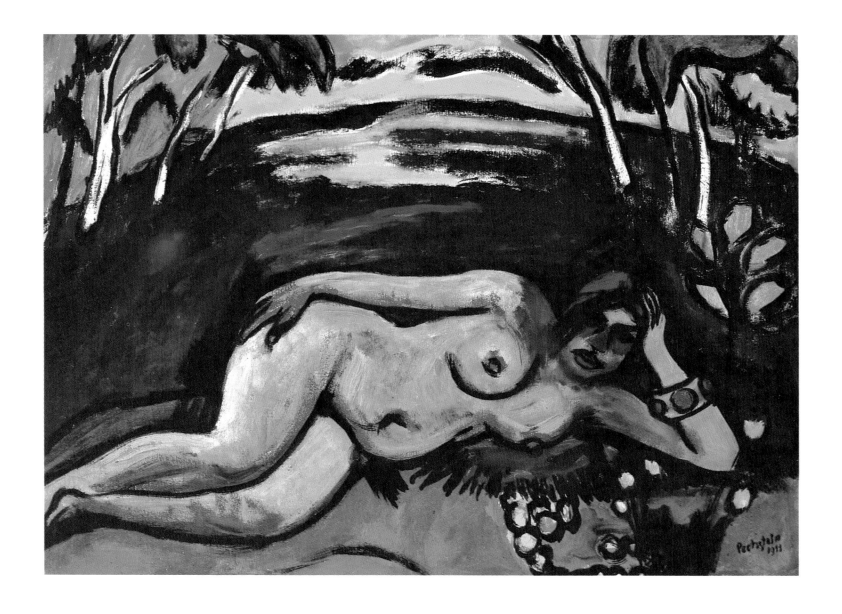

Max Pechstein:
Early Morning, 1911
Früher Morgen
Oil on canvas, 75 × 100 cm
Peter Selinka Collection, Ravensburg

impressions which most affected his art. Not only did they influence his own murals, but they also led to simpler and more obviously composed forms in his paintings. Although he did not paint his *Girl in Red with a Parasol* (p.81) until 1909 – quite a while after after his trip to Italy – he obviously made considerable use of those experiences. A woman is shown sitting on a chair, behind a table which is slightly at an angle on the left. Her right arm is leaning gently on the table, and in her right hand she is carrying an open parasol, placed above her right shoulder. However, it is not so much the theme itself that first captures the attention of the viewer but the dominance of the colour red. The tablecloth, the blouse and the parasol are all the same shade of red and, taken together, occupy nearly two thirds of the painting. And yet, unlike in other Expressionist paintings, this colour does not become independent of the subject, nor is it an autonomous mode of expression. This is because the structure of the painting is determined by its form, not the colour scheme. Following the examples of Giotto and Fra Angelico, Pechstein conceived all the elements of the picture as firm, three-dimensional shapes. The young

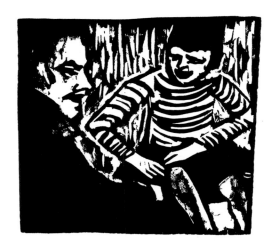

Max Pechstein:
Conversation, 1910
Unterhaltung
Woodcut, 20.4 × 22 cm

Max Pechstein:
Red Houses, 1923
Rote Häuser
Tempera on canvas, 70.5 × 95.4 cm
Sprengel Museum, Hanover

woman's body is not distorted for the sake of expressiveness. And his faithful depiction of the complicated bent and arched parasol shows Pechstein's previous academic training again. The yellow and green patchwork background sets the subject in an open space that cannot be identified. It is purely ornamental and thus comparable to Etruscan frescos, which may well have provided the idea.

The paintings which correspond most closely to our idea of a typical *Brücke* style are those of bathers and landscapes. Pechstein painted these on location during his numerous summer trips, and – like the other artists – he gave up spatial perspective in favour of two-dimensional areas, while at the same time emphasizing the contrasts of pure, unmixed colours. The brushwork in these pictures is nervously spontaneous, and the artist's excitement about his subjects seems to have directly affected the paintings themselves. Pechstein is known to have painted a number of such works in 1909, when he stayed for the first time in Nidden, East Prussia, and above all on his trip to the Moritzburg Lakes in the summer of the following year. *Open Air* (p. 83) shows a carefree group of six male and female nudes, playing and talking together uninhibitedly in a natural environment. Pechstein only painted their bodies very sketchily, with swiftly drawn contours. Their faces are merely indicated by simple lines, in light, vivid brush strokes. However, even within the forms themselves, the paint has not been applied two-dimensionally or without structure. Pechstein's treatment of the sky shows particularly clearly that he used a diversity of different shades of green or blue and applied them in broad, rhythmic strokes. Here, Pechstein achieved that immediacy of expression which was also characteristic of Kirchner and Heckel's Moritzburg works. However, it is distinguished from those of his two artist friends by a softer, more decorative touch, without any of those harsh contrasts between complementary, totally two-dimensional areas of colour.

In 1908, Pechstein was one of the first *Brücke* artists to move from peaceful Dresden to the big city of Berlin. His new environment, however, hardly afforded him any artistic stimuli. Townscapes, music halls, theatres and night clubs rarely found their way into the world of his paintings. Pechstein's move was primarily a matter of financial considerations. In Berlin he found the necessary clients and localities for his decorative work, which enabled him to survive and to paint. Remembering these first Berlin years in a letter of 1919, he wrote, "It was the beginning of a lovely time, full of work, and even though I was often hungry, life nevertheless seemed great." In 1911 he and Kirchner started an institute called MUIM (*Moderner Unterricht in Malerei*, Lessons in Modern Painting), which was to provide additional financial resources for the two painters. However, there was very little response so that, after the first few lessons in nude drawing, the project had to be abandoned.

On the other hand, the state authorities did show a great deal of interest in their endeavours. A number of files have recently become available which prove that the head of the Berlin Academy of Arts had complained

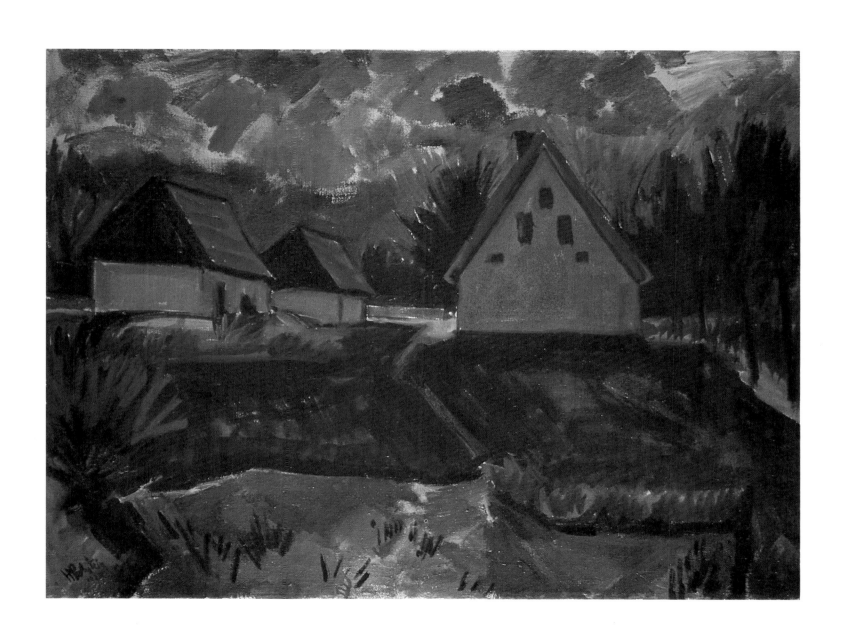

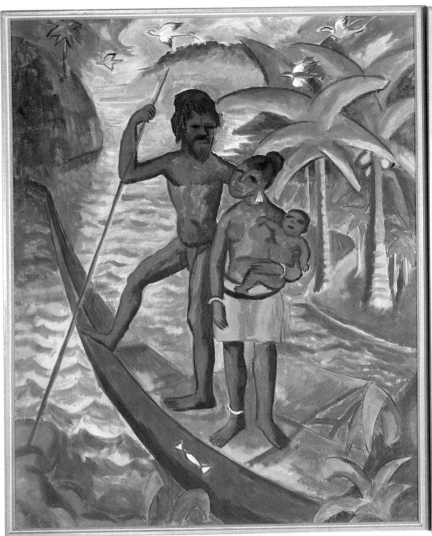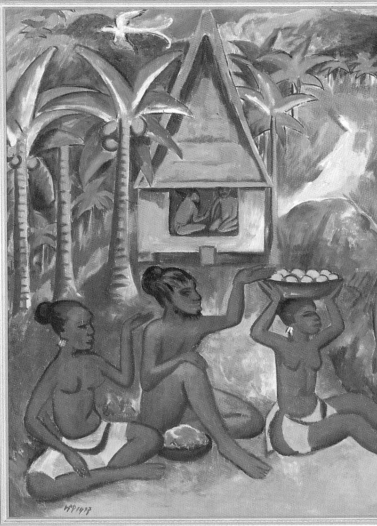

Max Pechstein:
Palau Triptych, 1917
Palau-Triptychon
Oil on canvas, 119 × 353 cm, centre
panel: 119 × 171 cm, wing panels:
119 × 91 cm each
Wilhelm Hack Museum,
Ludwigshafen

about their intended private painting lessons, and – as a result – the activities of the MUIM institute were suddenly placed under police surveillance. There is a secret report of 23 January 1912 which says: "With reference to the MUIM Institute at 14, Durlacher Strasse, 2nd floor, Wilmersdorf, it should be noted that the proprietors of the institute are two painters who are trying to direct the attention of their students as well as art enthusiasts to the beauty of lines, in order to promote interest in art, and to do so by means of visiting art institutes, museums etc. as well as theatres. They do not have any students as yet and are merely occupied with their own artistic creations. However, I gained the impression that Herr Kirchner is not in the best of pecuniary circumstances. I shall report back on the Kirchner/Pechstein matter as soon as the aforementioned visits and lessons have commenced." On 19 February 1912, a second report was written, this time about the painting lessons: "With reference to the MUIM Institute at 2nd floor, 14, Durlacher Strasse, Wilmersdorf, I attended two evening classes, which have now commenced, and found a limited number of participants drawing nudes." After this report, surveillance was stopped, and the authorities saw no

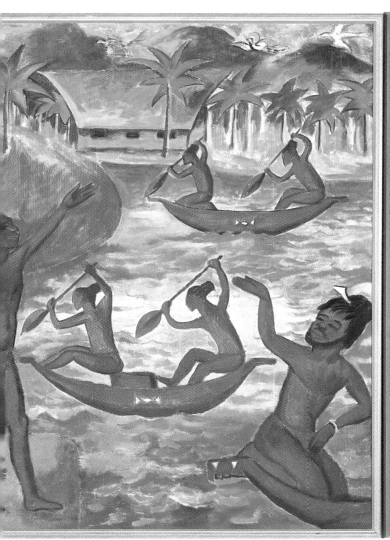
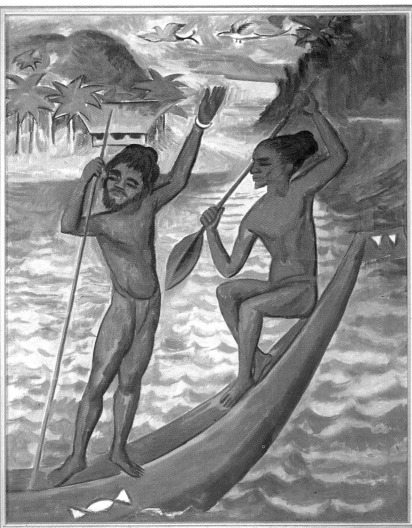

reason, for the time being, for any legal steps. In summer 1912 Pechstein again spent a considerable time in Nidden. As happened in Heckel's and Schmidt-Rottluff's art, there was now a change of style in his works. The decorative cheerfulness of the Moritzburg bathing scenes was gone. His nudes were no longer harmoniously integrated into nature. Large and statue-like, they stand side by side, without any interaction between them. Again, Pechstein emphasized the three-dimensional character of their bodies. The glowing colours of his earlier paintings were replaced by the cold contrast of an ochre beach and the grey-blue water. However, it is impossible to say unambiguously whether this stylistic change was a sensitive way of heralding the impending disaster. Pechstein's social background as well as his further development suggest that he was fully aware of political events, both in his thoughts and his actions. His Baltic paintings of 1912 were the first works after his exclusion from the *Brücke* group, and, as such, they may well have been his attempt to achieve a new beginning and to rid his style of the influence of the artists' circle.

When Pechstein's works had been rejected for the 1910 spring exhibi-

Max Pechstein:
Two Palau People, around 1920/21
Zwei Palauer
Woodcut, 17.4 × 11 cm

tion of the *Berlin Secession* he and Georg Tappert – another rejected artist – started the *New Secession*, of which Pechstein became the first president. To strengthen his position in the new society, the other *Brücke* members joined, too. It was decided that they would only exhibit at the *Berlin Secession* together. When, however, Pechstein was the only one to be invited by the *Secession* to exhibit his art and he actually accepted the invitation, he was excluded by the other *Brücke* members. In his *Memoirs* Pechstein describes the climate of the group in the words, "Berlin inexorably forced each one of us to fend for himself, all on his own", and he acted accordingly. Kirchner, Heckel, Schmidt-Rottluff and Mueller left the *New Secession* again at the end of 1912, not wanting to weaken the *Brücke* circle through their membership of other societies.

It was on their visits to the Dresden Museum of Ethnography that the *Brücke* artists, and particularly Pechstein, had first come across the artistic style of the Pacific Islands. This form of art filled them with great enthusiasm, and they were influenced by Palau wood carvings. They felt that the South Sea islanders had preserved an original lifestyle which was in harmony with nature – a life which the *Brücke* members had tried to recreate for themselves by means of their annual escapes from the city to the seaside and the Moritzburg Lakes. It was something which they themselves had wanted to capture in their art. In this sense, Pechstein was simply being consistent when he followed Gauguin's example and - like Nolde, a year earlier – went to live on the Palau Islands in the Pacific in April 1914. "Here is true unity between man and nature. Working, sleeping, everything is one, everything is life," he wrote enthusiastically in his diary about his new environment. However, this state of happiness did not last. When war broke out in November that year, he was put in an internment camp by Japanese troops and later returned to Germany in a rather adventurous way. He was taken along by various freight ships via Hawaii, New York and the Netherlands. As soon as he was home again, he was drafted into the army and had to serve on the Western front. This meant that, for the time being, Pechstein had no opportunity to inwardly digest his rich artistic impressions, even though he had already produced a large number of drawings as well as a painting.

Pechstein's spirit, however, was as sensitive as Kirchner's, and he was therefore unable to cope with the horrors of trench warfare. In 1917, he suffered a nervous breakdown, so that he had to be exempted from further military service and was sent to Berlin. After these experiences, it seems perfectly understandable that Pechstein now resumed his artistic work on his Pacific impressions, which had been broken off so suddenly by the war. He produced a number of paintings in which he remembered his time in Palau, and in them he portrayed a peaceful, harmonious anti-world, very much unlike that of his native Europe which had been destroying itself in a senseless war. His major work on this theme was his *Palau Triptych* (pp.88/89), a large panoramic painting with several different scenes. The left-hand panel shows a native family consisting of father, mother and child. The centre portion is also dominated by a group

of three, who, sitting on the ground, are turned towards the three male figures in the boat in the right-hand panel. This triad, which permeates the entire theme, is echoed in the depiction of water, earth and air and – correspondingly – of fish, men and birds. Both the format and the subject serve to emphasize this unity with three parts. Although Pechstein used the traditional, religious triptych, with a centre portion and two side panels, he counteracted this division into three separate parts by creating a theme that encompasses the entire width of the various portions.

In 1922 Pechstein discovered a place called Leba, where he was to spend every summer. Its scenery and its people soon came to dominate his art, with paintings of seascapes, coastal landscapes and the harbour. Furthermore, his art became narrative, as in his depictions of the fishermen at work, and he developed a love of detail. The colours of these painting are calmer, more delicately executed and richer in their variety of shades. Aggressive contrasts of complementary colours no longer occur at all.

In 1918, Pechstein, Heckel and Schmidt-Rottluff were founding members of the Co-Operative Council for Art. With the end of the war and the German November Revolution still fresh in their minds, the progressive forces among artists, architects and writers gathered here, propagating in manifestos a renewal of art, free from the fetters of academic traditions. However, the artists' demands soon turned out to be incompatible with reality, and so the Council broke up again. Pechstein, however, continued to be politically active. He became a member of the *Human Rights League* and actively supported the newly formed Soviet Union. In 1927, for example, he designed a poster, exhorting people to express their "solidarity with Soviet Russia" and to commemorate its tenth anniversary. It is therefore hardly surprising that he was one of the first victims to the Nazis attacks on the art world, after they had come to power in 1933. That same year he was officially barred from exhibitions and forbidden to paint. In 1937 he was excluded from the Prussian Academy of Arts, and 326 of his works were removed from German museums as "degenerate".

Max Pechstein:
Bathers, 1912
Badende
Woodcut, 20 × 22.5 cm

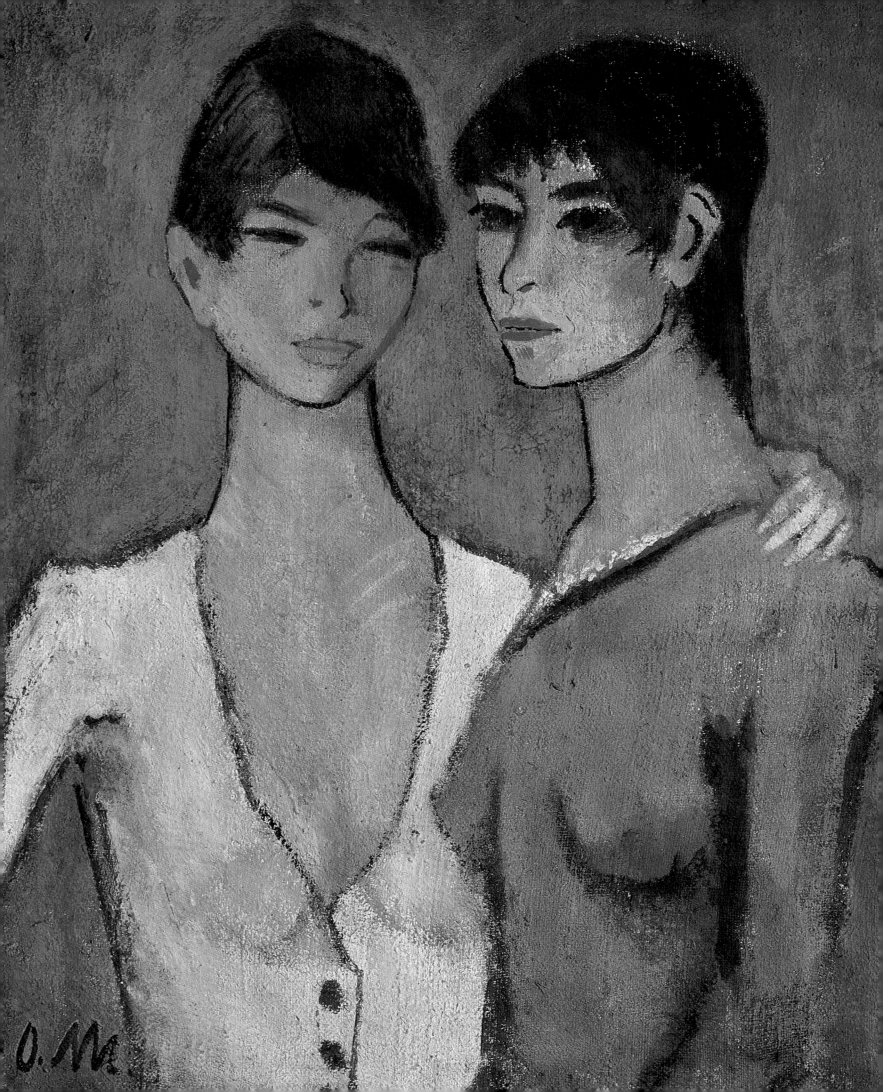

Otto Mueller

Otto Mueller was the last artist to join the *Brücke* circle, and he did so relatively late, in 1911 – only two years before its break-up. Like Kirchner, Pechstein, Schmidt-Rottluff and Heckel he had tried in vain to submit his paintings to the *Berlin Secession* in 1910. Instead, they were now exhibited side by side with those of the *Brücke* artists at an exhibition organized by the *New Secession* and together with other "rejects", at Maximilian Macht's gallery from 15 May to 15 June. In autumn 1910 Mueller took part in a special *Brücke* exhibition at the Arnold Gallery, Dresden, though only as a guest, and he did not become a full member until 1911. In his controversial *Chronicle* (see p.21) – the publication which led to the break-up of the group in 1913 – Kirchner justified Mueller's membership with the following words: "The sensuous harmony between his life and his work made Mueller an obvious member of the *Brücke*." A close look at the situation, however, shows that this decision was in fact far from obvious. The circle had already existed for six years, and for the last three years there had been no changes in its membership, i.e. since Nolde left the group. Pechstein was living in Berlin, and the other members, too, were visiting Berlin more and more, thus increasingly turning their backs on Dresden. Also, they were beginning to have their first commercial success. The times were really over when they could regard themselves as comrades-in-arms and when they welcomed every sympathetic fellow-artist with gratefulness in their hearts. What is more, Mueller's art was in many ways quite different from the typical *Brücke* style, which was perfected in the summer of that year, 1910.

The life of the cities, with scenes from cafés and cabarets, is missing in the world of his paintings. There is none of that direct and provocative eroticism about his nudes which is so typical of Kirchner's art. Neither does Mueller distort or disfigure his subjects, nor does he rid them of their natural colours in order to ecstatically enhance their impact. On the contrary. His paintings are calm, with the emphasis on harmony of composition. Their colours are restrained and balanced. The reason why he was such an "obvious" member for Kirchner was quite different. Because of our historical distance, we tend to concentrate more on the

Otto Mueller:
Two Girls, 1919
Zwei Mädchen
Lithograph, 43 × 33.3 cm

Otto Mueller:
Two Sisters, undated
Zwei Schwestern
Distemper on hessian, 90 × 71 cm
Morton D. May Collection, St. Louis
(Mo.)

Otto Mueller:
Five Bathing Nudes, 1911
Fünf badende Akte
Lithograph, 38.5 × 28.7 cm

differences between Kirchner, Heckel, Pechstein and Schmidt-Rottluff. People in those days, however, (and that included the *Brücke* artists themselves) saw above all the differences between them and Liebermann, Slevogt and Corinth. These were the leading members of the *Berlin Secession* and the main representatives of an art that was rejected by the younger generation and therefore also by the *Brücke* painters.

In the summer of 1909, Kirchner and Heckel took their models for painting sessions to the Moritzburg Lakes for the first time. A year later, they were joined by Pechstein. On these trips they were seeking a simple harmony between man and nature, unaffected by civilization, and this is what they also found in Mueller, both as a painter and as a person. Mueller certainly benefitted from the common, mutually stimulating work as a group, but Kirchner had to acknowledge in his *Chronicle* that the other members had also learnt from Mueller himself: "He brought us the charms of distemper." For Mueller, the year 1910, when he met the *Brücke*, proved the crucial date in his artistic development. That year he travelled to Bohemia with Kirchner, and the following year he went painting together with Kirchner and Heckel on the Baltic coast. In 1912, Mueller and Kirchner went to Uniczek, near Prague, together. Later, however, in 1926, when Kirchner painted *The Painters of Die Brücke* (p.14), he placed Mueller in the bottom left-hand corner, as if he had no interest in what was going on. Undisturbed, he is smoking his pipe, while the others (Kirchner, Heckel and Schmidt-Rottluff) are discussing the *Chronicle* of the *Brücke*.

Mueller was born on 16 October 1874. Although he was two years younger than Nolde – who left again after a short while – he was six years older than Kirchner, and indeed ten years older than Schmidt-Rottluff. He was an only child, and his father would have loved to see him as an army officer. However, he was only interested in drawing and eventually managed to assert himself. At the age of 16 Mueller began to train as a lithographer. He turned out to be very talented, and four years later he moved to the Dresden Academy of Arts. But he only stayed for a brief period (1894 – 1896). Like many young artists, Mueller rejected the rigid academic approach and the dull copying of classical painters. Instead, he developed a keen enthusiasm for painters such as Hans von Marées and Arnold Böcklin. However, when he tried to continue his studies with Franz von Stuck in Munich, he failed miserably. He soon argued with this prince among painters, left his class and travelled back to Dresden.

Mueller gained his most significant artistic experiences and contacts in the circle of the dramatist Gerhard Hauptmann, a distant relative of his. Hauptmann took him along on his trips, introduced him to important intellectuals, writers and – above all – painters in Dresden. Through Hauptmann he met the poet Rainer Maria Rilke and the sculptor Wilhelm Lehmbruck. In his epic *Till Eulenspiegel* Hauptmann depicts Mueller as a painting half-gipsy.

Mueller owed his nickname – Mueller the Gipsy – to two characteristic features, as an artist and a person. It is still very strongly believed that his

Otto Mueller:
Three Nudes in the Forest, 1911
Drei Akte im Walde
Distemper on hessian, 110.5 × 85 cm
Sprengel Museum, Hanover

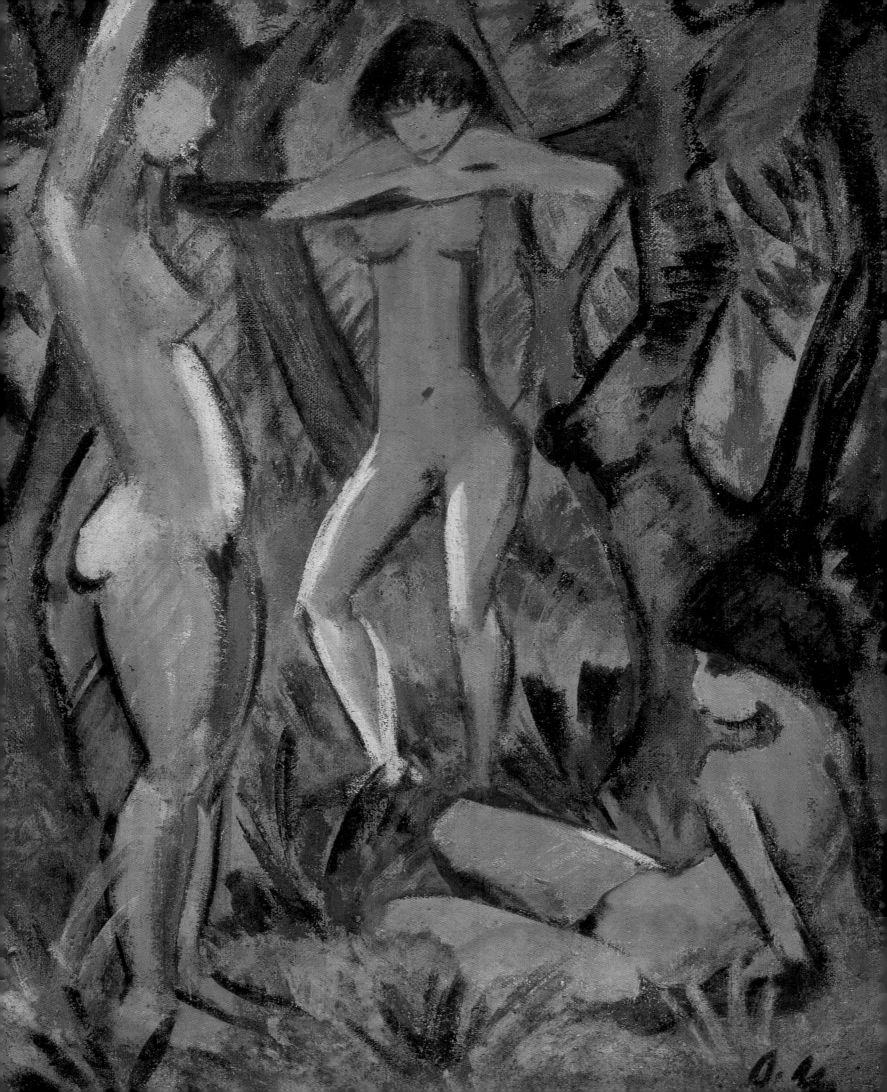

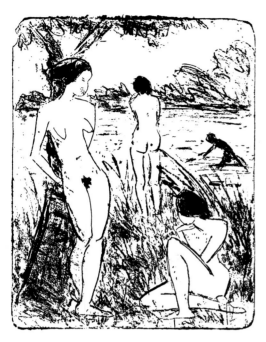

Otto Mueller:
Nudes by the Water, around 1914
Akte am Wasser
Lithograph, 30.8 × 22.9 cm

Otto Mueller:
Forest Lake with Two Nudes, around
1915
Waldsee mit zwei Akten
Distemper on hessian, 80 × 105.5 cm
Museum am Ostwall, Dortmund

mother had gipsy ancestors, although no proof can be offered. Mueller himself never contradicted this, and indeed supported such speculations by his behaviour. As a child, he always used to feel a great affinity to gipsies, whose geographical independence and unconventional life he admired. This yearning can also be found in his art, where he concentrated above all on groups of young, unclothed gipsy girls in natural settings. They do indeed dominate the world of his subjects, except for a few landscapes and portraits, though most of the latter are self-portraits. In 1910, when he met the *Brücke* painters, there was a distinct turning point in his art. He himself destroyed most of his previous paintings, so that not many works prior to 1910 still exist. It is also rather difficult to draw up a precise inventory because the artist did not date many of his paintings. However, Mueller now began to develop his own style and his own themes very rapidly, and he remained faithful to them without taking his art any further.

He was constantly drawn to paint the same scenes. His *Three Nudes in the Woods* of 1911 contains all the stylistic features which are characteristic of Mueller's paintings. Three female nudes are placed in the forefront of the painting, which they dominate. Indeed, one of them fills the entire length of the picture. Their slender, childlike bodies are turned towards one another in natural and uninhibited postures. Their thick, black hair identifies them as the gipsy models which were so typical of Mueller. The woods are indicated by several thick tree trunks, extending through the painting like an abstract lineament. The spaces are filled with thick grass and foliage. Mueller's colours do not go beyond Naturalism, and the brown bodies of the girls merge harmoniously into their green environment. The impact of the painting is not dramatically enhanced by complementary contrasts. Mueller was never affected by French Fauvism, which had become so important for the other *Brücke* artists. Instead of coloured areas, he emphasized coloured lines, which enclose the childishly angular bodies of his models in the form of dark contours. The three nudes are facing each other, defining the space in the painting on the two sides as well as its depth. In fact, they open up their circle to the front, towards the viewer, so that he can become part of their group. Thus, the nudes can also be regarded as three Graces. A "judgment of Paris" is required, in which the viewer has to make the decision and hand an apple to the most beautiful girl. And indeed such an interpretation is very likely, in view of another painting by Mueller which he had painted shortly beforehand and which is in fact called *The Judgment of Paris* (1910/11, private collection, Feldafing). In this way, the painting serves as evidence for Mueller's new bearings in about 1910/11 – a time which was very important for him. The idea of the *Three Graces* continued in the form of a painting, though their classic content had become totally secular.

Mueller probably received some very important ideas for his own art from the other *Brücke* artists. The tentative insecurity which was visible in his early works – or at least the ones we know – was soon replaced by a

firm structure in his paintings and led to concentration on a restricted number of subjects.

In 1911 Mueller left his studio in Steglitz (Berlin) to Heckel and moved to Friedenau. Like his comrades-in-arms of the *Brücke* circle, he was guided by the desire to go beyond traditional painting methods and to escape the rut of traditionalism. Like the others, he wanted to apply the circle's new artistic achievements to his own life. In Kirchner's case, there is impressive photographic evidence that he did his utmost to re-design his own environment – his studio – with home-made furniture and murals. Mueller, too, decorated his various flats with mural paint-ings – his Berlin flat and, after 1919, the one in Breslau, too, and he even decorated the military hospital in Neuss in 1917. But instead of using oil or tempera, he preferred the traditional fresco technique, whose dry, lustreless colours can be found again in his distemper paintings. How-ever, none of these works have been preserved. These occasional ven-tures into the world of applied art are now merely reflected in his home-made, painted picture frames. His *Three Bathers in a Pond* (p.95) of 1912 is mounted in one of these original frames.

Mueller used distemper, which gave his paintings their characteristic lustreless appearance and enabled him to get closer to the ancient Egyp-tian murals which he admired so much. However, his admiration of Egyptian art was not merely a matter of technique. He also tried to follow their two-dimensional, parallel composition and linear mode of expres-sion. As a surface, Mueller preferred to use coarse hessian which soaked up the paint more quickly. Both qualities – the lustreless appearance of the paint and the typical surface structure – are factors which contribute to today's responses to Mueller's art.

From 1916 to 1918, Mueller served in the infantry during the First World War. It is not known whether he shared the patriotic enthusiasm of most of his fellow-artists. But he certainly did not want to be given preferential treatment, and he refused to be exempted for health reasons, even though such a decision had already been taken. However, like other sensitive artists – such as Kirchner and Beckmann – he soon found that the reality of war was quite different from the idealistic world view of the artists. As an individualist, Mueller suffered from the uni-formity of life in the trenches, robbed of privacy and not being allowed to make his own decisions. In 1917, he developed pneumonia, and after a lengthy stay in a military hospital he was finally exempted from further military service. While he was recovering, Mueller had plenty of oppor-tunity to paint. It seems as if his paintings were totally untouched by the horrors of the war he had experienced, and he apparently continued where he had left off. No change can be discerned, either with regard to form or subject, and there is not even a touch of melancholy in his paintings. It is only when we look at his prints that we find one particular plate among all the peaceful, absent-minded nudes, where the horrors of the *Trenches* (1915 – 1918) are depicted with dramatic immediacy.

After the war, Mueller's art was also recognized at an official level by

Otto Mueller:
Lovers, 1919
Liebespaar
Distemper on hessian, 106 × 80 cm
Peter Selinka Collection, Ravensburg

the German authorities, and indeed far more than any of his former *Brücke* friends. As early as 1919, he was offered a professorship in painting at the Breslau Academy of Art. This is all the more surprising when we consider that there was in fact massive criticism of his art, even from some very knowledgeable people. The art critic and dramatist Carl Einstein, for example, expressed himself rather strongly in his book *Kunst des 20. Jahrhunderts* (20th Century Art) of 1926: "Mueller depicts nudes and German landscapes with a sickly sweet lack of restraint ... Occasionally, he does of course manage to create something attractive, but most of it gets bogged down in green and blue lustreless sweetness and the dull monotony of his lines."

In the mid-1920s, however, Mueller began to introduce a new element of melancholy into his works. With these new motifs, he distanced himself a little from his constantly repetitive Arcadian landscapes with nudes. The depiction of covered wagons, huts, villages, mothers with their children and old men meant that the real habitat of the gipsies now found its way into the world of his paintings. Nevertheless, it would be wrong to deduce that Mueller began to take any active interest in social issues.

With regard to theme and style, Mueller's work was very narrowly limited. Again and again, we come across similar motifs in related compositional schemes. The kind of girl he depicted was always the same. All his models have the same facial features, dark, medium-length hair, narrow faces and slender bodies. One cannot help suspecting that Mueller always used the same model. The artist himself actually saw this continuous artistic perseverance as a characteristic quality of his art. Having discovered that artists were unable to create anything new anyway, he concluded categorically for his own art that one could really only produce variations on the same theme. Mueller set himself the task of remaining true to himself without being repetitive or boring the viewer. With historical hindsight, we can now say that he did not always succeed in avoiding the dangers of these self-imposed limitations and that contemporary critics were not always wrong in their judgments. On the other hand, we must not give too much weight to these reservations. It is certainly true to say that Mueller found his own independent, Expressionist position, which enabled him to create paintings of extreme clarity and simplicity. They are elegiac in mood and express a romantic hope that man might be at peace and in harmony with nature.

Otto Mueller:
Gipsies with Sunflowers, 1927
Zigeuner mit Sonnenblumen
Distemper on hessian, 145 × 105 cm
Saarland Museum, Saarbrücken

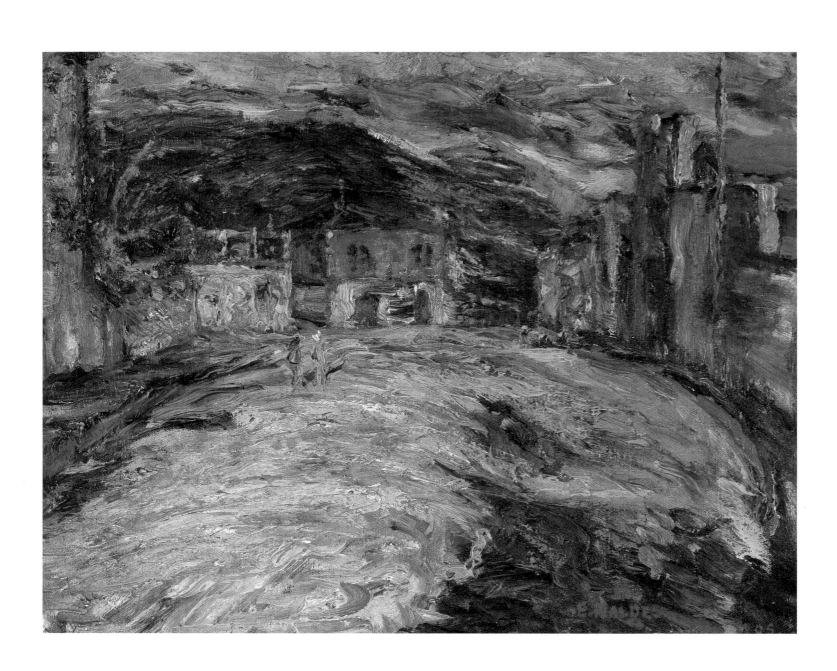

If we draw an imaginary map of German Expressionism, we will find that some cities and regions were more important than others. Dresden, where the *Brücke* painters formed their circle in 1905, can certainly be regarded as the capital of Expressionism. As for Munich, its counterpart, there was no single group that had its own theory and programme. After the artists had left the *Neue Künstlervereinigung München* (N.K.V.M., the New Artists' Association of Munich), they met informally, as friends, and gathered around Kandinsky and Marc's editorial team of the almanac *Der Blaue Reiter*, which was to give them their name.

Emil Nolde, Paula Modersohn-Becker and Christian Rohlfs, who will be regarded as representatives of Northern German Expressionism in the next three chapters, did not form an official circle or even an informal

Northern German Expressionism

group of friends. Indeed, they did not all know each other personally. Nolde only ever met Modersohn-Becker very briefly when he was in Paris in 1900; and in 1907, in Soest, he was introduced to Rohlfs by their mutual friend and sponsor Osthaus. Generally, however, the artists lived on their own and far away from one another. As a result, each of them evolved as artists quite independently. There are virtually no external, biographical parallels that might give them a common bond. Art historians frequently refer to Nolde as a *Brücke* artist, because of his 18-month-long membership, and Rohlfs is often regarded as a Rhenish Expressionist, together with Morgner, Macke and Campendonk.

As the three artists were totally independent of one another, it would be wrong to discuss them under the same heading merely because of their common Northern German background. Rather, their art is characterized by a number of stylistic features that are shared by all three: each artist formulated an artistic message in very simple terms, deliberately restricting his methods and refraining from skilful aesthetics and elaborate devices. Unlike in Macke or Marc's art, we find no compositional complexities, parallel structures of two-dimensional areas, or Cubist fragmentation of form. They differ from the *Brücke* artists in the emotional restraint with which they painted, even though they did so quite passionately and solemnly. For them, colour was not exclusively a matter of contrast and expressiveness, but was always symbolical in character, too. As a result, forms and colours in their pictures combine to form magnificent parables of the forces of nature. Within Expressionism, it is only in Nolde and Rohlf's paintings that we can feel a certain down-to-earth quality about their themes, firmly rooted in the rural Northern German area where they were painted. In paintings as well as prints, both artists depicted creatures from Nordic mythology – gnomes, goblins and mythical beasts.

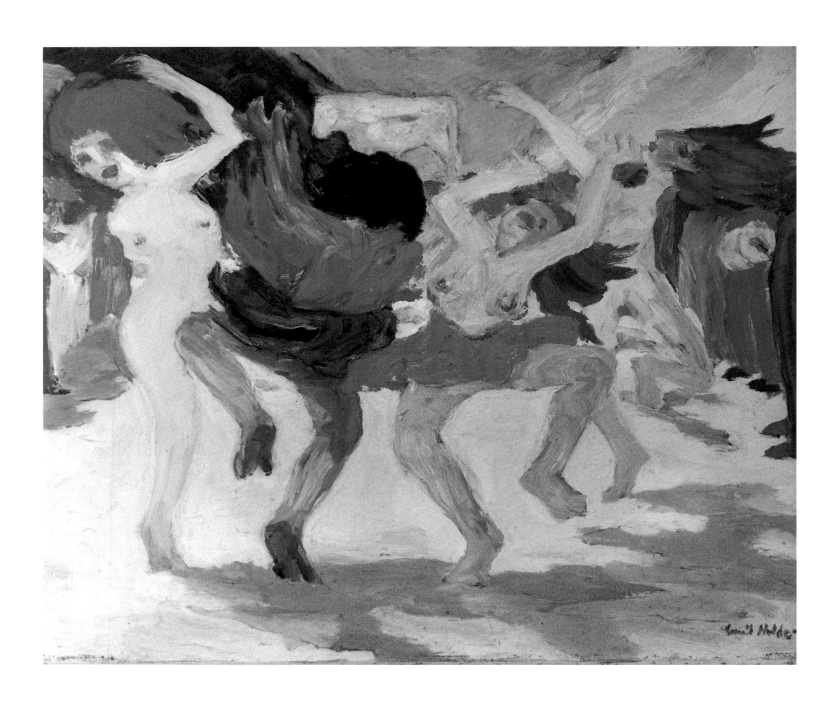

Emil Nolde

On 4 February 1906, Schmidt-Rottluff sent a letter to Nolde on behalf of the *Brücke*, inviting him to join the circle as an active member. When they saw Nolde's "tempestuous colours" in an exhibition at the Arnold Gallery, Dresden, they were profoundly impressed and recognized an artistic kinship that revealed similar aims. Although Nolde was already considerably older and had made a name for himself, he decided to join and remained a member until the end of 1907. However, he only spent one period of several months in Dresden itself, during which time his wife Ada had to stay at the local sanatorium. Every year he would spend the summer months on the Baltic island of Alsen, living in a little fisherman's hut. There Schmidt-Rottluff visited him in 1906.

His personal contact with the other *Brücke* artists was one of genuine friendship, which continued even though he left the group shortly afterwards. Although his art may in many ways have benefitted from the ideas of the other artists, Nolde failed to fit in with the rest of the group. He was too much of an individualist and therefore felt rather critical, suspicious, and even hostile towards any kind of collectivism that might tie him down. From his childhood, Nolde had always been an introvert, and he very much preferred the solitude of Alsen. We do not know why he accepted Schmidt-Rottluff's invitation, but he soon realized – probably during his stay in Dresden – that he would not be able to fit in with an artistic circle whose members regarded themselves as deeply committed comrades-in-arms. He was extremely reluctant to take part in their painting sessions and to subject the new fruits of his artistic endeavour to the critical eyes of the group. Later, in his memoirs he spoke of "tension, both on a human and an artistic level" which made him leave the group again. Also, he accused the others of having copied his ideas and turned them to unauthorized financial profit. This accusation was as untenable as Kirchner's same suspicion of his former friends. Although Nolde was only a member for a short time, both sides benefitted. Nolde introduced etching as a new artistic medium, and his friendship with Schiefler, a Hamburg art collector, opened up important contacts with sponsors and collectors in that city, especially for Schmidt-Rottluff.

Emil Nolde's original name was Emil Hansen, and he was born in a place called Nolde (in the province of Schleswig) in 1867. He adopted the

Emil Nolde:
Self-Portrait, 1908
Selbstbildnis
Etching, 31 × 23.5 cm

PAGE 102:
Emil Nolde:
Piazza San Dominico II, Taormina, 1905
Oil on canvas, 41 × 51.5 cm
Kunstmuseum, Düsseldorf

Emil Nolde:
The Dance Round the Golden Calf, 1910
Tanz um das Goldene Kalb
Oil on canvas, 88 × 105.5 cm
Staatsgalerie moderner Kunst, Munich

Emil Nolde:
Steam Trawler, 1910
Fischdampfer
Woodcut, 30.5 × 40 cm

name of his home town in 1902, as a personal and at the same time artistic affirmation of his geographic roots and the scenery which was to exert a considerable influence on his entire work as a painter. After training as a furniture designer, followed by a course at the School of Applied Arts in Karlsruhe and several years of job experience, Nolde moved to St. Gallen (Switzerland), to teach ornamental drawing and modelling at the local School of Applied Arts. This was a significant turning-point in his life. In his spare time, he continued to practice free-hand drawing, and on his trips into the Swiss Alps he created numerous works, personifying the mountains in the form of grotesque heads. After several of these drawings had been published in the popular magazine *Jugend* (Youth) and received with great enthusiasm, Nolde decided to have these motifs printed on postcards. Within a few weeks, he managed to sell such large numbers that he was able to give up his teaching job and establish himself as a freelance painter. During the following years he did a lot of travelling, first to Munich and later to attend Adolph Hölzel's school in Dachau and the Académie Julian in Paris. From there he moved to Copenhagen and finally settled down in Berlin in 1901, having spent two years gathering important artistic impressions and experiences. He had gained valuable insights at the Dachau School of Art and, in Paris, he had studied Titian, Rembrandt, Degas and Manet, whom he called "the greatest and most significant painter of light and beauty". All these artists had influenced his own works. From now on, light was to acquire an outstanding compositional function for him, though, for the time being, it was still tied to traditional shades of light and darkness, without being dominated by unbroken colour chords. During his time in Paris he did not meet Gauguin or van Gogh, whose art he was to follow later.

It was not until 1903, when he moved to the Isle of Alsen, that his colours gradually began to acquire the Expressionist forcefulness which was so typical of his motifs. This was the time when he started painting his garden and flower scenes. His *Piazza San Dominico II, Taormina* (p.102), painted during a trip to Sicily in the spring of 1905, was still one of his transitional works. On the one hand, his brushwork is already far more relaxed and permeates the entire motif in thickly opaque layers, so that all the shapes - the square, the trees and the building – acquire the same swirling movement. On the other hand, this cannot be said for his colours. At the time, Nolde did not yet dare to separate the colours from their respective objects and to use colour as a formal device to enhance the expressiveness of his paintings. Nolde could even (easily) outdo the stunning, contrastive colours of the gardens with their many bright flowers, but in this painting he still adhered very closely to the earthy, restrained colour shades of the Sicilian square.

But when Nolde encountered van Gogh's ecstatic streams of colour, Gauguin's exoticism and Munch's mysticism, his own work was greatly enriched. His brief association with the young *Brücke* artists helped to confirm and consolidate his art. Pictures such as his *Flower Garden* of 1908 (p.107) benefitted considerably from these contacts and influences.

Emil Nolde:
Big and Small Steamers, 1910
Grosser und kleiner Dampfer
Woodcut, 30.5 × 39.8 cm

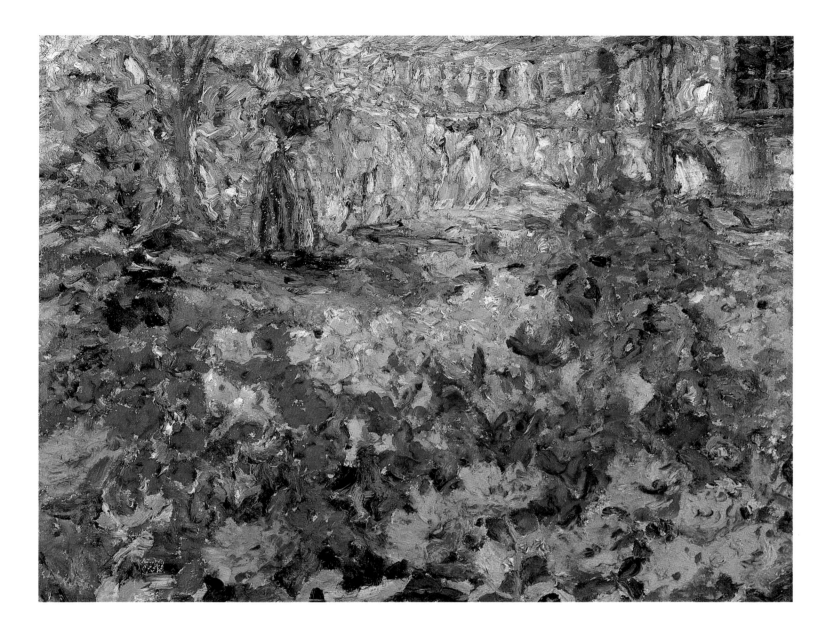

Nolde applied the paint very densely, as a thick hotchpotch, giving up the illusion of depth and perspective in favour of two-dimensional space. It is no longer the densely placed, short brush strokes that dissolve the static quality of the forms and cause movement. In fact, the theme acquires a vividly ecstatic quality because of the contrasts between unmixed colours, placed densely side by side and therefore enhancing each other's forcefulness. In 1908, Nolde's oeuvre was dominated by *Flower Gardens*, and indeed flower gardens remained one of his most important sources of artistic inspiration. Later, in Seebüll (1928) Nolde followed Monet's example of Givenchy (1883) and had a garden built where a rich variety of different flowers served as motifs for his paintings. Apart from flowers, the most significant subjects in his art are coastal landscapes and religious scenes.

In his attitude to work, too, Nolde was in many ways akin to van Gogh. When he stood before the canvas, it was with the same passionate emotions. He was unable to work regularly or follow a fixed work schedule. Every time he painted a picture, it was an act of self-renunciation. And

Emil Nolde:
Flower Garden (Girl and Washing), 1908
Blumengarten (Mädchen und Wäsche)
Oil on canvas, 65.5 × 83 cm
Kunstmuseum, Düsseldorf

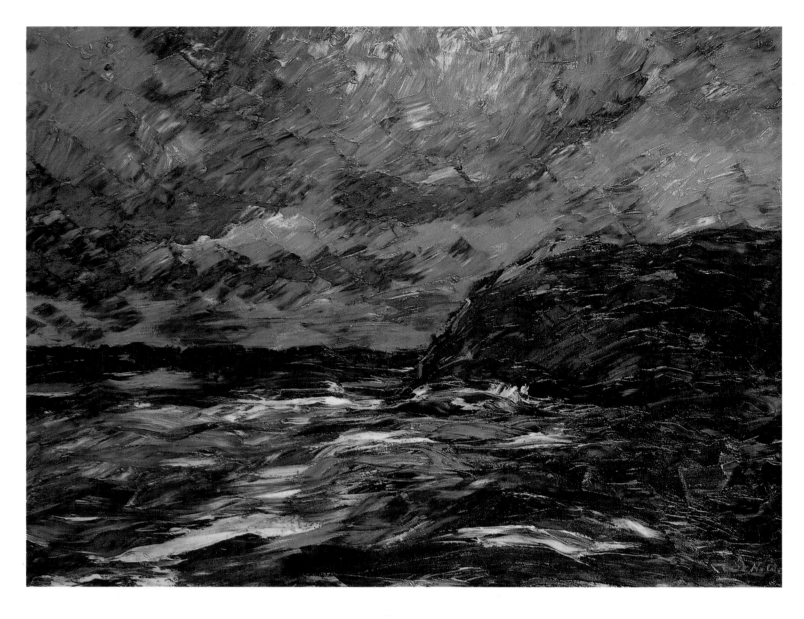

Emil Nolde:
Autumn Sea XI, 1910
Herbstmeer XI
Oil on canvas, 73 × 88 cm
Kunsthaus, Zurich

the more he connected his life and his work in this way, the more he was beset by self-doubt. Happy and artistically productive periods were followed by phases of resignation when he was unable to work at all. At such times, whenever Nolde was dissatisfied with a result, he destroyed or cut up numerous paintings and then regretted it later. "There are some pictures I destroyed," he wrote wistfully in his autobiography, "which I sometimes remember like lost moments of happiness."

With his move to the Isle of Alsen and his return to the landscape of his childhood, the Northern German plain now became the central motif in Nolde's work. His views of the coast and the sea became magnificent atmospheric depictions of nature. Man – or indeed anything that might point to the presence of man, such as houses or ships – was now extremely rare in his art. Where man does occur, he is shown as rebelling or trying to hold his own against the forces of nature – the water and the wind. In a number of cases, he seems to be totally at their mercy. Painted as late as 1910, his *Inland Lake* has that typical opaque and loosened-up touch which also characterizes the works of the transitional period of many other Expressionists, when they were still working under the

108

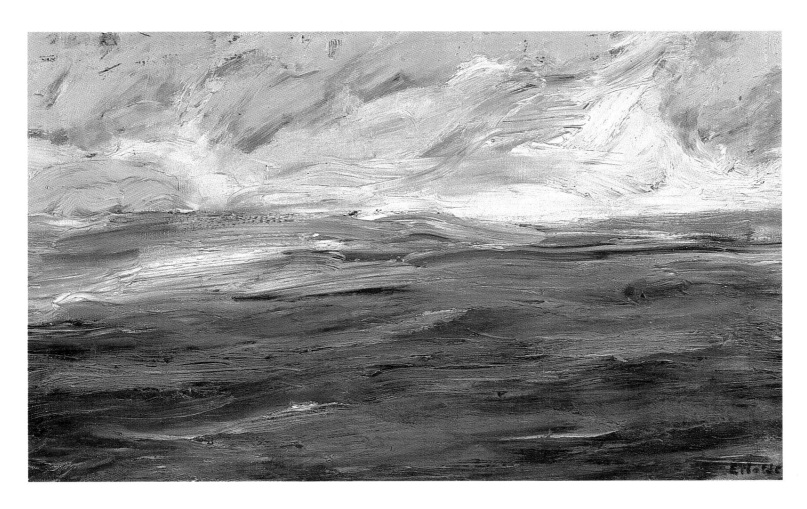

Emil Nolde:
Autumn Sea I, 1910
Herbstmeer I
Oil on canvas, 39.5 × 65 cm
Museum am Ostwall, Dortmund

influence of French Impressionism. While the *Brücke* artists had already abandoned this kind of style by 1910 and even Nolde himself had begun to structure his figures far more in terms of coloured areas, he continued to use a pointillist technique in his landscapes for quite some time. However, he stretched the individual spots of colour more and more so that they became broad and elongated, and in some cases these areas dominate the whole painting. The formal variation is hardly surprising, when we consider that it was in keeping with the themes of his landscapes. The rippling surface of the sea and movement of the clouds was reflected quite ideally in the rhythmic motions of his brushwork. As we can see in his *Inland Lake*, the sky and the water, with no more than a narrow strip of land, simply do not have any firm, compact forms, but are in a constant state of flux, changing continuously from one moment to the next. There is probably no other theme that gives the artist so much freedom and which offers virtually no resistance to the free flow of his brush. Nolde applied the paint in broad, horizontal strips, expressively juxtaposing ultramarine blue and yellow, so that they enhanced one another. In paintings such as *Autumn Seascape I* (above), which dates from the same

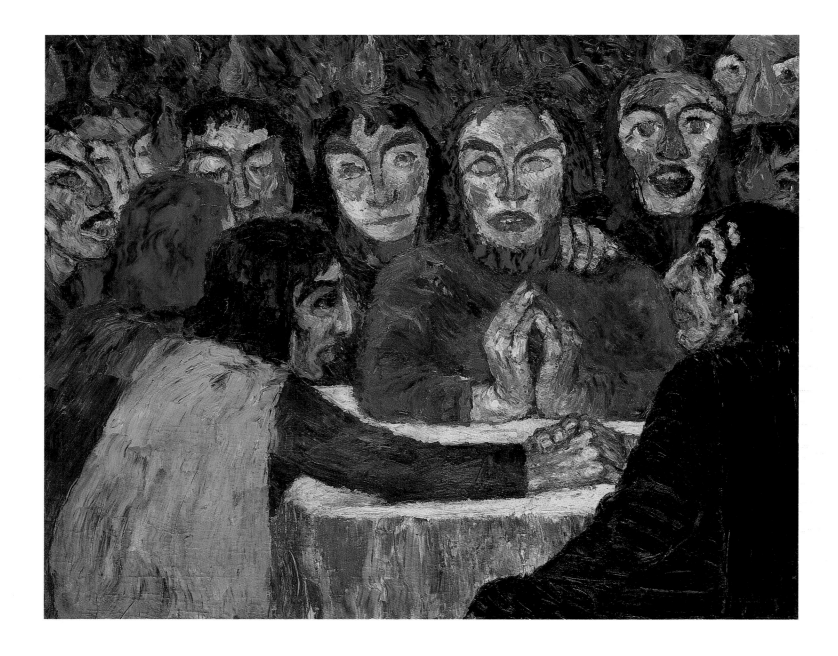

Emil Nolde:
Pentecost, 1909
Pfingsten
Oil on canvas, 87 × 107 cm
Nationalgalerie SPMK, West Berlin

year, the colours are almost autonomous, as if they were independent of the original subject itself. These works by Nolde seem uncommonly topical and contemporary, and one almost wants to place them alongside painters like Mark Rothko. With his *Autumn Seascapes*, Nolde was certainly one of Rothko's forerunners.

In 1910, Nolde was faced with the choice of taking an important step in the further development of his landscapes. It was the year that Kandinsky in Munich, who had to make the same decision, stepped into the realm of the unknown and painted his first abstract water-colour. Thus his lines and colours achieved that autonomy which Nolde's colours were now beginning to approach as well. Nevertheless, although such a step would have followed quite logically, Nolde did not take it. In his 21 versions of the *Autumn Seascape*, painted in 1910 and 1911, he ventured most closely towards abstract art, without, however, giving up the link with the naturalist motif altogether. Nolde must have been aware of the extreme point which his art had reached, yet he shied away from the conse-

110

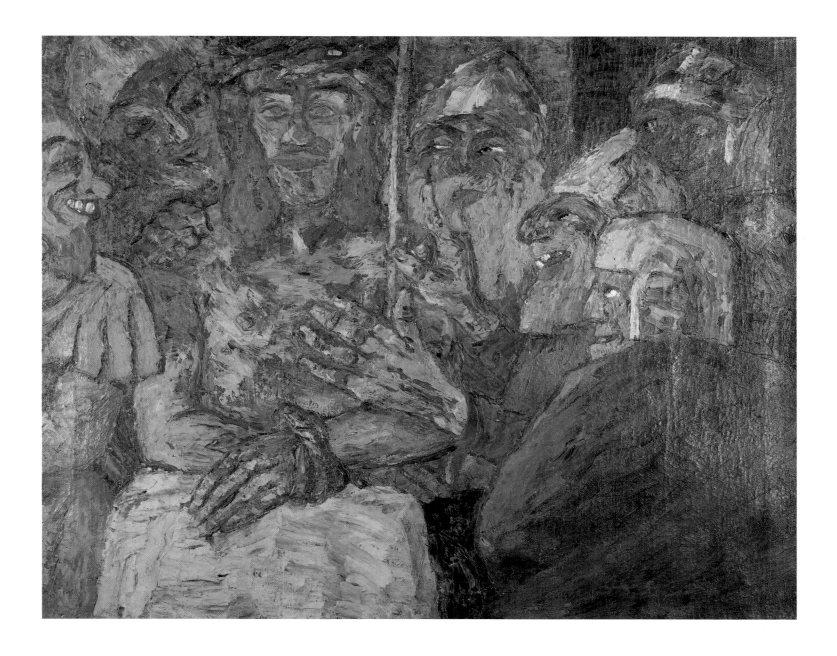

Emil Nolde:
Mocking of Christ, 1909
Verspottung Christi
Oil on canvas, 86 × 106.5 cm
Brücke Museum, West Berlin

quences and subsequently took up the theme of seascapes rather hesitantly. In 1912, he only created one more painting of this kind, called *The Sea* (Norton Simon Museum of Art, Pasadena). Furthermore, his brush-work had changed and was now following the two-dimensional, non-perspective organization of space which had already gained ground in his religious subjects three years earlier.

From 1902 onwards, Nolde submitted his works to the exhibitions of the *Berlin Secession*. However, he was only included four times (in 1902/3 and 1907/8) and only with drawings and prints, not paintings. After the jury had rejected him again in 1910, Nolde wrote a strong letter to the magazine *Kunst und Künstler* (Art and Artists), in which he attacked the *Secession* chairman, Max Liebermann. Nolde accused him of not knowing his limits and said that his art was so feeble and tawdry that "the entire younger generation was fed up with it and could not bear to look at it any longer." It seemed at first as if Liebermann could take these insults in his stride, and Nolde was immediately excluded from the *Secession*.

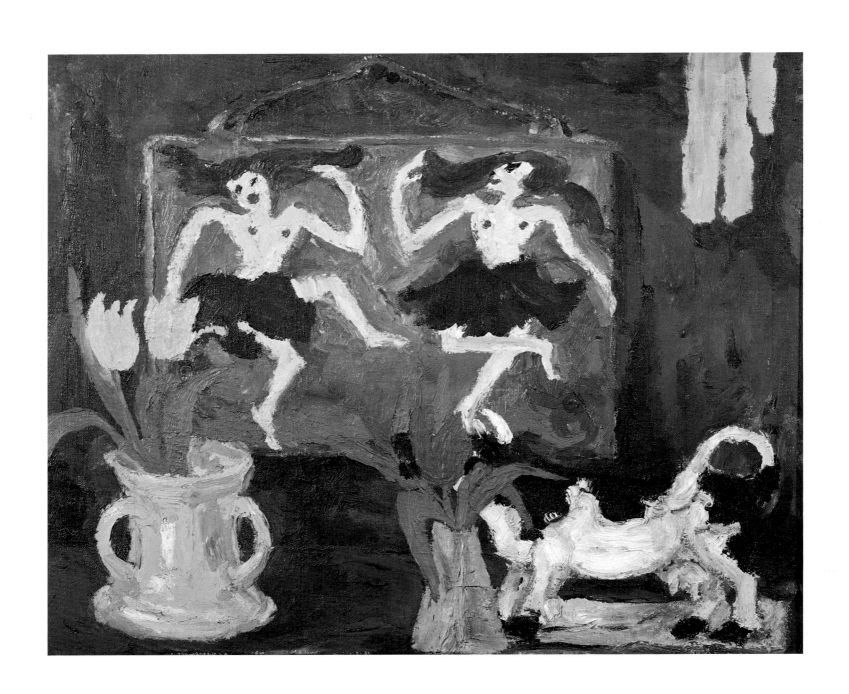

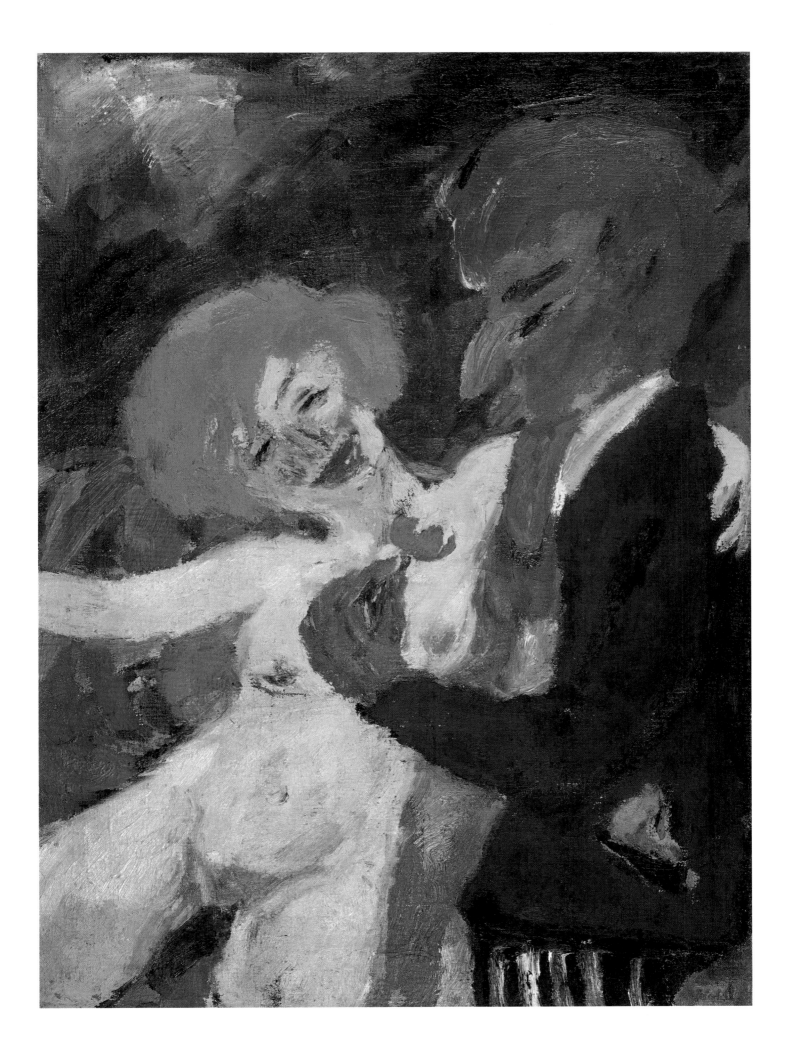

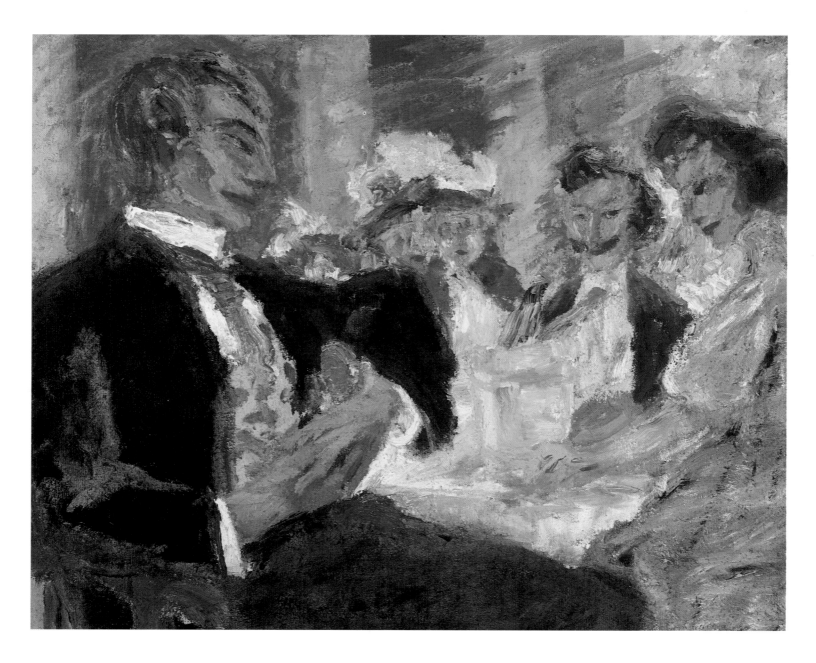

Emil Nolde:
At the Café, 1911
Im Café
Oil on canvas, 73 × 89 cm
Folkwang Museum, Essen

PAGE 112:

Emil Nolde:
Still Life with Dancers, 1914
Stilleben mit Tänzerinnen
Oil on canvas, 73 × 89 cm
Musée National d'Art Moderne
Centre Georges Pompidou, Paris

PAGE 113:

Emil Nolde:
The Enthusiast, 1919
Der Schwärmer
Oil on canvas, 101.3 × 73.6 cm
Sprengel Museum, Hanover

But tension had already been smouldering within the art association for quite a while, and this was merely the first time that it erupted and became visible to the outside. That same year Liebermann resigned the chair. However, even this did not prevent a split within the *Secession*, and the younger generation of Berlin artists now started their own society, the *New Secession*, which was immediately joined by Emil Nolde and all the *Brücke* members and gave them an opportunity to exhibit their rejected works.

In autumn 1910 Nolde spent several months in Berlin, in a flat of his own. During this time he discovered a new theme which only ever featured in his art in that brief period of winter 1910/11 and which seems uncommonly out of place among his flower gardens and coastal land-scapes. Like the *Brücke* artists, Nolde discovered the fascinations of life in the city – the world of music halls, bars and night clubs. However, he concentrated almost exclusively on the same situations, guests sitting at their tables. The variety show on the stage remained in the background.

Kirchner's Berlin prostitutes, who were very much at the centre of his city themes, can also be found in Nolde's art, sharing a table with respectable middle-class gentlemen. Nolde was interested in the psychological relationships between the different people, though in his art he also translated these into aesthetic problems of formal composition. And indeed he was fascinated by the unreal sheen of the rooms, with the green and yellow faces of his models reflecting the light.

This interest of Nolde's can be seen very clearly in his painting *At the Café* (p.114) of 1911. The parallel areas of red and yellow give the theme a gleaming radiance that is almost hallucinatory. The dark clothes of the figure sitting on the left further enhances the effect of the bright colours. The large male figure on the left is balanced by the man and woman at the table. Everybody seems to be calm and relaxed, and yet there is an electrified excitement about the painting, which can also be felt in its aggressive colours. An erotic atmosphere is created by the glances with which the two men are sizing up the woman. Feigning shyness, she has lowered her eyes. As in other paintings, two elderly ladies are participating as voyeurs in the background. Nolde has ventured a glimpse into the night life of the big city, something that is alien to him with its excessive abundance of optical and erotic stimuli.

It was with the same curiosity that he approached the artistic forms of expression in German folk art and primitive, exotic tribes. In the same year, in 1911, Nolde was preparing to write a book on *Artistic Expression among Primitive Tribes*. Although he never completed it for publication, it provides further evidence that Nolde was deeply interested in these artistic forms of expression which, until then, had been largely ignored. Not only did he depict figures from Nordic mythology, but he also looked for inspiration – with regard to both form and theme – in Egyptian and Assyrian art as well as the tribal art of Africa, South East Asia and the South Seas. The Berlin Ethnological Museum was his most important source of inspiration at the time. Two years later, in 1913, Nolde was given the opportunity to accompany a scientific expedition to New Guinea, which took him via Russia, China, Korea and Japan to the South Seas. Although his artistic expression did not undergo any substantial changes, Nolde nevertheless soaked up a number of new impressions, far more direct, in a way, than through the exhibits at the museum. On the trip itself, he mainly produced drawings as well as a few paintings. When war broke out in 1914, his return journey had to be delayed, and it was not until afterwards that he made use of his fresh impressions of the foreign cultures in the form of numerous works. If, in previous years, he had frequently depicted cultic objects and masks, these were now replaced by groups of Russian peasants and South Sea islanders or exotic landscapes. Years before the expedition, as early as 1910, he had painted the *Dance around the Golden Calf* (p.104). The title shows that it was modelled on a scene from the Old Testament, and this is also indicated by the golden calf itself, far away in the background. However, Nolde merely took the original theme as a pretext to paint a wildly orgiastic scene. Four

young women, naked or scantily clad in short skirts, are ecstatically performing a wild cultic dance, a joyful pagan celebration full of glowing colours. Although this painting is unusual among Nolde's religious themes, in that it merely uses the biblical topic as the setting for a cultic scene, it nevertheless ranks among his most significant Expressionist works.

Religious topics constitute a very important part of Nolde's art. This is by no means unusual for an Expressionist artist. Numerous comparable examples can be found in the works of Schmidt-Rottluff, Kokoschka, Rohlfs and Morgner. But unlike the others, Nolde used the Bible as a significant source of inspiration throughout his artistic career, whereas the other Expressionists thought about Christianity mainly during the brief period around and during the First World War, when religious topics served as immediate expressions of their own anxieties and their powerlessness in the face of the political events. Nolde's religious themes, on the other hand, do not seem to be mere reflections of contemporary history. Starting in 1909, he continued to paint them for whole decades, which means that they must have had different origins.

Nor does there seem to be any obvious reason for these religious paintings when we look at his biographical background. However, when Nolde had been in Paris in 1900, he had spent a great deal of time at the Louvre, studying the works and religious scenes of Rembrandt, Rubens, Giorgione and Titian. It was during his time in Paris that Nolde first ventured into religious motifs, with paintings such as *Christ Heals the Sick*, *Joseph is Sold into Slavery* and *Abraham and Isaac* (all at the Nolde Foundation, Seebüll), and then again in 1904 with *Christ at Emmaus* (at a church in Olstrup, Denmark). Now, nine years later, Nolde may well have felt that his art was mature enough to match that of the old masters and to use a style in religious art which was both modern and Expressionist. One of his first paintings of this kind was *The Last Supper* (Statens Museum før Kunst, Copenhagen). (His *Pentecost* (p.110), which has the same format and was painted in the same year, is almost identical in the composition of the figures.) In the *Last Supper* thirteen figures are huddled together closely, and the format is almost too small to accommodate them all. The faces are cut off rather drastically at the top and the sides. Jesus is the dominant figure at the centre of the painting and has a carafe of wine in both hands. He is surrounded by his disciples in a semi-circle. The space at the front of the table has been left empty, so that the viewer looks straight at Christ, while at the same time becoming part of the circle himself. This empty space within the composition is formally bridged by a figure on the left stretching out towards the right. The densely packed figures are matched by Nolde's opaque manner of painting. This was the first picture in which Nolde did not use the loosely rhythmical touch of Impressionism, and his colours now formed solid areas.

During the war, Nolde lived in Berlin and then for a short while in Alsen, which he left again in 1917. From then onwards he spent the summer months in Utenwarf on the North See island of Föhr. In 1926, he

finally moved to Seebüll, where he lived until his death in 1956. Significant stylistic innovations ceased to occur after 1911, at the latest. Although he sometimes applied the paint more thinly, placing areas of colour more obviously and two-dimensionally, he only did so in a very small number of paintings, without starting any new stylistic development. Also, he remained true to the subjects which he had discovered for himself, i.e. seascapes, portraits and religious motifs. In addition, he painted hundreds of water-colours of flowers and landscapes, and these have had a decisive influence on our present ideas about Nolde's art.

When the Nazis came to power in Germany in 1933, Nolde fell victim to a misunderstanding. The Nazi concept of art was based on their belief in the superiority of the Nordic race, and it was felt that this was fully reflected in Nolde's Expressionist paintings of Northern German landscapes. The error was followed by a rude awakening. In 1937, the authorities confiscated 1,052 of his works in German museums – paintings, water-colours, drawings, prints – on the grounds that they were "degenerate". There was even an exhibition of "degenerate art" which held up 29 of Nolde's paintings to the contempt and derision of the general public.

Emil Nolde:
Young Black Horses, 1916
Junge Rappen
Oil on canvas, 73 × 100 cm
Museum am Ostwall, Dortmund

117

Paula Modersohn-Becker

We have already seen that there is a lack of clarity about the term Expressionism and that it eludes any attempts to give it a clear-cut definition. Even when we divide it into smaller categories, we are still unable to identify a common denominator among the artists concerned. Christian Rohlfs and Paula Modersohn-Becker – who are seen here as representing the Northern German variant of Expressionism – did not even work at the same time. And when Modersohn-Becker died in 1907, Rohlfs was only just beginning to acquire an Expressionist style.

Modersohn-Becker's early death at the age of 31 gave her just under a decade to develop her art. During this time she was hardly recognized by anyone. In all, she only managed to sell three paintings and took part in an equal number of exhibitions, and, sadly, none of the painters at the artists' colony in Worpswede took her very seriously. Indeed, most of the time she was not even acknowledged as an artist at all. Even her husband, Otto Modersohn, took a long time to recognize the significance of her art.

Paula Becker, the third child of respectable middle-class parents, was born in 1876. Paula soon began to show signs of artistic talent, and her parents were at first very willing to support her by paying for private drawing lessons – a favourite pastime for young ladies at the time. When Paula, however, seriously expressed her intention of becoming an artist, she met with her father's resistance at first. Nevertheless, he was prepared to sponsor her studies quite generously, enabling her to take lessons with the Worpswede painter, Fritz Mackensen, and later at a painting school in Berlin which was run by the *Verein Berliner Künstlerinnen* (Society of Women Artists in Berlin), from 1896 to 1898. He also sponsored her first trip to Paris, in 1900, where she stayed for six months. Paula went to classes at the Académie Cola Rossi, the Ecole des Beaux Arts and was a frequent visitor to numerous museums and art galleries in the French metropolis. During her stay in Paris she met Nolde, although their meeting was of no consequence with regard to their biographies. She also met a painter called Otto Modersohn and decided to join him in Worpswede. A year later they married. The marriage gave her the financial security which enabled her to continue painting. On the other hand,

Paula Modersohn-Becker:
Self-Portrait, around 1903
Selbstbildnis
Black and coloured crayon,
22 × 20 cm
Owner unknown

Paula Modersohn-Becker:
Self-Portrait with Camellia Branch,
1906/7
Selbstbildnis mit Kamelienzweig
Oil on wood, 61 × 30.5 cm
Folkwang Museum, Essen

she did not develop much talent for the duties of a housewife. In 1889 Otto Modersohn, Hans am Ende, Johann Friedrich Overbeck, Heinrich Vogeler and Carl Vinnen had founded the *Künstlerkolonie Worpswede* (Worpswede Artists' Colony). In 1911 Vinnen achieved a certain amount of notoriety among Expressionist circles when he commented on the purchase of a van Gogh painting by the Kunsthalle Museum in Bremen, expressing himself rather vehemently against modern French art in general.

The withdrawal of the Worpswede painters into peasant-style landscapes was a flight from the academic scene and studio art, as well as the increasingly industrialized society of the big cities. In their ardent enthusiasm for unspoilt nature and the simple life of the peasants, they were full of romantic idealism, without any regard to the living conditions of the country population – a lifestyle that had nothing "romantic" about it whatever. One is reminded of Gauguin, who also pushed Western civilization out of his paintings, even though people's lives in Tahiti had long been invaded by it. The poetic naturalism of the Worpswede artists expressed itself stylistically in firm lines and pragmatic forms, and it was only occasionally – as in Modersohn's art – that they incorporated Impressionist ideas. They tried, instead, to capture an ephemeral atmosphere of wistfulness, to conjure up a non-existent idyllic life and to ardently pay homage to life in the country. On the art market, however, they were very successful. As is the case today, their themes met people's need of a world without sickness or problems.

Paula Modersohn-Becker soon came to realize that her artistic open-mindedness was incompatible with the Worpswede artists, who had cut themselves off from all international developments and influences. From the very beginning, she refused to paint landscapes that looked like photographs or to depict cliché-like figures. Instead, she always tried to find general principles in individual instances, to express herself in such a way that each work of art was meaningful outside its specific context. Her pictures therefore always include a symbolical meaning in addition to the naturalist theme. Unlike the Worpswede landscapes – which are instances of specific situations, intended to evoke a certain mood – her paintings are fundamental symbols of eternal nature and were in contrast with the finiteness of man's existence. This existential character, with a dichotomy of growth and transitoriness, occurs again and again in her entire art – her still-lifes, her portraits of children, and her self-portraits as a pregnant woman and a mother. It is also possible that her anxiety about an early death, which she expressed on several occasions, found its expression in her art.

In her art, Modersohn-Becker never looked upon the rural population around Worpswede with romantic idealism. The young people in her pictures were marked by the harsh conditions of daily life, and her children's portraits were devoid of any traditional middle class romanticism. It was as if she had deliberately depicted the exact opposite of the idealized views that the Worpswede artists used to give. Even her hus-

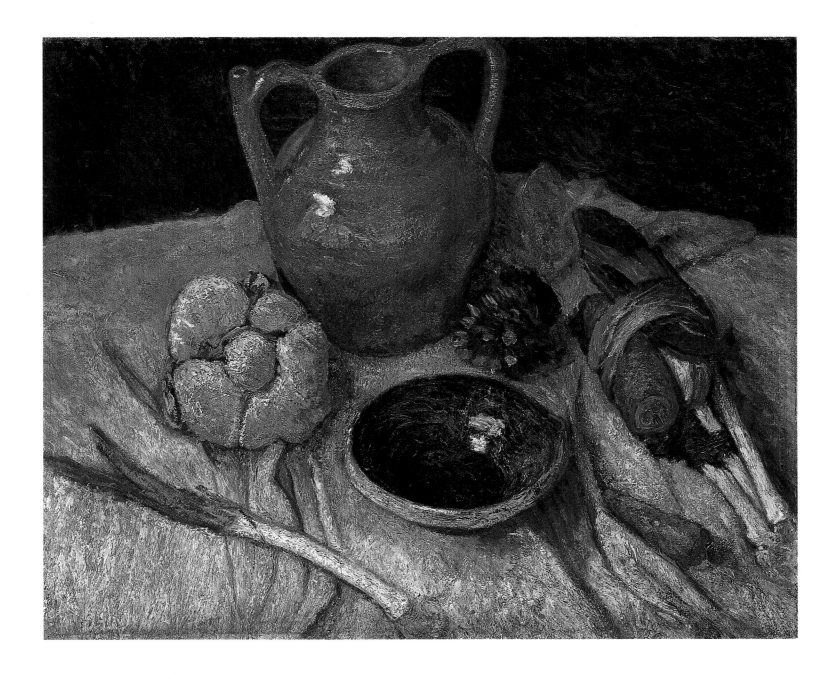

band was horrified at these pictures. However, he knew that his wife would not listen to artistic advice. "Paula hates all conventions, and she has now fallen for the mistake of making everything angular, ugly, bizarre and wooden. The colours are great – but the forms? The style! Hands like spoons, noses like conkers, mouths like gashes, faces like imbeciles. She's attempting too much. Two heads and four hands in a minute space, nothing less will do, and then children as well. She won't listen to advice, as usual," he confided in his diary in 1903.

Although Modersohn-Becker produced her work in the ten years leading up to 1907 and she had no contacts with Expressionist artists, we are justified in placing it alongside other Expressionist art. It is true, of course, that her colours did not have that dominant formal value which was so characteristic of the Expressionists, but she managed to enhance the expressive forcefulness of her forms by reducing and simplifying them, thus following the examples of Roman and early Gothic art. And it

Paula Modersohn-Becker:
Still Life with Yellow Jug, around 1905
Stilleben mit gelbem Krug
Oil on canvas, 59.5 × 71.5 cm
Niedersächsisches Landesmuseum,
Hanover

is equally right to treat her as a Northern German Expressionist, because her art was so much influenced by the scenery and the people around her that it could not have developed in this way anywhere else.

Among Modersohn-Becker's limited thematic areas, her self-portraits played a central part. They made their appearance as early as her first years in Berlin and continued until her early death in 1907. They tell us a good deal about her artistic development as well as her private situation and changes of mood. Using herself as a subject was not so much a matter of constant availability as a strong desire to question herself continuously and reflect upon her own position - not just as an artist. However, it was also a consequence of her isolation within the Worpswede painters' colony. Because of its cheerfulness, her *Self-Portrait with Trees in Blossom* (p.123) of 1902 has a special position. That serious, even melancholy expression, which can so often be observed in Modersohn-Becker's face, is completely missing here. Instead, she seems relaxed and self-confident. The head is surrounded by the branches in the background, as if they formed a halo. The forces of nature, forever renewed, symbolically represent the growing artistic power of expression which she could feel at the time. A year earlier, she had married the Worpswede painter Otto Modersohn, and this had been the beginning of a fruitful, though rather short, period of artistic co-operation. Full of self-confidence, she wrote her new name along the lower edge of the picture, covering the entire length: PAULA MODERSOHN.

Anyone who looks for orgiastic colour contrasts or Expressionist distortions of forms in Modersohn-Becker's paintings will be disappointed. Her colours are close to that of her local environment, even though they overtly follow their own laws. The forms are simpler and broader. This can be seen clearly in the landscapes in the background of her paintings. There are no unnecessary or anecdotal details. The artist has reduced the landscape to its distinctive features – the paths, the green meadows, the flat horizon and the blossoming trees.

It was not only in her self-portraits that Modersohn-Becker tried to reflect on her own situation. She also endeavoured to find her own place within art history. Endowed with an inquisitive mind, she thought deeply about a vast range of styles and developments, without necessarily being influenced in her own work. She was fascinated by all the periods that led to more simplicity and broader forms as well as greater clarity of style. Her encounter with the artistic style of the ancient Greeks and Romans and the monumentalized forms of the Gothic period left a visible mark in her paintings. "I can feel an intricate kinship," she wrote in a letter in 1903, "between antiquity – especially early antiquity – and the Gothic period, and between the Gothic and my own perception of form."

Her first visit to Paris as a young art student in 1900 was a revelation. There was no other city where she could so intensively study the history of art by looking at its most outstanding examples, while at the same time being right at the centre of the latest and most exciting artistic developments. Even later, whenever she needed some fresh air among the

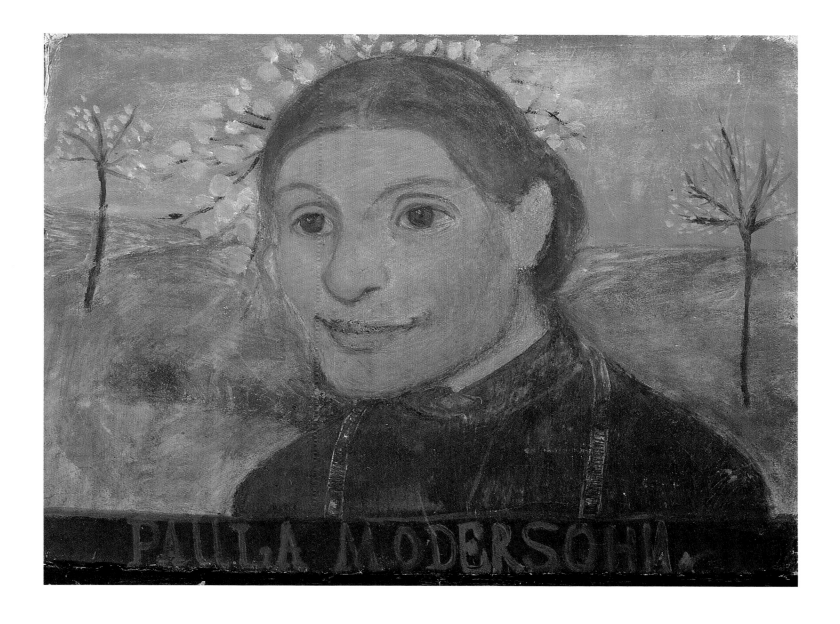

geographically isolated artists and their refusal to yield to any modern, intellectual stimuli, she escaped to the metropolitan openness of Paris. And this happened quite frequently. In 1903 Modersohn-Becker paid her first return visit to Paris, where she stayed for two months. In 1905, she was there again, from February until April. In February 1906 she visited Paris for the last time. This time she stayed for a whole year, intending to leave Worpswede and her husband for good. It was in Paris – the world capital of art – that she received her most important and most fruitful impulses. Her last stay in particular left its unmistakable marks on her work. She was fascinated by the Nabis, Maurice Denis, Pierre Bonnard, Paul Sérusier and above all Gauguin, who had died three years earlier. But she was also influenced and impressed by the forms in Matisse's paintings and those of Paul Cézanne, a painter who was still controversial at the time. Under their influence, Modersohn-Becker's range of colours became lighter. The heavy, earth-like quality of her Worpswede colours gained in luminosity, with contrasts that enhanced one another. Her lines became more emphatic, particularly in their decorative effect,

Paula Modersohn-Becker:
Self-Portrait with Trees in Blossom, around 1902
Selbstbildnis vor blühenden Bäumen
Oil tempera on hardboard,
33 × 45.5 cm
Museum am Ostwall, Dortmund

and softer in their expressiveness. The numerous still lifes which she painted that year would have been unthinkable without the influence of contemporary French art.

In autumn 1906 Modersohn followed his wife to Paris. He persuaded her to return to Worpswede with him. Next spring, the Modersohns were back in their idyllic but remote artists' colony. Modersohn-Becker had become pregnant in Paris. During this last year of her life, the subject *Mother and Child* as well as portraits of herself as a pregnant woman figured increasingly in her work, though not for the first time. The motherhood motif fitted easily into the basic symbolism of her entire work. The constant recurrence of the forces of life, nature, birth and growth, expressed in a variety of different metaphors, is probably the most typical feature that characterizes her art as feminine. This aspect is expressed in numerous self-portraits, where she depicts herself with a fruit or a plant as an additional attribute, as well as her children's portraits and landscapes with budding birch trees. And yet her symbolism always includes a subtle reference to death and the transience of life as

Paula Modersohn-Becker:
Pram with Goat, 1905
Kinderwagen mit Ziege
Oil on canvas, 34 × 49.6 cm
Von der Heydt Museum, Wuppertal

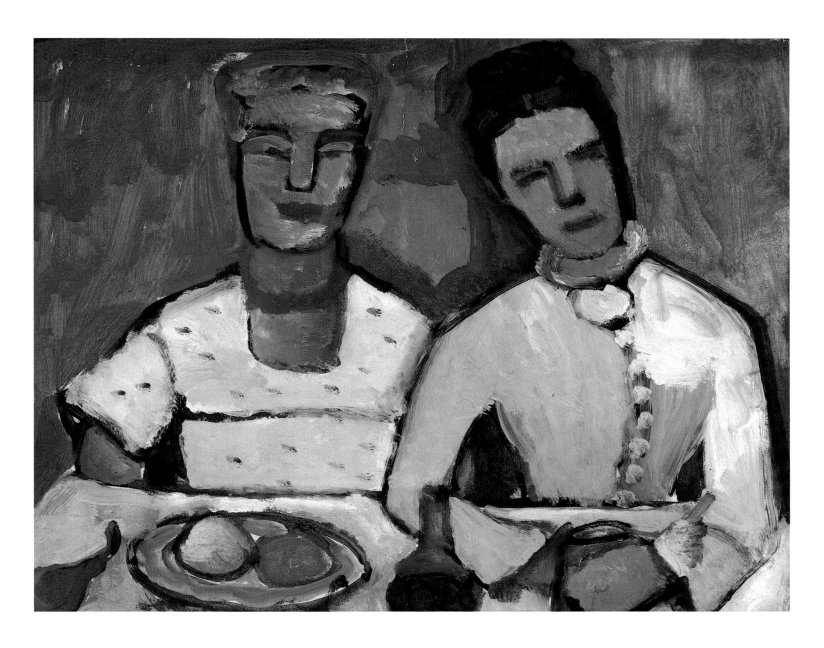

Paula Modersohn-Becker:
Lee Hoetger and Her Sister, 1906/7
Lee Hoetger und ihre Schwester
Tempera on paper, 36.5 × 46.5 cm
Museum am Ostwall, Dortmund

well. Her nude paintings render the female body in a way which could only be achieved by a woman artist – with a natural empathy that does not bear the slightest hint of the voyeurism which can be found in the lascivious naked bodies of the *Brücke* models.

Her later portraits were considerably influenced by reproductions of Egyptian mummies. Modersohn-Becker was particularly touched by the vivid facial features and clear structures in these pictures, painted on small wooden plates and used as grave furnishings during the first centuries of our era. It confirmed her own insistence on form, which was to lead to a greater simplicity of structure. Her popular *Self-Portrait with Camellia Branch* of 1906/7 (p.118) was also painted on wood, and its narrow, upright format, bears a direct reference to Egyptian wooden plates. The subject consists entirely of reduced two-dimensional areas. It is dominated by hard contours and colourful contrasts between the shades of brown of the half-length figure in the shade and the brilliant, light blue background around her head. Her hand is holding a camellia branch – a symbol of growth and fertility.

Christian Rohlfs

We have already pointed out that, because of his age difference, Mueller occupied a somewhat special position within the *Brücke*. But when we look at German Expressionism as a whole, the age difference is even more noticeable in the case of Christian Rohlfs. Born in Niendorf (in the province of Holstein) in 1849, he was a contemporary of Monet (born in 1840) and Gauguin (1848). In fact, Gauguin (1853) and Seurat (1859) were both younger than him. When Rohlfs was first influenced by Expressionism around 1907, he was nearly 60 years old and could look back to an extensive oeuvre. From 1870 he studied art at the Weimar Academy, where he stayed for 14 years. During this time he closely followed his teachers. After some early studies of portraits and figures, he concentrated almost exclusively on realistic landscapes. It was only in the 1890s that his range of colours became lighter, after he had seen two paintings by Monet in an exhibition at the beginning of the decade. Formal innovations occured in Rohlfs's works more frequently than in those of other painters, and indeed without that unshakeable stubbornness which might have come after a long learning process. This meant that he willingly gave up new styles as soon as he had acquired them.

However, it was not until ten years later that Rohlfs's development as an artist received its significant impulses. In 1900 he met Osthaus, the collector and patron. Osthaus ran his own private museum – the Folkwang Museum – in Hagen, and he intended to start a painting school, with Rohlfs as one of its teachers. A year later Rohlfs moved from Weimar to Hagen. Here, with Osthaus's collection at hand, he had the most exquisite works of modern French art before his eyes, and so – inevitably – he was profoundly influenced by Monet, Signac, Cézanne, Gauguin and even van Gogh. In 1902 Rohlfs adopted a more systematic approach in his application of paint, stippling it onto the canvas in the manner of pointillism. It was only in the eye of the viewer that the pure colours, straight from the tube, were to be mixed. Another characteristic became significant during those years, to be given up again until he reached his late period, when he rediscovered it with even greater enthusiasm in his tempera-on-paper paintings. Unlike the typical paintings of the *Brücke* group, Rohlfs did not treat colours as surface elements in their own rights

Christian Rohlfs:
Counsel, 1913
Beratung
Woodcut, 36.4 × 26.8 cm

Christian Rohlfs:
Sunflowers, 1903
Sonnenblumen
Oil on canvas, 73.2 × 57.8 cm
Museum am Ostwall, Dortmund

or complementary contrasts. His colours go beyond mere colour values. They have values of light, and the surfaces of his paintings seem to have a radiance of their own, shining through the forms. The material character of the colours, which the *Brücke* artists emphasized quite deliberately, was consciously negated by Rohlfs and became purely a matter of light.

Rohlfs's art was first noticeably influenced by van Gogh in 1903, with a kinship that could even be seen in his choice of subjects. Among the first works in which he followed this new style were two paintings of *Sun Flowers* (p.126). A year later he painted his *Studio in Weimar* (Museum am Ostwall, Dortmund) – a subject which he subsequently abandoned completely – as well as numerous landscapes with *Meadows*. These last are extremely reminiscent of similar motifs by van Gogh. The evenly pointillist surfaces disappeared from his art and were replaced by more rhythmic brush strokes. Rohlfs began to apply the paint more thickly, with more contrasts as well as short, wavy stripes. Thus he completely gave up the illusion of spatial perspective. The entire surface was now in motion, though this motion remained a formal adaptation and not an expression of self-renunciation as in van Gogh's art.

Christian Rohlfs:
Still Life with Fruit, 1926
Früchtestilleben
Water tempera on paper,
58.8 × 79 cm
Folkwang Museum, Essen

Christian Rohlfs:
Conversation between Two Clowns,
1912
Clowngespräch
Tempera and oil on canvas,
61.5 × 80.5 cm
Museum am Ostwall, Dortmund

It was at least three years later, in 1906/7, that the Dresden artists managed to reach a comparable stage in their adoption of French styles. In 1906, they saw his paintings for the first time at the *Third German Handicraft Exhibition* in Dresden. Indeed, they even considered inviting Rohlfs to be an active member of their group. The plan failed, however, due to Nolde's objections, though we do not know his reasons. That same year, Nolde had exhibited at Osthaus's Folkwang Museum. He even knew Nolde personally, and the two had become friends. A year later, in 1907, Osthaus exhibited *Brücke* prints in Hagen, which first inspired Rohlfs – who was already 58 – to try out this technique for himself. He produced mainly woodcuts and linocuts, which he often coloured in afterwards and whose black contours began to have a considerable influence on his style a few years later.

Rohlfs's *Conversation between Two Clowns* (above) of 1912 is a good example of his art at that time. The dark contours of the two figures are in sharp contrast with the light colour and spatial indistinctness of the background. The expressiveness of the double portrait is further enhanced by the clowns' make-up and the exaggerated posture of the

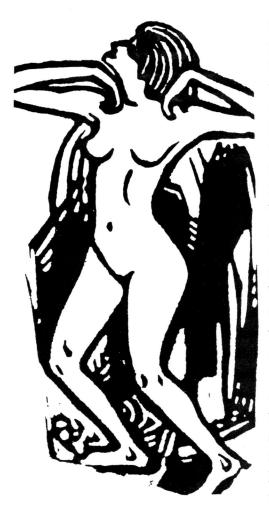

Christian Rohlfs:
Female Nude, 1910
Weiblicher Akt
Woodcut, 27.6 × 13.2 cm

Christian Rohlfs:
Female Nude, Dancing, 1927
Tanzender weiblicher Akt
Tempera, crayon, etching, pastel
crayon with paint on water-colour
paper, 60 × 48.5 cm
Museum am Ostwall, Dortmund

figure on the right – elements which make it a typical Expressionist painting. The paint is thick and heavy, and the white background has been broken several times by the yellow undercoat. The brushwork as well as the theme – which came from the world of entertainment, the circus and the music hall – are akin to Nolde's Berlin themes of the year before. Furthermore, Rohlfs's work also included the same characteristics as Nolde's Northern German Expressionism. He, too, was intensely interested in Nordic legends and biblical subject, though – unlike Nolde – he only made use of the latter during the years around the First World War. Trolls and goblins can be found, above all, in his graphic prints. His landscapes, on the other hand, show a marked difference between his own style and Nolde's way of treating this subject. Rohlfs, too, felt a very close artistic affinity to his immediate environment, especially the little Westphalian town of Soest, where he spent every summer from 1905 onwards. He painted numerous views of its streets, houses and towers, without, however, generalizing their shapes in the form of allegories, as did Nolde in his archetypal landscapes.

In view of the historical context in which Rohlfs painted his *Conversation between Clowns*, it somehow seems like a scene from the "world theatre" on the eve of the First World War. Under their masks, the clowns allow themselves a final moment of relaxed cheerfulness before disaster strikes. This interpretation is supported by a later work, painted at the height of the war, in 1917. His painting *People without Masks* (owner unknown) shows a man holding his mask in both hands, while his face is ugly and distorted with fear.

At this time, religious motifs became extremely important in Rohlfs's art. The themes depicted in the decade until 1924 are always parables of the current political situation or his own private life: *Expulsion from the Garden of Eden*, *The Prodigal Son* and *The Good Shepherd* were typical titles during those years. Alongside this broadening of his thematic range, Rohlfs also adopted a new style, which may well have been occasioned by his religious topics. He changed from smooth, thick oil colours to tempera, which has a more brittle quality. His firm, black contours – a stylistic feature which he first used for his graphic prints – now encompassed the entire surface of each painting, structuring its composition like the network of lead in a glass window. The thin, liquid quality of tempera took away the independent, material character of the surface. More and more frequently, and especially in his later works, Rohlfs would wash off the colour again with a piece of cloth or a brush, living only a hint or a suspicion of colour. His *Female Nude, Dancing* (right) of 1927 is a typical example. In the course of the twenties he painted increasingly on paper, and from the early thirties onwards he ceased to use canvas altogether. However, in his *Still Life with Fruit* (p.128) of 1926, we again see the bright radiance of his colours for the last time, as in a stained glass window.

Not until these late works – after 1913 and at the age of 64 – did Rohlfs achieve stylistic independence and artistic maturity.

The *Blaue Reiter* artists in Munich are often seen in German Expressionism as diametrically opposed to the Dresden-based (and, later, Berlin-based) *Brücke*. This is because their approaches were in many ways totally different and, in a large number of cases, cannot be compared at all. The Munich artists were not a fixed group that expressed its views publicly in the form of joint manifestos. Nor did they develop a collective style that was shared by every single one of them. Instead, each of them created his own characteristic world of motifs.

The *Blaue Reiter* (Blue Horseman) was originally the title of a publication by Reinhard Piper Publishers, planned as an almanac and edited by Wassily Kandinsky together with Franz Marc. Twice, in 1911 and 1912, they organized exhibitions to demonstrate their theories in the form of

The Blaue Reiter

actual works of art. The first exhibition took place at the Thannhauser Gallery in Munich and opened on 18 November 1911. Apart from Kandinsky and Marc, there were also works by Gabriele Münter, the composer Arnold Schönberg, August Macke and Heinrich Campendonk (both Rhenish artists), and Delaunay (who was French). It was not until afterwards, when the exhibition was shown at the *Sturm* Gallery in Berlin, that it also included works by Alexei von Jawlensky, Marianne von Werefkin and Paul Klee. In one way or another, most of these artists also appeared in the *Blaue Reiter* almanac, either with articles or reproductions of pictures. The second presentation in 1912, which bore the programmatic title *Black and White*, was exclusively limited to graphic prints and drawings, and also included works by *Brücke* artists.

Kandinsky and Marc first met at the end of 1910, after Marc had written a positive review of the second exhibition of the *Neue Künstlervereinigung München* (N.K.V.M., New Artists' Association of Munich). In 1909 and 1910, the N.K.V.M. was the legitimate predecessor of the *Blaue Reiter*. It started off with a colony of exiled Russian artists (Kandinsky, Jawlensky, Marianne von Werefkin, Vladimir von Berekhteyev) in Munich and soon attracted a motley mixture of painters (including Alexander Kanoldt, Paul Baum, Carl Hofer, Adolf Erbslöh and Gabriele Münter), art historians (Heinrich Schnabel, Oskar Wittgenstein and Otto Fischer), dancers (Alexander Sakharov), musicians and writers. This diversity was probably Kandinsky's idea. As the chairman of the association, he wanted to unite all the various arts which, until then, had been totally separate.

In his circular letter on the occasion of the foundation of the N.K.V.M., he stated that all the artists were aiming to integrate not only their impressions of the outside world, but also of their inner world, and to do so with a new artistic form of expression. "By founding this association," he concluded, "we are hoping to give material shape to the spiritual

kinship between artists, a form that will give us occasion to address the public with joint forces." This idea, taken by Kandinsky from the age of Romanticism, is also reflected in the publication of the *Blaue Reiter*.

PAGE 132:

Wassily Kandinsky:
Front cover for the Almanac *Der Blaue Reiter* (The Blue Horseman), 1912
Coloured woodcut, 27.9 × 21.1 cm
Städtische Galerie im Lenbachhaus, Munich

A second historical source in the development of the *Blaue Reiter* can be found in Art Nouveau, which had one of its artistic centres in Munich. Two magazines had been published here from 1896 onwards – *Jugend* (Youth) and *Simplicissimus*. The most significant Art Nouveau representative in Munich was von Stuck, in whose house and studio the idea of total works of art was put into practice. The proposals stated by Kandinsky in his circular letter were therefore merely ideals which were already quite common in his environment. Munich was a city with a great deal of openness to the world of art and therefore provided fertile ground for new artists' associations. And yet the N.K.V.M exhibition generally met with criticism and disapproval.

The *New Artists' Association of Munich* had already organized two exhibitions when there was a serious clash and a split during the preparations for the third one. In December 1909, the members exhibited their art at Thannhauser's for the first time. A year later, from 1 – 14 September, another exhibition took place on the same premises, which also included works by a number of guests, such as Picasso, Braque, Derain, van Dongen and Georges Rouault. While this exhibition was intended to point out parallel developments in France and thus legitimize their artistic endeavours, there were now increasingly open tensions within the association itself. Two parties had formed – a more traditional one around Kanoldt, Erbslöh and Moissey Kogan, and another around Kandinsky and Marc. Jawlensky, who felt closer to Kandinsky in his art, tried in vain to mediate between the two warring factions. Kandinsky described Kanoldt's paintings as "cemented Cubism", whereas the latter was not only unable to follow Kandinsky's increasingly free experiments with forms and colours but also disapproved of them. Kandinsky created his first non-representational work as early as 1910, which he gave the programmatic title *First Abstract Water-Colour*. In 1911, after continuous arguments he resigned as N.K.V.M. chairman and was succeeded by Erbslöh. When Kandinsky's painting *Composition V* was not included in the third exhibition for formal reasons - according to the rules, it was several centimetres too big – he and Marc resigned their membership on 2 December 1911. They were followed by Gabriele Münter and Alfred Kubin, who left in sympathy. Jawlensky and Marianne von Werefkin, on the other hand, stayed until 1912.

Kandinsky and Marc had already started the editorial team *Der Blaue Reiter* in the summer of 1911. As soon as they left the N.K.V.M. they hurriedly organized a counter-event which opened on the same day and was meant as a demonstration of progressive artistic forces.

The idea of publishing *Der Blaue Reiter* came from Kandinsky. He had told Marc about his ideas in a letter of June 1911, while at the same time asking him to keep silent about the matter. "In such cases," he wrote, "it

is very important to be 'discreet'." At the beginning, it was meant to be no more than an almanac, but this idea was given up shortly before it was published. Kandinsky's first idea for a title was *Die Kette* (The Chain), an annual chronicle with reports on the important exhibitions of the preceding year as well as articles written by none except artists, writers and musicians. As for the illustrations, Kandinsky wanted to show Chinese art side by side with paintings by Henri Rousseau, and "popular" works of art alongside Picasso. Even when it came to financing such an almanac, he had his definite ideas. "The authors probably won't get paid," he told Marc. "They may want to pay for their own clichés." Years later, Kan-

Wassily Kandinsky:
The Blue Horseman, 1903
Der Blaue Reiter
Oil on canvas, 52 × 54 cm
E.G. Bührle Collection, Zurich

dinsky said that the final name had been found "while drinking coffee in the summer house at Sindelsdorf. We both loved blue, Marc liked horses, and I like horsemen. So the name really suggested itself." And there are indeed a number of paintings among Kandinsky's early works that include this motif – even a small-format painting of 1903, which he later renamed *The Blue Horseman* (p.135).

Marc responded to Kandinsky's suggestion with great enthusiasm, especially because he, too, had been thinking about the need for such a publication. They spent the next few months in Murnau, Sindelsdorf and Munich, working intensively on the almanac and asking friends for texts and illustration material. Kandinsky translated the Russian contributions. The synthesis between the various arts, which had already been the aim of the N.K.V.D., was now to be continued and perfected. It took about eight months for the two artists to prepare the editorial side of the almanac, during which time their concept became increasingly broader. Its publication in May 1912 was preceded by Kandinsky's programmatic monograph *Über das Geistige in der Kunst* (On the Spiritual in Art). *Der Blaue Reiter* included, among others, contributions by Marc about "Germany's *Savages*" and by David Burlyuk about "Russia's *Savages*". Nicolai Kulbin wrote about "Free Music". And Kandinsky expressed his ideas on "Stage Composition", which he illustrated with *The Yellow Sound*. Schönberg wrote an article on music and its "Relationship with Texts", and the almanac also included reproductions of two of his paintings. Marc and Kandinsky, who were profoundly impressed by Schönberg's music, saw that there were parallels between its tonality and their own paintings.

According to Kandinsky, the illustrations had to be chosen in such a way that they caused "confrontations which were as enlightening as possible", with themes from totally different cultures. We can still see Kandinsky's idea in this first letter to Marc, even though the actual results are not always convincing. It was entirely due to Marc that the *Blaue Reiter* also included reproductions of works by Kirchner, Heckel, Pechstein and Mueller – even though this was restricted to their prints. When he met the *Brücke* artists on his trip to Berlin early in 1912, he suggested including their graphic works in his almanac. Kandinsky was reluctant, however. "Of course, one has to exhibit this sort of thing," he admitted, though he did not want to "immortalize them in a documentary of contemporary art", because they did not have that "decisive force which gives direction." In the end, he was prepared to include small-format reproductions of them, on the grounds that "small reproductions mean that this is one way of doing it. Large ones mean: this is how it is done."

In all, Kandinsky designed ten different title pages for *Der Blaue Reiter*. Most of these are water-colours, and the playful lines with their translucent colours clearly show that he had been inspired by Art Nouveau and peasant-style glass paintings. Kandinsky himself repeated a number of his motifs in the form of folk glass paintings. Only the final draft reversed the original proportion between horseman and landscape. The woodcut that eventually appeared on the title page was based on this (p.132), and it

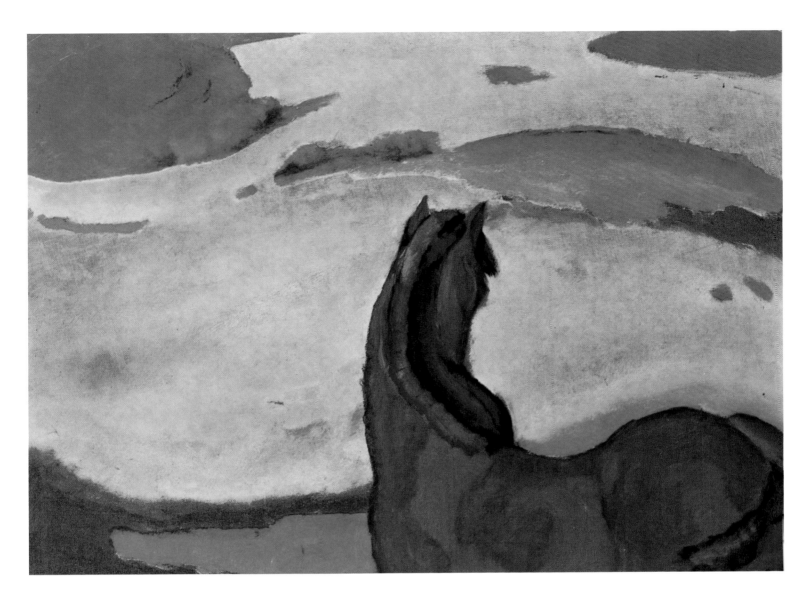

shows the man and his horse dominating the entire foreground. The colourful impact of blue and orange is now detached from the subject. Yet even this tenth draft still bore the name 'almanac'. It was not until shortly before the actual printing itself that the publisher, Reinhard Piper, intervened and deleted it. We do not know why Piper interfered or why Kandinsky gave in. Piper probably wanted to make it clear, from the start, that the *Blaue Reiter* was to be an exception for his publishing house.

On the whole, the project turned out to be rather difficult to finance, and the authors' willingness to do without fees did not solve the problem, either. Piper was merely prepared to publish the book under commission. The publishing company added its famous name and handled advertising and sales. The production costs had to be paid by Kandinsky and Marc themselves. After several unsuccessful attempts to raise money, they finally managed to get sponsorship from the Berlin industrialist and collector, Bernhard Koehler, whom they had met through Macke. Koehler, who was an uncle of Macke's wife, Elisabeth, was willing to meet the entire production costs. "If it had not been for his helping hand," wrote Wassily Kandinsky in a note, "the *Blaue Reiter* would have remained a beautiful utopian idea."

Franc Marc:
Horse in a Landscape, 1910
Pferd in Landschaft
Oil on canvas, 85 × 112 cm
Folkwang Museum, Essen

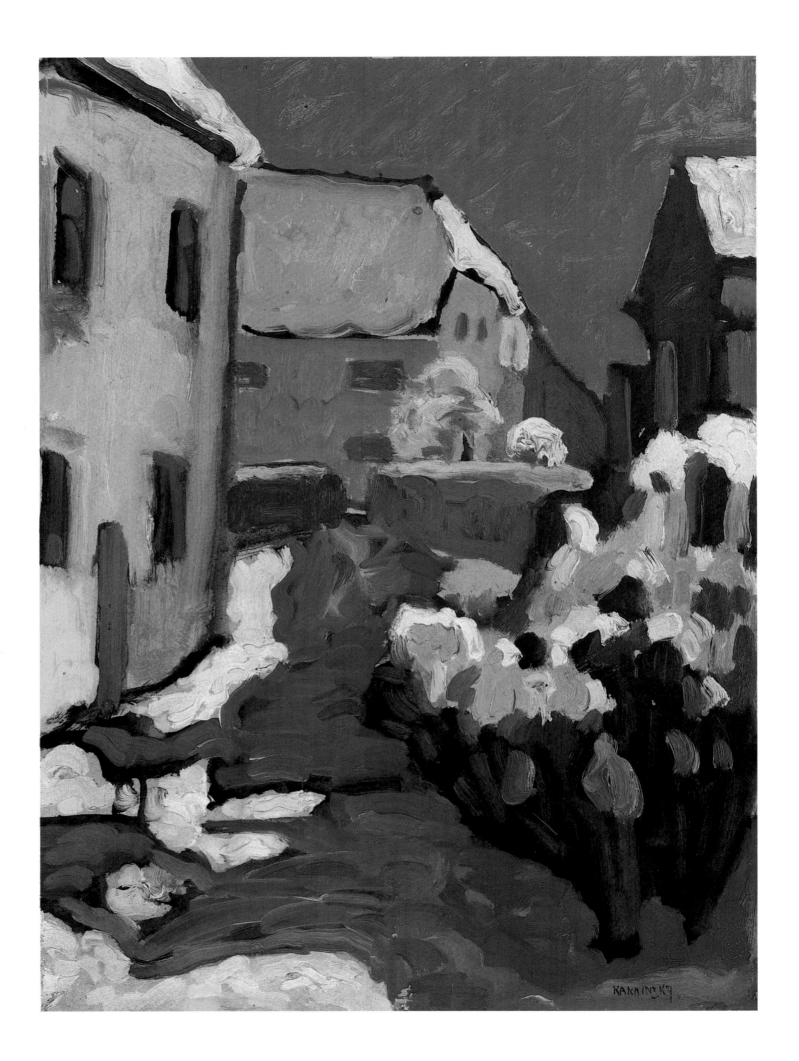

Wassily Kandinsky

The most outstanding figure among Munich's Expressionists is the Russian artist Wassily Kandinsky. He was the one who first led the activities of the *Phalanx*, and later the *Neue Künslervereinigung München* (N.K.V.M, New Artists' Association of Munich). Eventually, he became the most significant artist among the *Blaue Reiter* painters. Kandinsky was one of the few Expressionists in Germany whose artistic activities were based on a comprehensive and well-founded theory. And he was the only one whose writings achieved such a far-reaching effect on modern art, going far beyond his own works. His most important attainment, however, was that he managed to overcome the language of Expressionism in his own works in favour of freer artistic techniques that did not follow the examples of naturalism.

Kandinsky was born in Moscow on 4 December 1866. Having taken a law degree, he studied for a doctorate and worked as a lecturer at the Faculty of Law at Moscow University from 1893 onwards. After two trips to Paris, where he eagerly visited the various museums and art galleries, as well as an Impressionists' exhibition in Moscow in 1895, he finally decided to train as an artist. Among those Impressionist works Kandinsky saw one of Monet's famous hay-stack motifs. Years later, this was to serve as important evidence in *On the Spiritual in Art*. Kandinsky decided not to take the professorship that was offered to him at the University of Dorpat (Russia) and went to Munich instead. Already 30, he now began to study at Anton Azbè's renowned private painting school. Munich had not yet developed into that second centre of European art – after Paris – which it was to become within the next two decades. Indeed, that change was partly due to Kandinsky himself, whose activities were to have considerable influence.

Kandinsky chose Munich because he had a good knowledge of German and because he knew that he could easily make friends with other like-minded Russian ex-patriots. And so, while he was still at Azbè's school, he met Jawlensky and Marianne von Werefkin. At that time, he was aiming to gain access to von Stuck's academy classes, but when he finally succeeded – after two attempts – he found that von Stuck was unable to teach him anything he really wanted to learn. He stayed with von Stuck for less

Wassily Kandinsky:
Front cover for the first *Blaue Reiter* exhibition catalogue, after an Indian ink drawing, 1911

Wassily Kandinsky:
Church Yard and Vicarage in Kochel, 1909
Friedhof und Pfarrhaus in Kochel
Oil on hardboard, 44.4 × 32.7 cm
Städtische Galerie im Lenbachhaus, Munich

Wassily Kandinsky:
Two Birds, 1907
Zwei Vögel
Woodcut, 13.6 × 14.4 cm

Wassily Kandinsky:
Gabriele Münter Painting in Kall-
münz, 1903
Gabriele Münter beim Malen in Kall-
münz
Oil on canvas, 58.5 × 58.5 cm
Städtische Galerie im Lenbachhaus,
Munich

than a year and then founded the artists' group *Phalanx*, together with Waldemar Hecker, Wilhelm Hüsgen and Rolf Niczky. Before long he became the head of the circle, which also had the *Phalanx* painting school attached to it. In this way, he changed from being a student to being a teacher virtually without transition. And indeed, he was a very good teacher. There are not many historical sources of that time, but they all agree that he was extraordinarily talented. In 1902, the *Phalanx* school was joined by Gabriele Münter, who became one of his students and also travelled with him to Russia several times during the following years, as well as Vienna, Venice, Amsterdam, Berlin and of course Paris. On these trips he gathered new impressions and significant influences. As chairman of the *Phalanx*, the *New Artists' Association of Munich* and the *Blaue Reiter*, he was responsible for a number of exhibitions in which he acquainted the public with French art – Renoir, Monet, van Gogh, Signac, Toulouse-Lautrec, Bonnard (1903 and 1904), and later Picasso, Braque, Derain, van Dongen, Rouault (1910), and finally Delaunay and Rousseau.

In these early, preliminary years, Kandinsky derived his inspiration from a variety of cultural sources. Again and again, his themes are mingled with influences from his rural Russian background and its fairy tales. The very titles in paintings such as *An Old Russian Sunday* (Boymans van Beuningen Museum, Amsterdam) point to these origins. Art Nouveau, too, left its mark on Kandinsky's style. Until 1906, he sometimes painted landscapes which are more reminiscent of psychological symbolism than on-site studies of nature. Nevertheless, his favourite subject during his time of travelling – until 1908 – was landscapes based on his own, personal impressions. With regard to form, Kandinsky took his bearings from French Neo-Impressionism. The colours in his art display that typical lightness of open-air paintings. The individual colour values have been divided up into short, vivid brush strokes which give a vibrant quality to the entire picture. It seems that a characteristic quality of Kandinsky's began to emerge in these works, which continued to prevail in his later art, when – between 1909 and 1914 – he gradually adopted an increasingly abstract style.

Kandinsky's development during his eight *Phalanx* years (1901-1908) did not proceed continuously or with stylistic consistency, as one might have expected. His parallel brush strokes did not gradually become more and more solid until they turned into compact two-dimensional shapes. Rather, he applied them with differing degrees of density, occasionally leaving the structure of the canvas to shine through very clearly, whereas in other works of the same period the paint forms a thick, self-contained carpet of colours. In this way, Kandinsky tried to adapt his technique to each artistic motif. This is particularly obvious in paintings where his memories of his native Russian folk-tales shine through. Leaving out elongated – and therefore dynamic – brush-strokes as well as pointillism, he managed to approach the style of Russian folk art far more closely than he would otherwise.

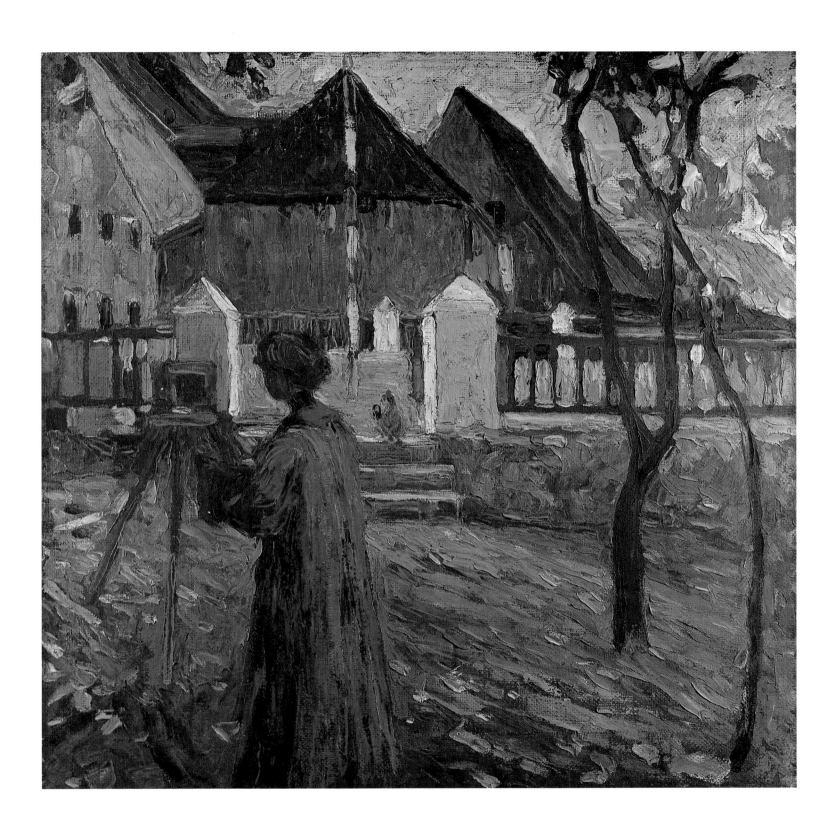

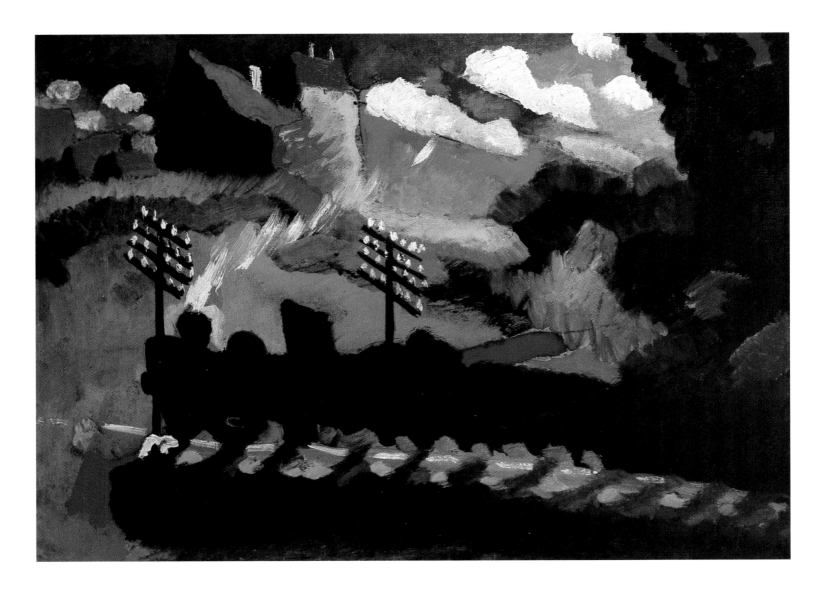

In 1908, Kandinsky and his chosen partner, Gabriele Münter, settled in Munich again. Having lived in a rented flat in Schwabing for a year, they then bought a villa in Murnau, where they spent the summer of 1909 together with Jawlensky and Marianne von Werefkin. At that time Jawlensky's art had already progressed a lot further towards an independent, Expressionist treatment of colours and forms, and their close co-operation with one another meant that Kandinsky, too, could now develop his important artistic ideas and a re-orientation of his style.

Kandinsky's development during his years of rootless travelling can be seen very clearly when we compare two of his works – *Gabriele Münter Painting in Kallmünz* (p.141) of 1903 and *Grüngasse in Murnau* (p.143), which dates from the summer of 1909. The earlier painting shows Gabriele Münter standing before a small easel, painting. The middle ground is occupied by a fence, with a gate just above her head. There are several buildings in the background – probably a farm. Following Impressionist examples, Kandinsky's brushwork consists of individual, parallel brush strokes. There is a spatial perspective about the painting, as well as a clay-like hue, which makes it appear more akin to the natural lyricism of the Worpswede artists than Neo-Impressionism or even Expressionism.

Wassily Kandinsky:
Murnau – View with Railway and Castle, 1909
Murnau – Aussicht mit Eisenbahn und Schloss
Oil on hardboard, 36 × 49 cm
Städtische Galerie im Lenbachhaus, Munich

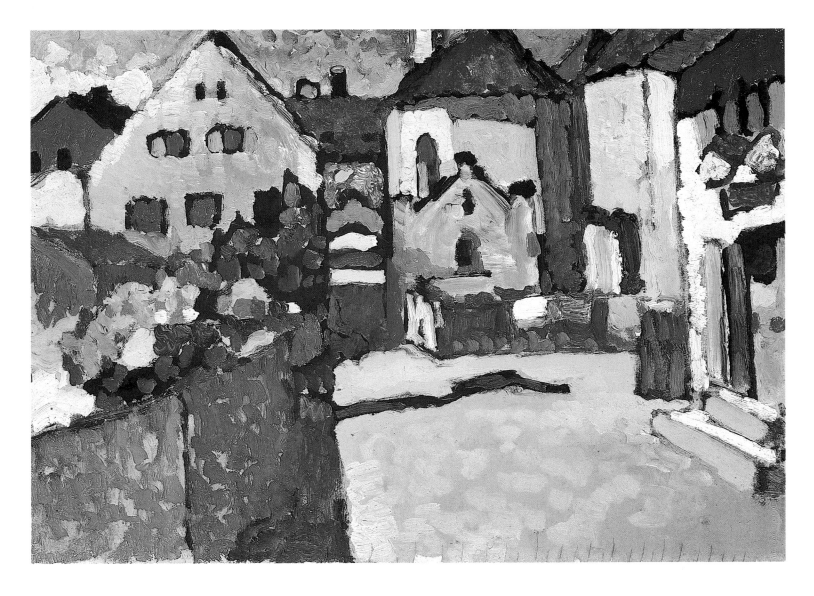

Wassily Kandinsky:
Grüngasse in Murnau, 1909
Oil on hardboard, 33 × 44.6 cm
Städtische Galerie im Lenbachhaus,
Munich

Furthermore, the woman in her long, shapeless, blue garment shows Kandinsky's tendency towards Romanticism.

Kandinsky's painting of 1909 also shows houses and a view of a street. The buildings, the road and the flowering shrubs are clearly visible, though they are only hinted at – as if they were a mere pretext for the colourful play of glowing contrasts. The shapes are reduced, and the loose, thick areas of colour are spread broadly and generously. The distribution of colours is still determined by the theme – houses with their walls, doors and windows – but these colours are no longer the natural, local ones. At that time Kandinsky had already started using purely aesthetic considerations for his contrasts, such as yellow vs. orange or blue. As Kandinsky's colours became increasingly independent, he also reduced the effect of perspective within the picture.

During the following years in Munich and Murnau, Kandinsky worked on his theory of art, which he finally submitted for publication in the form of two separate essays in 1911 and 1912. *On the Spiritual in Art* was published as a book in December 1911, and five months later *Über die Formfrage* (On the Question of Form) appeared as an article in the *Blaue Reiter* almanac. Whether an artist also expresses himself theoretically

about his own works or whether he lets them speak for themselves is a matter of his personal preference. There have been a vast variety of different attitudes in the history of art, and it is questionable whether the painter's own words necessarily help us to understand his works any better. Beckmann, for instance, admitted in 1918: "Nowadays, realizing with amazement how eloquent some painters are, I sometimes feel a little hot under my collar. My poor mouth is just totally incapable of expressing so aptly and beautifully that inner enthusiasm and burning passion for the things in the visible world. However, I finally calmed down again, and now I'm really quite happy. I just tell myself, 'You're a painter, get on with your job, and let them talk if that's what they're good at'."

Kandinsky, however, was taking a radical step towards a composition that was no longer bound to outward form but exclusively to inner necessities, and he did not dare to do this without the appropriate theoretical edifice to support and justify his actions. And so he formulated a consistent theory in which he advocated a new form of artistic composition. In practice, though, he followed his own ideas with considerable hesitation. After his first purely abstract water-colour of 1910, Kandinsky continued to incorporate representational elements – albeit in a reduced form – until 1914. In this way, he reassured himself that there was still a connection with reality. And, in fact, when he made statements such as "A line is ... just as practical and purposeful in its meaning as a chair", it showed that, even though he had entered upon virgin soil, he was still trying to hold on to familiar Naturalist ideas. Interestingly, though, his book was reprinted twice within less than a year, and we can therefore draw at least two conclusions. Either the theoretical foundation was indispensable for an understanding of his new works, or – more likely – Kandinsky's theory met with a public that was already prepared and interested in it. And indeed, artists in different countries had already been thinking independently of one another how they might conquer the non-representational world of autonomous forms and colours. Apart from Kandinsky in Germany, there was also Delaunay ("As long as art cannot detach itself from the object, it will remain descriptive") and František Kupka in France, Mondrian in Holland, and Malevich in Russia. When Hoelzel had created his first abstract paintings at the Dachau artists' colony around 1905, it still failed to have an effect, possibly because the time was not ripe and the artists were still insufficiently prepared.

Even Kandinsky's theoretical statements and his first abstract water-colour had been preceded by a lengthy process of learning and understanding. His feeling for the autonomous compositional qualities of form and colour had been sharpened by two incidents. When he saw Monet's *Hay Stack* in Moscow in 1895, he was full of enthusiasm about the colourful luminosity of the painting, without at first being aware of the object depicted. Later, when he was already in Munich, he noticed some strange painting in his studio and was fascinated by its free rhythm, until

Wassily Kandinsky:
Improvization 6 (African), 1909
Improvisation 6 (Afrikanisches)
Oil on canvas, 107.5 × 95.5 cm
Städtische Galerie im Lenbachhaus, Munich

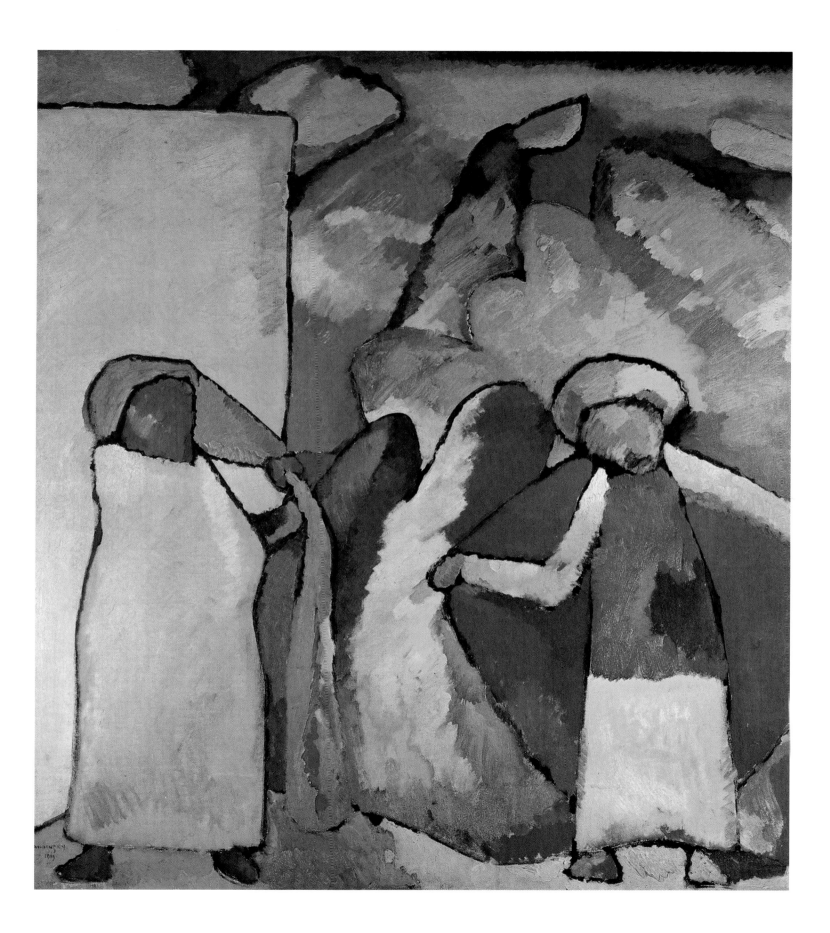

he realized that it was in fact his own work – upside down. The two incidents convinced Kandinsky, or at least confirmed his conviction, that art did not necessarily need to represent realistic objects, but that a composition could be the free combination of forms and colours. Upon reading Wilhelm Worringer's thesis *Abstraktion und Einfühlung* (Abstraction and Empathy), which was published in book form in 1907, he met with similar ideas about a "work of art as an independent organism and on the same level as nature". It is a sentence which reminds one of Cézanne's famous understanding of art as being "parallel with nature". Kandinsky found further confirmation in a fellow discipline, music. He saw its free chords and harmonic tone rows as an analogy of abstract art. The composer and theorist Schönberg, in particular, Kandinsky felt, had succeeded in expressing in his music "what I am trying to find in the form of paintings". At the same time, however, he rejected the verdict that his art might just be music with different means: "Personally, I cannot wish to paint music, because I believe that such art is basically impossible and unattainable."

Kandinsky identified two important artistic poles in his theoretical foundations – the "great realism" and the "great abstraction". Both have their respective synonyms, "representational works" and "purely artistic works", which also form opposites of one another. The former aims at rendering objects in a non-abstract way and as truthfully as possible. "Purely artistic works", on the other hand, aim at avoiding all representational forms as much as possible and to give an outward form only to the "inner sound", which is then projected onto a surface. The materials available for an abstract composition are forms and colours, though they do not have any independent qualities but merely serve to express emotions. Each colour has a different effect which, in turn, is dependent upon other adjoining colours as well as the shape it is associated with. A blue circle will affect the viewer differently from a blue square. And every viewer will respond differently to the composition of a painting, depending on his personal disposition. Kandinsky saw this problem very clearly and gave form as an example. "The question of form," said he in the *Blaue Reiter* almanac, "becomes the question which form shall I use in this case in order to achieve the necessary expression of my inner experiences?" And he decided that "a form which is the best in one case can be the worst in a different one: everything depends on the inner necessity which alone can make a form the right one." In his paintings, Kandinsky endeavoured above all to exclude all ornament and to unite form and colour on the canvas according to this "inner necessity".

Thanks to Kandinsky, it was now no longer an intrinsic part of art to imitate nature. Instead, it could now develop freely and creatively. As early as 1907, the Cubists and Futurists had already shattered the idea of a central spatial perspective, so that the space could now be used for depicting several perspectives simultaneously. Both developments were often understood as the outcome of a new scientific world view which was gaining ground at that time. In 1905 Albert Einstein developed his

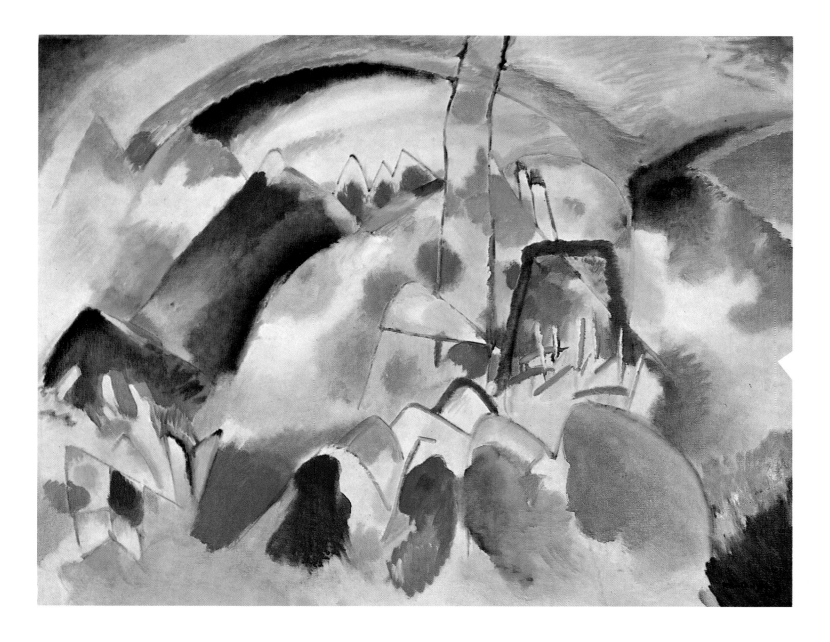

special theory of relativity, and in 1912 Nils Bohr provided the first understandable model of the atom. Later, Kandinsky made a number of remarks which show, in retrospect, that he had been well aware of the revolutionary physical research of the time ("In my soul the splitting of the atom was like the disintegration of the whole world"). Nevertheless, despite these remarks, it would be wrong to establish a causal relationship between scientific discoveries and Kandinsky's experiments with artistic form. Both developed independently of one another, though it was no mere chance that there were parallels between them.

Kandinsky recorded his artistic ideas in two extensive essays – *On the Spiritual in Art* (1911) and *On the Question of Form* (1912). Not only did his reflections help Kandinsky himself to gain a more precise understanding of his own artistic activities, but they also influenced many other artists and speeded up their development. But we do not necessarily need them in order to understand his paintings. Art had been going through a clear development, starting with Cézanne and continuing via Monet, van Gogh, Matisse and Picasso, and this continued quite consistently in Kan-

Wassily Kandinsky:
Landscape with Church, 1913
Landschaft mit Kirche
Oil on canvas, 78 × 100 cm
Folkwang Museum, Essen

147

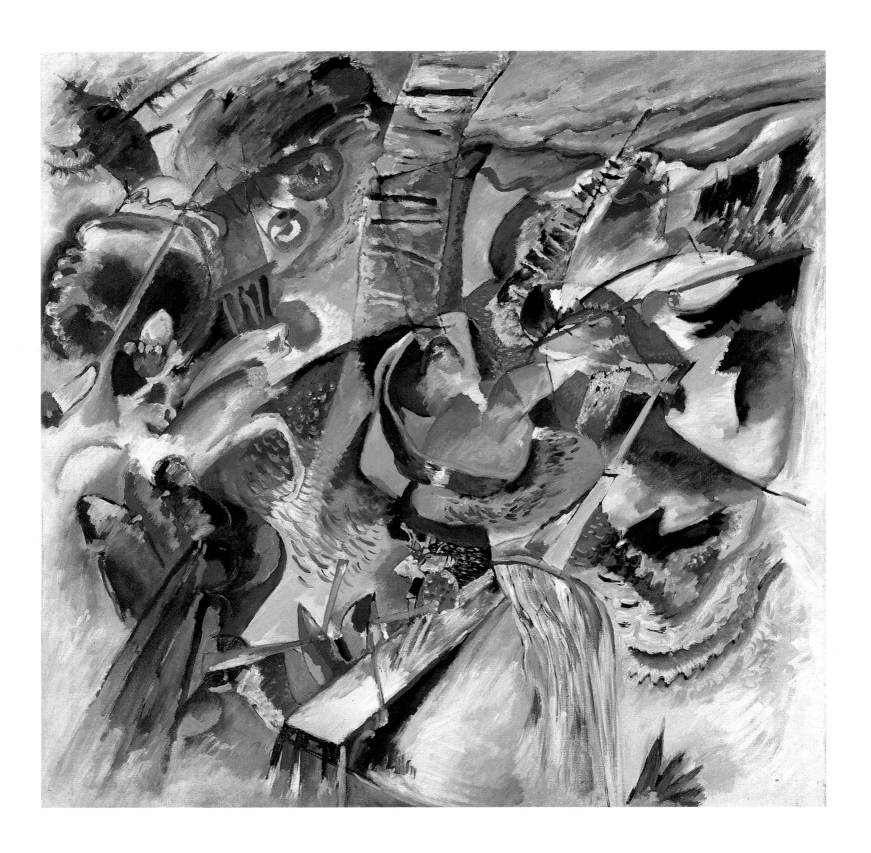

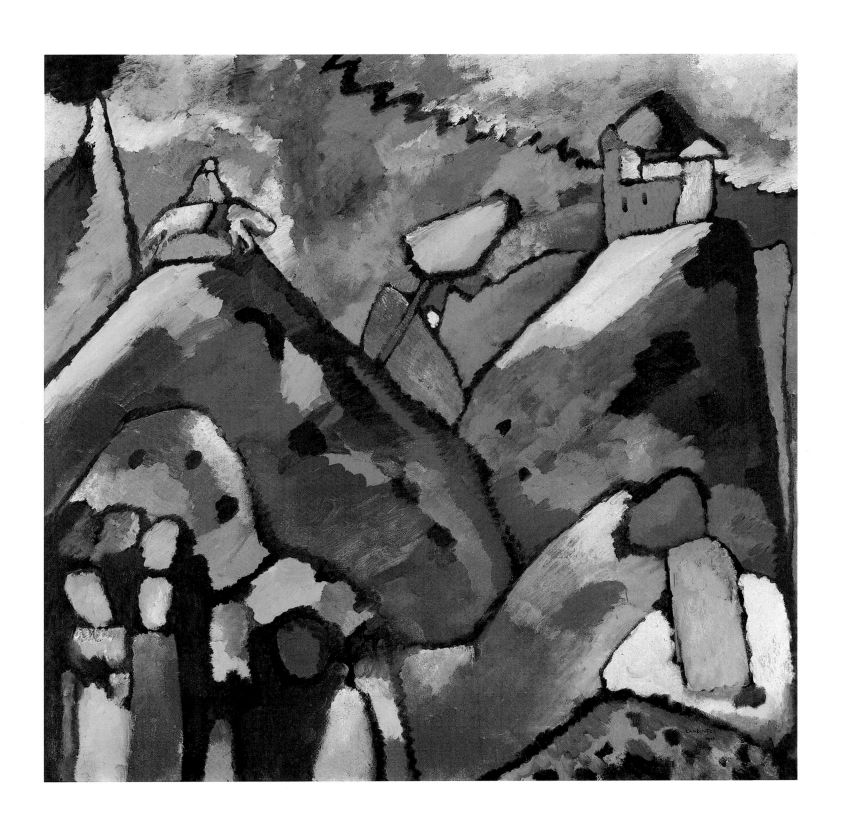

Wassily Kandinsky:
The Blue Horseman, 1911/12
Der Blaue Reiter
Woodcut for the title page of the almanac, print from black plate,
28x 21.2 cm

PAGE 148:

Wassily Kandinsky:
Improvization "Klamm", 1914
Oil on canvas, 110 × 110 cm
Städtische Galerie im Lenbachhaus,
Munich

PAGE 149:

Wassily Kandinsky:
Improvization 9, 1910
Oil on canvas, 110 × 110 cm
Staatsgalerie, Stuttgart

dinsky's work. It is within this tradition that we must see Kandinsky's paintings between 1909 and 1914.

Kandinsky's own classification of *impressions, improvizations* and *compositions* suggests a degree of abstraction in his art, which had gradually increased and developed historically. *Impressions* are still related to a naturalist model, which inspires artistic creation and which also continues in the design of reduced forms. *Improvizations* are pictures which are painted spontaneously and are meant to project the "inner sound" onto the canvas immediately. Kandinsky only painted ten *compositions* altogether, seven of them before the war. These are his most mature works. All of them are large-format paintings and the result of lengthy processes, preceded by numerous drawings, water-colours and oil sketches of details or the entire compositions. He also produced a number of other paintings, which he did not ascribe to any of these categories. The seemingly sequential logic of this development which underlies Kandinsky's classification – from impressions of nature via spontaneous recordings to well-planned but free compositions – cannot be confirmed by the dates of his works. All his *impressions* were painted in 1911, his *improvizations* started as early as 1909, and his *compositions* a year later. Also, it is not always easy to follow Kandinsky's method of ascribing his own works to one category or another, and indeed it sometimes seems contradictory. However, terms such as *improvization* and *composition* point again to the intended analogy of art and music. Kandinsky frequently gave his works explanatory subtitles, such as *Improvization 6 (African), Improvization 26 (Rowing),* or *Improvization, Deluge,* though these were not meant as direct descriptions of the pictures, but merely as associative titles which he found later and which served to distinguish them from each other.

Kandinsky's painting *Improvization 9* (p.149) of 1910 belongs to that group of works which he described as "mainly unconscious expressions of events in one's inner character, i.e. impressions of one's 'inner nature', which most of the time came about suddenly." However, the work cannot have been produced quite so spontaneously and automatically with regard to composition. The choice of colour is well calculated, and it is still very close to the model of nature with its broad panoramic landscape. Indeed, this was the prevailing theme in nearly all his paintings between 1909 and 1914, which included very few views of buildings or figures, and no portraits at all. For Kandinsky, landscapes offered the best opportunity to achieve the highest degree of abstraction while at the same time preserving a link with the representational subject. The same function is fulfilled by the horseman with his horse and the church, which occurs in many paintings that are otherwise purely abstract, thus providing the last representational link. In *Improvization 9*, the landscape is recognizable in the form of arched black lines. They indicate hills and mountains in a strongly abstract manner and serve as symbols or hieroglyphs of a landscape. Within the composition, however, their black contours also have the formal function of subdividing the large canvas into smaller units and

structuring the different areas of colour. Here, Kandinsky was already beginning to use colour as a completely autonomous element, by placing it onto the entire picture so that it formed a carpet with many different shades. The expressiveness of the painting is determined by the dominant impact of purple and its complementary colours. This basic chord is accompanied by a number of additional ones. The composition is made harmonically complete by shades of red, yellow and green, though these also bring an element of dissonance. The rhythm of the painting is determined by the artist's brush stroke, which – in *Improvization 9* - is short and swift.

During the following years, Kandinsky began to abandon representational elements altogether. His contours, which were mostly black, now no longer served to separate colours from one another, as they had obviously done in *Improvization 9*, but formed dividing lines within the colour areas. Form and colour – i.e. lines and areas – became two independent means of composition in Kandinsky's most mature works, constituting an aesthetic compositional whole within each painting. Kandinsky's range of colour became increasingly lighter and also more transparent in these pictures. They often extended over wider areas now, freely occupying the white canvas, without being surrounded by adjoining areas of colour. Thus, their powerful expressiveness acquired a spiritual, meditative quality. His *Landscape with Church* (p.147) of 1913 has this pastel quality, brightened up with white and with delicate transitions between the various shades hovering like mist over the painting's surface.

Wassily Kandinsky:
From *Klänge* (Sounds), 1913
Woodcut, 16.3 × 21 cm

The town where he lived, Murnau, was a centre of Bavarian folk glass painting, and Kandinsky was fascinated by the unsophisticated, strongly colourful depictions, which also reminded him of the peasant art of his native Russia. Kandinsky and Marc therefore included several examples in their publication *Der Blaue Reiter*. Kandinsky's religious ties with the Russian Orthodox Church and his native country left their traces on nearly all his works. The churches in his free, abstract compositions seem like a bastion, a final reminder that man is still present, and his titles have a similar function. In 1911, he painted a *Pastoral Scene*, two years later *Improvization, Deluge*, and in 1914 the prophetic stained glass window, *Apocalyptic Horseman*.

When war broke out in 1914, Kandinsky was forced to return to Russia, while his chosen partner, Gabriele Münter, remained in Munich. In 1916 they separated for good. In Moscow, Kandinsky continued his consistent development towards an autonomous, increasingly geometrical art. He returned to Germany in 1921, where he was asked to teach at the Bauhaus school of art in Weimar. However, it was in Munich and Murnau that he had experienced his most significant artistic development. There he wrote his ideas *On the Spiritual in Art* and painted his first non-representational water-colour in 1910. His theoretical writings and – to an even greater extent – his artistic achievements have influenced other painters and continue to do so today.

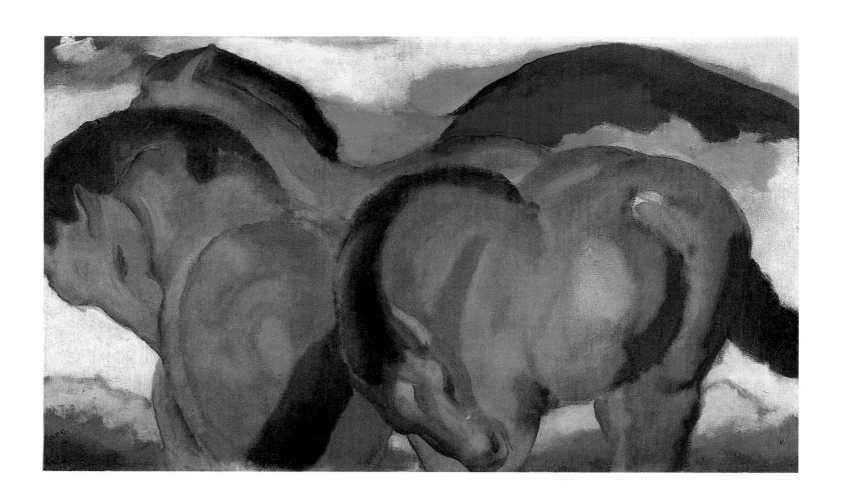

Franz Marc

The name of Franz Marc is closely connected with that of Kandinsky because of their common editorship of the almanac *Der Blaue Reiter*. In September 1910 Marc visited the second exhibition of the *Neue Künstler-vereinigung München* (N.K.V.M., New Artists' Association of Munich), which gave him significant inspiration for his own work. The event met with massive criticism, but Marc wrote a long sympathetic review, which he also sent to the association. Because of his favourable attitude towards these young artists, they invited him to become a member. At the end of 1910, Marc and Kandinsky met in person.

Marc was born on 8 February 1880. His father, Wilhelm Marc, was a painter. While most of the Expressionists came from respectable middle class families and had difficulties persuading their fathers of their unconventional desire to become artists, Marc would undoubtedly have met with more understanding. However, he did not really aim at an artistic career at all, but – at the age of 17 – expressed his long-cherished wish to study theology. Two years later he enrolled at the Arts Faculty of Munich University, though he first had to complete a year's military service, after which he decided to change to the Academy of Art. Among his teachers were Gabriel Hackl and Wilhelm von Diesz – two painters who were fully in the tradition of the Munich School. For the time being, Marc followed their style in his own artistic expression. And so, until 1903, his works displayed the same typical features of compositional structure and the same restrained, emotionally evocative shades of colour. However, a trip to Paris that year brought about a necessary re-orientation on his part. There he first saw the works of the Impressionists and above all of Manet. He also acquired several Japanese woodcuts for study purposes. One sign of his new artistic beginning was that Marc did not return to the Academy after this trip to Paris. His colours became lighter, and he took his easel out into the open air. His forms became simpler, and a two-dimensional effect emerged, without splitting up the colours in an Impressionist manner. In this he followed Manet rather than Monet. In 1907, he briefly went to Paris for a second visit, on which he gleaned further new ideas from the art of Gauguin and van Gogh. Van Gogh's style, especially, influenced him greatly. The static effect of the

Franz Marc:
Horses at Rest, 1912
Ruhende Pferde
Woodcut, 17 × 23 cm

Franz Marc:
The Little Blue Horses, 1911
Die kleinen blauen Pferde
Oil on canvas, 61 × 101 cm
Private collection, Hamburg

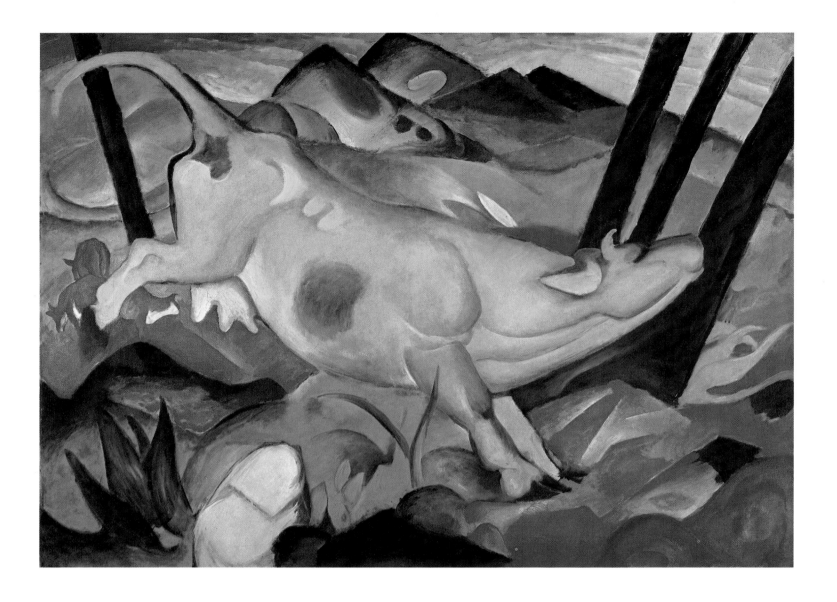

surface was broken up, and his brush strokes became more rhythmic and dynamic. There was now movement in his paintings – or at least in his landscapes. His other subjects did not show this development. It was probably while he was in Lenggries in the summer of 1908 that Marc's oeuvre began to be increasingly dominated by animals, and human beings disappeared almost completely. Landscapes continued, though only as the habitats for animals.

Yet Marc never turned to animal paintings as a genre. Rather, his groups of horses and deer are substitutes for people in his art. For him, they embody everything that is "pure", "true" and "beautiful" – features which he was unable to find in his fellow human beings. Later, he compared the two very clearly in a letter to his wife: "On the whole, instinct has never failed to guide me ...; especially the instinct which led me away from man's awareness of life and towards that of a 'pure' animal. The ungodly people who surrounded me (especially the male variety) did not inspire me very much, whereas an animal's unadulterated awareness of life made me respond with everything that was good in

Franz Marc:
The Yellow Cow, 1911
Die gelbe Kuh
Oil on canvas, 140 × 190 cm
Solomon R. Guggenheim Museum,
New York

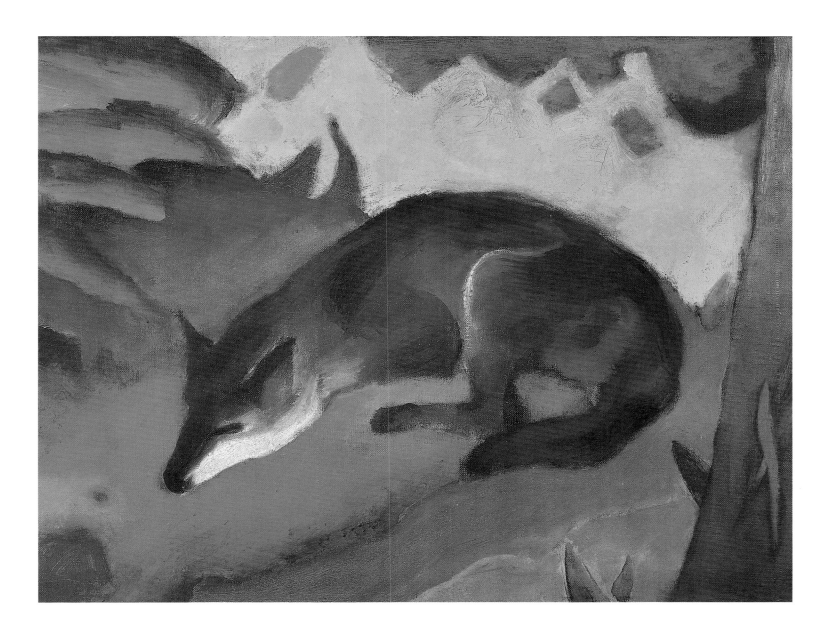

Franz Marc:
Fox (Bluish Black Fox), 1911
Fuchs (Blauschwarzer Fuchs)
Oil on canvas, 50 × 63.5 cm
Von der Heydt Museum, Wuppertal

me." Apparently, then, he must have aimed at more than a naturalist depiction of reality, although his studies of animals' skeletons provided a good basis for this. He realized that the "basic tenor of all art" must not be concerned with mere outward appearances, but that it should go deeper and try to depict the "absolute essence". However, Marc knew that his artistic scope was still rather limited for this step from mere appearances to the underlying reality. In order to depict the "absolute essence" of things in a picture, one has to to invest one's formal means (form and colour) with special expressiveness.

In 1909, Marc moved from the city of Munich to Sindelsdorf in Upper Bavaria. This was the first step towards his goal, as he was hoping to capture in his art some of the pristine idyllic beauty that still prevailed in the country. However, it was the following year which brought him freedom from his isolation in the form of important new contacts with other like-minded artists. In January 1910 he was visited by August Macke and his cousin Helmuth, and also by Bernhard Koehler, the son of the keen collector and patron in Berlin. They had seen his works at the

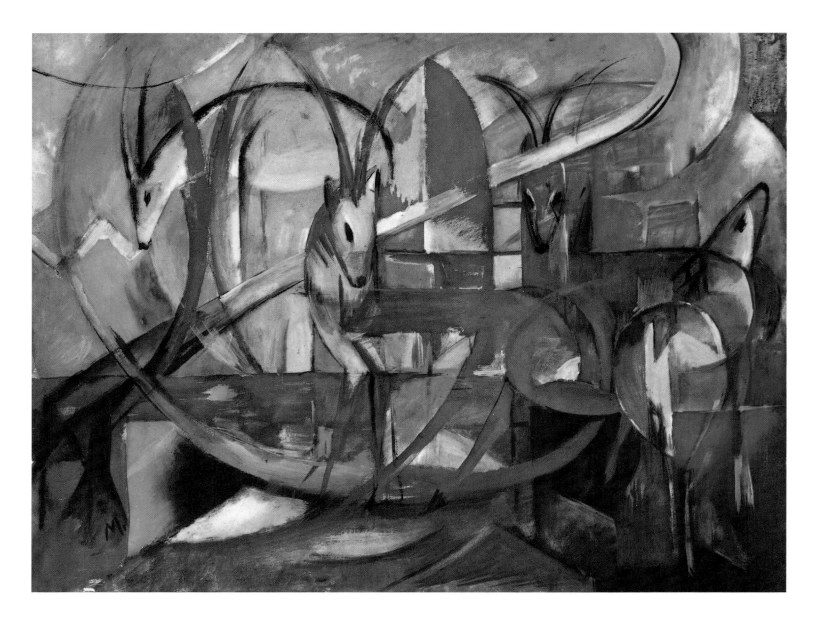

Brakl Gallery in Munich and had responded with great enthusiasm, wanting to meet the artist in person. It soon turned out that they shared a number of interests as well as likes and dislikes, and Marc was hopeful that he had "found a circle of intelligent painters". With Macke, in particular, he developed a close, life-long friendship, with mutual visits, common trips and shared painting sessions. Three months later, at the end of April, Marc went to Berlin where he also visited Koehler, the industrialist. In his collection he was able to admire paintings by Gustave Courbet, Cézanne, Manet, Monet, Gauguin, Renoir, Seurat and others. Koehler made him an attractive offer: he suggested paying Marc 200 marks for one year, and in return he would receive half of the artist's works painted during that period. This meant that, for the first time in his life, Marc could paint free of financial worries. At the end of the year he came in contact with the *New Artists' Association of Munich* and was accepted as a new member. His friendship with Kandinsky was to be

Franz Marc:
Gazelles, 1913
Gazellen
Tempera on paper, 55.5 × 71 cm
Private collection, Krefeld

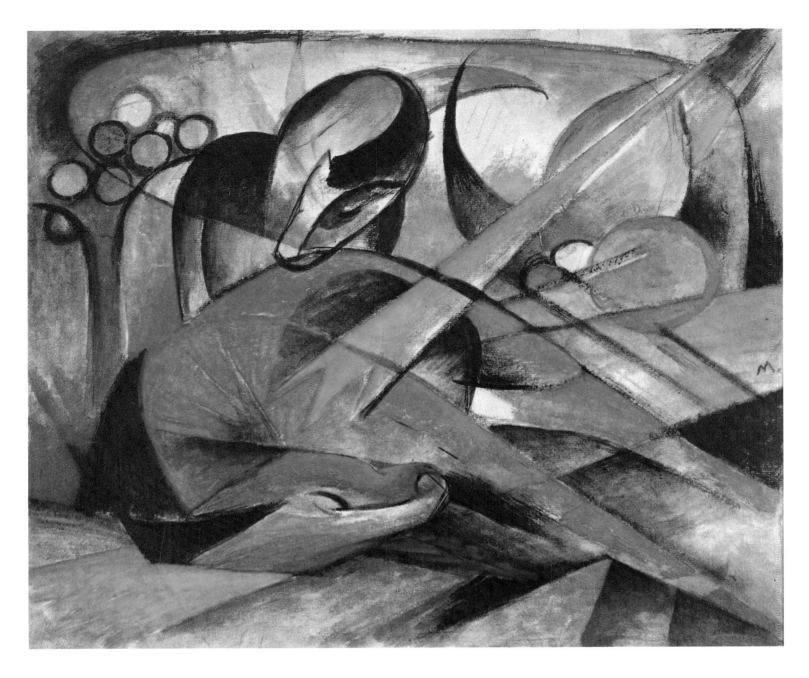

Franz Marc:
Horse, Dreaming, 1913
Träumendes Pferd
Water-colour on paper, 39.4 × 46.3 cm
Solomon R. Guggenheim Museum,
New York

particularly important for him. His friend Macke, on the other hand, had reservations about the association, which he expressed towards Marc: "I think they struggle too much with form … I feel that for true greatness they lack that natural unselfconsciousness of artists like Busch, Daumier, and sometimes also Matisse and Japanese erotica."

By this time Marc had already solved the problem of compositional form in his endeavours to reach the "absolute essence" of art. In the years 1908 - 1910 he managed to achieve an increasing simplication of form by reducing the lines in his paintings. He gave up individual and anecdotal elements in favour of a stylization of landscapes and animals. He was seeking something for which Kirchner had found the term hieroglyph in his art. Consequently, Marc now aimed to avoid any chance elements in his composition and to use such a condensed formal language that it would be impossible to "take away, add or shift the slightest line" without destroying the order and compositional expressiveness of the painting.

But although Marc succeeded in achieving the necessary simplification of form, the colours in his paintings continued to be grounded in the traditions of Naturalism. This did not change until he began to work with Macke, who stayed with him in Sindelsdorf from June to November 1910, and then visited the N.K.V.M. exhibition at the Thannhauser Gallery in September. Not only was he impressed by the Munich artists, but particularly by the French painters Derain and Maurice de Vlaminck as well as van Dongen. They gave him a vivid demonstration that it was possible to abandon the local colours and to employ colour as an autonomous element in one's art. Marc himself mentioned quite explicitly that the exhibition had helped him in important ways – "extremely valuable examples of the distribution of space, rhythm and colour theory", as he put it. In his own art he was consistent with these theoretical insights, and his colours duly changed from "outward appearance" – the colour of the object itself – to the "essence", the colour of expression.

Marc's *Horse in a Landscape* (p.137) is one of the first examples of his new understanding of colour. He painted it in 1910, while Macke was still with him. The horse has been placed right at the front edge, and – turning its back to the viewer – it is looking at the landscape. Thus, in painting an animal, the artist took up the melancholy theme of man contemplating a landscape, which was particularly widespread in Romanticism and Art Nouveau. Even later, Marc chose to be guided in his composition by portraits of individual people and groups rather than by traditional paintings of animals. The colour of the horse – despite the bright red – is still relatively restrained, enhancing the effect of depth. The landscape, on the other hand, derives its effect from the large areas of colour, with their pure tone values as well as the vivid contrast between red and its complementary colour, green.

Franz Marc:
Mews, 1913/14
Stallungen
Oil on canvas, 73.5 × 157.5 cm
Solomon R. Guggenheim Museum,
New York

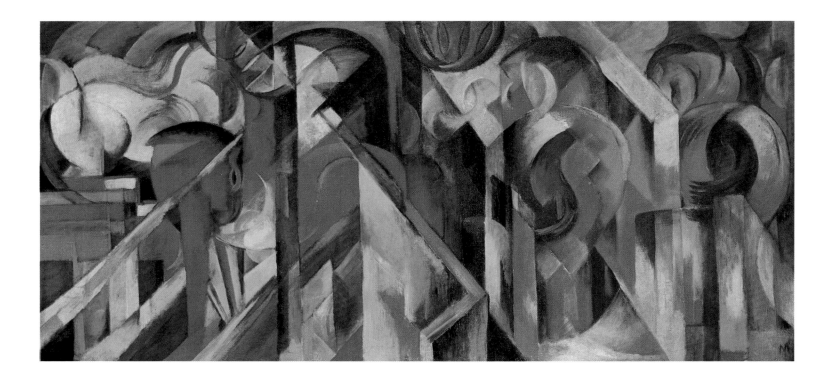

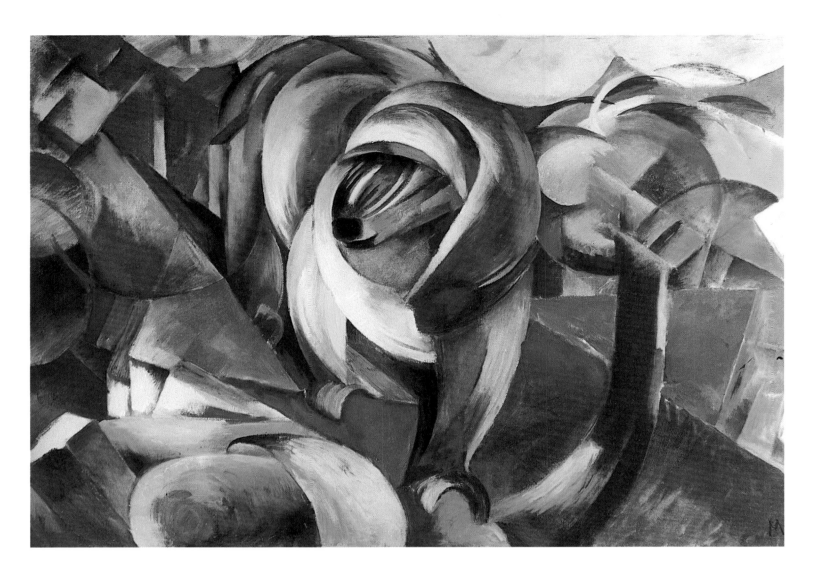

Franz Marc:
The Mandrill, 1913
Der Mandrill
Oil on canvas, 91 × 131 cm
Staatsgalerie moderner Kunst,
Munich

Marc aimed at using his artistic means economically and in accordance with certain rules. No redundant line was allowed to weaken the overall composition, no autonomous area of colour was free to spread across the canvas at random. To counteract the "randomness of colour", which became an important compositional problem for Marc, he developed a theory of complementary contrasts which he explained in great detail in a letter to Macke in December 1910. Each primary colour was seen as representing characteristic qualities. Blue stands for "masculinity, austere ruggedness and intellect". Yellow, which represents the feminine element, is gentle, cheerful and sensual. Red, on the other hand, embodies the material world. It has a "brutal heaviness" about it and is fought against by the other colours which seek to overcome it. Mixing these colours therefore leads to a mutual penetration of their corresponding characteristics: "When you mix red and yellow to get orange," he said to his fellow artist, Macke, "you add a sensuous, Magaera-like forcefulness to the passive feminine yellow, so that the cool, intellectual blue – the male element – becomes indispensable again. Indeed, blue immediately and automatically takes its place alongside orange, the two colours love each other." Marc composed his paintings on this psychological colour theory – a theory which, as he himself

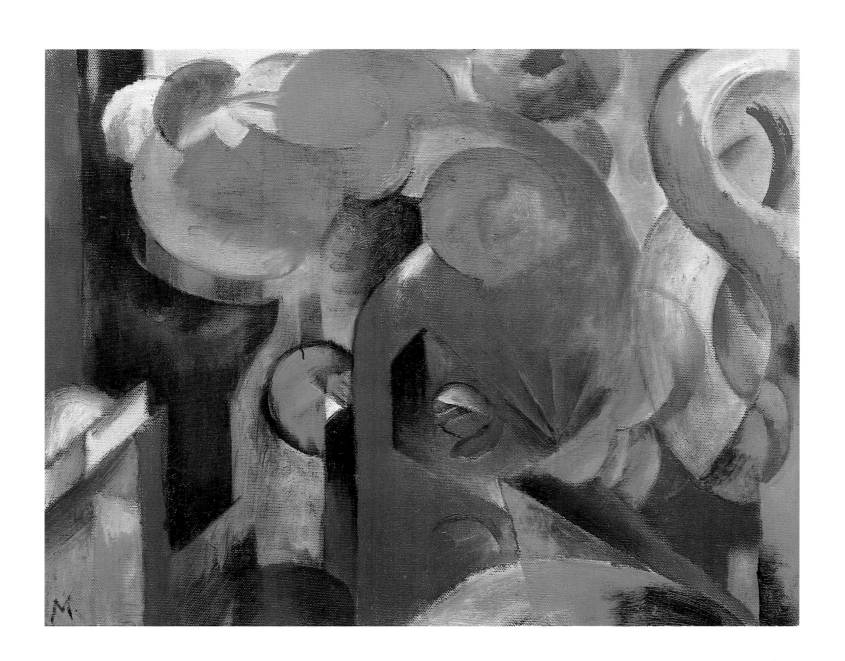

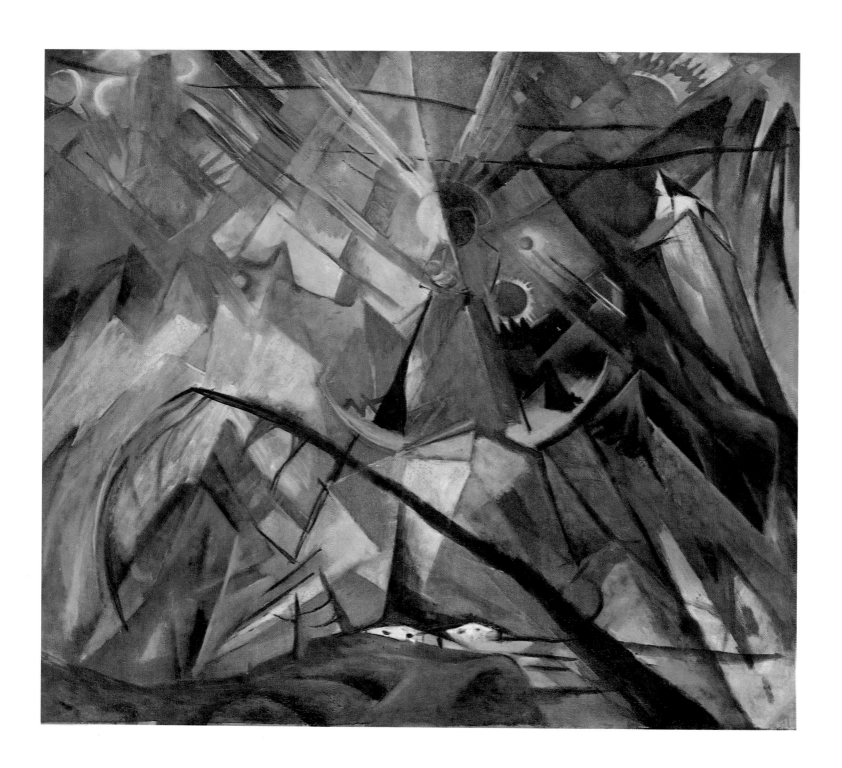

admitted to Macke, "probably seems as odd to you as my face". He did of course realize that such a theory did not automatically lead to successful works of art, but it helped him to achieve a "guaranteed effect of three-dimensional plasticity and a richness of colour". According to these ideas, it would follow that Marc's famous blue horses also embody the male principle. Powerful, austere and intellectual, they point to the Romantic heritage in his works.

In 1912 Macke and Marc travelled to Paris where they visited Delaunay. Marc found fresh inspiration in the Orphism of Delaunay's window paintings (p.12), which were to have a considerable influence on his own style and to lead to a renewal in his use of form. On his way back he passed through Cologne and became acquainted with Futurist works at an exhibition there, for which he expressed "unrestrained enthusiasm". His large-format painting *Mews* (p.158) of 1913 is a synthesis of both experiences. In his composition of the painting, Marc had abandoned the expressive simplicity of monochrome areas. Instead, the colours are subject to a complicated surface arrangement. The motif has been broken up prismatically and consists exclusively of straight lines running vertically or diagonally, angles and circular shapes. The depiction of the horses' bodies and the mews thus acquires a dynamic simultaneity, with a variety of perspectives. The fragmented forms penetrate one another, the colours have attained a degree of transparence hitherto unknown.

From about 1913 onwards, Marc's attitude towards animals began to change. He had started off by excluding man from his paintings, because he saw him as a relatively "impure" creature, cut off from his original sources. During the last years of his life, however, his sense of animals became increasingly broken, too. At first he had tried to overcome the conventions of animal paintings, while at the same time seeking an artistic expression of the way "an animal sees the world". Now he began to see animals in the same light as man – ugly and repulsive – "so that his depiction instinctively became … more and more schematic and abstract. From one year to the next, trees, flowers, the earth, everything showed me more and more ugly and repulsive sides, and so it was not until now that I became aware of the hideousness of nature and its impurity." His experience of Delaunay's Orphism as well as Futurism enabled him to draw the necessary practical conclusions for his artistic style from these theoretical insights. In paintings such as *The Mandrill* (p.159) and *Horse, Dreaming* (p.157) – both 1913 – the unspoilt Naturalist image of animals is broken up, fragmented and replaced by a complicated simultaneity of different perspectives. It followed logically that Marc's next step was non-representational art, without any Naturalist sources whatever.

Marc took this step at the turn of the year 1913/14, thus continuing a development which had already been started four years earlier by Kandinsky. Shortly before the First World War, Marc created four paintings which must be taken together, because he himself apparently saw them

PAGE 160:

Franz Marc:
Small Composition, around 1913/14
Kleine Komposition
Oil on canvas, 46.5 × 58 cm
Karl Ernst Osthaus Museum, Hagen

PAGE 161:

Franz Marc:
Tyrol, 1914
Tirol
Oil on canvas, 135.7 × 144.7 cm
Staatsgalerie moderner Kunst, Munich

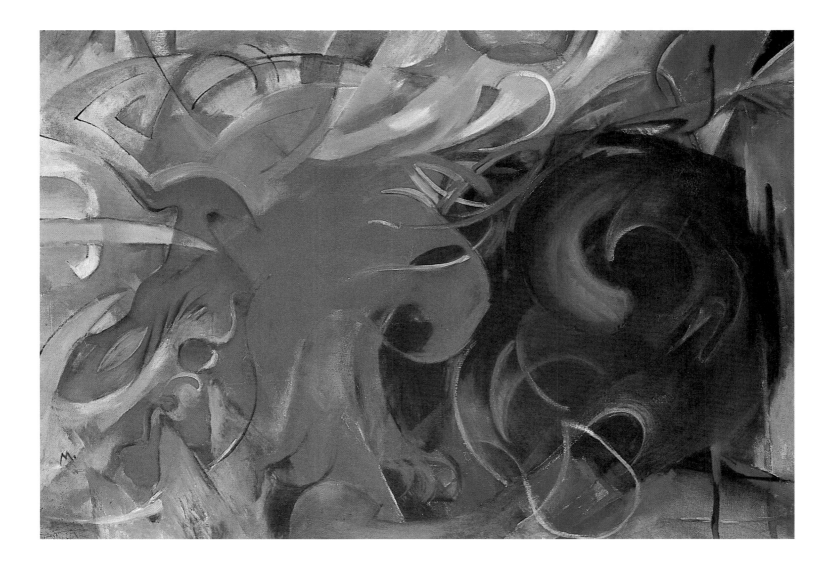

as a demonstration of the artistic options that were provided by his newly acquired abstract stylistic range – *Cheerful Forms* (destroyed), *Playing Forms* (Estate of the Artist, Munich), *Forms in Combat* (above) and *Broken Forms* (Solomon R. Guggenheim Museum, New York). Their very titles suggest that a certain freedom of composition has been attained. This sequence of four paintings seems to have been a prophecy of the impending war, even in its development, from "playing" via "combat" to "broken" forms. Landscape motifs can hardly be recognized at all in the *Forms in Combat*. Rather, the painting is dominated by two large red and black shapes, swirling around dynamically. They divide the surface diagonally into a bright, colourful zone and a dark one. The colours penetrate one another at their boundaries and engulf the forms.

When war broke out in 1914, Marc joined the army voluntarily and with great enthusiasm. He was one of those artists who took a very rosy view of the war and saw it as a great communal adventure that would cleanse and renew society. "This is the only way of cleaning out the Augean stable of Europe," he wrote to Kandinsky, "or is there a single person who does not wish this war might happen?" However, he hardly had any opportunity to start any new paintings, and he mainly produced small pencil drawings in sketch books. On 4 March 1916, Marc fell near Verdun.

Franz Marc:
Forms in Combat, 1914
Kämpfende Formen
Oil on canvas, 91 × 131.5 cm
Staatsgalerie moderner Kunst,
Munich

163

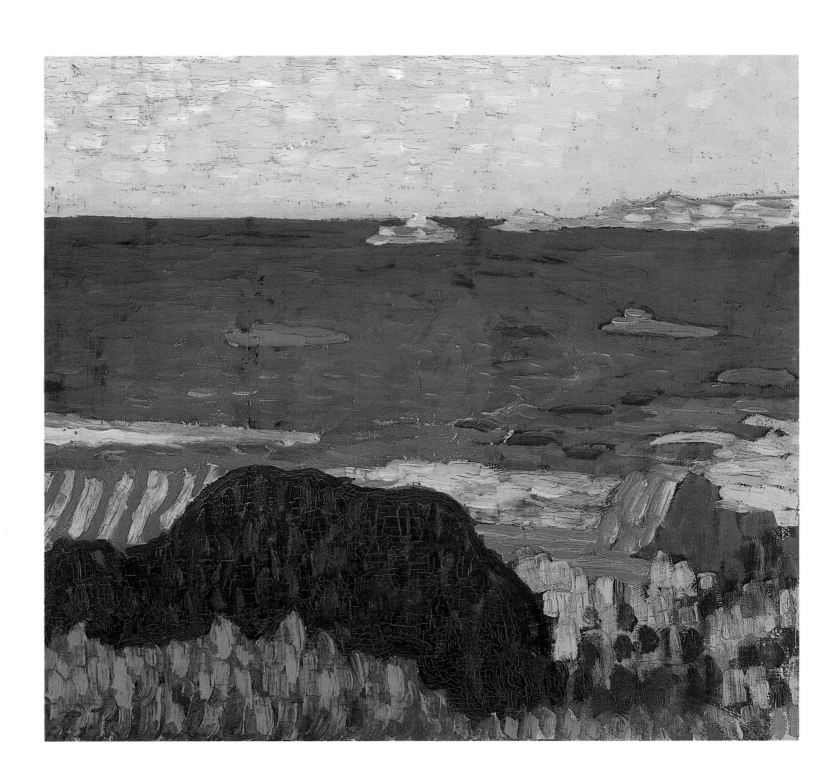

Alexei von Jawlensky

Alexei von Jawlensky moved to Germany at the age of 32, in 1896. He was accompanied by Marianne von Werefkin, who was 3 years older. Until then, he had been a captain in the Russian army, but he now wanted to devote his life entirely to art. Even before his military service, he had studied painting in St. Petersburg, so that when he joined Azbè's private painting and drawing school in Munich, he was not entirely unprepared. A year later, he met Kandinsky at this school, and their acquaintance grew into a lasting friendship. While they were both in Munich, they occasionally worked together very closely as artists.

Due to his previous training in St. Petersburg, Jawlensky was more advanced in his artistic skills than Kandinsky. Also, he had already had contact with Paris and had taken over several ideas into his own work. At the very beginning, during his first years in Munich, Jawlensky's paintings displayed the same earthy colours that dominated the salons of the time. However, this was only a very brief period, and in 1900, his colours acquired a richness and expressiveness which was to become increasingly dominant in his artistic output. However, Jawlensky remained totally untouched by Art Nouveau, which was beginning to develop in those days, particularly in Munich, which was one of its centres. Although the distinctive brush stroke of Art Nouveau is very much in evidence in Kandinsky's earlier works, it never left any demonstrable traces in Jawlensky's art. From the very beginning, his art was dominated mainly by colours rather than the quality of the lines, and his works were most emphatically paintings rather than drawings. Nor did he take any interest in historical, mythological or biblical scenes while he was in Munich. Jawlensky concentrated exclusively on motifs from his immediate environment – landscapes, portraits and still-lifes. We can understand this limitation if we consider that he always endeavoured to achieve a synthesis in his paintings between the original object and his own feelings.

Jawlensky stayed at the private painting school for three years. During this time, he developed so much talent that he was even asked to teach. At the end of the course, in 1899, he and Marianne travelled to Venice, together with his teacher Azbè. However, he was not very impressed by the great masters of the Renaissance and Baroque. Instead, he saw them

Alexei von Jawlensky:
Seated Nude, around 1920
Sitzender Akt
Lithograph from a series called
Female Nudes

Alexei von Jawlensky:
Mediterranean Coast, 1907
Mittelmeerküste
Oil on hardboard, 47.5 × 53 cm
Staatsgalerie moderner Kunst,
Munich

as competitors for his own position as an artist and felt that they represented a tradition from which he was trying to break away. It was only when he travelled to Normandy and then to Paris, in 1903, that he discovered an artist whose work was a revelation to him. "The whole of French art," he wrote later, looking back on this encounter, "is a matter of seeing nature as beautiful, very beautiful in fact. But on the whole, this is not enough. You have to create your own nature – van Gogh." His knowledge of van Gogh's works, particularly his landscapes, was more than a short-term influence that set his own art onto the right track.

Under van Gogh's influence, Jawlensky's colours became even lighter, and he began to juxtapose them in pure, unmixed forms. Short brush strokes now dominated his paintings, adding dynamic movement to them. Also, the artist felt drawn to the country, where he could paint in the open air. He spent the summer of 1904 in Reichertshausen, Bavaria, and a year later he travelled to France for several months, where he visited Brittany, Provence and the Mediterranean coast. In Paris, he went to see Matisse, whose art afforded him further proof that colour could be autonomous, used as a compositional element independently of the object. In 1907, after a further visit to Matisse's studio, Jawlensky reached his goal. His *Mediterranean Coast* (p.164), painted on cardboard in the south of France during that time, still displays an Impressionist touch. However, the individual dots add up to far more obvious, monochrome areas. The colours have gained in intensity, which is further emphasized by the strong contrasts. The structure of the painting is strictly vertical. The upper half is dominated by the primary contrast of a yellow sky and dark blue water. The areas of colour are clearly separated from one another by a horizontal line. The landscape, which consists of a rocky coastline and vegetation, has been composed of the complementary contrast between red and green. Here, however, his brush stroke does not quite add up to distinct colour areas. His touch is relatively loose, and the colours penetrate one another. With its consistent use of colour and reduction of form, the *Mediterranean Coast* can be regarded as a key painting in Jawlensky's oeuvre. With this single painting, Jawlensky created, as it were, an analysis of his own artistic programme. The emphasis is primarily on colour, and the theme is of secondary importance. The only contrasts which occur are primary and complementary. There is no modelling of volumes, no depth of space. The coast, the water and the horizon are not placed behind one another to add perspective. Rather, the picture is structured in terms of colour contrasts which occur above each other – areas of red, green, blue and yellow. "My paintings were aglow with colours," Jawlensky commented in retrospect, "and so my soul was contented with them." It seems likely that he was referring to this *Mediterranean Coast*. Incidentally, it is doubtful whether this is really a stretch of Mediterranean coast.

In January 1909, Jawlensky and several other artist friends started the *Neue Künstlervereinigung München* (N.K.V.M., New Artists' Association of Munich). Kandinsky became chairman, and Jawlensky his deputy. In

Alexei von Jawlensky:
Still Life with Vase and Jug, 1909
Stilleben mit Vase und Krug
Oil on hardboard, 49.5 × 43.5 cm
Museum Ludwig, Cologne

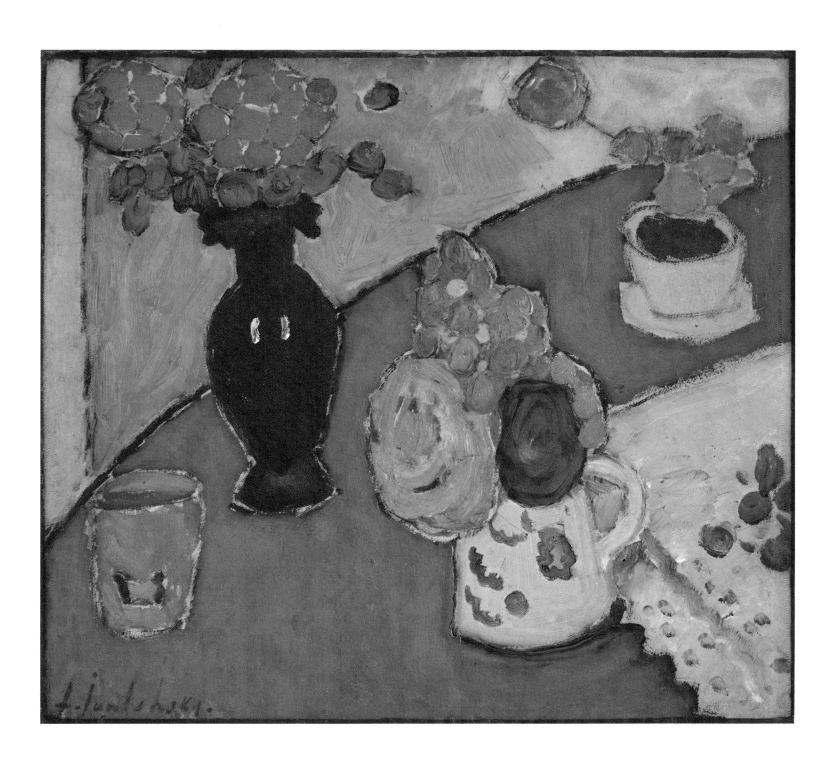

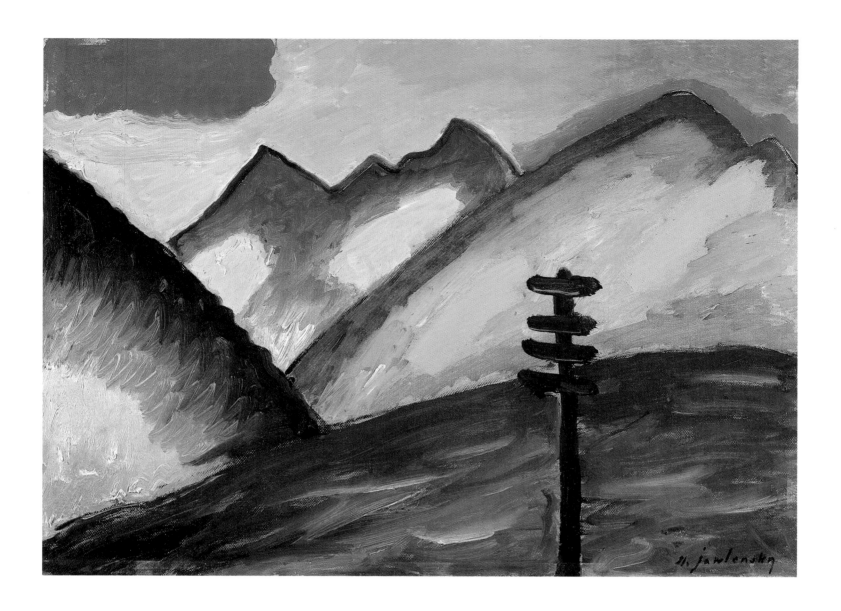

Alexei von Jawlensky:
Solitude, 1912
Einsamkeit
Oil on hardboard, 33.7 × 45.5 cm
Museum am Ostwall, Dortmund

their joint circular letter for the foundation of the association, they wrote, "Our starting point is the idea that the artist not only receives new impressions from the world outside, from nature, but that he also gathers experiences in an inner world. And indeed, it seems to us that at the moment more artists are again spiritually united in their search for artistic forms. They are looking for forms that will express the mutual interdependence of all these experiences and which are free from everything irrelevant. The aim is that only those elements which are actually necessary should be expressed with emphasis. In other words, they are striving for an artistic synthesis. ..." The first part of this artistic creed is expressed in almost identical words in Kandinsky's programmatic essay *On the Spiritual in Art.* The demand that an artist should draw from his inner world refers to his abstract compositions, where he aimed to put precisely this into practice. Jawlensky was more concerned with *synthesis* - a term which he liked and therefore used quite frequently to describe his artistic intentions. However, he did not use the word unambiguously. His own words make it quite clear that the term *synthesis* could have a diversity of meanings, some of them even contradictory. On

the one hand, Jawlensky aimed to achieve a synthesis between the impressions from the outer world and the experiences of an inner world; that is to say, he tried to harmonize the original object with his ambition to achieve expressive colours. Frequently, on the other hand, *synthesis* had a much simpler meaning and expressed the harmonious result of pictorial composition and a balance of forms and colours.

Jawlensky did not follow Kandinsky on his journey into the abstract. His art always remained linked to representational motifs. As, however, he considered colour to be the most important element, the object itself simply provided a basis for the compositional structure. In an enthusiastic account of his artistic aim, he said, "Apples, trees and human faces merely help me to see something different in them – the life of colour, as comprehended by someone who is passionately in love." Nevertheless, in the same year – 1909 – he painted his impressive, psychologically profound portrait studies of the Russian dancer Alexander Sakharov. The practical application of his words can be seen in his *Still Life with Vase and Jug* (p.167) of 1909. The simplified forms, the intensively vivid colours and the decorative lines show very clearly that Jawlensky followed Matisse with this painting. The immediate contrast between the adjacent areas of red and blue underlines the two-dimensional character of the picture. The individual areas are separated from one another by sharp, dark contours, which adds even more stability to its structure.

With Kanoldt and Erbslöh on the one hand, and Kandinsky and Marc on the other, conflict within the New Artists' Association seemed inevitable. Jawlensky tried to act as a mediator. However, when Kandinsky, Marc and Gabriele Münter resigned their membership, he felt unable to show his solidarity by doing the same. It took another few years until, in 1912, further differences of opinion made Jawlensky and Marianne von Werefkin leave the association. Two characteristics became increasingly noticeable in his work from then on: he began to concentrate on portraits, while at the same time reducing his formal stylistic means. There was a direct link between his artistic development and the world events of the following years. When war broke out, Jawlensky had to leave Germany, as did Kandinsky. Together with Marianne von Werefkin, he went to Switzerland, where he settled in St. Prex on Lake Geneva for a while. From St. Prex he moved to Ascona, and finally, after he had separated from Marianne, to Wiesbaden, back in Germany.

In the following years Jawlensky concentrated exclusively on depicting head-and-shoulder portraits until, in 1937, he had to give up painting for health reasons. The human head was a theme which he painted in numerous variations and extensive series, progressively reducing its form and making it more and more abstract. Later, his small-format *Meditations*, with their concentration on horizontal and vertical forms, took up the motif of the cross. With his *Saints' Faces*, *Abstract Heads* and *Meditations*, Jawlensky drew on the tradition of meditative religious art, used for worship in the Orthodox Church of his native Russia. These paintings are modern icons.

PAGE 170:
Alexei von Jawlensky:
Hills, 1912
Hügel
Oil on hardboard, 53.5 × 64 cm
Museum am Ostwall, Dortmund

PAGE 171:
Alexei von Jawlensky:
Head of a Young Man (Called Hercules), 1912
Jünglingskopf (genannt Herakles)
Oil on hardboard, 59 × 53.5 cm
Museum am Ostwall, Dortmund

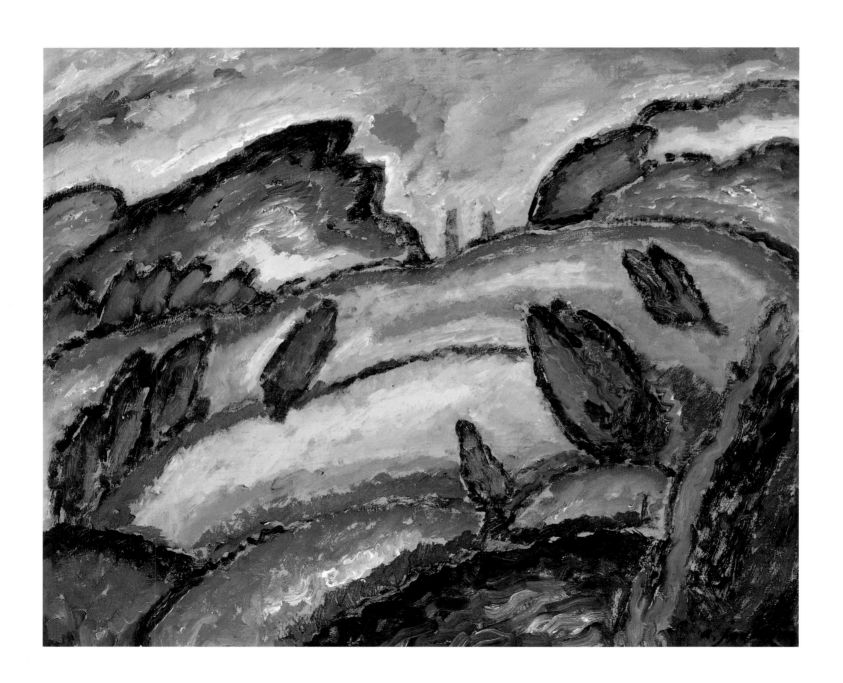

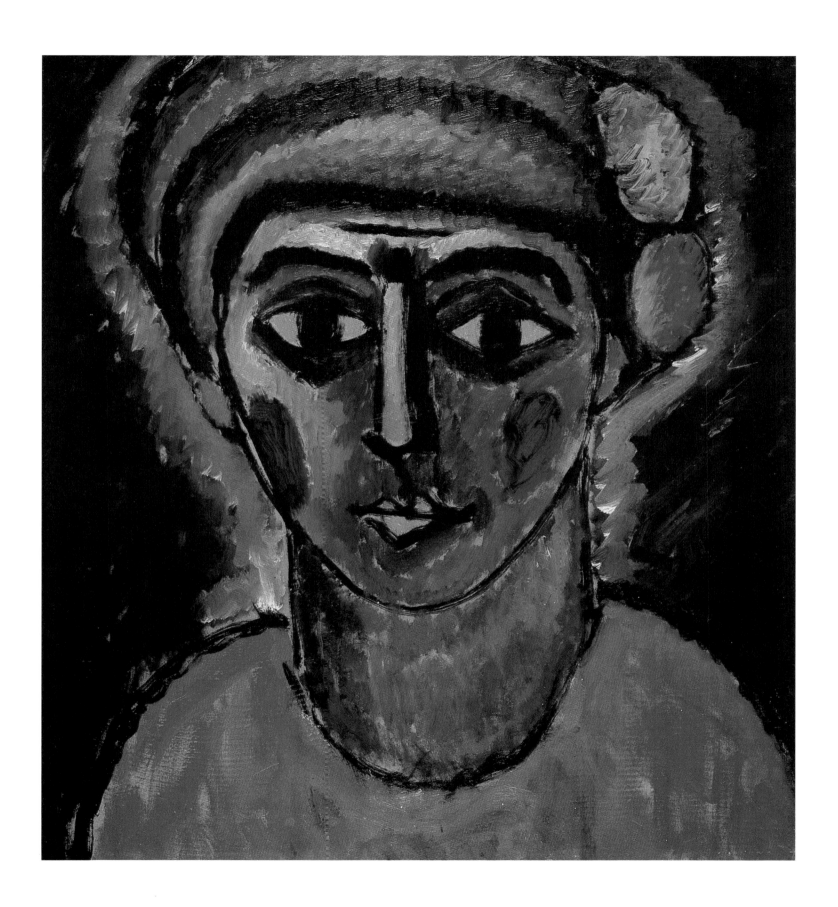

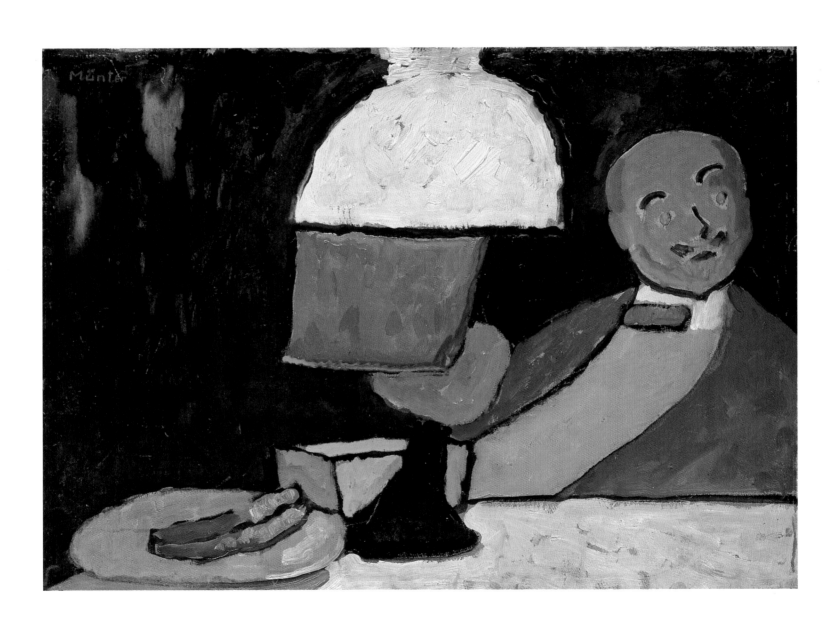

Gabriele Münter

Gabriele Münter's first contact with painting came relatively late in life. Her parents had no interest in art, and when, at the age of 20, she began her training at the Ladies' School of Art in Düsseldorf in 1897, she had no ambition to exchange her respectable middle-class life for the unconventional existence of an artist. Instead, Gabriele wanted to become an art teacher. This was a new profession, but nevertheless socially acceptable. However, she was soon dissatisfied with the school, left it again and travelled to the United States with her sister to stay with relatives.

In 1901 she returned to Germany and settled down in Munich, where an inheritance gave her the necessary financial independence. For a brief period she attended the school of the Women Artists' Society. By now, Gabriele Münter had become more self-confident and ambitious with her artistic goals. She wanted to fend for herself, independently and in free competition with other artists. State academies were closed to women at the time, and she felt that the special training colleges for ladies were merely enclaves where she was not taken seriously enough. The newly opened *Phalanx* school offered her the right alternative in this situation. The two sexes were not taught separately here, and she was accepted as an equal among equals. In particular Kandinsky, who was not only her teacher but also became her chosen partner, was able to support her. "Unlike the other teachers," said Gabriele Münter, "he would explain everything thoroughly and in depth, and he looked upon me as a person with conscious goals and as someone who was able to set herself tasks and objectives."

Gabriele Münter's aim was to be recognized as a serious artist, and during her first Munich years this led her to keep away from all artistic sources that might influence her. She did not visit any museums, galleries or exhibitions. Nor did she take part in discussions with her fellow-students. Then, in 1904, she joined Kandinsky on a four-year trip to Venice, Tunisia, Holland, France and several times to Russia. The last leg of their journey was Berlin. Back in Munich, she was accepted by a circle of like-minded artists – first the New Artists' Association of Munich and then the *Blaue Reiter*. Finally she had reached her aim. Now she was recognized as an equal partner by her male fellow-artists, and her art

Gabriele Münter:
Listening (Portrait of Jawlensky), 1909
Zuhören (Bildnis Jawlensky)
Oil on hardboard, 50 × 69
Städtische Galerie am Lenbachhaus, Munich

was appropriately represented at the various art exhibitions. During this time up to 1908, her style had changed. While in Paris, she had absorbed the influences of the Futurists, Gauguin and van Gogh, and her technique was now dominated by an Impressionist brush stroke. Applying the paint in unbroken shades, she managed to enhance the general effect of her landscapes. Also, she often used a spatula instead of a paintbrush. In 1908, Gabriele Münter first joined Kandinsky in Murnau to paint, and a year later they settled down there. The house which Gabriele Münter had bought for the two of them became a meeting point for young Munich artists from the Artists' Association and, later, for *Blaue Reiter* artists.

The summer of 1909, which she spent together with Jawlensky and Marianne von Werefkin in Murnau, was particularly influential on her further artistic development. At the time, Jawlensky was well versed in French art and his work seemed to be the most progressive, so that the others were able to receive important ideas for their own paintings. Even Kandinsky benefitted from his advice. However, it was Gabriele Münter's paintings that were most strongly influenced by his art. Almost without any period of transition, her art acquired a new style. A simplification of forms began to gain ground, and her loose touch became thicker, forming compact areas of colour. When we look at the pictures of that time, it becomes obvious that she did her utmost to create autonomous works of art which were not mere copies of real life – a demand that was undoubtedly discussed quite vehemently in Murnau – while at the same time avoiding any illusion of spatial perspective by means of her composition and distribution of colours. Gabriele Münter's procedure was well calculated to be of help in her efforts. Before painting a picture, she often started with small sketch-like line drawings which she then transposed almost identically onto the canvas in the form of solid, black contours, before colouring in the internal structures. By refusing to model the colour areas or use different shades within them, she managed to avoid three-dimensional effects. Also, Gabriele Münter was the first artist to discover Bavarian stained glass windows which came very close to her ideal of simplified forms. She even used this technique herself, which then inspired Kandinsky, Jawlensky and Marianne von Werefkin to experiment with it.

During the summer of that year, Gabriele Münter succeeded in developing her own expressive style, which she never abandoned throughout her whole life. The artist who helped her most at this time was Jawlensky. This can be seen when we compare his *Still Life with Vase and Jug* (p.167) of 1909 with her own painting of the same title. However, she did not feel able to follow Kandinsky's journey into abstract, absolute art. Her *Abstraction* of 1912 was no more than an isolated occurrence in her work and must therefore be regarded as a stylistic study, based on her close private ties with Kandinsky, rather than evidence of her own artistic development.

One of her best works is the painting *Listening* (p.172), also painted in 1909. "All three of them," commented Gabriele Münter, "were forever

Gabriele Münter:
Landscape with White Wall, 1910
Landschaft mit weisser Mauer
Oil on hardboard, 50 × 65 cm
Karl Ernst Osthaus Museum, Hagen

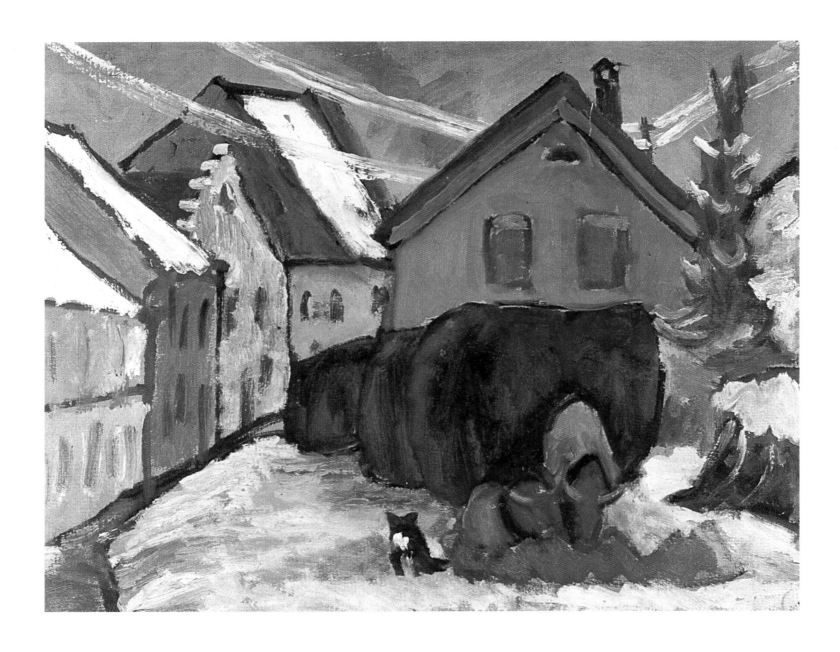

Gabriele Münter:
Chaff Waggons, 1911
Spreufuhren
Oil on hardboard, 32.9 × 40.8 cm
Städtische Galerie am Lenbachhaus,
Munich

discussing art, and at first everybody had their own views and their own style. Jawlensky was less intellectual or intelligent than Kandinsky or Klee, and he was often confused by their theories. On one occasion, I painted a portrait which I called *Listening*. It shows Jawlensky with an expression of puzzlement on his chubby face, listening to Kandinsky's new artistic theories ... Like many great artists of the Paris school, he was no theoretician, but a really great craftsman and artist."

When war broke out, Kandinsky and Gabriele Münter left Germany and went to Switzerland first. However, they soon separated, and Kandinsky returned to Russia on his own. In 1915, they met in Stockholm again where they showed their works in a number of joint exhibitions. Two years later, Gabriele Münter was very much hurt to learn that Kandinsky had got married in Russia. She returned to Murnau, but did not feel able to paint very much during the next few years. It was not until the end of the twenties that she succeeded in painting regularly once again.

Marianne von Werefkin

It was not only as a painter that Marianne von Werefkin had an active and influential position with the activities of the New Artists' Association and, later, the *Blaue Reiter*. What was even more important was probably her function as a mediator in the background, supporting the activities of other artists and promoting a climate in which the theories and ideas of the group could thrive. Indeed, we cannot overestimate her influence on her friend and chosen partner, Jawlensky.

Marianne von Werefkin was born in 1860. She came from a rich, aristocratic Russian family. Her mother, who also painted, supported her desire to be creative from the very beginning. After private tuition, she went to the Moscow School of Art, and in 1886 became a private pupil of the renowned history painter Ilya Repin in St. Petersburg. There she first met Jawlensky. She soon had her first artistic success, receiving good reviews, prizes and awards. We can best form an idea of her style at the time when we consider that she was regarded as the "Russian Rembrandt". In 1896, she and Jawlensky went to Munich – a decision which was probably on her initiative. Marianne von Werefkin was wealthy enough to support them both. She gave up her own painting so that she could live entirely for Jawlensky and support him in his artistic development. According to some authors, she thought Jawlensky was more talented than herself. Others believe she was afraid of not finding enough recognition on the art market. And some think that her crippled right hand – a late consequence of an accident - made it difficult for her to paint. However, her diary notes make it quite clear that she did not resign herself passively to her new role as a mediator between artists and between them and the public, but regarded it as an active task: "Unless there is harmony between the genius and his public, universal culture will grind to a halt. – A public therefore has to be created. This is the role of the woman. Her function is to proclaim the new idea, especially in art, so that the masses understand the genius." Marianne ran a large *salon*, where artists, writers, musicians, art historians and interested laymen had vehement discussions on new artistic theories. Even Marc's art benefitted from her theoretical knowledge, and for Kandinsky she was one of the few people with whom he could discuss his ideas about

abstract art. It was Marianne's idea to start the New Artists' Association of Munich and that Jawlensky should be its chairman. When he declined, Kandinsky was asked.

However, already in 1901 there were serious artistic and personal clashes between her and Jawlensky. "I was convinced that I could create with somebody else's hands," she wrote with an air of resignation, "but now – too late, too late." The complicated nature of her relationship with Jawlensky is reflected in a note, written five years earlier, in Russia: "I was looking for the other half of my own self. I thought I could create or educate it in Jawlensky. I saw my limits, and today there's nothing I can do." This shows that Marianne did not just aim at supporting Jawlensky and promoting his art. She wanted to use him as the tool of her own artistic ideas. However, Jawlensky found his own way, and so it seemed only logical that she produced her own paintings again in 1905. This was undoubtedly due to the impressions gained on a trip to France, where they stayed several months. The Futurists and Nabis had a lasting influence on her work, though she approached art rather cautiously, and during the following two years she produced only drawings. It was not until 1907 that she also began to paint again.

In her paintings she used colours in a typically Expressionist manner, with glowing contrasts. However, she did not allow them to dominate over forms. At the same time, she retained lines as vital structural elements so that the space in her paintings never has that two-dimensional effect of Jawlensky's works. Her subjects were often influenced by Symbolism and the Nabis. Mystically coloured landscapes with funeral processions and women in black lend a mysterious, enigmatic quality to them.

When war broke out, Marianne von Werefkin went to Switzerland with Jawlensky. In 1920, they separated, and she stayed in Ascona where she tried in vain to recall her *Blaue Reiter* days with artists' association called *The Great Bear*.

Marianne von Werefkin:
Self-Portrait I, around 1910
Selbstbildnis I
Tempera on paper on hardboard,
51 × 34 cm
Städtische Galerie am Lenbachhaus,
Munich

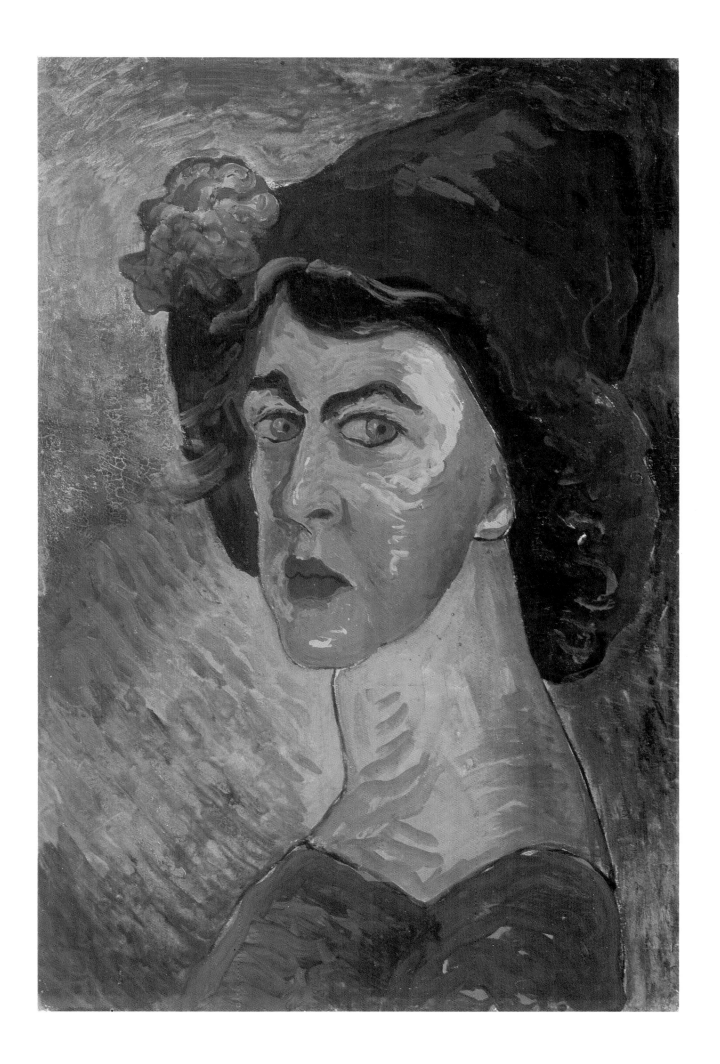

In the Rhineland, Expressionism was dominated by a number of individual artists who did not share a common programme. Apart from loose friendships among themselves, each artist also had close links with the other centres of German Expressionism and – because of their special geographic proximity – Paris. When Osthaus opened the Folkwang Museum in Hagen in 1902, it became the most important centre for the propagation of their art.

The person who frequently took the initiative among Rhenish artists and had a leadership function as well as outstanding artistic talent was August Macke. On a number of occasions he even took a political role in the cultural scene. In 1912 he acted as a member of the panel at the

Rhenish Expressionism

Sonderbund exhibition in Cologne, and he had considerable influence on the programme of the *Gereon Club*. However, it was only later, in 1913, after years of friendship with the other painters, that he united them as a group of artists. This was a result of an exhibition held at Friedrich Cohen's bookshop in Bonn, called *Rhenish Expressionists*. The aim of this presentation was to establish the Rhineland – alongside Berlin and Munich – as a third centre in which progressive artistic forces could find fellowship.

Later, the term *Rhenish Expressionism* became almost more controversial among art historians than the concept of Expressionism itself. None of the 16 artists represented at Cohen's exhibition were united by a common stylistic aim, and the selection of participants was mainly dictated by chance. Apart from Macke and Campendonk, who are discussed in detail in the following chapters, the exhibition also included works by Franz Henseler, Helmuth Macke, Carlo Mense, Heinrich Nauen, his wife Maria Nauen von Malachowski, Paul Adolf Seehaus, Hans Thuar and Max Ernst, who was to become a leading figure in Surrealism. This stylistic pluralism within the group was also recognized very clearly by contemporary critics. Reviewing the exhibition for a Bonn paper called *Volksmund*, Ernst stated, "The exhibition shows that a number of different forces are active in this great movement, Expressionism – forces that do not have any external similarities but the common 'direction' of their energy, that is, the endeavour to give expression to something psychological by means of form alone. The aim is absolute painting."

August Macke

August Macke's oeuvre is in many ways characterized by typically Expressionist features. In one area, however, it seems to be rather different from the others and indeed the exact opposite of the themes painted by *Brücke* artists as well as by Beckmann, Kokoschka, Schiele, Dix and Grosz. One point on which the younger generation of Expressionists all agreed was their spirit of non-conformity – not just towards the established artistic norms of the academic traditions, but also the norms and values of respectable middle-class society under Kaiser Wilhelm II. The young artists were aiming to achieve an aesthetic renewal, some of them even a political revolution. Some deliberately chose to be outsiders and depicted social outcasts in their art. Dix, Grosz and Beckmann created impressive testimonies of suffering in wars and revolutions. The *Brücke* artists found their subjects in the world of Berlin's night life, the circus, music halls and night clubs. With their bathing nudes, painted, for instance, at the Moritzburg Lakes, they adumbrated a paradise or anti-world in which man was at harmony with untouched nature.

Macke's entire oeuvre is permeated by his desire to achieve harmony, while pushing aside political and social reality completely. Work, suffering and death do not occur in his art. The same also applies to Marc, with whom Macke had always had close links. Marc, however, felt that man had forfeited his claim to be included in this paradise altogether. Instead, the only creatures he could imagine as being in harmony with nature were animals. It must therefore seem rather odd, by contrast, that Macke's "gardens of Eden" are populated by ladies in fashionable white clothes with broad-brimmed hats, gentlemen wearing elegant suits and bowler hats. They stroll leisurely in Sunday style past shop windows, along avenues and through parks, or we see them relaxing in garden cafés. They are typical representatives of precisely that social class – with all their respectable middle class values - which the Expressionists felt disgusted by and were generally opposed to.

Macke was born in Meschede, a town in a rural area called the Sauerland, on 3 January 1887. He spent his childhood first in Cologne and then in Bonn. Going against his parents' wishes, he left grammar school before completing his schooling to study at the Düsseldorf Academy of

August Macke:
Girl at the Fence, 1907
Mädchen am Zaun
Woodcut

PAGE 180:

August Macke:
Woman Reading in Red Armchair, 1910
Lesende Frau im roten Sessel,
Oil on canvas, 45 × 36.5 cm
Wilhelm Hack Museum, Ludwigshafen

August Macke:
Blond Girl with Doll, 1910
Blondes Mädchen mit Puppe
Oil on canvas, 76.3 × 54.5 cm
Sprengel Museum, Hanover

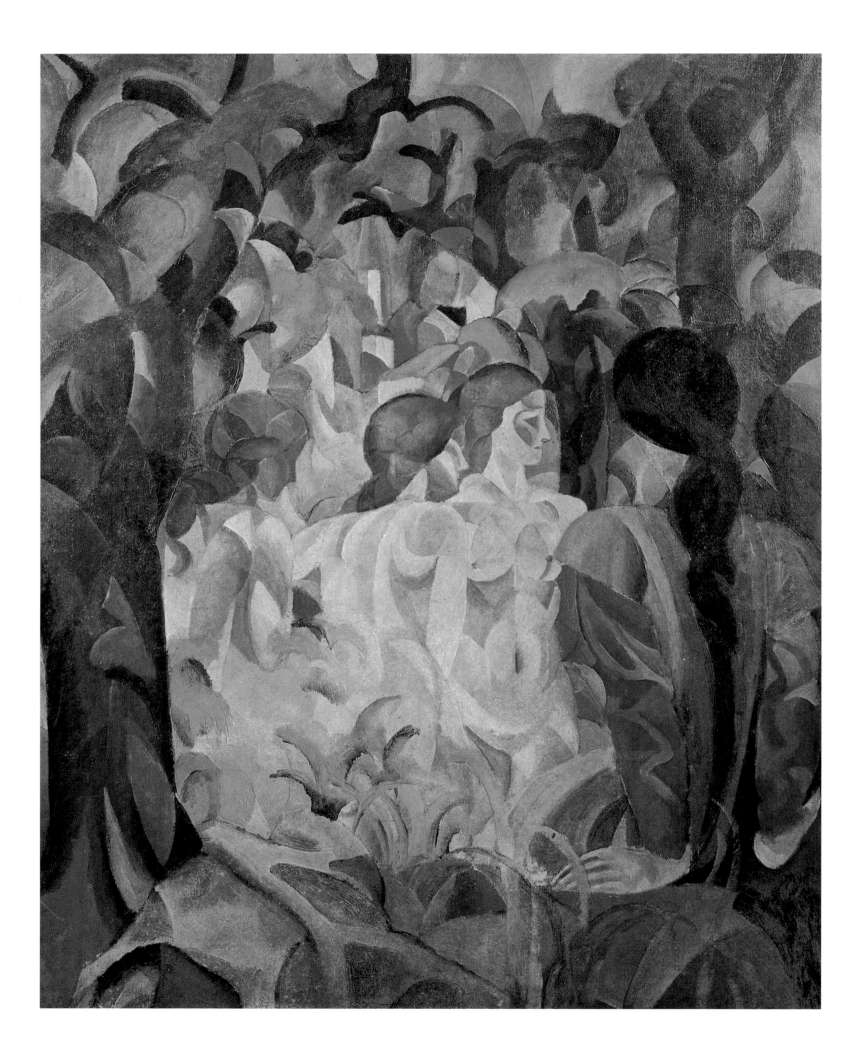

Art in 1904. After only two years, however, he was disappointed and moved to Berlin to study under Corinth. Here, too, he soon felt that he was in the wrong place and believed that he could teach himself much more efficiently. The painter whom he decided to emulate for the time being was Böcklin, whose paintings he had seen at the *Kunstmuseum* in Basle. However, it was not until his first encounter with Impressionism that he began to develop his own independent style. In June 1907, Macke went to Paris for the first time, spending a month there. The necessary financial means were provided by Bernhard Koehler, the uncle of Elisabeth Gerhardt who later became Macke's wife. Koehler, a sign and rubber-stamp manufacturer in Berlin, owned a large collection of French art, with works by Courbet, Cézanne, Manet, Monet, van Gogh and many others. Both as a patron and by purchasing their works, he supported not only Macke but also the *Blaue Reiter* and the *Brücke* artists quite substantially. In fact, it was due to his financial help that the *Blaue Reiter* almanac could be published at all.

Macke had already gained a first idea of Impressionism from books and photographs, so that when he arrived in Paris, he was prepared for their new, unusual themes and their free brushwork. But his first-hand experience of the overwhelmingly beautiful colours of these paintings came as quite a revelation. "Having seen everything at the Louvre, including – finally – Rembrandt in all his sombre magnitude, I went to the Musée du Luxembourg. And seeing Manet, Degas, Pissarro and Monet was like coming out of a crater into the sunshine," he wrote enthusiastically in a letter to Elisabeth Gerhardt.

A cursory glance at his sketch books reveals that during his first stay in Paris Macke felt particularly inspired by Manet, of whose paintings he made numerous small drawings. Thus, he finally moved away completely from the influence of Böcklin, whose art he characterized as "concept painting" as opposed to the emphasis on "form and colour" in French art. This was Macke's way of affirming an artistic style which was determined above all by formal values. From now on he became increasingly interested in problems of form and colour, while at the same time keeping his subjects as simple and unsensational as possible. Subsequently his paintings included numerous themes from Manet. The dramatically dark colours of his earlier paintings, those still under Böcklin's influence, became lighter. However, unlike the other Expressionists, Macke never went through a stage in which he took over that typically Impressionist touch in his brushwork. Again, this can only be explained by his strong leanings towards Manet. But French art continued to provide new impulses even in Macke's later development. And indeed, influences from Fauvism, Cubism and Orphism can each be detected in his paintings.

In 1909, Macke and Elisabeth Gerhardt married, and their honeymoon took them to Paris again. The young couple then settled near Lake Tegern in Upper Bavaria, where Macke experienced a phase of creativeness and his art reached a further stage of maturity. When, in February

August Macke:
Three Girls in the Wood, 1913
Drei Mädchen im Wald
Pencil, 21 × 16.2 cm
Städtisches Kunstmuseum, Bonn

August Macke:
Bathing Girls with Town in the Background, 1913
Badende Mädchen mit Stadt im Hintergrund
Oil on canvas, 100 × 80 cm
Staatsgalerie moderner Kunst, Munich

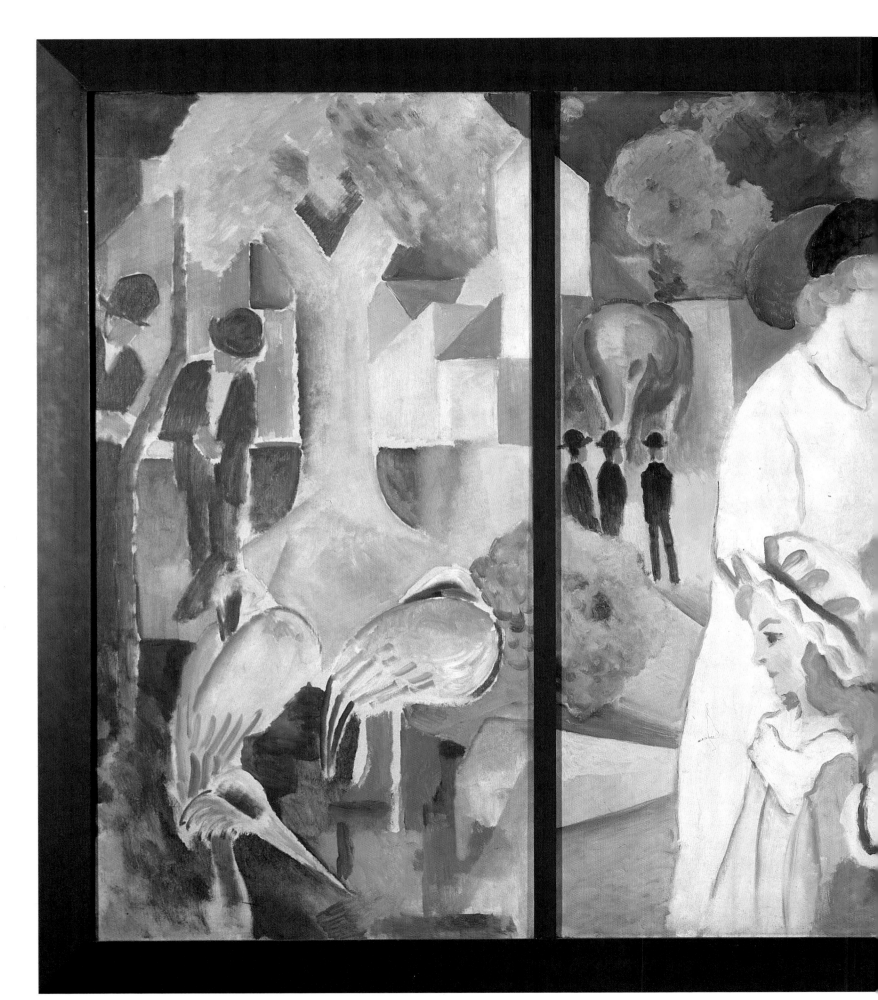

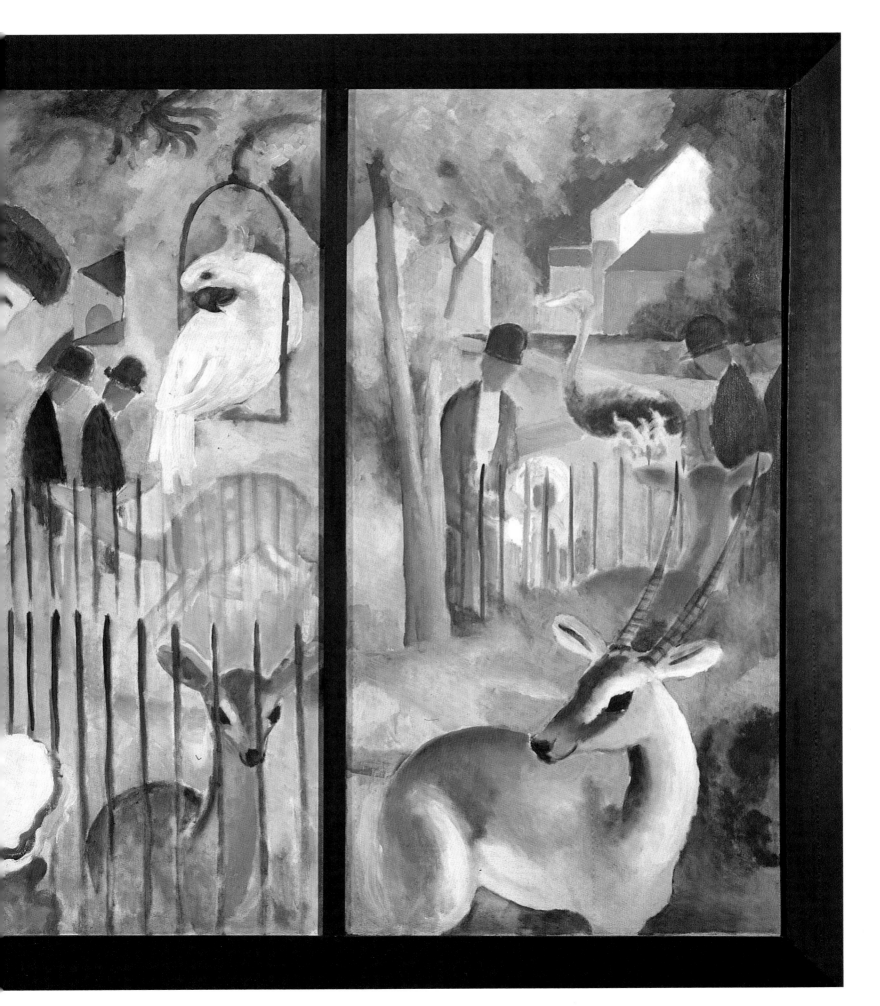

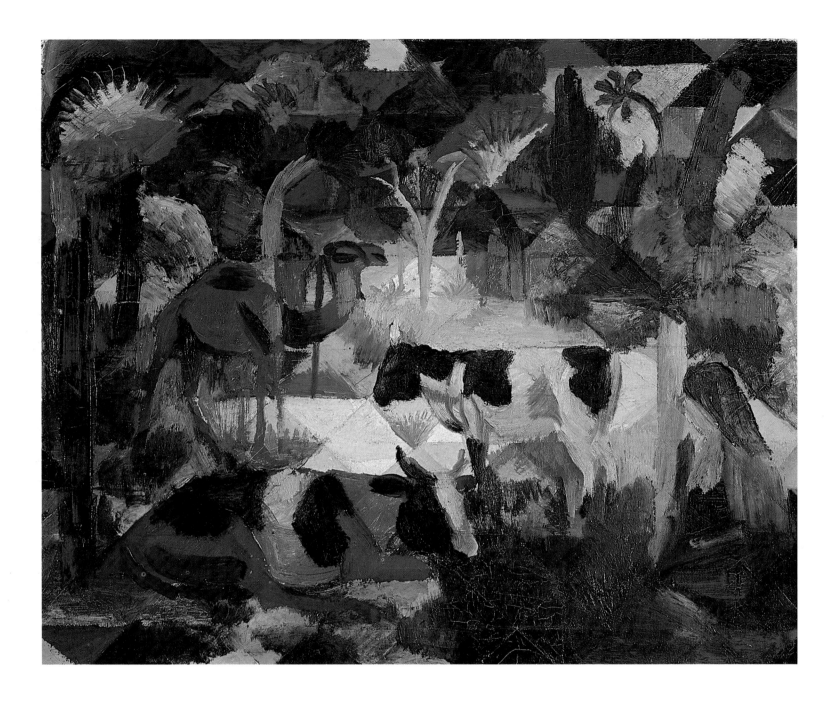

1910, he saw a number of paintings by Matisse at the Thannhaus Gallery in Munich, he was deeply impressed, and the highly colourful, two-dimensional style that followed was due to this experience. The individual colour values were now very clearly distinct from one another. Each painting acquired a simple, static structure, showing clearly that Macke was aiming at an inner harmony. In fact, he had been trying to achieve this from the very beginning, and Matisse's example only seemed to confirm his endeavour. For Matisse, art had to be "something like a good armchair" – a quality which Macke demonstrated in paintings like his *Blonde Girl with Doll* (p.182). It is already dominated by that complementary contrast of red and green which was to characterize his later motifs of "walks in the park".

On 6 January 1910, Macke went to Munich, together with his cousin Helmuth Macke and Bernhard Koehler, the son of the Berlin art collector.

August Macke:
Landscape with Cows and Camel, 1914
Landschaft mit Kühen und Kamel
Oil on canvas, 47 × 54 cm
Kunsthaus, Zurich

PAGE 186/7:

August Macke:
Great Zoological Garden, 1912
Grosser Zoologischer Garten
Triptych, oil on canvas
Total: 129.5 × 230.5 cm
Centre panel: 129.5 × 100.5 cm
Side panels: 129.5 × 65 cm each
Museum am Ostwall, Dortmund

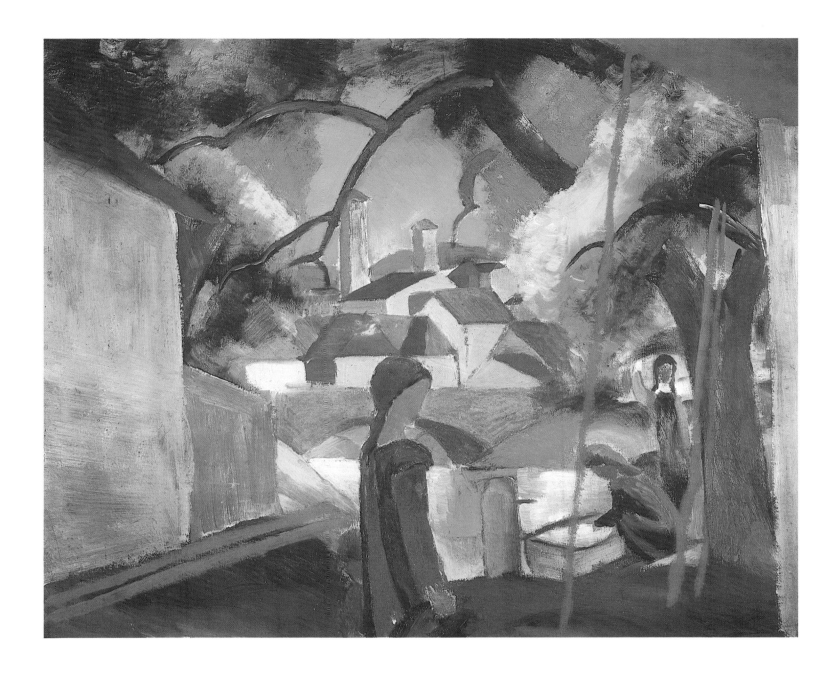

August Macke:
Children at the Pump, 1914
Kinder am Brunnen
Oil on canvas, 62.5 × 75.3 cm
Städtisches Museum, Bonn

They wanted to meet Marc, whose works they had seen at the Brakl Gallery. This was the beginning of a life-long friendship between Macke and Marc, with the result that Macke also met Kandinsky and other *Blaue Reiter* artists. A close relationship developed, despite psychological differences and – after Macke's move back to Bonn in November 1910 – the geographical distance between them. Macke contributed his own paintings to their two exhibitions, wrote an article ("Masks") with two illustrations for their almanac, and as a member of the *Sonderbund* panel in 1912, he advocated their participation in the exhibition. Furthermore, he acted as an agent between the *Blaue Reiter* and museums, galleries, and collectors as well as Koehler, the patron. However, on several occasions, Macke also expressed his doubts in letters to Marc: "The *Blaue Reiter* artists are often rather blind, full of self-love, and they act as if they were hen-pecked husbands. Those grand words about the beginnings of great

spirituality keep ringing in my ear. It's all right for Kandinsky to say that sort of thing in private, and lots besides about revolutionary changes. I find it rather unpleasant, especially after this exhibition [at the Gereon Club in Cologne, January 1912]. I can only advise you to work without thinking too much about the *Blaue Reiter* and blue horses."

Two important artistic encounters brought about full maturity in Macke's works at the end of 1912 and the beginning of the next year. Under the influence of Delaunay's Orphism, his colours became more rhythmic, while Cubism and Futurism resulted in a more solid structure of his forms. In October 1912, at the great Futurists' exhibition in Cologne, he saw paintings by Umberto Boccioni, Gino Severini and Carlo Carrà for the first time. Fascinated by contemporary French art, Macke confessed: "Modern art can avoid these ideas even less than it can Picasso." This was after he had already seen Picasso's works in 1910, at the second exhibition of the New Artists' Association of Munich. At the time, Picasso's Cubism had not affected his own work. Two years later, however, probably through the mediation of Futurism, his own art could no longer avoid the idea of a Cubist or prismatic reduction of form. Nevertheless, although Macke adopted quite a few of their stylistic devices, he felt rather critical towards the artistic ideologies that went with Futurism. He had no understanding of their solemn words, their iconoclastic ideas or their glorification of war.

These new ideas from Cubism and Futurism led Macke towards greater strictness in structuring his own paintings, to incorporate two-dimensional areas more dominantly into an orderly formal structure and thus to achieve greater stability of composition. His *Bathing Girls with Town in the Background* (p.184) of 1913 is an extreme example, because the entire painting consists of small, block-like, sections of circles. His adaptation of Orphism is most strikingly illustrated by his *Landscape with Cows and Camel* (p.188), and his increasing process of abstraction can be seen in his *Colourful Composition* of 1912. In each of these works, Macke took one particular formal innovation and studied it intensively, so that the innovation itself became the real subject of the painting. Again and again, however, he withdrew from such extreme positions, endeavouring to create a harmonious equilibrium between all the formal stylistic elements. This can be seen very clearly in *Children at the Pump* (p.189) of 1914, which is quite different from *Bathing Girls with Town in the Background* painted a year earlier. It is only in the architectural details that Macke used block-like forms. Formally, these are balanced by purely two-dimensional colour areas, and – with regard to the subject – the natural shapes of the landscape. The dynamic rendering and the simultaneity of the subject – which is so typical of Futurism – were not reflected in Macke's art. He continued to treat the space within a painting as unified and non-fragmented. The only paintings in which he paid his respects to the Futurist concept of movement were his numerous groups of men or women strolling around at leisure (cf. p. 191).

When Macke saw the Futurists' exhibition in Cologne in October 1912,

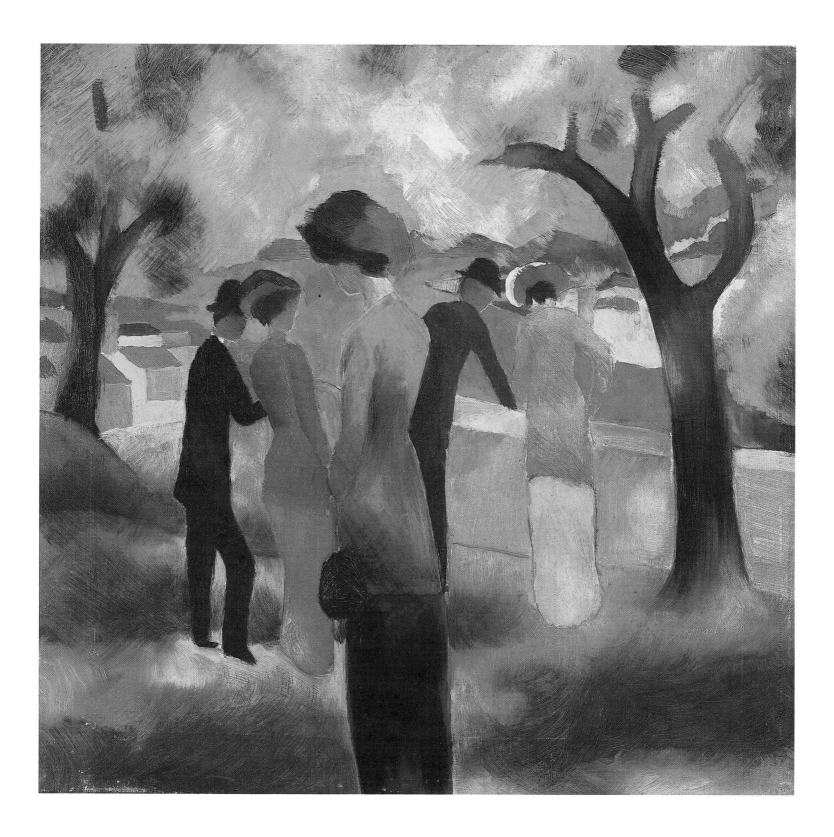

he had just returned from a fairly long trip to Paris, together with Marc. They had visited Delaunay and seen his Orphist window paintings, on which he had only been working for the last few months. A year later, in January, Delaunay and the poet Guillaume Apollinaire visited Macke in Bonn. Delaunay's Orphism, which had developed from Cubism, subsequently became an important influence in Macke's art. With reduced colours and cubic shapes, Delaunay had created an art that consisted entirely of pure, prismatically fragmented colours. Each painting had

August Macke:
Woman in the Green Jacket, 1913
Dame mit grüner Jacke
Oil on canvas, 44 × 43.5 cm
Museum Ludwig, Cologne

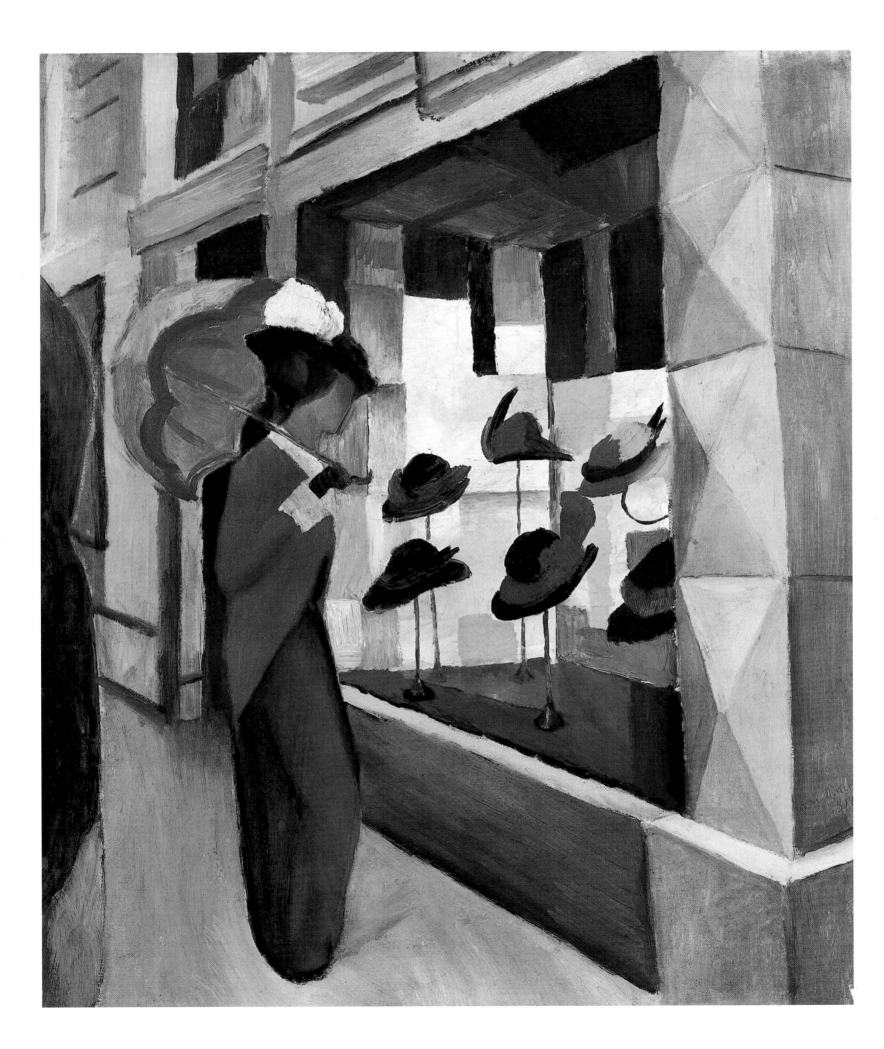

geometrically structured areas superimposed onto it, their static character dissolved into brightly transparent colour contrasts that permeated it rhythmically. Naturalist motifs – roofs, church towers and the Eiffel Tower again and again – merely occur as reduced, abstract and fragmented forms in Delaunay's paintings. Using the motif of the window, with bright daylight entering in from outside, he made light itself one of the themes of Orphism.

Macke now followed Delaunay's ideas and no longer depicted light in an illusionist way. He achieved this by modelling his subjects three-dimensionally, with light and shady portions. The idea was that the luminosity of the colours should enhance the contrast so that the light itself would shine from the paintings. Macke's *Landscape with Cows and Camel* shows that, in trying to systematize his composition, he finally achieved a strictly geometrical grid structure of triangles set against each other. The subject itself is subject to this grid. The area of yellow at the centre of the composition shines forth brightly and provides a striking contrast with the dark colours at the edge. Thus, the colours produce an extreme effect of spatial depth, counteracting the totally two-dimensional structures of the forms. It is one of several paintings in which Macke took a radical position in experimenting with formal structures. On the other hand, in his *Girls under Trees* (p.195) of the same year, on the other hand, Macke abandons this strictly geometrical, two-dimensional structure again, in favour of a freer composition of form. However, the luminosity and transparence of the painting is enhanced by the contrast between blue and white.

Macke's *Great Zoological Garden* (pp.186/187), which was painted as late as 1912, occupied a special position within his art. Not only is it his largest painting, but also his only triptych – a format which was mainly used by mediaeval Christian painters. However, the three-panel effect – with a central portion and two wings – was neutralized by Macke again by creating a unified composition that encompasses all three panels. The *Great Zoological Garden* sums up his entire artistic work until then – both formally and iconographically, that is, in his use of Futurism and Orphism as well as in the occurrence of his typical motifs. The zoo theme, which Macke also used in a number of pictures on canvas and on paper, was his most perfect rendering of an earthly paradise. Man and beast meet face to face in nature. The cage bars are still there, but without fulfilling their function as barriers that separate. The figures in the painting seem frozen, and a meditative stillness pervades the scene, with virtually no narrative details at all. Each element is only important in its function as part of a whole. Man, who is depicted as being in harmony with the animals and with nature, is never shown as an individual, with portrait-like features. He remains schematic, faceless and is merely characterized as a representative of his species and his social class. The woman in a fashionable white dress and the man in a suit and bowler hat represent contemporary middle-class society in the age of industrialism.

It was on his Sunday walks in the idealized landscape of his surround-

August Macke:
Woman and Child before a Milliner's (from the artist's sketchbook No. 55b), 1913
Frau mit Kind vor Hutladen
Pencil drawing
Westphalian State Museum for the History of Art and Culture, Münster

August Macke:
The Milliner's, 1914
Hutladen
Oil on canvas, 60.5 × 50.5 cm
Folkwang Museum, Essen

ings and Cologne Zoo that Macke tried to find his motifs for his ideas of an earthly paradise. However, like other artists, he also felt enthusiastic about remote parts of the world and exotic tribes. He had already painted several pictures of North American Indians, but he was even more excited about the world of the Orient, whose art he expected to have some fruitful effect on his own work. "The blending of two styles yields a third style, a new one … Europe and the Orient," said Macke in his essay for the *Blaue Reiter*, "Masks". Having read a large number of Romantic descriptions of travels into the Middle East, he had an exaggerated idea of these countries as a world of dangerous adventures and fantastic wealth, and full of the exotic and erotic.

In autumn 1913, Macke went to Hilterfingen on Lake Thun, where he was visited almost daily by the painter Louis Mouillet. The two artists worked together quite intensively and, on 8 January 1914, they were joined by Paul Klee who suggested that they should all travel to Tunis together. Macke found this idea attractive for a number of reasons. The Orient (or Africa) was still the mysterious place of his secret yearnings where he was literally hoping to find paradise on earth. He must have realized, when comparing with the reality around him, that the idyllic world of his paintings had never been more than illusion. His American Indian theme had been limited to a few paintings of 1911, after he had been inspired by tales of the free and natural life of the "noble savage". However, he himself found the artistic outcome rather unsatisfactory, probably because they were not the results of first-hand experience but only came from literary sources. He was therefore hopeful that his journey would fill a gap and give him plenty of personal and immediate impressions. While he was in Hilterfingen, Macke was assimilating the impressions prompted by Delaunay's *window paintings*, in a synthesis of colour and light. This obviously appealed to Macke, for it offered him an opportunity to test what he had learnt under the clearer, much brighter light of a southern country.

To finance the trip, Macke was able to rely on Koehler's support again. At the beginning of April 1914, he first travelled alone to Marseille, where he was joined by Klee and Mouillet. Then they went together to Tunis by ship, also visiting other places in the interior of Morocco. Although the entire trip took barely three weeks, it was to be of extreme importance for all three artists. Macke did not produce any oil paintings during that time, but a total of 38 water-colours, 110 drawings and hundreds of sketches in his note books. He also took quite a number of photographs. During these weeks he assembled an extensive collection of motifs which he did not begin to evaluate and use artistically until his return to Germany. In his on-site water-colours, Macke achieved a further intensification of his two-dimensional colour style. Water-colour was an ideal medium for applying the paint more transparently and in light contrasts so that light and colour were given an immediate expressiveness. Back in Germany, Macke summed up his journey in a letter of thanks to Koehler, "I've been working very hard. Now I'll have to see how I can work it all out." During

the following months, he produced 36 paintings based on the motifs which he had brought home from Tunis.

When war broke out, this productive phase of Macke's work came to a sudden end. He was drafted into the army and fell after only a few weeks, on 26 September 1914. Marc wrote an obituary for his friend: "In a war, we are all equal. But amongst a thousand brave men, one bullet has hit someone who cannot be replaced. His death means that a hand has been cut off a nation's culture, an eye has been put out ... We, the painters, know full well that with the loss of his harmony of colours German art will become paler by several shades and that it will acquire a drier and more lustreless note. More than anybody else, he gave the brightest and purest note to his colours, just as his entire personality was one of clarity and brightness."

August Macke:
Girls under Trees, 1914
Mädchen unter Bäumen
Oil on canvas, 119.5 × 159 cm
Staatsgalerie moderner Kunst,
Munich

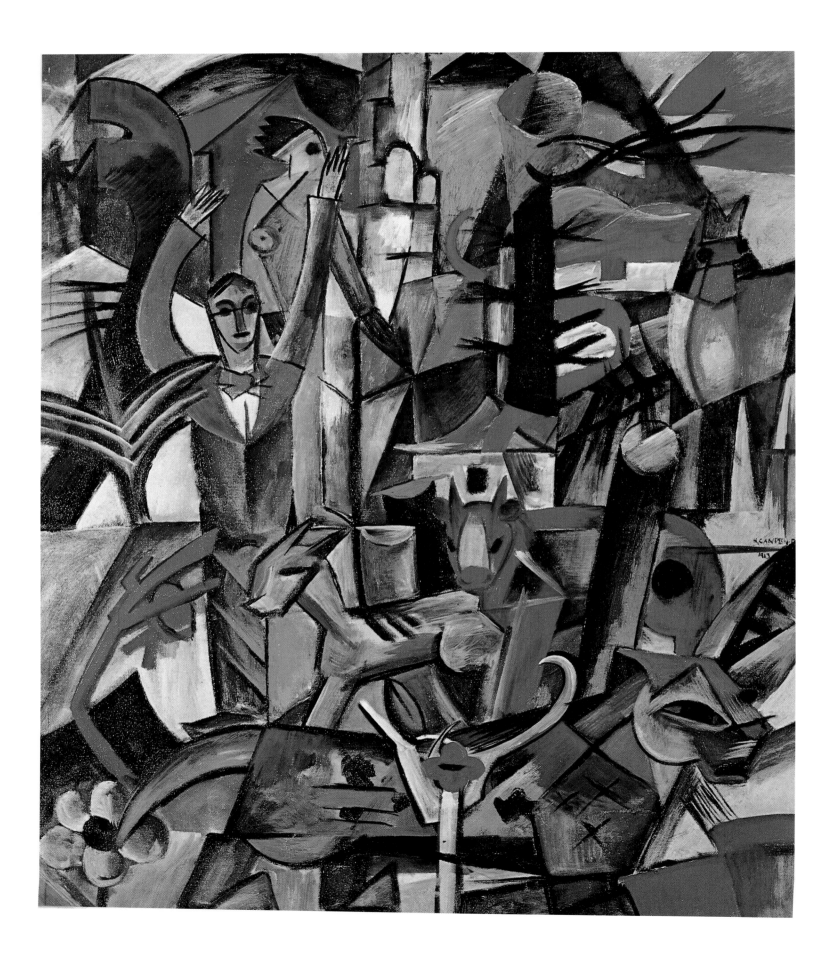

Heinrich Campendonk

There is more than one way in which Campendonk can be regarded as a Rhenish Expressionist. He was born in Krefeld in 1889 and produced most of his works in his home town and later in Düsseldorf. He was a close friend of August and Helmuth Macke, and whenever there was an exhibition of Rhenish Expressionism, he was one of its foremost representatives. Nevertheless, between 1911 and 1914 – the most significant years in his artistic development – he was mostly influenced by the *Blaue Reiter* artists in Munich. He even exhibited his art together with them and spent some time in Sindelsdorf, where Marc was living at the time. In fact, Marc became an important mediator for Campendonk, giving him important formal impulses as well as a thematic re-orientation.

However, Campendonk's art had already begun to take shape between 1905 and 1909, when he was a student at the Krefeld School of Applied Art and his teacher Jan Thorn-Prikker acquainted him with the works of Cézanne and van Gogh. He taught him their artistic ideas of autonomous composition, with colours and lines as purely formal means. Campendonk's own paintings were subsequently dominated by powerful colour contrasts, and his brushwork, especially in his landscapes, followed Impressionist examples. At this stage, however, he still retained a unified perspective with spatial depth, and it was only when Marc began to influence him that the space in his paintings was broken up in a Cubist manner, with a transparent fragmentation of the motifs. In separating the colours from their objects, he discovered them as independent means of expression.

Contemporary French art, particularly Delaunay's Orphism, never found its way into Campendonk's art directly, but always through the mediation of Marc. Indeed, it was not only with regard to form that he followed Marc, but also in his choice of subjects. In a large number of variations, he combined animals and abstract figures – not depicted in portrait style – in landscapes that had no precise location. As a result, there are no unambiguous spatial dimensions in his paintings, and the individual motifs are freely suspended on the surface of the picture. The forms penetrate each other, and the colours are superimposed on one another in transparent layers. Thus, the entire composition becomes a

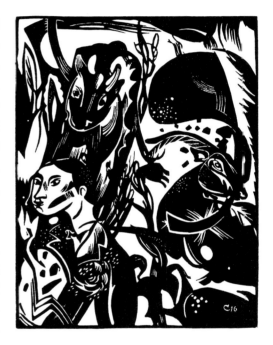

Heinrich Campendonk:
Girl with Animals, 1916
Mädchen mit Tieren
Woodcut, 28 × 21 cm

Heinrich Campendonk:
Bucolic Landscape, 1913
Bukolische Landschaft
Oil on canvas, 100 × 85.5 cm
Morton D. May Collection, St. Louis
(Mo.)

firmly coherent structure and appropriately reflects the artist's iconographic intentions. Campendonk's paintings conjure up the idyllic atmosphere of a harmonious communion between man, beast and nature. The romantic mood of these pictures is determined above all by the balanced contrasts between the translucent colours.

During his last years in Munich – in 1913/14 – Campendonk began to reduce his forms, while at the same time rendering them more and more abstract. Again, he was following Marc's example. His motifs now consisted of strictly geometrical elements. However, when war broke out, the creative artists' communities in Sindelsdorf and Murnau disintegrated. Kandinsky and Jawlensky had to leave Germany, and Marc was soon killed as a soldier. After the war Campendonk returned to Krefeld, where he discovered stained glass windows as a new technique – these were very much akin to what he had been doing until then. The translucence of the windows ideally matched the transparency of his colours.

In 1933 Campendonk emigrated to Belgium and later to Amsterdam, where he died in 1957.

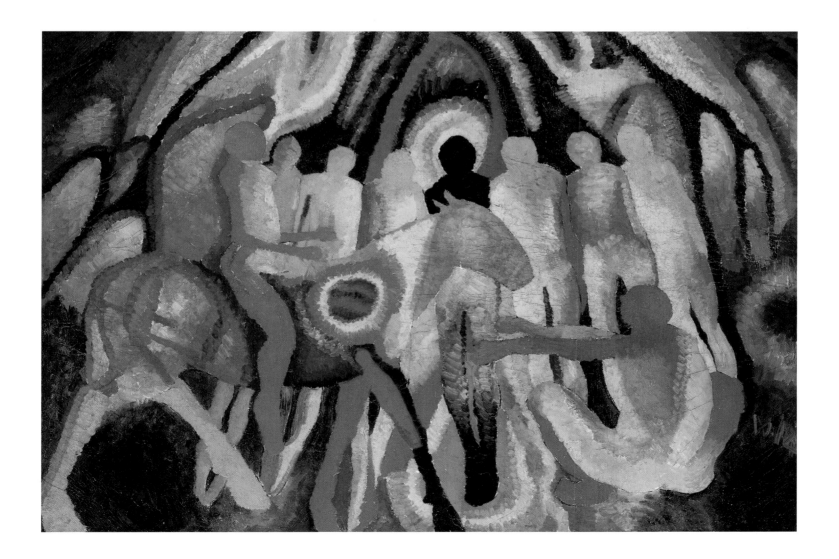

Wilhelm Morgner

Although Wilhelm Morgner lived in the same place as Rohlfs, it seems appropriate to discuss him in the context of Rhenish Expressionism. Like the Rhenish artists, Morgner was influenced quite considerably by Delaunay's Orphism, while the Northern German Expressionists – such as Rohlfs – showed no response to it at all. Morgner was born in Soest in 1891. In 1908/9 he attended Georg Tappert's private painting school for a few months, and although it was only for a short time, Tappert's lyrical naturalism left its mark on Morgner's art for a while. During these first years, it was dominated above all by the theme of peasants working in the fields. In addition, he concentrated mostly on portraits and the vastness of the Northern German landscape. These paintings are marked by atmospheric naturalism and a characteristic clay-like colour scheme.

At first Morgner had been mainly interested in his subjects, but after 1911 he turned his attention more and more to formal elements, which he used as autonomous stylistic means. His forms became simpler and at the same time monumental, and his brush strokes - though already recognizable – became broader, longer and more systematic in the way he applied them. Placed accurately beside one another, they now covered, rather like a tapestry, the entire format of the painting. Within less than a year, Morgner changed his pointillist brushwork so much that he eventually applied the paint very broadly and decoratively, stretching across the entire format. At the same time, his colours became increasingly lighter until they were dominated by contrasts of bright red or orange and blue or green. His emphasis on colours and lines gradually pushed aside all illusions of perspective, and Morgner enhanced this two-dimensional effect even further by organizing the motifs parallel to each other, with figures mainly in profile. There can be no doubt that this artistic re-orientation came as the result of his new impressions in Berlin. In April 1911, through Tappert's mediation, Morgner had exhibited his art at the third exhibition of the *New Secession*, together with the *Brücke* artists.

In the same year, Morgner had taken an important step in his development. Instead of pure descriptions of nature, he had begun to give his formal stylistic means an expressive quality of their own. However, when

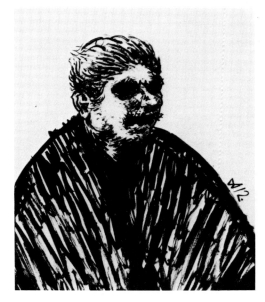

Wilhelm Morgner:
Self-Portrait, 1912
Selbstbildnis
Indian ink, 61 × 48 cm
Robert Gore Rifkind Foundation,
Beverly Hills (Cal.)

Wilhelm Morgner:
Entry into Jerusalem, 1912
Einzug in Jerusalem
Oil on canvas, 119 × 170.5 cm
Museum am Ostwall, Dortmund

faced with the *Blaue Reiter* paintings as well as van Gogh and Delaunay at the *Sonderbund* exhibition in Cologne, he also recognized the limitations of his own art. His lines had been too stylized, and he had been over-emphasizing the special visual effectiveness of his colours. His art had the quality of drawings, rather than paintings. What particularly fascinated Morgner and inspired him to try similar experiments in his own work was Delaunay's solution of depicting light not indirectly, by means of light-and-dark contrasts, but with the colours themselves.

Morgner's painting *Entry into Jerusalem* (p.198) of 1912 shows the immediacy with which he was able to put these new ideas into practice. Like so many other paintings of his, it has a parallel structure. Seated on a donkey, the most significant figure is advancing towards the centre from the left. In the foreground, on the right, a figure is squatting, and the centre is occupied by a motley group of people tightly packed together, with the landscape looming up behind them. All the elements in the painting are rendered in an extremely simplified form. However, although man and beast are merely shown as silhouettes, they are by no means dark shadows but shine forth brightly. The expressiveness of this painting is achieved by colours alone – colours and striking colour contrasts. Unlike his paintings of the previous year, Morgner's brushwork has loosened up again so that the whole surface now has a vibrant quality, with even more intensive colours. Although his colours do not have the transparence of Delaunay's "window" paintings, they nevertheless seem to share the same bright luminescence.

During the same year – 1912 – Morgner's work came to be increasingly dominated by Christian themes. Deeply devoted to Christ, he began to identify with His Passion. Like other artists at the time, Morgner felt that this central theme of the New Testament was the only source for an adequate description of his own situation and his state of mind on the eve of the First World War. Thus, his motifs never became a mere occasion for a vehement display of colour.

In the following years Morgner's art became almost abstract. His *Astral Compositions* of 1913 already showed an extreme reduction of mountainous landscapes. However, this development came to an abrupt halt again when war broke out. From 1914 onwards he only produced small drawings and sketches. In 1917, when he was only 26, Wilhelm Morgner died as a soldier in Flanders.

Wilhelm Morgner:
Raising the Cross, 1913
Kreuzaufrichtung
Oil on hardboard, 77 × 102 cm
Sprengel Museum, Hanover

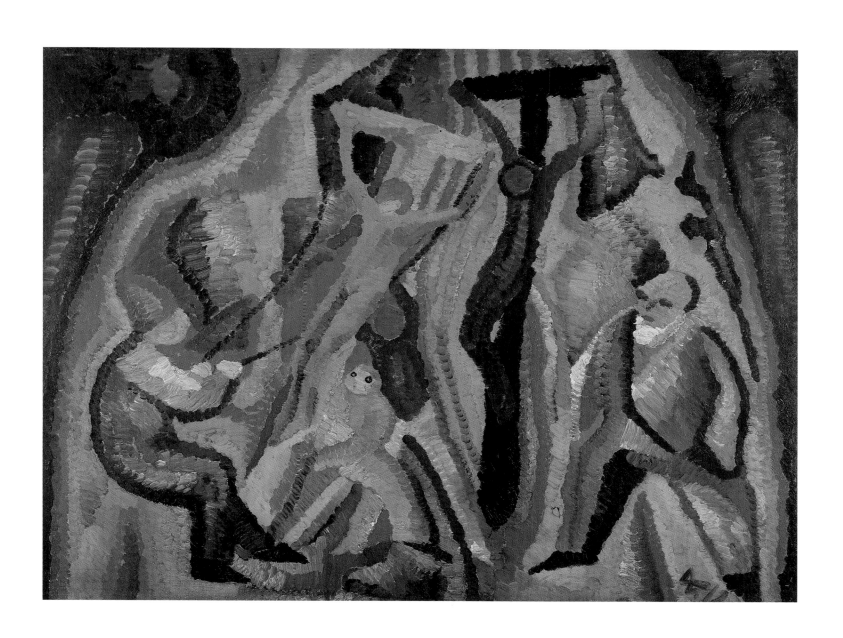

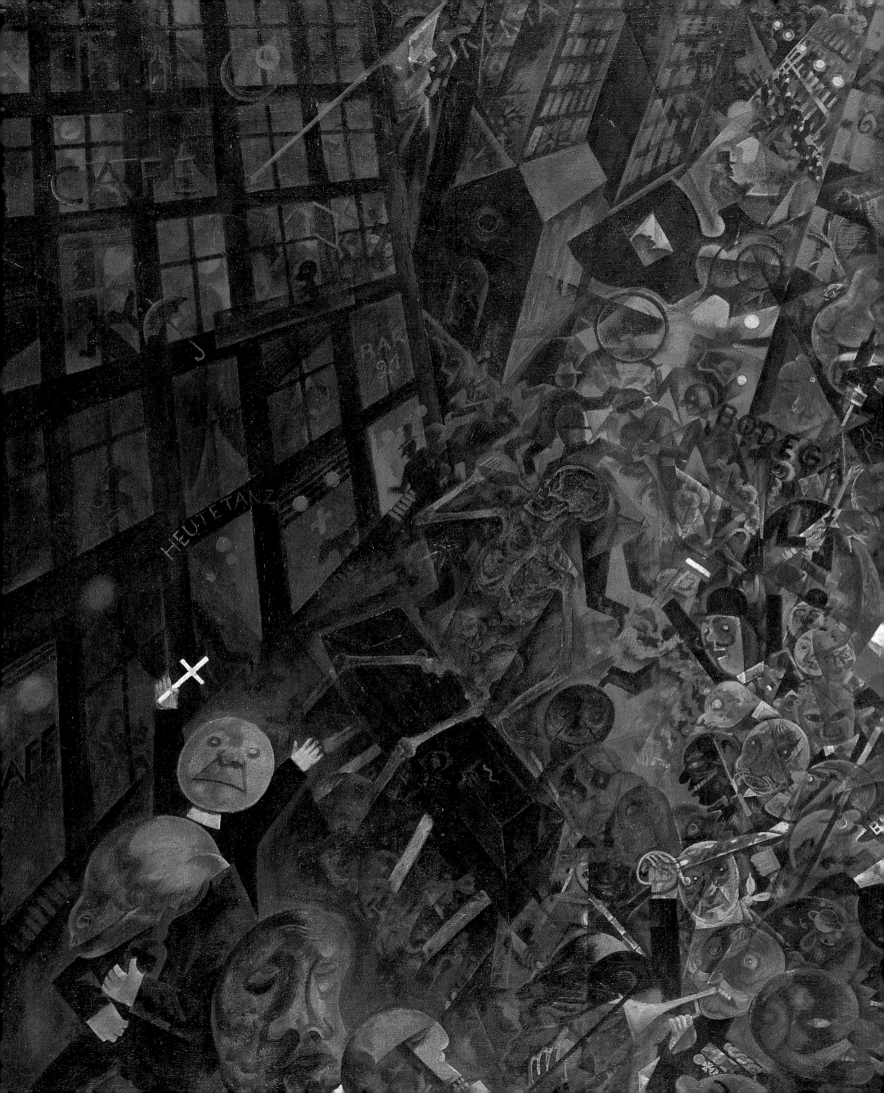

Not all of the six artists discussed in this chapter were personally acquainted with each other. Nor did they live in the same place or develop along comparable stylistic lines. Unlike all the other Expressionists, they cannot be associated with a particular town or area – such as Dresden, Munich, Vienna, Northern Germany or the Rhineland. Max Beckmann spent his early, formative years in Frankfurt, Otto Dix and Conrad Felixmüller lived in Dresden, and George Grosz, Ludwig Meidner and Lyonel Feininger were based in Berlin. The common element in their art was therefore not any particular geographical area, but in fact the city itself, both for its architecture and as a place in which people lived.

The Subject of the City

"Let us paint the most obvious thing," said Meidner in 1914, "let us paint the world of our city, its chaotic streets, the elegance of iron suspension bridges, the gasometers, the colours of omnibuses and express train locomotives, the welter of telephone wires ... and then the night ... the night of the big city."

What also distinguishes these artists from the ones discussed so far is their experience of the First World War. It did, of course, leave its mark on nearly all the Expressionists, but while it meant the end of their circle for the *Brücke* artists and very often a rejection of their common pre-war style, Beckmann and the younger painters who were born in the nineties (such as Dix, Grosz and Felixmüller) experienced the war as something that initiated their whole art and had a lasting effect on it.

Before the First World War, Expressionism was a private, aesthetic revolution, if not a self-centred one. The artists' central quest was for qualities of form and colour that were neutral and autonomous. However, whenever these two elements were used consciously and purposefully, they reflected mainly the mood and private state of mind of the individual painter himself. The painters of the city, on the other hand, did not begin to develop their own artistic standards until they had gone through the war, and instead of painting people as individuals, they saw man more as a social creature and a victim of political intrigue. Nevertheless, Grosz and Felixmüller remained the only artists who were willing to go beyond their artistic expression and to become involved in party politics.

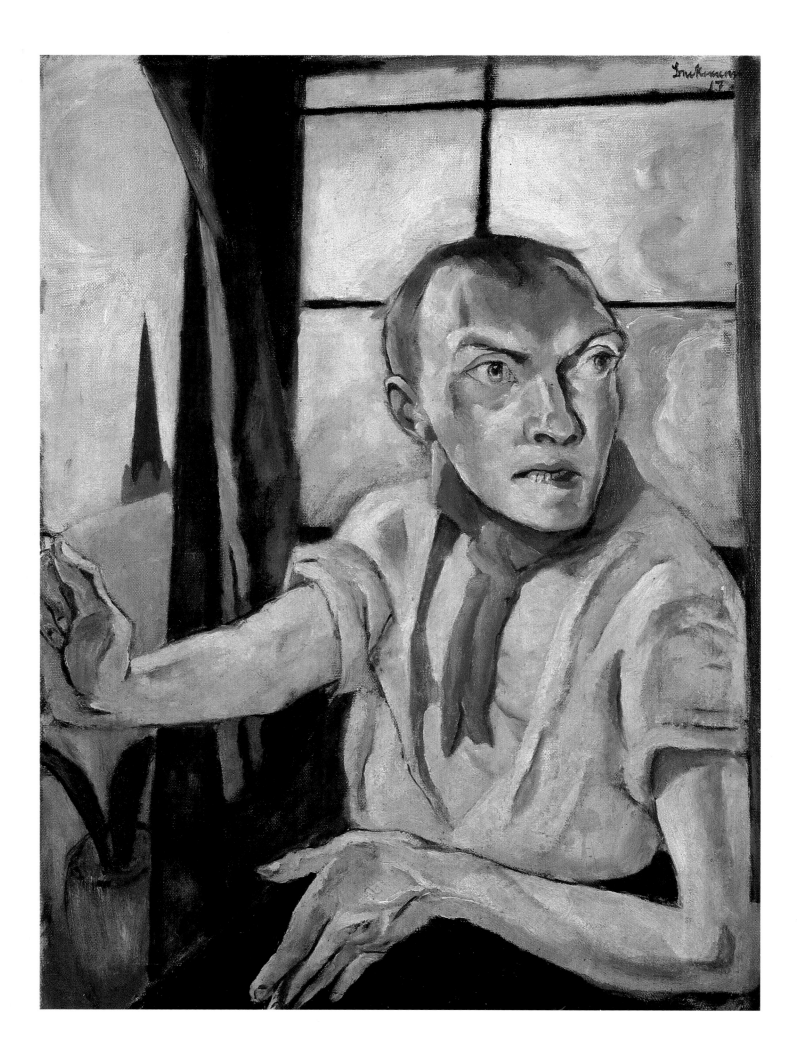

Max Beckmann

Max Beckmann's position in 20th century art is unique. Throughout his early years and even during the first war years, he very nearly established himself as an anti-modernist painter of traditional Biblical and historical themes. The members of the *Berlin Secession* panel – who rejected the works of the *Brücke* painters – gladly accepted his art for their annual exhibitions. From 1906 onwards, Beckmann was a regular and indeed quite successful member of this conservative artists' association under the chairmanship of Liebermann.

One particular incident, in 1910, may well have been characteristic of Beckmann's isolated position within the rebellious young generation of artists and of his reservations towards the Expressionist movement. It was the year when the *New Secession* had been founded under the leadership of the Expressionists and when the established *Berlin Secession* had reorganized itself, due to Liebermann's resignation. Beckmann allowed himself to be voted onto its managing board, as one of its youngest members. And indeed, his art between 1909 and 1912 prompted the critic Peter Selz to call him a "German Delacroix". This was before Beckmann began to paint his scenarios of disasters and battles with their multitudes of people.

Beckmann was born in Leipzig on 12 February 1884. After his father's early death, when Max was only 10, his family moved to Brunswick, and he was sent to a boarding school. In 1906, his mother died of cancer after a long period of suffering. As a result of these two early encounters with death he was cut off from the protection and security of his family – early impressions that were to have a significant and lasting effect on his art and came to dominate his later themes.

Beckmann began to draw during his time at boarding school. His classmates did him service as models and were given something from his food parcels in return. He painted his first self-portrait at the age of 15 (Sprengel Museum, Hanover). It was the beginning of a whole series in which he questioned himself relentlessly and without mercy and which was to continue until his death in New York in 1950. That same year, in 1899, his application to the Dresden Academy was rejected, though a year later he was accepted at the School of Art in Weimar. Apart from land-

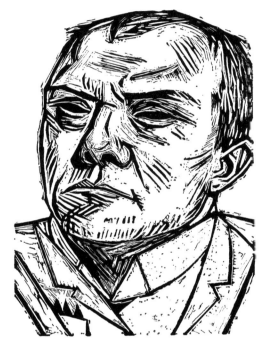

Max Beckmann:
Self-Portrait, 1922
Selbstbildnis
Woodcut, 22.2 × 15.5 cm

PAGE 202:
George Grosz:
Funeral Procession – Dedicated to Oskar Panizza, around 1917/18
Leichenbegängnis – Widmung an Oskar Panizza
Oil on canvas, 140 × 110 cm
Staatsgalerie, Stuttgart

Max Beckmann:
Self-Portrait with Red Scarf, 1917
Selbstbildnis mit rotem Schal
Oil on canvas, 80 × 60 cm
Staatsgalerie, Stuttgart

scapes, which he learnt to paint from his Norwegian teacher Frithjof Smith, he was interested, above all, in portraits and physiognomical studies. After his graduation in 1903, Beckmann went to Paris where he was hoping to find new ideas. He stayed there for nearly six months, and his brushwork became lighter under the influence of French Impressionism. Van Gogh, too, made an impression on Beckmann.

In 1906, Beckmann painted his *Great Scene of Death* (p.215) and *Small Scene of Death* (National Gallery, Berlin), in which he tried to express and come to terms with his own grief at his mother's painful death. There is no light Impressionist touch in these paintings. His brushwork is firm and solid. The colours are reduced to a a few dark, lustreless shades of brown and ochre. This serves to emphasize the whiteness of the bed at the centre of the painting. The format of Beckmann's *Great Scene of Death* is almost square, and it is dominated by the dying woman on the bed. Weak and emaciated, with her mouth wide open and her eyes already closed, she is wrestling powerlessly with death. Around her, Beckmann has placed a group of three people, with differing gestures and postures. With a topic like this, Beckmann came closest to an Expressionist style, even though he was more akin to artists such as Munch (*Death Chamber*, 1893, National Gallery, Oslo) than the *Brücke* or the *Blaue Reiter*. His painting shows human beings in an extraordinary situation. Faced with a crucial moment in their lives, the mourners express their grief and despair in different ways, ranging from an attitude of stillness to one of pathos.

Beckmann subtitled the painting *HBSL August 06*, his private abbreviation of *Herr Beckmann seiner Liebsten* ('from Mr. Beckmann to his Darling'). Other paintings of that time bore the letters *MBSL* (*Max Beckmann seiner Liebsten*). These paintings were dedicated to Minna Tube, a fellow-student whom he had met at Weimar in 1902 and married in autumn 1906. Their honeymoon took him to Paris again, after which he spent six months on a scholarship at the Villa Romana in Florence. Here, Beckmann gained new impressions, found new subjects and became more self-confident as an artist. Between 1906 and the beginning of the First World War he produced a number of large-format paintings in which he tried to continue the artistic tradition of painters like Théodore Géricault and Eugène Delacroix. Beckmann created works with a religious content (*The Crucifixion of Christ*, 1909; private collection, Schweinfurt) and mythological themes (*Battle of the Amazons*, 1911; Robert Gore Rifkind Collection, Beverley Hills). With paintings such as *Scenes from the Destruction of Messina* (1909) and *The Sinking of the Titanic* (1912; both in the St. Louis Art Museum, St. Louis) he was aiming to revive the genre of history paintings – something which was no longer felt to be modern enough. He did so by using topical events and depicting them in many different and highly detailed narrative compositions.

Beckmann had learnt a good deal about the two disasters – the earthquake in Sicily and the collision of the *Titanic* with an iceberg – from the daily papers in Berlin. In these paintings, he depicted detailed scenes of

anonymous people fighting for survival in a disaster. They show man rebelling against unpredictable nature as well against his fellow human beings. Based on traditional art, Beckmann intended to create a modern metaphor of man's current situation in his daily struggle for survival. However, the critics were unable to follow, and when the *Sinking of the Titanic* was shown at the *Berlin Secession* in 1913, it received a negative response. It was said, among other things, that the dramatic impact of the painting was not "convincing" enough and that the artist had merely tried to achieve artistic "effects". The only aspect which was seen positively was Beckmann's courage to "fail, for once".

On 11 April 1913, Beckmann noted down in his diary, "tired and depressed again because of new competitors although I like the Titanic

Max Beckmann:
Great Scene of Death, 1906
Grosse Sterbeszene
Oil on canvas, 131 × 141 cm
Staatsgalerie moderner Kunst,
Munich

Max Beckmann:
Woman with Candle, 1920
Frau mit Kerze
Woodcut, 30 × 15 cm

Max Beckmann:
Portrait of Fridel Battenberg, 1920
Bildnis Fridel Battenberg
Oil on canvas, 97 × 48.7 cm
Sprengel Museum, Hanover

very much." Beckmann did not feel happy with his own position as an artist. As a renowned, established member of the *Secession* he was closer to his father's generation, artists like Corinth, Slevogt and Liebermann, than his avantgardist peer group – Kirchner, Heckel, Kandinsky, Marc, and others – who were becoming increasingly popular. On the other hand, however, he also felt that there was a distinct difference between their themes and his own artistic aims. This controversy came to a head when it was discussed openly between Beckmann and Marc in a magazine called PAN. Beckmann published a reply to Marc's ideas on "The New Art". While emphasizing his admiration for Cézanne, he sharply criticized Gauguin, Matisse and Picasso, whose art he thought was closer to commercial handicrafts and more like wallpaper patterns and posters. "Gauguin's wallpaper, Matisse's materials and Picasso's chess boards", he said, were quite decorative and nice to look at, but they did not have that "artistic sensuousness, together with the palpable objectivity of the real objects". In the same way, they lacked any correct artistic rendering of spatial depth, and the surfaces of the objects were equally defective, without "the peach-coloured hue of someone's skin" or the "shining quality of a fingernail". Also, he criticized Gauguin, as a representative of Expressionism, for adopting the formal repertoire of primitive tribes, without due regard to their religious or ethnic origins. Undoubtedly, this was partly justified. Beckmann went one step further when he said that Matisse was "an even more pathetic representive of this ethnological museum art. In the Asian Department. Except that his art is all second hand and comes originally from Gauguin and Munch."

Beckmann's experience of the war resulted in a fundamental re-orientation, both with regard to formal technique and symbolism. Like many other Expressionists, Beckmann at first welcomed this murderous inferno. As early as 1909, he had written in his diary, "Martin [i.e. his brother-in-law, Martin Tube] thinks there'll be war. Russia, France and England against Germany. We both agree that it would not be a bad thing for today's rather demoralized civilisation if people's drives and instincts were all fixed on a common interest again." When war broke out, Beckmann volunteered as a medical orderly and was sent to the Western front in Belgium. There, he thought idealistically, he could take part as an observer and chronicler in an atmosphere of universal doom and the solemn heroism of man's struggle for survival. The only reason, he felt, why there were so few paintings like his *Scene from the Destruction of Messina* or *The Sinking of the Titanic*, was that he had not been able to witness such scenes at first hand but had been entirely dependent on newspaper reports. Beckmann therefore wanted to gain his own experiences in the battlefield. "For me, war is a miracle," he wrote almost euphorically to his wife in April 1915, "though rather an uncomfortable one. It's fodder for my art." But even Beckmann was soon to find out that the anonymous deaths of masses of soldiers in the trenches had nothing in common with naive ideas of a heroic fight. In his numerous drawings and prints he increasingly depicted the horrors of war. The enthusiasm

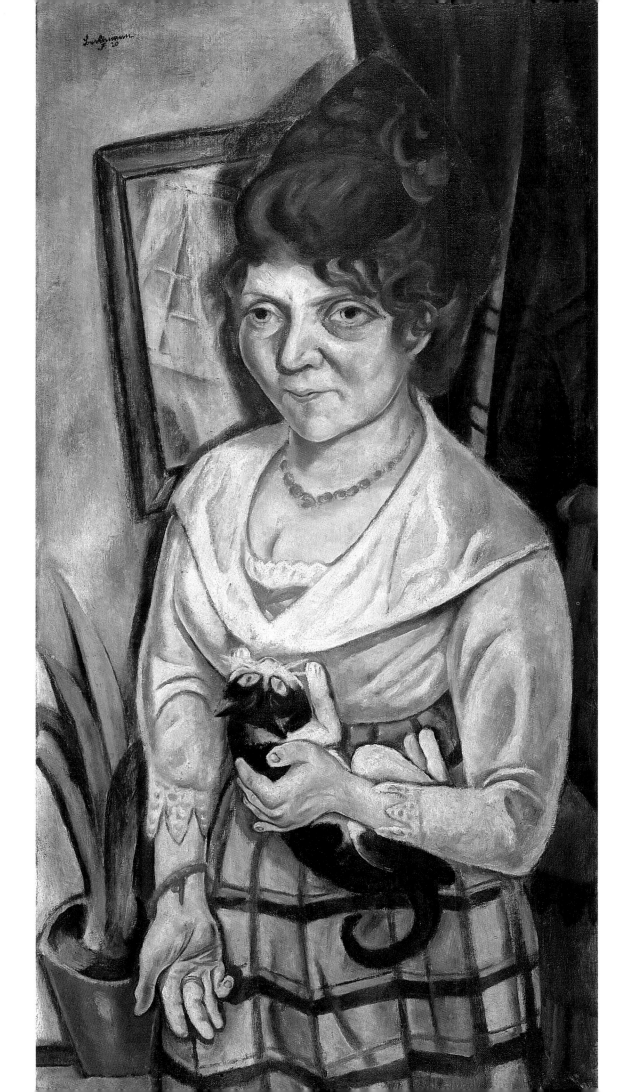

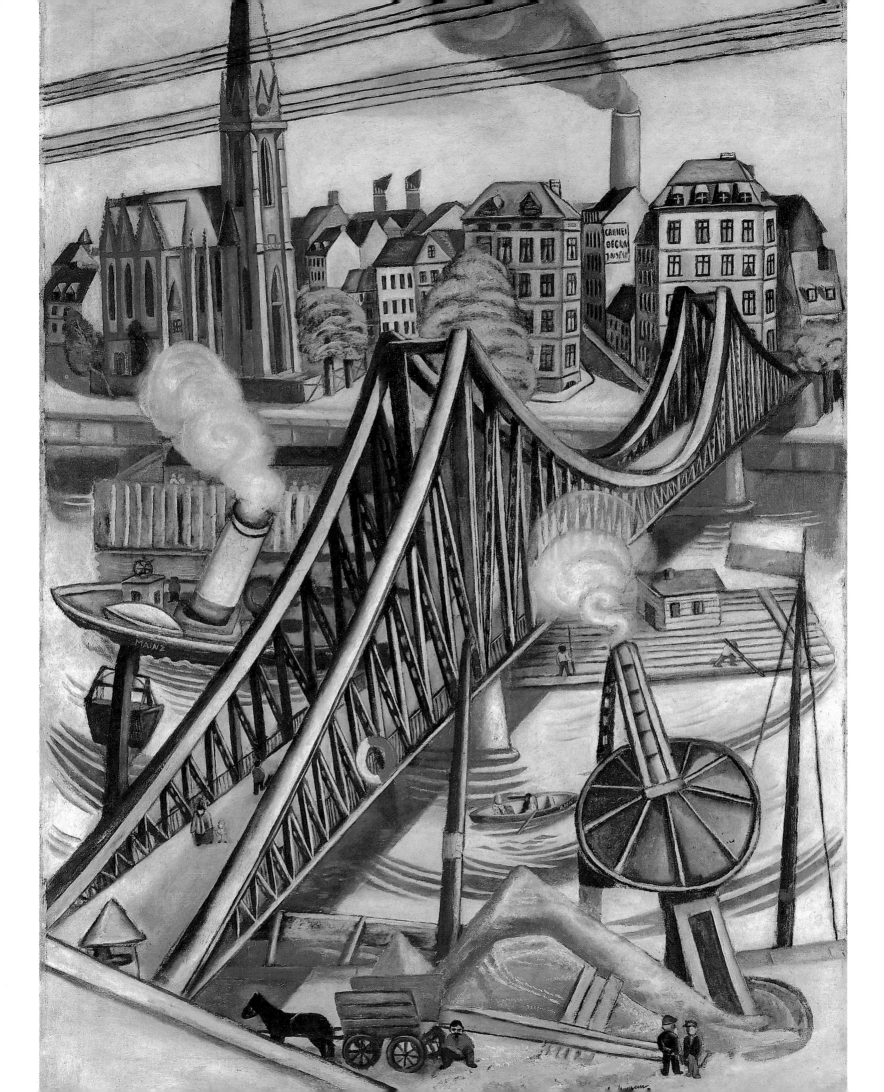

gradually disappeared from his letters, and they became more pensive in tone. Finally, in July 1915, he had a physical and psychological breakdown. He was exempted from service and moved to Frankfurt.

Beckmann's *Self-Portrait with Red Scarf* (p. 204) of 1917 was meant as an attempt to define his own position, after he had escaped from the inferno of war. It is a painting of himself at the easel in his studio. His eyes, wide open, are fixed rigidly on a scene not disclosed to us. His mouth is distorted, his head is haggard and completely unlike that broad shape which is so typical of his other self-portraits. His face is an impressive reflexion of the horrors he had witnessed. The window with the glazing bars behind his head is empty, affording no view of a landscape or the outside world. The latter occurs merely in the form of a vase with flowers, a church tower and the gleaming sun on the painter's canvas in the left-hand corner. Here, Beckmann shows himself as a chronicler who does not take part in the events around him, though he does not close his eyes but is wide awake and registers and digests everything, in order to "create characters of our time, with all its confusion and disjointedness, characters who can be to us nowadays what the gods and heroes used to be to the ancients." This is what he suggested to Marc as early as 1912.

After the war, Beckmann did not resume the theme of large-format anonymous scenes of mass destruction. Instead, he began to concentrate on the individual and his powerlessness and helplessness in view of a world full of desperation and violence. Thus, by putting the individual at the centre of his interest, the artist refused to yield to any ideological generalization. Unlike Dix and Grosz, Beckmann's art could never be used for political means. His new subjects also brought about a change in his formal and aesthetic stylistic repertoire. He reduced his colours and applied the paint more thinly. The canvas was now dominated by lustreless brown, grey and yellow, with only very few spots of brightness flaring up here and there. The faces and bodies seemed pale and always a little morbid. Their bodies were now extremely elongated, with firm, angular contours and, sometimes, ecstatically contorted limbs. After Beckmann's wartime experience of the closeness of death, he abandoned the Baroque figures of his history paintings and replaced them with a more Gothic type of person, marked by suffering. Beckmann went back to the same artistic source for his frequent use of narrow, upright formats, which corresponded to the elongated bodies encased in narrow enclosures.

It was no mere coincidence that these pictures between 1915 and 1922 were mainly graphic prints, whereas only about thirty paintings became well-known. Drypoint, in particular, allowed Beckmann to capture his impressions far more spontaneously in the forms of brief sketches than the time-consuming methods of painting. During this time he created several series of prints which were among his most impressive works – *Faces*, (1916), *Hell* (1919), *Night in the City* (1920), *The Fun Fare* (1921) and *Trip to Berlin* (1922). But it was not only in the last of these series that Beckmann concentrated on Berlin with its events and living conditions. Although he continued to live in Frankfurt and only ever went to Berlin

Max Beckmann:
Wooden Bridge, 1922
Holzbrücke
Etching

Max Beckmann:
The Iron Bridge, 1922
Der Eiserne Steg
Oil on canvas, 120.5 × 84.5 cm
Kunstsammlung Nordrhein-
Westfalen, Düsseldorf

for short trips, his motifs – until 1922 – were centred again and again upon the capital of the Reich, with its music halls and cafés, townscapes and street fights. It was in the quiet peacefulness of Frankfurt, however, that he found the detachment which he needed for his chosen role as a chronicler, without getting himself deeply involved in Berlin's social and political events and thus losing his objectivity. His series of lithographs entitled *Hell* of 1919 is a metaphor of the revolutionary situation immediately after the war. The title sheet is a self-portrait in which Beckmann is looking with horror at this hell of hunger, violence, ideological quibbling and misguided patriotism. The series culminates in sheet six – *Night* - which repeats a theme he had created shortly beforehand in the form of a painting.

Beckmann's large-format oil painting *Night* (right) is the most outstanding among these early works. He dated it with an uncommon degree of precision – "August 1918 to March 1919". Obviously the artist must have felt that it was important to tell posterity when he had created the painting and which events it referred to. After the outbreak of the November Revolution in 1918, life was ruled by violence, chaos, political murder, there was a famine among the people, and in March 1919 a general strike was cruelly suppressed. In Beckmann's *Night* the violence of the streets has entered the home. Three bailiffs have invaded a little attic room and are now harassing a peaceful, helpless family. The husband is being strangled and his left arm is being broken. His wife, tied up and half undressed, has been raped. One of the torturers has just grabbed hold of the frightened, helpless child. The floor boards, table, rafters and above all the widely spread-out bodies fill the narrow format so that a complex network of tensely distorted lines stretches across the entire canvas. The spatial perspective, too, seems broken and distorted. The effect of violence, which dominates this vivid scene, is further enhanced by the "sharp, crystal-clear lines and areas" (Beckmann) of the composition. Nevertheless, the painting is not an attempt to give an authentic account of a terrorist attack. The figures are too general, and the room is too stylized. With his waistcoat, tie and pipe, the evildoer at the centre of the painting seems more like the typical peaceful petty bourgeois. The figure on the right was taken from a 14th century fresco by Francesco Traini. The female figure in the background, on the left, is difficult to read. She seems like a mere observer, who is not actually involved, and the question arises whether she might be the force behind this wanton act of violence. The person who served as a model was Beckmann's chosen partner Fridel Battenberg in Frankfurt (cf. *Portrait of Fridel Battenberg* p.209). For the first time, Beckmann used his personal, private metaphors in conjunction with symbols that had a long tradition in the history of art, such as the extinguished candle in the foreground, at the front of the painting. Even today, not all the details and innuendoes are entirely comprehensible in this painting. However, Beckmann clearly transformed the little attic room into a stage where the mystery of all mankind is represented by the suffering and the violence that were

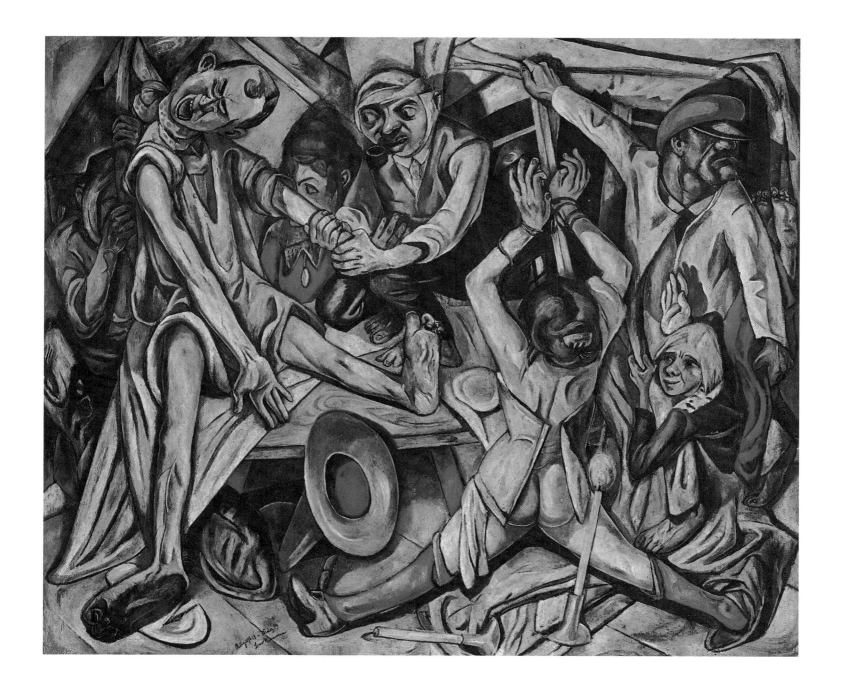

carried into this family. He himself stated that the artistic purpose of this painting was to "give mankind a picture of their fate".

It was during these years that Beckmann found an independent, artistic style, without engaging in aesthetic experiments with form. His pre-war history paintings were now replaced by a mode of expression that repeatedly combined Beckmann's own symbolism with themes from Christian religion and Greek mythology. Also, Beckmann frequently chose the social surroundings of actors and circus artistes. His scenes and allegories – both private and public – take place on the stage of a universal theatre.

Max Beckmann:
Night, 1918/19
Die Nacht
Oil on canvas, 133 × 154 cm
Kunstsammlung Nordrhein-
Westfalen, Düsseldorf

Otto Dix

Otto Dix, born in Gera in 1891, is equally difficult to fit into the general category of Expressionism. He had no contact whatever with its outstanding representatives – the *Brücke* in Dresden, the *Blaue Reiter* in Munich or Macke in Bonn. Although he had seen *Brücke* paintings in Dresden, they did not impress him very greatly, let alone influence his own style. His Expressionist style was limited to his early works, until 1919. It was followed by a brief Dadaist phase, and in 1920 he took part in the *First International DADA Fair* in Berlin, before he adopted a Verist style which was to dominate his entire oeuvre and made Dix one of the leading representatives of the New Objectivity. His choice of subjects was very different from that of the Expressionists, and he can probably only be compared with Grosz, who is often mentioned alongside him. Nevertheless, there are vast differences in the symbolic content of their art.

Grosz thought of himself as a political activist, with art as his medium. Whenever he turned his attention to the victims of society, he also showed the culprits – the military, industrialists, the representatives of the nationalist parties and the press. Grosz's paintings are political accusations. Dix's art, on the other hand, shows us the victims, their suffering and despair. His art was of a humanist kind, and he would keep away from the political problems of the time. "No," he said, "artists should not improve or convert others. They are far too insignificant. But they must bear witness." Dix saw his entire artistic oeuvre as a testimony, with himself - like Beckmann – in the role of a chronicler who took part in the events and communicated his experiences. It was an attitude which was impossible ever to put into practice. Quite apart from all the other elements which influenced his art, his choice of subjects was never a neutral decision but always, at the same time, a political comment.

Dix developed an artistic talent at a very early age, and his teachers did their best to promote it. At the age of 14, however, following his father's advice, he decided to become a craftsman and took up an appenticeship with a decorative painter. In 1909, he enroled at the School of Applied Art in Dresden, where he met Meidner. This contact led him to conduct his own Expressionist experiments with form, though it was two different

Otto Dix:
Morning, 1919
Der Morgen
Woodcut, 24 × 17.7 cm

Otto Dix:
Self-Portrait as Mars, 1915
Selbstbildnis als Mars
Oil on canvas, 81 × 66 cm
Haus der Heimat, Freital (GDR)

215

artistic examples that gave him his vital impulses during that time. In 1912 he saw works by van Gogh at the Arnold Gallery in Dresden, and in the summer of the following year he travelled to Italy, where he had his first encounter with Futurism. From this point onwards, he was influenced both by van Gogh's dynamic brush stroke and by the Cubist fragmentation of form which was so typical of Futurist art. However, until the end of the decade, his formal composition continued to be determined by the subject. And so, without any homogeneous line of development and alongside paintings that were influenced by Expressionism and Futurism, he also painted motifs with the formal elements of Cubism (*Warrior with Pipe* 1918; private collection) and Naive Realism (*Self-Portrait as a Shooting Target*, 1915; Otto Dix Foundation, Vaduz). And as early as 1912, Dix painted a self-portrait in the Verist style of old masters – a style that did not become characteristic of his art until ten years later.

In 1914, Dix volunteered for military service and experienced the war as a front-line soldier until its very end. It is true that on several occasions he described the war as a "natural phenomenon" which was nobody's fault and simply took mankind by surprise, but - unlike many of the German Expressionists and particularly the Italian Futurists – he never eulogized the war as a grand act that cleansed and renewed the old society. Rather, he saw himself as a reporter whose duty it was not to stand aside but to take part and to report. Years later, when he described his artistic position of that time, he said: "I studied the war exactly. You have to depict it realistically for people to understand it. The artist needs to do his work in such a way that others can see what it was like ... I chose to report the war truthfully." Consequently, he produced hundreds of small sketches, drawings and gouaches, some of which served as the basis for oil paintings. However, unlike a reporter, Dix did not just depict single, individual scenes, but always sought to show a general, archetypal situation in his pictures of figures and trenches.

While in some paintings it was Dix's brushwork and colours that bore witness to his artistic use of Expressionist style, there were other works dominated by Futurism. Following the example of Italian art, the spatial unity of these paintings is broken up by Cubist forms and powerful lines – an ideal formal equivalent of detonating hand grenades, bodies of soldiers torn to pieces and a landscape ravaged and scarred by bomb craters. Unlike his later works, these drawings and gouaches were produced on location and as a direct response to the events, which explains the immediacy of their impact. After the war, Dix painted from memory, using the glazing technique of the old masters. The scenes which he painted in this truthful and Naturalist vein were usually the moments after the battle. An unnatural, apocalyptic tranquillity pervades the ruined landscape, and Dix shows the tortured bodies of the injured and fallen soldiers in painstaking detail. Again and again, he emphasized that he did not see his paintings as propaganda but – true to his duty as a chronicler – as mere descriptions. But not only was there vehement controversy over the political effect of these paintings. The artist was also

repeatedly accused of having yielded to a "fascination of horror" in these pictures.

After the war, Dix continued his studies and attended the Dresden Academy of Art as a mature student. At the same time, he abandoned the emphasis on expressiveness in his style. Under the influence of Dada, he incorporated collages into his composition. In his pictures of crippled war victims, Dix's claim to truthfulness and verisimilitude was now enhanced by fragments of reality – newspaper cuttings, playing cards and bank notes. The theme of war and its consequences remained foremost in Dix's work. The terrible, traumatic memories of those years never left him so that war and death dominated his entire oeuvre – almost like a leitmotif. In his series of etchings *The War* of 1924 (above), his paintings *The Trench* (1919-1923; destroyed), the triptych *The War* (Gemäldegalerie Neue Meister, Dresden) of 1929-1932, *Trench Warfare* (Gallery of the City of Stuttgart) of 1932 and *Flanders* of 1936 (National Gallery, Berlin) he gave vivid accounts of his experiences as a front-line soldier. These are dramatic scenes, and his last works, especially, had a prophetic significance for the near future.

Otto Dix:
The Dead near the Position at Tahure, 1924
Sheet 10 from Portfolio No. V, "The War"
Tote vor der Stellung bei Tahure
Etching, 19.7 × 25.8 cm
Otto Dix Foundation, Vaduz

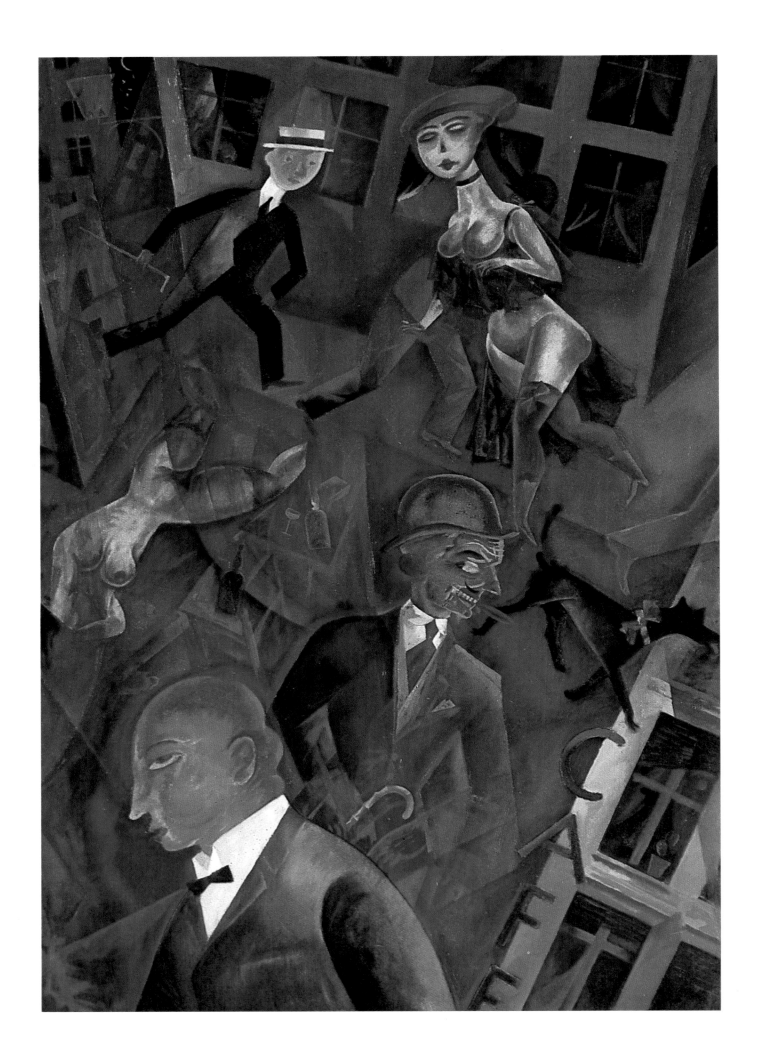

George Grosz

Dix and Grosz's art had a political effect, but only Grosz used his drawings and paintings quite deliberately as a means of political argumentation. However, he did not use it for the purpose of party-political advertising, even though he joined the German Communist Party in 1918. Grosz was first and foremost a graphic artist and – until the beginning of the twenties – painted very few oils. He had distanced himself very early from the art market and the traditional art public. "Art as a commodity," he said, "is totally unimportant for me". And so he never tried to establish himself in art galleries or exhibitions. Grosz did not wish to serve a bourgeois public so that the radicalism in his graphic prints would simply confirm people in their supposed liberalism. The messages of his drawing required different methods of distribution. Grosz co-operated particularly with the publishers Franz Pfemfert and Wieland Herzfelde, who printed his works in their magazines *Die Aktion* and *Neue Jugend* (New Youth). He also illustrated several books for them.

Grosz was born in Berlin in 1893 and began to train at the Dresden Academy in 1909. He and his fellow-students followed contemporary artistic developments with great interest. Not only were they familiar with the *Brücke* - who were also based in Dresden – but also with the activities of the *Blaue Reiter* and modern French art. However, Grosz did not follow any of these examples, even though he was dissatisfied with the training conditions and his conservative lecturers. Instead, he devoted his time to his own, private studies. He drew a lot, and was inspired by Toulouse-Lautrec, Henri Daumier, Japanese woodcuts, and drawings in the *Simplicissimus* magazine. After his first success with his own graphic prints, published by the daily paper *Berliner Tageblatt*, he felt that it was right to turn to popular illustrations rather than élitist art.

However, by the time he moved to Berlin in 1912, the folklore element and the occasional glimpse of humour in his art had changed. Like Kirchner and Nolde before him, he fell under the spell of the big city and its pleasures, fascinated by its night clubs and music halls, bars and brothels. Grosz immersed himself completely in this night life, and his drawings became dramatic testimonies of a world full of violence and sex. The outbreak of the First World War necessarily deepened his

George Grosz:
The Olympia Cinema, Berlin, 1917
Olympia-Kino, Berlin
Reed pen, 29 × 22.6 cm
L. and P. Grosz Collection, Princeton

George Grosz:
Metropolis, 1917
Oil on hardboard, 68 × 47.5 cm
Museum of Modern Art, New York

Anhalter Railway Station and König-
grätzer Strasse, Berlin, around 1910

political commitment. He was one of the few people who could see the madness of the war from the very beginning and who did not join in the universal shouts of patriotism. The events of the following years sharpened both his political awareness and his expertise at drawing. Grosz reduced his lines, eliminated all shades and hatchings from his pictures and, instead of a pencil, began to use a drawing pen, which considerably increased the contrastive blackness of his contours. He wanted to banish all individualist features from his art. It was to be pragmatic and its message was to appear objective by virtue of its very form. Grosz believed that he had to exclude all subjectivity if he was to use his drawings as a political instrument. "I painted and drew," said Grosz, "because I was rebellious and tried to use my art to convince the world of its ugliness, sickness and hypocrisy." Nevertheless, even these drawings had a clearly identifiable, personal style about them.

Like Dix, Grosz would show the victims of war and society under Kaiser Wilhelm in his art – the disfigured bodies of dead soldiers, the crippled war victims, the famished beggars at the street corners, and also the prostitutes. Grosz, however, always made it quite clear that there were no victims without culprits, and the guilty ones were the bourgeoisie, who continued to indulge in their luxuries back home despite the war, the war-mongers in the military hierarchy, the nationalist politicians and the rich industrialists whose profits had increased as a result of the war. Grosz's drawings go beyond superficial appearances. They are an analysis of the causes which brought about these conditions. They are bitterly radical indictments of injustice and violence between human beings. Grosz saw that the humanist ideal of a community of nations – which had been cherished by the pre-war Expressionists – had suddenly been shattered. And he was pained to find that this rift went through his own nation and that even Germany was divided into victims and culprits. He began to hate everything that he perceived as typically German, changed his German name *Georg* into *George* and enjoyed talking loudly in public in the language of his country's enemies. This, too, was a form of protest for him against the empty, patriotic platitudes of conservative nationalists. "There can be no doubt," he later wrote to his publisher Herzfelde, "my drawings are among the most powerful statements that have ever been made against this German brutality. Today they are more truthful than ever. And one day, when there are – if I may say so – more 'humane' times, they will be shown in the same way that Goya's art is shown today …" Grosz always showed his figures as typical representatives of whole groups. He never showed a person as an individual, but always as someone who represented a particular social class or level. Whenever he depicted a lawyer, a militarist, a bourgeois or a capitalist, he produced a study of a character that was caustic and cynical. However, having been lashed in this way, the ruling classes responded in kind. In 1920, 1924 and 1931 he was fined for the dissemination of blasphemous and pornographic illustrations. And when the Nazis came to power in 1933, he was one of the first victims of their attack on the art

world and was unable to return to Germany from a visit to the United States.

Grosz had started to produce oil paintings in 1912, and the most productive year of this early phase was 1918. He painted about a dozen pictures, of which many are lost. His *Funeral Procession* (p.202) was one of the first among these works, painted as early as winter 1917/18. Oskar Panizza (1853-1921), to whom it was dedicated, was a satirical writer who had attacked the state and the church and in whom Grosz had found a kindred spirit. Although Grosz was mainly a graphic artist and therefore less skilled at using the brush, he managed to create a composition that was full of tension and expressive colours. In this, he followed the examples of several modern painters whose works he knew extremely well, due to his regular visits to Herwarth Walden's *Sturm* gallery. From a raised viewpoint, we look at a street and into the windows of a building. The picture is filled with a chaotic multitude of people. The noisy confusion of the street – borrowed from Futurism – is reflected in the prismatic complexity of the painting's structure. The tint of red which covers the entire surface serves to emphasize the aggressiveness of the painting, while at the same time transforming the motif into a flaming, apocalyptic inferno. The large skeleton on the coffin at the centre of the picture, together with the words *HEUTE TANZ* (Today: Dance) provides a key to the symbolism in the painting – a Dance of Death. Grosz himself commented, "a hellish procession of dehumanized figures surges forward in a strange street at night, with faces that reflect alcohol, syphilis and the plague ... I painted it as a protest against a mankind which had gone mad."

The Futurist principle of composition, in which space is split into many interlocking fragments, can also be found in Grosz's drawings and – from 1918 onwards – in his Dadaist collages, especially whenever it was important to produce a certain atmosphere by means of formal elements. It was in this context, in 1920, that Grosz and Dix met for the first time, probably at the First International DADA Fair. Both their personal attitudes and their art undoubtedly displayed Expressionist features. And so they did not object to being counted among that young generation of artists and writers who rebelled against the fossilized structures of Kaiser Wilhelm's superannuated empire.

Conrad Felixmüller

Conrad Felixmüller's outstanding artistic talent was recognized at a very early stage, with the result that even his training could be financed by a patron. Born in Dresden in 1897, Felixmüller joined the local Academy of Art at the age of 15 and passed with special distinction after only two years, in 1914.

The outbreak of war in the same year was to be Felixmüller's most significant experience, one which shaped his artistic attitude for the rest of his life. From the very beginning he felt revulsion towards the events of the time, and he was one of the few people who refused to join in the patriotic war euphoria. Subsequent events proved to him that his pacifism was right. Felixmüller also began to think of his art as a form of political commitment. Apart from paintings, he produced graphic prints in the form of woodcuts. It was a technique that enabled him to work more spontaneously and to translate his ideas more directly into pictures. Thus, whenever he produced illustrations for various publications, above all for Pfemfert's weekly magazine *Die Aktion*, he could respond immediately to current political events. In 1915, Felixmüller travelled to Berlin, where he met a number of people to whom he could relate and who became important for his further work. Having first sought contact and co-operation with Walden's *Sturm* Gallery, he then joined Pfemfert's circle of artists and writers. In his magazine, Pfemfert took an uncompromising stand against the bourgeoisie and militarism, while at the same time rejecting any form of aestheticism. Through him, Felixmüller met Meidner, Raoul Hausmann, Grosz, Herzfelde and the poet Theodor Däubler, who had similar artistic and political views.

Felixmüller's pictorial idiom drew upon two artistic sources. While in Dresden, the *Brücke* artists – even though they had been unable to influence official art – left their mark on the young Felixmüller. He gladly emulated their pure colour contrasts. And in 1917, the Arnold Gallery in Dresden even exhibited Felixmüller's works side by side with paintings by Kirchner, Heckel and Schmidt-Rottluff. The exhibition enabled him to make a direct comparison. His art had already been dominated by red and purple, but now he sometimes enhanced this even further, to achieve garishly ecstatic contrasts.

Conrad Felixmüller:
Self-Portrait, 1920
Selbstbildnis
Woodcut, 24 × 16.8 cm

Conrad Felixmüller:
Workers on Their Way Home, 1921
Arbeiter auf dem Heimweg
Oil on canvas, 95 × 95 cm
Private collection, West Berlin

223

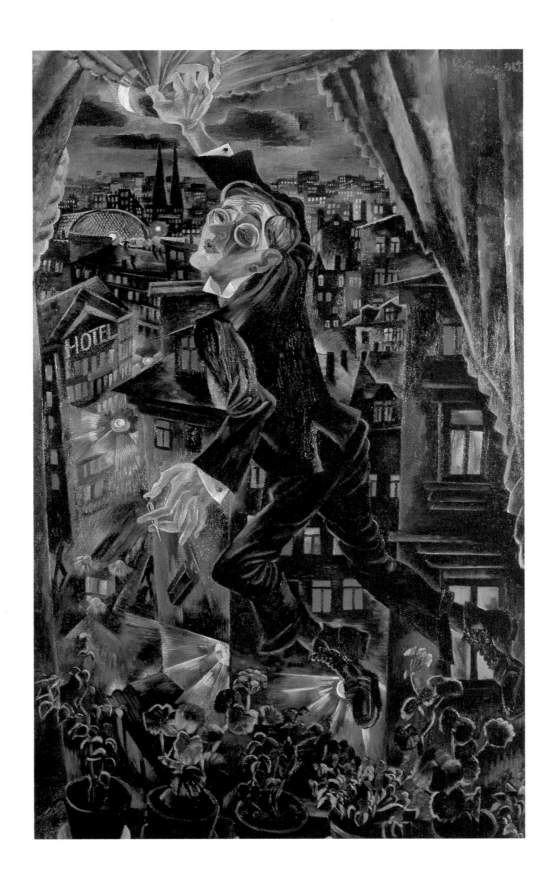

His formal repertoire, on the other hand, benefitted from the achievements of Cubism. Only in very few cases – and then in woodcuts rather than paintings – did he dare to split the motif into different fragments in order to achieve a multiple perspective. Examples can only be found for 1917 and 1918, when Felixmüller was just beginning to integrate Cubist elements into his own style. However, he soon found these experiments too formalistic, and so he reduced his abstractions to a measure that was more appropriate to his thematic intentions. But although Felixmüller never gave up the unity of space in his paintings, he simplified the motifs by composing them from angular, block-like shapes. "Without being a 'Cubist'," he said, "I imposed the form of nature on the basic shape, on 'absolute form'." He regarded this as his own, personal expression of *Synthetic Cubism*, though the term was already being used quite differently by art historians.

Nevertheless, Felixmüller never regarded the formal elements of Expressionism and Cubism as independent artistic qualities. For him, they were no more than formal methods which, a decade earlier, artists had conquered for themselves in an aesthetic revolution and which he now used as an instrument to achieve a greater concentration of purpose for his art. At the same time, Felixmüller's art is never impartial. His pictures always express solidarity with the harsh living and working conditions of the common people, particularly miners. In this he was closer to Dix for a while – whose friendship he enjoyed for a brief period – than Grosz with his political agitation. *Workers on Their Way Home* (p.222) of 1921 and *Factory Workers in the Rain* (1922; private collection) as well as *Death of the Poet Walter Rheiner* (p.232) are typical examples of Felixmüller's Expressionist paintings, both with regard to his choice of subjects and formal composition. When Felixmüller was offered a scholarship in Rome in 1920, he decided to study the heavily industrialized Ruhr area instead – an attitude which was no more than consistent with his views.

It was not only through his art that Felixmüller would point out evil conditions in this world; he was also actively involved in the German Communist Party in order to achieve the necessary political changes. In the mid-twenties, however, he realized that his revolutionary aims had failed and therefore changed his artistic style. His expressive distortions and harsh colours disappeared and were replaced by a Naturalist concept of space and more restrained colours. The private subjects, which had always been present in his politically committed work, now came to the fore.

Conrad Felixmüller:
Death of the Poet Walter Rheiner,
1925
Der Tod des Dichters Walter Rheiner
Oil on canvas, 180 × 115 cm
Los Angeles County Museum, Los
Angeles

Ludwig Meidner

The most outstanding and significant works among Ludwig Meidner's oeuvre are his townscapes, which are also his most independent paintings. No other Expressionist artist achieved such concise ecstatic and visionary expressiveness in architectural motifs. The artist, who was born in Silesia in 1884, discovered the subject of the city in 1912. His paintings – often entitled *Apocalyptic Landscapes* - are prophetic images of the impending events. Meidner projected the horrors of war into his cities. Buildings explode under artillery fire and go up in flames. The surface of the earth begins to shake, and only ruins are left.

Meidner always showed the big city from a raised and remote point of view. Stretching out panoramically before us, his scenes of doom afford a view which is both grandiose and horrifying. Human beings are often pushed right to the front edge so that the apocalyptic landscape can be reflected in people's terrified, distorted and desperate faces.

We almost feel as if the infernal noise of exploding bombs and collapsing buildings can be heard. Meidner achieved this effect by using the stylistic means of the Futurists, whose exhibition he had visited at the *Sturm* Gallery in Berlin in April 1912.

For Meidner, their angular, fragmented lines were the ideal formal equivalent of his artistic messages. "It is high time," wrote Meidner, "that we started painting our own native environment, the city, which we love so immeasurably. On innumerable fresco-like canvases our trembling hands should scribble down everything that is magnificent and strange, monstrous and dramatic about avenues, railway stations, factories and towers." These are the introductory words of his *Anleitung zum Malen von Grosstadtbildern* (How to Paint the City) of 1914, a book which he intended as an encouragement for other artists to take an interest in this subject. However, even Meidner's own townscapes fell short of these demands. After all, he concentrated not so much on the city itself as on the external, extraneous influences on it. The streets and buildings in his painting *Apocalyptic City* (p.226) of 1913 are swallowed up in the infernal explosions of bombs. Thus, the painting reflects the artist's emotional state when faced with the political situation on the eve of the First World War.

Delaunay, who exhibited his art in Berlin in 1913, also provided impor-

Ludwig Meidner:
Head, around 1920
Kopf
Etching

Ludwig Meidner:
Apocalyptic City, 1913
Apokalyptische Stadt
Oil on canvas, 79 × 119 cm
Westphalian State Museum for the
History of Art and Culture, Münster

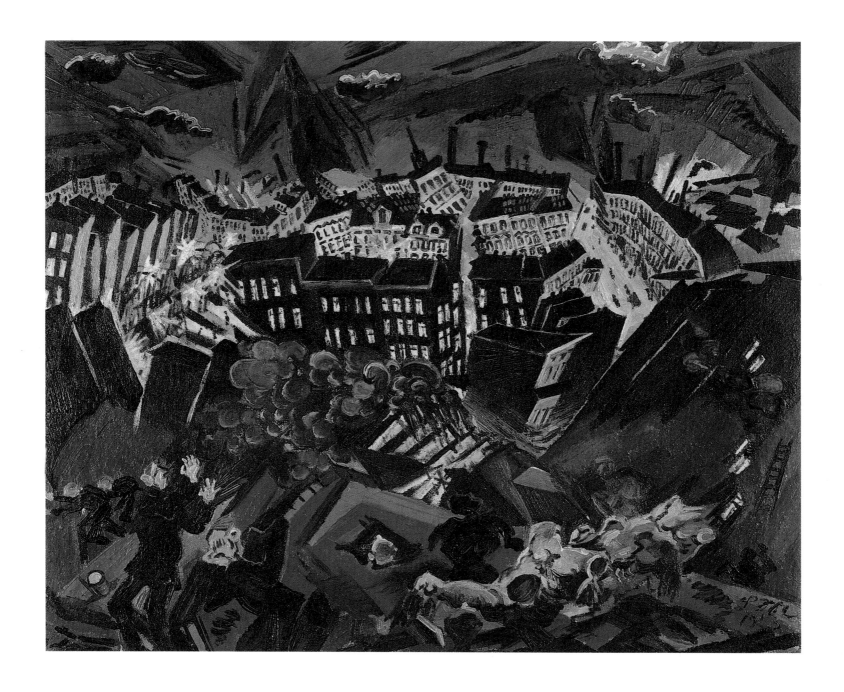

Ludwig Meidner:
The Burning City, 1913
Die brennende Stadt
Oil on canvas, 66.5 × 78.5
St. Louis Art Museum, St. Louis (Mo.)

tant artistic stimuli for Meidner, who was particularly keen on Delaunay's depictions of modern cities and his prismatically fragmented views of the Eiffel Tower. The Orphist idea of pure colour values failed to impress him, though. Meidner's colours never acquired Delaunay's transparent lightness. His brushwork remained thick and his colours mainly dark, which gave them a heaviness appropriate to his themes. In his book, he argued that "we cannot carry our easel into the chaos of the street in order to identify (with a squint) 'tone values' there. A street does not consist of tone values but is a bombardment of sizzling lines of windows, buzzing cones of light between all manner of vehicles and a thousand bouncing spheres, scraps of humanity, adverts and roaring, shapeless masses of colour … We cannot all of a sudden capture the random and chaotic element of our motifs and then turn it into a painting."

In 1912, Ludwig Meidner, Jakob Steinhardt and Richard Janthier formed a group of artists called *Die Pathetiker* (The Solemn Ones) – a word that very aptly described the passionately vivid expressiveness of their paintings. Meidner, who also wrote Expressionist poetry and prose, actively participated in the *Arbeitsrat für Kunst* (Co-Operative Council for Art) in 1918. In 1923, an important break occurred in his artistic development. Meidner now turned away from the townscapes which had dominated his oeuvre and took his Jewish religion as his subject matter.

Lyonel Feininger

Lyonel Feininger's position among German Expressionists is unique, with an artistic style that was both independent and highly individual. Although he had contacts with the various groups, his art did not fit into any of them. In 1912, he developed a close friendship with the *Brücke* artists in Berlin, especially Heckel and Schmidt-Rottluff. A year later he accepted Marc's invitation and exhibited his paintings alongside the *Blaue Reiter* at the *First German Autumn Salon*. After the war, from 1919 to 1925, he became one of the first *Bauhaus* teachers in Weimar, and from 1926 to 1932 he taught at the *Bauhaus* in Dessau. Founded by Walter Gropius, the institute was dominated by Expressionist ideas at that time and was yet to become a workshop for constructivist and rationalist teachings.

Feininger was born in New York in 1871. When he was 16, he and his parents moved to Europe, where he spent most of his time in Berlin. In 1936, pressurized by German discrimination, he decided to return to America. Although he was equally gifted in music and art, his enthusiasm for drawing and painting eventually turned out to be stronger than his love of the violin. However, despite a series of very successful illustrations, Feininger took a long time to be recognized as an artist. From 1905 onwards he produced cartoons for the humorous magazines *Ulk* (Fooling Around) and *Fliegende Blätter* (Loose Leaves). In 1906/7 he wrote the texts and designed the drawings for a comic strip series in the *Chicago Tribune*. For a number of years these jobs helped him to make a living.

Feininger's paintings between 1906 and 1911 were influenced by his illustrations. His uniquely angular lines, elongated figures and extreme spatial perspective are typical features that can also be found in his paintings, such as *Street at Dusk* (p.232) of 1910. Like other works of this stylistic period, it is dominated by shades of red and blue as well as a combination of them – purple – so that the painting has a mysteriously unreal quality about it.

It was not until 1911, in Paris, when Feininger had his first encounter with Cubism, that his art reached maturity and he found his own style. Figurative elements disappeared almost completely from his repertoire,

Lyonel Feininger:
Cathedral of Socialism, 1919
Kathedrale des Sozialismus
Woodcut for the Bauhaus state project, 30.5 × 18.9 cm

Lyonel Feininger:
Market Church in Halle, 1929
Marktkirche in Halle
Oil on canvas, 100 × 82 cm
Kunsthalle, Mannheim

and the dominant theme of his paintings became townscapes. Feininger was fascinated by the architecture of villages in Thuringia, and a big church tower dominates the centre of many of his pictures. During and immediately after the war, in particular, Feininger's tower was regarded as a symbol of hope for a more peaceful world. It was a direct reference to the Expressionist notion of a Gothic cathedral, which was idealized by the artists as a common endeavour, created in peace and harmony. Feininger's *Bauhaus* foundation manifesto – his woodcut, *Cathedral of Socialism* (p.231) – made similar claims.

Influenced by Cubism, Feininger now began to negate spatial perspective in these pictures. Instead, he constructed his architectural motifs synthetically out of complicated, interlocking, cubic forms, which were prismatically fragmented and which give the structure of each painting an architectural strictness and a monumental quality. However, Feininger's architecture never has that closed, block-like character of town-

Lyonel Feininger:
Street at Dusk, 1910
Strasse im Dämmern
Oil on canvas, 80 × 105 cm
Sprengel Museum, Hanover

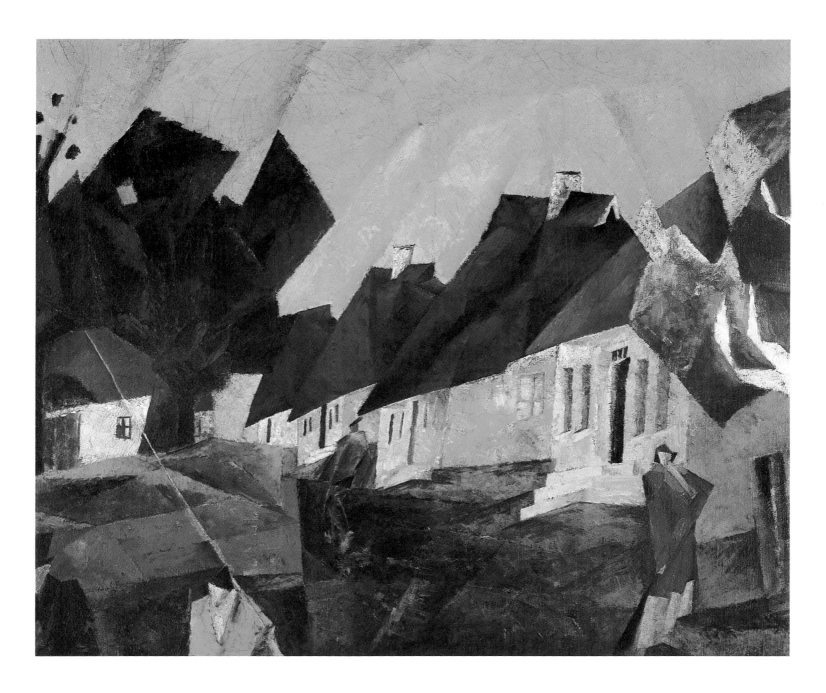

Lyonel Feininger:
The Village of Alt-Sallenthin, 1913
Dorf Alt-Sallenthin
Oil on canvas, 80 × 100 cm
Folkwang Museum, Essen

scapes in Cubism. He adopted Delaunay's Orphist colour theory, and so his motifs are always brightly transparent, as if flooded by light.

In the twenties, Feininger began to complement his townscapes with coastal landscapes. While in the former he managed to dissolve the compact shapes of the buildings in delicately translucent layers of colour, he now added a firmly geometrical structure to his seascapes, despite the lightness and lack of definition which is commonly associated with water and air. "Having aimed at movement and restlessness," he commented, "I could now feel the perfectly solid peace of the objects, even of the surrounding air, and tried to express it. 'The world' could not be more remote from reality."

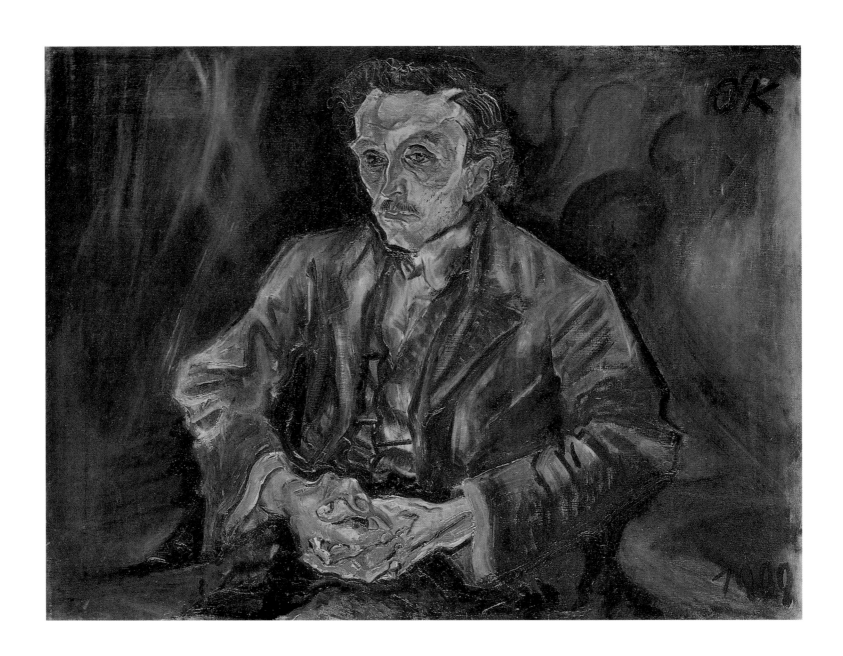

The Viennese art scene shortly after the turn of the century was dominated by the architectural and artistic activities of the *Viennese Workshops* with only one outstanding painter among them – Gustav Klimt. However, even Klimt had achieved this recognition indirectly, through a large number of decorative murals and ceiling paintings which he had produced between 1886 and 1899. Even Kokoschka and Schiele regarded him as someone they could emulate. In 1908, Kokoschka dedicated a book to him – a collection of fairy tales called *Die träumenden Knaben* (The Dreaming Boys). And it was only because of Klimt's influence that they found their own Expressionist style. Klimt, too, was very appreciative of the work of his younger colleagues. He praised Kokoschka as the

Expressionism in Vienna

most talented among the younger generation and gave personal support to Schiele on a number of occasions. Unlike Berlin, there does not seem to have been the usual conflict between established and younger artists in Vienna. Part of the reason may have been that Klimt and several other kindred spirits – the so-called *Klimt Group* - had quarrelled with the conservative, "Naturalist" wing of the Viennese *Secession* and had left the organisation, so that Klimt himself was in fact pushed into the role of a revolutionary.

In 1908, on the occasion of the *Kunstschau* (Art Exhibition) of the *Secession* and the *Viennese Workshops*, a critic complained that art was "being ruined by good taste". It was the first time that Kokoschka was publicly exhibiting his drawings, and he and Schiele were trying to banish this "good taste" from their own art. They abandoned the lavish profusion of Klimt's style, his ornamental elements, the harmony of his brush stroke and his preciously golden colours. Instead, they sought an artistic style that was direct, radical, and above all unembellished.

However, despite this break in style, we can observe a continuity in the artists' themes. Both Klimt and his younger colleagues, Kokoschka and Schiele, were virtually obsessed with the existential areas of human existence – sexuality, illness and death - even though, in Klimt's art, these subjects were still hidden under a rich layer of arabesques and could only be seen more clearly in his more private drawings. Indeed, the social climate and political situation in Vienna seemed almost predestined as a basis for depicting these fundamental themes of humanity. Not only was it the place where Sigmund Freund was working and developing his theories of psychoanalysis and sexual instincts, but the tradition has continued until today, with artists such as the *Viennese Actionists* and Arnulf Rainer.

Oskar Kokoschka

Oskar Kokoschka began his artistic career as a commercial artist for the *Viennese Workshops* . Indeed, he became an active member in 1907, while he was still studying at the renowned School of Applied Art in Vienna. In 1903, Josef Hoffmann and Koloman Moser hat started these *Workshops* as a community of artists and craftsmen. The aim was to depict all areas of life in accordance with a common aesthetic principle. At the beginning, they concentrated exclusively on producing gold, silver, metal and textile articles, designed by Hoffmann and Moser. The standard of craftsmanship was generally very high and the workshops were successful, whether they were designing book covers or complete rooms. Kokoschka designed mainly postcards, fans and vignettes. His later habit of signing paintings merely with his initials – *OK* - is a relic from his time with the *Viennese Workshops*, when all designers and craftsmen used to mark their works in this way.

Even though Kokoschka's designs for the *Viennese Workshops* displayed their typical decorative lines and Art Nouveau style, we can already detect Expressionist elements in them. 1908 was an important year for Kokoschka, who was now 22. Not only did he design the poster for the *Secession* and *Workshops* art exhibition, but he also exhibited several of his tapestry designs as well as drawings and gouaches for the first time. His delicately sensitive depictions of nude young girls immediately became a *succès de scandale* so that Kokoschka suddenly became a famous – and at the same time notorious – personality. His art made the press feel that they were in a "chamber of horrors and torture", and for decades to come, Kokoschka was publicly branded as a "chief of savages". However, his work also met with ardent enthusiasm, though only from a small number of people.

Klimt, at any rate, who was the leading artistic personality in Vienna at that time, recognized in Kokoschka "the greatest talent among the younger generation". However, what was even more important for him than the encouraging words of a professional was his friendship with Adolf Loos, whom he had met at the *Kunstschau*. This renowned architect and architectural theoretician (author of *Ornament und Verbrechen* - 'Ornament and Crime', 1908) also recognized the talent of the young artist and urged him to leave the *Workshops* so that he could devote

Oskar Kokoschka:
Portrait of Walter Hasenclever, 1918
Bildnis Walter Hasenclever
Lithograph, 61 × 42 cm

Oskar Kokoschka:
The Power of Music, 1918/19
Die Macht der Music
Oil on canvas, 100 × 151.5 cm
Stedelijk Van Abbemuseum, Eindhoven

PAGE 234:

Oskar Kokoschka:
Portrait of Adolf Loos, 1909
Bildnis Adolf Loos
Oil on canvas, 74 × 91 cm
Nationalgalerie SMPK, West Berlin

himself to the untrammelled pursuit of his own art. Loos introduced Kokoschka to several important personalities among Vienna's intellectuals and took him along on his journeys. And when Kokoschka was no longer able to rely on a good income from the *Workshops*, he also gave him financial assistance. As well as commissioning his own portraits and finding Kokoschka plenty of clients, he intervened whenever people refused to accept or pay for his paintings. This was often necessary because his portraits could be far from flattering.

Kokoschka's portraits are in many ways unique within Expressionism. No other artist concentrated on this particular subject as much as he did, and – until 1923 – we are justified in referring to him as a portrait artist. The portraits of, say, the *Brücke* painters were mainly intended as experiments in complementary colour contrasts and are therefore only of interest for their formal composition (with exceptions during the Berlin years, from 1911 onwards). Kokoschka's portraits are never superficial. Aiming at psychological depth, he endeavoured to express the inner state of his models by means of their features, gestures and his brushwork. It is often said in this context that Kokoschka had "X-ray eyes" and reached deeper levels where the true essence of a person could be discerned. In Vienna at this time, Freud was beginning to develop his theory of psychoanalysis. This was no coincidence, but a fin-de-siècle reaction to respectable middle class society, a response which was equally strong in the art world and in science.

Kokoschka usually chose half-length figures for his portraits. As a

Oskar Kokoschka:
Portrait of Hans Tietze and Erica Tietze-Conrat, 1909
Bildnis Hans Tietze und Erica Tietze-Conrat
Oil on canvas, 76.5 × 136.2 cm
Museum of Modern Art, New York

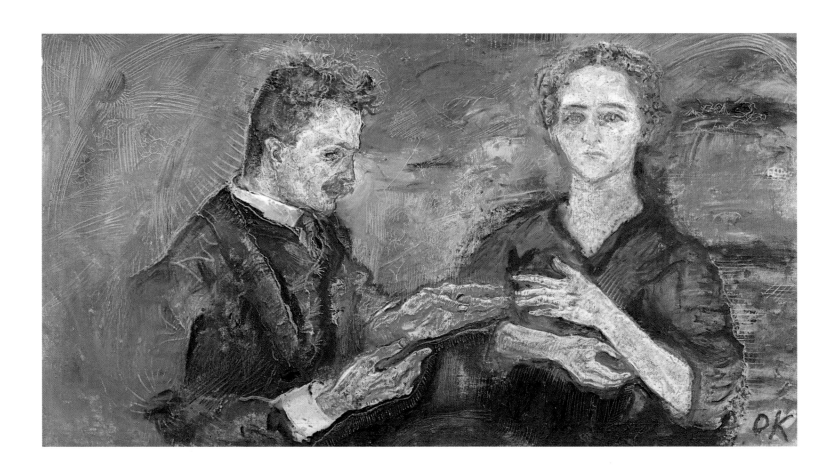

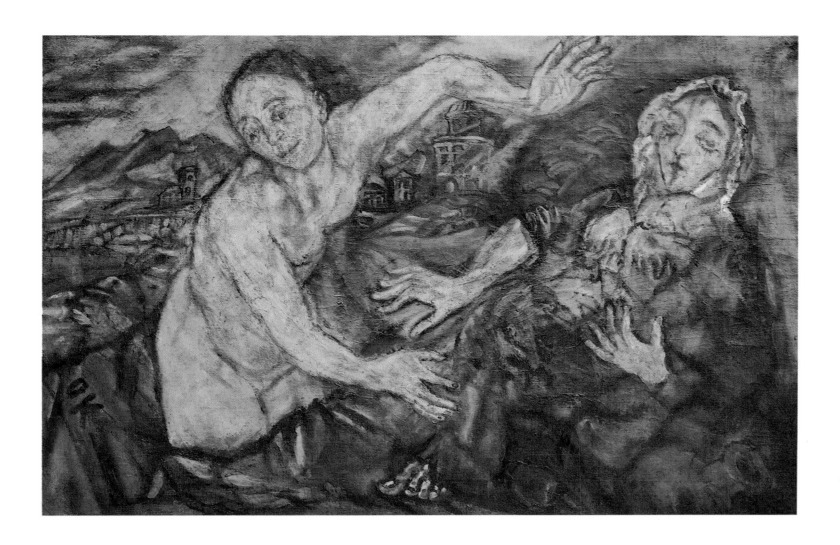

Oskar Kokoschka:
Annunciation, 1911
Verkündigung
Oil on canvas, 83 × 122.5 cm
Museum am Ostwall, Dortmund

result, not only the person's face but also the gestures of his hands became an important element with which the artist characterized his model. In most of his paintings, the model's hands are larger than life so that their significance is emphasized even further. Gesticulating wildly or clasped firmly, they are often the only active elements in these portraits of people who are sitting motionlessly, almost impassively. And yet a nervous tension emanates from all these pictures, due to Kokoschka's unusual style. Unlike other Expressionist painters, he never sought to achieve a pleasantly harmonious effect. The entire surface is always dominated by a restrained, clay-like quality, without powerful contrasts. Indeed, Kokoschka always applied the paint very thinly, either with his brush or directly with his hand. In a number of paintings he added some graphic lines to the colours with the handle of his brush. The background is always modelled entirely in colour, even though it remains spatially indistinct, while the contours of the person's body often seem rather hazy so that the background and the figure penetrate one another.

Kokoschka's *Portrait of Hans Tietze and Erica Tietze-Conrat* (p.242) of 1909 displays all the features that were so typical of his early Viennese portraits. The entire surface consists of golden brown colour values against which the bodies of the two figures stand out. However, the art historian Tietze and his wife are not shown as a happily married couple.

Except for the similarity in colour, there is not the faintest harmony of expression or posture between the two figures. While Tietze is bent slightly forward and stretching his hands out to his wife, she recoils with a stony expression on her face, her arms folded defensively on her chest. Despite their physical closeness, the two bodies seem isolated, and their eyes are looking in different directions.

The psychological depiction of individuals gives Kokoschka's art a pathological, almost morbid quality. Apparently, therefore, his portraits are more than mere descriptions of individual people but add up to an accurate image of society at the turn of the century. Though still externally intact, Kokoschka's art began to foreshadow its instability and impending breakdown at the outbreak of the First World War. Personally, he was beginning to find the social climate in Vienna more and more intolerable. "I can't bear it here any longer," he complained in a letter of 1909. "There is a rigidity about everything as if nobody had ever heard the screams. Everybody's relationships proceed in such a deadly and totally predictable manner, and the people are such uncanny results of their own character types, it's as if they were puppets."

A year later, Kokoschka went to Berlin where he helped Walden establish his magazine *Der Sturm* ('The Storm'). During the first year of its publication, Kokoschka regularly published reproductions of his drawings so that he soon achieved a measure of fame and appreciation among young German writers and artists. In addition, his play *Murder - the Hope of Women* (p.241) established him as one of the most acclaimed representatives of Expressionist literature. In Vienna, however, where he returned in 1911 after his wild, bohemian life in Berlin, he remained the *enfant terrible* of the younger generation of artists and only met with hostility from the public and the critics.

In 1912, Kokoschka met Alma Mahler, the widow of the composer Gustav Mahler. A passionately intense relationship developed between them and determined his life during the following years. Although she increasingly alienated him from his friend and supporter Adolf Loos, she strengthened his self-confidence vis-à-vis public criticism. Kokoschka painted several portraits of Alma, and we can detect her features in a large number of paintings, drawings and prints.

In 1911, Kokoschka began to produce a series of large-format oil paintings with biblical themes: *Flight to Egypt* (1911/12; private collection, Zurich), *Crucifixion (Calvary)* (1912; private collection) and his *Annunciation* (p.237) of 1911. Stylistically, these works are the result of his time in Berlin and the artistic impressions he had received. The compositional structure is more solid and condensed, and the surface is more opaque. Inspired by Cubist and Orphist examples, they are covered by a network of prismatically interwoven brush strokes so that the colours of the paintings appear to be split into multiple fragments. These religious paintings form a group of works that are on the same level as his portraits of the same period and which are of much greater expressive scope than his later city panoramas. Paintings such as his *Annunciation*

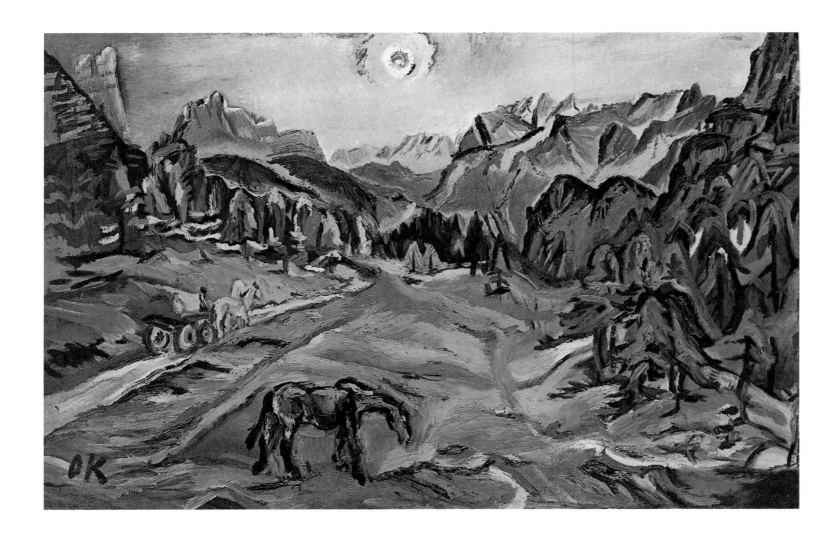

are a combination of both subjects, because they integrate landscapes into depictions of people. In showing Mary at the height of her pregnancy together with the naked, sexless figure of an angel, Kokoschka created an extremely private symbolic language of his own that was totally independent of traditional biblical iconography. By profaning biblical themes, he was trying to express his own individual situation in his relationship with Alma, while at the same time reflecting his role as an artist on the eve of the war. Both in the *Annunciation* and in his double portrait of *Hans Tietze and Erica Tietze-Conrat* people's hands have an important function within the overall composition. Both are subtly composed accounts of the tense interplay between gestures of protection and defence.

In 1915, Alma separated from Kokoschka and – in the same year – married the architect and later founder of the *Bauhaus*, Wilhelm Gropius. Kokoschka, who was serving as a voluntary front-line soldier at the time, took many years to get over this separation. Sinking into deep depression, he produced a number of paintings, such as *Lovers with a Cat* (1917; above), some drawings and a play called *Orpheus and Eurydice*, in which he expressed his fervent love for Alma Mahler. These attempts at preserving his lost relationship in his art culminated in a mysterious episode in 1918 when he commissioned a woman tailor to make a life-size doll for him. What exactly the purpose or function of this

Oskar Kokoschka:
Dolomite Landscape: Tre Croci, around 1913
Dolomitenlandschaft: Tre Croci
Oil on canvas, 82 × 119 cm
Private collection

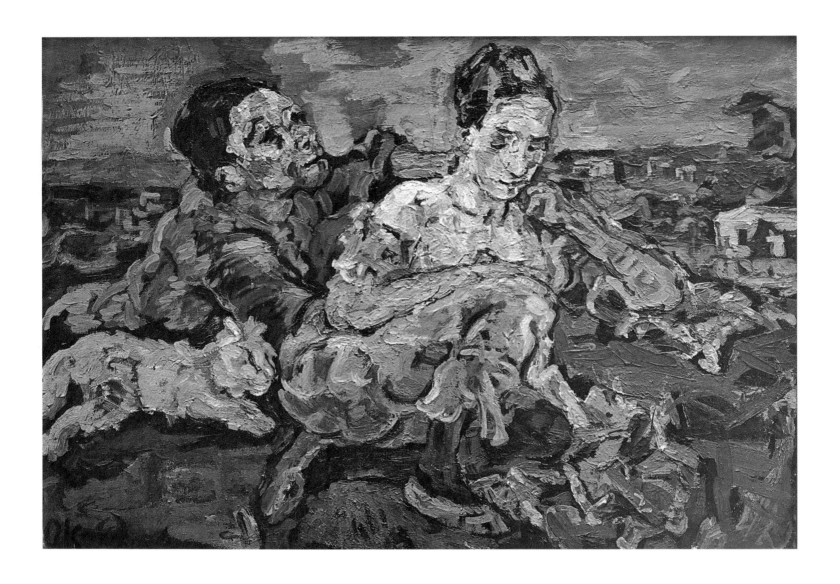

Oskar Kokoschka:
Lovers with a Cat, 1917
Liebespaar mit Katze
Oil on canvas, 93.5 × 130.5 cm
Kunsthaus, Zurich

fetish was meant to be remains uncertain to this very day. Presumably, however, it was not merely the model for a number of paintings (such as *Lady in Blue*, 1919, Staatsgalerie, Stuttgart, and *Self-Portrait with Doll*, 1920/21, National Gallery, Berlin).

Kokoschka took an active interest in its production, and he gave precise instructions in a great number of letters, where he described his ideas in minute detail: "You must also make sure that the hands and feet are still lively and attractive even when the doll is naked, that they don't seem heavy but wiry. The size should be such that some elegant lady's shoes can be fitted onto them, because I've kept plenty of beautiful women's clothes and garments in Vienna for precisely this purpose. So far as the face is concerned, it should be very very expressive and, if anything, the expression should be enhanced even further, though all traces of artificiality and craftsmanship should be eliminated, if possible! Can the mouth be opened? Are there teeth and a tongue in it? I'd be very happy if that were so." Predictably, the result did not satisfy Kokoschka's exaggerated and exuberant imagination. He was disappointed, even horrified when he wrote to "Dear Miss M ..." (i.e. Hermine Moos) in April 1919: "What shall we do now? Quite frankly, I am horrified at your doll.

Although I have long been willing to make certain allowances for the discrepancy between my own imagination and reality, your doll seems in many ways to contradict everything I expected from it and hoped you would achieve. The outer skin is like the hide of a polar bear, which would be good enough as an imitation of a shaggy bearskin rug in a bedroom, but never for the smooth softness of a woman's skin. And that even though we have always emphasized the deception of our sense of touch."

Kokoschka's separation from Alma and his subsequent depression brought about another change in his painting style. He now applied his colours more thickly and in long, opaque, wavy streams. This made his paintings livelier and introduced an element of nervous restlessness. Thus, the figures and landscapes in paintings like *Lovers with a Cat* (p.247) were modelled more three-dimensionally and therefore more realistically. The painting, which shows a woman turning away from a passionately insistent man, is one of the works in which Kokoschka tried to come to terms with his own private situation.

In 1919, Kokoschka was offered a lectureship in free painting at the Academy of Art in Dresden. From 1916 onwards, he had already been bound by contract to Cassirer, the owner of a gallery in Berlin, so that he had a guaranteed monthly income. His art had now won recognition. He exhibited in a number of German cities and soon outside Germany, too, and his paintings were bought by collectors and museums. In 1921, he began to paint the magnificent townscapes which were to dominate his oeuvre throughout the following years. This was the end of his Expressionist phase. He produced the first of these paintings in Dresden, with a panoramic view from the window of his flat. In 1923, he left Dresden, though he did not settle down again until 1933, when he moved back to Vienna. During those nine years Kokoschka was almost constantly travelling around, painting pictures in no less than eleven European countries as well as Northern Africa and the Middle East.

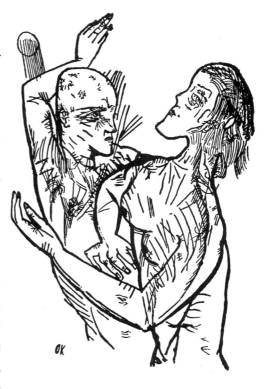

Oskar Kokoschka:
Pen sketch for *Murder – Hope of Women*, 1910

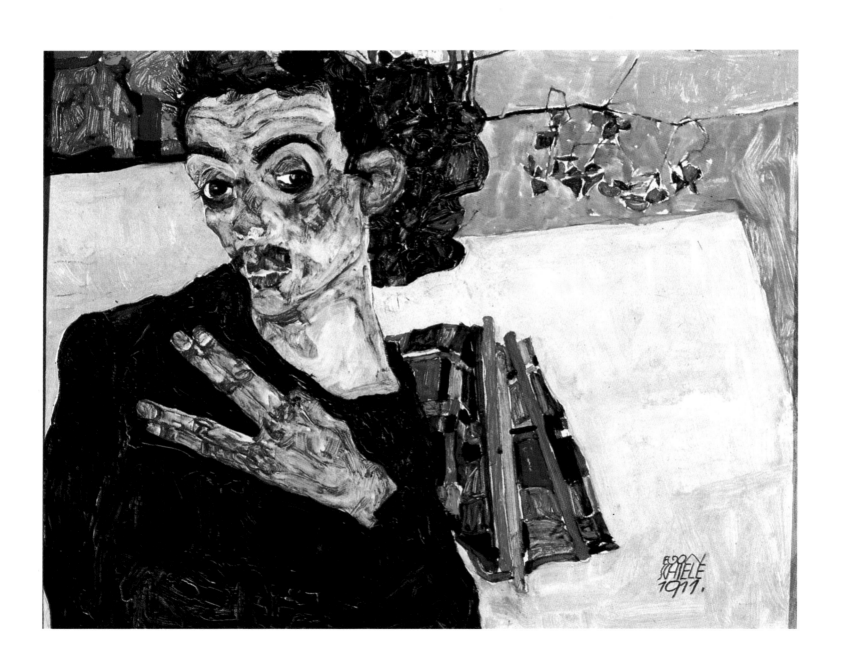

Egon Schiele

Four years younger than Kokoschka, Schiele was the second most outstanding figure of Expressionism in Vienna. In 1907 he submitted some drawings to Klimt in which he had abandoned – for the first time in his life - the academic tradition of copying antique plaster models. Klimt immediately recognized the artistic talent of this young man who was barely 17. He gave him plenty of support in the following years, and it was probably through Klimt that Schiele became a member of the *Viennese Workshops* two years later. But although Schiele was still very much under the influence of Klimt's ornamental style during that time, his designs were hardly ever accepted or carried out by the *Viennese Workshops*. The decorativeness that was demanded had already made way for a rather obstinate brittleness in his brushwork.

During this brief period from 1907 to 1909, Schiele's art went through a period when he developed his major compositional elements in response to Klimt's Art Nouveau. After he had given up his academic style, which had been as bloodless as the plaster models he used to copy, he radically reduced and abstracted his forms. He now concentrated exclusively on contours so that they became the only expressive elements. These were then supplemented only very sparingly by internal shapes. However, his nudes still had that decorative body line which was demanded by Art Nouveau. Painted in 1909, his portrait of his sister Gertrude (private collection, Graz), displays all the formal attributes which are also characteristic of Klimt's paintings – a figure, placed in the free area of some undefined space, the wealth of arabesque shapes, the precious shades of silver and gold, together with ordinary oil colours. Stylistically, however, Schiele also went beyond Klimt. His contours no longer flow harmoniously. The body of his sister seems straight and angular, and there is an element of disharmony in Schiele's ornamental composition.

By 1910 Schiele's works had come to occupy a fully independent artistic position, and although he produced a large number of paintings which were no less expressive than his drawings, it was the latter which became his real medium of expression. At the same time, he reduced his subject range to a small number of themes, with nudes in numerous variations as the most central group. He also made several portraits, both of himself and of others, but – unlike other Expressionists – he never

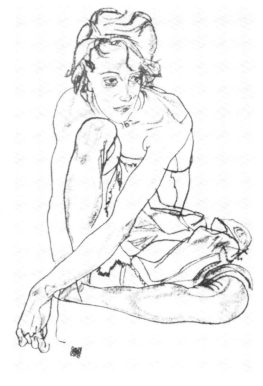

Egon Schiele:
Crouching Woman, 1918
Kauernde
Black chalk, 45 × 29.5 cm
Albertina Graphic Collection, Vienna

Egon Schiele:
Self-Portrait with Black Earthenware
Vessel, 1911
Selbstbildnis mit schwarzem
Tongefäß
Oil on canvas, 27.5 × 34 cm
Historical Museum of the City
of Vienna, Vienna

attempted to read the character of a model from his or her face alone. We have already seen that Kokoschka often showed people's hands in such a way that they told us more about them then their faces. Schiele went even further and made the entire body with all its limbs a carrier of artistic expression. By isolating the depicted person within the picture, without the slightest hint of a surrounding environment or landscape, Schiele tried to concentrate particularly on his subjects. Especially in his small-format drawings of individual models or couples, he exposed extremely intimate situations and moments to the inquisitive eyes of the viewer and indeed the public, situations which should really have remained totally private.

However, there is never any erotic charm about Schiele's models – unlike the lasciviously sensuous nudes of the *Brücke* artists in Dresden, where such an element was always present. Nevertheless, his works came under vehement attack, both from critics and the general public. In 1912 he was even accused of "disseminating pornographic drawings" and had to serve three days in gaol. Two years later he designed the poster for an exhibition at Guido Arnot's Viennese gallery, depicting himself as St. Sebastian in the pose of a martyr. There are only very few works in which Schiele abandoned the private sphere of the studio. Whenever he did, he produced truly impressive portrait studies of friends as well as a number of landscapes, without, however, turning them into straightforward observations of nature. Schiele's landscapes were always psychological reflexions of his own situation. "Everything is dead," Schiele wrote, "while it is alive." This cryptic message tells us a great deal about the character of his art which always seems to have its setting in the borderline area between life and death. His self-portraits and pictures of other people always appear to be closer to death than to life. Their bodies seem emaciated and sick. The inner tension which can be felt is created both by the theatrical body language of the models and by Schiele's pictorial idiom. The twisted postures and distorted gestures of the bodies are highly exaggerated, and Schiele often added to this effect by using an extreme perspective that would enhance the distortions even further.

In his depiction of couples, Schiele repeatedly chose the motif of two embracing bodies. Clinging closely to one another and seeking mutual support, the figures seem totally immersed in one another and oblivious of the world around them. With these pictures, Schiele broke completely with his leanings towards Klimt's Art Nouveau and his soft, decorative contours. His brush stroke is fine and harsh, his contours angular and without any roundness. The various forms collide aggressively with one another. Instead of harmony and balance, Schiele aimed at tense contrasts in his compositions. In his drawings, he only ever used colours very sparingly as a stylistic medium. Occasionally he would trace the contours in colours, and at times he would use them for adding volume, though this never led to powerfully athletic bodies. Indeed, the colours themselves always prevented such an impression. His transparent coatings of

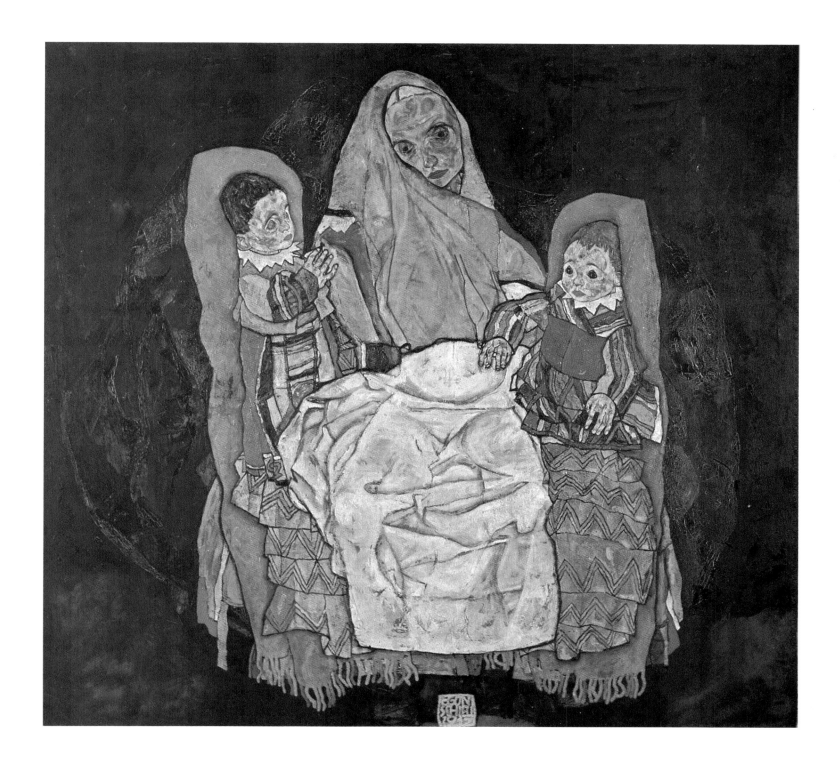

red and blue only ever showed the bodies in a state of pathological morbidity.

Despite vehement public hostility towards Schiele's art, there had always been a small but nevertheless very committed circle of sponsors and collectors who supported the artist and bought his works. Furthermore, he was always able to exhibit his art, though mostly in Germany rather than his native Austria. When he married a respectable middle class girl, Edith Harms, in 1915, his private life acquired that element of peace and balance which he needed so much. Three years later, however, Schiele died of Spanish influenza at the age 28, the same disease which killed Klimt.

Egon Schiele:
Mother with Two Children, III, 1915-1917
Mutter mit zwei Kindern, III
Oil on canvas, 150 × 159 cm
Austrian Nineteenth Century Gallery, Vienna

247

Biographical Notes and Literature

Max Beckmann 1884 Leipzig – **1950** New York

1894 Death of his father. The Beckmanns move to Braunschweig. **1900 – 1903** Studies at the School of Art in Weimar. **1903** Spends a long time in Paris. **1904** Moves to Berlin. **1906** Spends some time at the Villa Romana in Florence. Marries Minna Tube. **1907 – 1913** Member of the Berlin *Secession*. **1914** Volunteers for military service in the medical corps. **1915** Moves to Frankfurt after a nervous breakdown. **1925** Teaches at the Städelschule in Frankfurt. **1929** Professorship in Free Painting at the Städelschule. **1929 – 1932** Spends several months in Paris, in a rented flat. **1933** Moves to Berlin after his dismissal from his job. **1937** 590 of his "degenerate" works in German museums are confiscated by the Nazis. Emigrates to Amsterdam. **1947** Emigrates to the United States, where he teaches at the Washington University Art School in St. Louis. **1949** Professorship at the Art School of the Brooklyn Museum in New York.

BY MAX BECKMANN: M.B.: Briefe im Kriege, Berlin 1916. – M.B.: On My Painting, New York 1941. – M.B.: Tagebücher (diaries) 1940-1950, Munich 1955. – H. Kinkel (ed.): M.B. Leben in Berlin. Tagebuch 1908/ 1909, Munich 1966. – D. Schmidt (ed.): Frühe Tagebücher 1903/04 und 1912/13, Munich 1985.
OEUVRE CATALOGUES: K. Gallwitz: M.B. Die Druckgraphik [prints], Karlsruhe 1962. – E. and B. Göpel: M.B. Katalog der Gemälde [paintings], 2 volumes, Berne 1976. – J. Hofmaier: Catalogue raisonné der Druckgraphik, Berne 1984
MONOGRAPHS AND CATALOGUES: C. Glaser et al.: M.B., Munich 1924. – B. Reifenberg and W. Hausenstein: M.B., Munich 1949. – F.W. Fischer: Der Maler M.B., Cologne 1972. – F.W. Fischer: M.B. Symbol und Weltbild,

Munich 1972. – P. Selz: M.B., New York 1964. – S. Lackner: M.B., New York 1977. – S. von Wiese: M.B.s zeichnerisches Werk 1903-1925, Düsseldorf 1978. – M.B. Frankfurt 1915-1933 (Cat.), Städelsches Kunstinstitut, Frankfurt 1983. – M.B. Retrospektive (Cat.), Haus der Kunst Munich et al., Munich 1984. – M. Eberle: Die Nacht – Passion ohne Erlösung, Frankfurt 1984. – F. Erpel: M.B. Leben im Werk. Die Selbstbildnisse, Munich 1985.

Heinrich Campendonk 1889 Krefeld – **1957** Amsterdam

1905 – 1909 Studies under Thorn-Prikker at the School of Applied Art in Krefeld. **1911** Moves to Sindelsdorf. Makes friends with Marc and Macke. **1913** Takes part in the *First German Autumn Salon* in Berlin at the *Rhenish Expressionists Exhibition* in Bonn. **1914 – 1916** Military service. Moves to Seeshaupt on Lake Starnberg. **1919 – 1921** Member of the *Cooperative Council for Art*. **1922** Returns to Krefeld, where he teaches at the local School of Applied Art. **1926** Professorship at the State Academy of Art in Düsseldorf. **1934** Emigrates to Belgium. **1935** Moves to Amsterdam, where he teaches at the local Academy of Art. **1937** 87 of his "degenerate" works in German museums are confiscated.

OEUVRE CATALOGUES: M.T. Engels: H.C. Werkverzeichnis der Holzschnitte (woodcuts), Stuttgart 1959. – P. Wember: H.C., Krefeld 1960 [contains an oeuvre catalogue of paintings].
MONOGRAPHS AND CATALOGUES: C. Biermann: H.C., Leipzig 1921. – M.T. Engels: C. als Glasmaler, Krefeld 1966. – H.C. (Cat.), Städtisches Kunstmuseum, Bonn 1973. – H.C. (Cat.) Pfalzgalerie Kaiserslautern, Kaiserslautern 1982.

Otto Dix 1891 Unternharmhaus near Gera – **1969** Singen

1905 – 1909 Apprenticeship as a decorative painter. **1909 – 1914** Studies at the School of Applied Art in Dresden. **1914** Volunteers for military service. **1918** Studies at the Dresden Academy of Art. **1919** Co-founder of the *Dresden Secession – Group 1919*. **1920** Takes part in the *First International DADA Fair* in Berlin. **1919 – 1922** Studies at the Düsseldorf Academy of Art. **1927** Professorship at the Dresden Academy of Art. **1931** Member of the Prussian Academy of Arts. **1933** Dismissed from his job. **1936** Withdraws to Hemmingen on Lake Constance. **1937** Branded as "degenerate" by the Nazi authorities, 260 of his works are confiscated. **1939** Short spell in prison. **1950** Professorship at the Düsseldorf Academy of Art.

BY OTTO DIX: Selbstzeugnisse, Schriften, Briefe, Erinnerungen. In: D. Schmidt: O.D. im Selbstbildnis, pp. 199-253, Berlin 1978.
OEUVRE CATALOGUES: F. Karsch: O.D. Das graphische Werk 1913 – 1969 [prints], Hanover 1970. – F. Löffler: O.D. Oeuvre der Gemälde [paintings], Recklinghausen 1981 [not complete].
MONOGRAPHS AND CATALOGUES: P.F. Schmidt: O.D., Cologne 1923. – O. Conzelmann: O.D., Hanover 1959. – F.Löffler: O.D. Leben und Werk, Dresden 1960, 5/ 1982. – D. Schubert: O.D. in Selbstzeugnissen und Bilddokumenten, Reinbek 1980. – B.S. Barton: O.D. und die Neue Sachlichkeit 1918 – 1925, Michigan 1981. – L. Fischer: O.D., ein Malerleben in Deutschland, Berlin 1981. – O. Conzelmann: Der andere D. – Sein Bild vom Menschen und vom Krieg, Stuttgart 1983. – O.D. (Cat.), Museum Villa Stuck, Munich 1985. – O.D.-(Cat.), Kestner-Gesellschaft et al., Hanover 1987. – E. Karcher: O.D. 1891 – 19698. Leben und Werk, Cologne 1988.

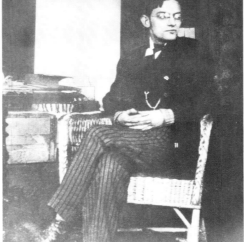

Lyonel Feininger 1871 New York – **1956** New York

1887 Lyonel's family move to Germany. **1888 – 1892** Studies at the Berlin Academy of Art. **1890** Produces his first cartoons. **1892/93** Studies at the Académie Cola Rossi in Paris. **1893-1906** Returns to Berlin, where he works as a cartoonist for German and American magazines. **1906/07** Spends some time in Paris. **1907** Begins to concentrate on painting only. **1909** Member of the *Berlin Secession*. **1918** Member of the *November Group*. **1919 – 1933** Responsible position at the Bauhaus in Weimar and Dessau. **1924** Together with Jawlensky, Kandinsky and Klee, he founds a group called *Die Blauen Vier (The Blue Four)*. **1933** moves to Berlin. **1936** Emigrates to the United States, where he teaches at Mills College in Oakland, California. **1937** Moves to New York. **1945** Teaches at Black Mountain College, North Carolina.

OEUVRE CATALOGUES: H. Hess: L.F., Stuttgart 1959 [pp. 249-300: oeuvre catalogue of paintings]. – L.E. Prasse: L.F. Das graphische Werk, Cleveland (Ohio) and Berlin 1972.
MONOGRAPHS AND CATALOGUES: D. Miller (ed.): L.F. (Cat.), Museum of Modern Art, New York. – L. Schreyer: L.F. Dokumente und Visionen, Munich 1957. – F.F. 1871 – 1956 (Cat.), Kunsthaus Zürich et al., Zurich 1973. – J. Ness: L.F., New York 1974. – L.F. Karikaturen, Comic strips, Illustrationen 1888 – 1915 (Cat.), Museum für Kunst und Gewerbe, Hamburg 1981. – L.F. (Cat.) Kunsthalle zu Kiel, Kiel 1982.

Conrad Felixmüller 1897 Dresden – **1977** Berlin

1911 Studies at the School of Applied Art in Dresden. **1912 – 1915** Studies at the Dresden Academy of Art. **1917** Member of the Expressionists' Association in Dresden. Becomes a conscientious objector. **1919** Co-founder of the *Dresden Secession Group 1919*, member of the *November Group*.

1934 Moves to Berlin. **1937** 151 of his "degenerate" works in German museums are confiscated. **1944** His Berlin studio is destroyed during an air raid, and he moves to Tauenhain near Leipzig. Military service. **1949 – 1962** Professorship at the University of Halle, East Germany. **1967** Moves to West Berlin.

BY CONRAD FELIXMÜLLER: C.F. Legenden 1912 – 1976, ed. by G.H. Herzog, Tübingen 1977. – G. Söhn (ed.): C.F. von ihm – über ihn, Düsseldorf 1977. – C.F. Werke und Dokumente (Cat.), Germanisches Nationalmuseum, Nuremberg 1981.
OEUVRE CATALOGUES: G. Söhn (ed.): C.F. Das graphische Werk 1912 – 1974 [prints], Düsseldorf 1975. - G. Söhn (ed.): C.F. Das graphische Werk 1975 – 1977 [prints], Düsseldorf 1980.

MONOGRAPHS AND CATALOGUES: H. Heinz: C.F. Gezeichnetes Menschenbild, Dresden 1958. – H. Scherf: C.F., Leipzig 1959. – P. Raabe: F. Größe und Wandlung des späten Expressionismus, Biberach a.d. Riß 1968. – C.F. Gemälde, Aquarelle, Zeichnungen, Druckgraphiken (Cat.), Staatliche Kunstsammlungen Dresden et al., Dresden 1975. – C.F. Gemälde, Aquarelle, Zeichnungen, Druckgraphik (Cat.), Düsseldorf 1975. – C.F. 1897 – 1977 (Cat.), Dortmund et al., Dortmund 1978. – C.F. 1897 – 1977. Gemälde, Aquarelle, Zeichnungen (Cat.), Hamburg 1981. – D. Gleisberg: C.F. Leben und Werk, Dresden 1982.

George Grosz 1893 Berlin – **1959** Berlin

1909 – 1912 Studies at the Dresden Academy of Art. **1912 – 1916** Studies at the School of Applied Art in Berlin. **1913** Trip to Paris. **1914** Military service. **1917** Discharge. Makes friends with Herzfelde. **1917** Drafted into territorial army. Military hospital. **1918** Court-martialled for attacking an officer. Co-founder of the *Club Dada*. **1919/20** Co-edits the magazines *Der blutige Ernst* (Dead Seriously), *Die Pleite* (Flat Broke), and *DER DADA*. **1920** Helps to organize the *First International DADA Fair*

in Berlin. **1928** Fined for blasphemy. **1931** Guest lecturer at the Art Students League in New York. **1933** When Nazis comes to power, he does not return to Germany but remains in the United States as an immigrant, and his guest lectureship is turned into a permanent post. **1937** 285 of his "degenerate" works in German museums are confiscated. **1938** American citizenship. **1941/42** Lectureship at Columbia University, New York. **1959** Returns to West Berlin.

BY GEORGE GROSZ G.G.: Die Kunst ist in Gefahr, Berlin 1925. – G.G.: Ein kleines Ja und ein großes Nein, Hamburg 1955. Translated as *A Small Yes and a Big No* by Arnold J. Pomerans, London 1982. – G.G.: Briefe 1913 – 1959, Reinbek 1979.
OEUVRE CATALOGUES: G.G.: Frühe Druckgraphik, Sammelwerke, Illustrierte Bücher 1914 – 1923 (Cat.), Kupferstichkabinett, Berlin 1971. – A. Dückers: G.G. Das druckgraphische Werk, Berlin 1978.
MONOGRAPHS AND CATALOGUES: J. Baur: G.G., New York 1954. – H. Bittner: G.G., Cologne 1961. – H. Hess: G.G., London 1974. – U.M. Schneede: G.G.: Leben und Werk, Stuttgart 1975. – G.G. Seine Kunst und seine Zeit (Cat.), Kunstverein Hamburg, Hamburg 1975. – U.M. Schneede: G.G., der Künstler in seiner Gesellschaft, Cologne 1975. – L. Fischer: G.G. in Selbstzeugnissen und Bilddokumenten, Reinbek 1976. – H. Hess: G.G., Dresden 1982. – G.G. Die Berliner Jahre (Cat.), Kestner-Gesellschaft, Hanover 1987.

Erich Heckel 1883 Döbeln (Saxony) – **1970** Radolfzell (Lake Constance).

1901 Makes friends with Schmidt-Rottluff **1904** Finishes grammar school in Chemnitz and studies architecture at the Saxon Technical College in Dresden. **1905** Together with Bleyl, Kirchner and Schmidt-Rottluff, he founds he *Brücke* artists' circle on 17 June. Works at Wilhelm Kreis's architectural studio. Rents a former butcher's shop in 60, Berliner Strasse as the joint

Brücke studio. **1907** finishes his job at Kreis's. First trip to the Dangast Moors. **1908** Spends May to October with Schmidt-Rottluff in Dangast. **1909** Travels to Italy (Verona, Padua, Venice and Rome). Spends the summer at the Moritzburg Lakes, together with Kirchner (subsequently also in 1910 and 1911). **1911** Moves to Berlin. **1912** Makes friends with Marc and Feininger. **1913** Break-up of the *Brücke* group. First solo exhibition at the Gurlitt Gallery in Berlin. **1914** Takes part in the *Werkbund* exhibition in Cologne. Volunteers for military service in the medical corps. **1915** Meets Beckmann and Ensor. Marries Milda Frieda Georgi, called Sidi. **1918** Settles down in Berlin in November. **1919 – 1944** Spends the summer in Osterholz each year. **1929** Trip to the Provence, the Pyrenees, Northern Spain and Aquitania. **1931** Trip to Northern Italy. **1937** Branded as "degenerate" by the Nazi authorities. 729 of his works are confiscated in German museums. **1944** His Berlin studio is destroyed during an air raid. Moves to Hemmenhofen on Lake Constance. **1949 – 1955** Professorship at the School of Fine Arts in Karlsruhe.

OEUVRE CATALOGUES: A. and W. Dube: E.H. Das graphische Werk, 3 volumes, New York and Berlin 1964 – 1974. – P. Vogt: E.H., Recklinghausen 1965 [pp. 211-326: oeuvre catalogue of his paintings, murals and sculptures].
MONOGRAPHS AND CATALOGUES: L. Thormaehlen: E.H., Berlin 1932. – H. Köhn, E.H., Berlin 1948. – P.O. Raven: E.H., Berlin 1948. – E. Rathenau (ed.), E.H. Handzeichnungen [drawings], New York 1973. – E.H. Zeichnungen und Aquarelle (drawings and water-colours) (Cat.), Städtische Galerie im Prinz-Max-Palais, Karlsruhe et al., Karlsruhe 1983. – E.H. 1883 – 1970 (Cat.), Folkwang Museum et al., Munich 1983. – K. Gabler: E.H. und sein Kreis. Dokumente, Stuttgart and Zurich 1983. – A. Henze: E.H. Leben und Werk, Stuttgart and Zurich 1983. – E.H. (Cat.), Kunstverein Braunschweig, 1985.

Alexei von Jawlensky 1864 Torshik (Russia) – **1941** Wiesbaden

1874 The Jawlenskys move to Moscow, where he studies at the grammar school. **1882 – 1896** Military service as an officer. **1889 – 1896** Part-time student at the Academy of Art in St. Petersburg. **1896** Moves to Munich, together with Marianne von Werefkin, and studies at Azbè's private art school. Makes friends with Kandinsky. **1903** Trip to Berlin, where he takes part in the Berlin *Secession*. **1907** Meets Matisse in Paris. **1909** Co-founder of the *New Artists' Association of Munich*. **1912** Leaves the Association again, takes part in *Blaue Reiter* exhibitions. **1914 - 1921** Exile in Switzerland. **1921** Separates from Marianne von Werefkin and moves to Wiesbaden. **1929** Together with Kandinsky, Klee and Feininger, he founds the *Blue Four*. First signs of paralysis. **1933** Barred from exhibitions by the Nazis. **1937** 72 of his "degenerate" works in German museums are confiscated by the Nazis. **1938** His illness deteriorates until he is completely paralyzed.

OEUVRE CATALOGUE: C. Weiler: A. J., Cologne 1959 [incomplete].
MONOGRAPHS AND CATALOGUES: A. J. (Cat.), Kunstverein Hamburg, Hamburg 1967. – E. Rathke: A. J.. Hanau 1968. – J. Schultze: A. J.. Cologne 1970. – C. Weiler: J. – Köpfe, Gesichte, Meditationen, Hanau 1970. - A. J. 1864 – 1941 (Cat.), Städtische Galerie im Lenbachhaus et al., Munich 1983. – A. J. Zeichnung, Graphik, Dokumente (Cat.), Museum Wiesbaden, Wiesbaden 1983.

Wassily Kandinsky 1866 Moscow – **1944** Neuilly-sur-Seine

1886 – 1892 Law degree at Moscow University. **1893** Lecturer at Moscow University. **1896** Moves to Munich. **1897** Studies at Azbè's private art school. **1900** Changes to the the Munich Academy of Art, where he studies under Von Stuck. **1901** Co-founds the *Phalanx* group of artists. **1902** Meets Gabriele Münter. **1903 – 1908** Together with Gabriele Münter, he travels to Italy, Holland, France, Switzerland, Tunisia and several times to Russia. **1908** Returns to Munich, where he makes friends with Marianne von Werefkin and Jawlensky. First study trip to Murnau. **1910** Makes friends with Marc. **1911** Leaves *New Artists' Association of Munich*, and starts an editorial team called *Der Blaue Reiter*, together with Marc. **1912** Publication of his book, *On the Spiritual in Art*, and the almanac *Der Blaue Reiter*. **1913** Takes part in the *First German Autumn Salon* in Berlin. **1914** War breaks out, and he returns to Russia. **1916** Final separation from Gabriele Münter. **1918** Professorship at the State Art Workshops in Moscow. **1921** Co-founds the Academy of Arts and moves to Berlin. **1922 – 1933** Teaches at the Bauhaus in Weimar and Dresden. **1924** Together with Feininger, Klee and Jawlensky, founds the *Blue Four* group of artists. **1928** Takes German citizenship. **1933** Leaves Germany and moves to Paris. **1939** Takes French citizenship.

BY WASSILY KANDINSKY: W. K.: Über das Geistige in der Kunst (On the Spiritual in Art), Munich 1911. – W. K.: Klänge, Munich, undated (1912). – W. K. and Franz Marc (eds.): Der Blaue Reiter, Munich 1972. - W. K.: Rückblicke, Berlin 1913. – W. K.: Punkt zu Linie zu Fläche, Munich 1926. – W. K.: Essays über Kunst und Künstler, Stuttgart 1955. – P. Sers (ed.), W. K., Ecrits complets, 3 volumes (2 have appeared so far), Paris 1970 and 1975. – H.K. Roethel (ed.): K. – Die Gesammelten Schriften, vol. 1, Berne 1980. – W. K., Complete Writings on Art, 2 volumes, Boston and London 1982. – K. Lankheit (ed.): W.K. – Franz Marc. Briefwechsel, Munich 1983.
OEUVRE CATALOGUES: H.K. Roethel: Wassily Kandinsky. Das graphische Werk, Cologne 1970. – H.K. Roethel and J.K. Benjamin: Wassily Kandinsky, Werkverzeichnis der Ölgemälde (oil paintings), 2 volumes, Munich 1982 and 1984.
MONOGRAPHS AND CATALOGUES: H. Zehder:

Wassily Kandinsky (with K.'s permission to use his Russian autobiography), Dresden 1920. – J. Eichner: K. and Gabriele Münter, Munich 1957. – W. Grohmann: Wassily Kandinsky, Leben und Werk, Cologne 1958. – J. Lassaigne: Wassily Kandinsky Zeichnungen und Aquarelle, Munich 1974. – Wassily Kandinsky 1866 – 1944 (Cat.), Haus der Kunst, Munich 1977. – R.C. Long: Kandinsky. The Development of an Abstract Style, Oxford 1980. – H.K. Roethel: K., München and Zurich 1982. – A. Zweite (ed.): Kandinsky und München (Cat.), Städtische Galerie am Lenbachhaus, Munich 1982. – R.T. Bellido: Kandinsky. Les Chefs d'Oeuvres. Paris 1987.

Ernst Ludwig Kirchner 1880 Aschaffenburg – **1938** Frauenkirch-Wildboden near Davos

1901 Leaves grammar school in Chemnitz. **1901 – 1903** Studies architecture in Dresden, where he meets Bleyl. **1903/4** Studies at Debschitz and Obrist's school of art in Munich. **1904** Continues to study architecture in Dresden. **1905** Degree in architecture. 17 June: founds the *Brücke* group of artists, together with Bleyl, Heckel and Schmidt-Rottluff. **1906:** writes the group's programme. **1907** Spends summer in Goppeln near Dresden, together with Pechstein. **1908** First trip to the Isle of Fehmarn. **1909 - 1911** Frequent trips to the Moritzburg Lakes. **1910/11** Member of the *New Secession*. **1911** Moves to Berlin in October. Meets Erna Schilling. Founds the MUIM Institute (Modern Painting Lessons) together with Pechstein. **1913** His *Chronicle* of the *Brücke* group leads to its break-up. **1914** Takes part in the *Werkbund* exhibition in Cologne. Volunteers for military service. **1915** He is discharged from the army and spends some time in a sanatorium in Königstein/Taunus. **1917** Moves to a village near Davos. Sanatorium in Kreuzlingen until July 1918. **1922** Works together with the weaver Lise Gujer for the first time. **1923** Moves to Wildboden. Large-scale exhibition of his works in

Basle. **1925/26** Trip around Germany: Frankfurt, Chemnitz, Dresden and Berlin. **1933** Large-scale exhibition in Berne. **1937** Kirchner is branded by the Nazis as "degenerate" and 639 of his works are confiscated in public collections.

By Ernst Ludwig Kirchner: Chronik der KG Brücke, Berlin 1913. – Briefe an Nele und Henry van de Velde, Munich 1961. – L. Grisebach (ed.): E.L.K.s Davoser Tagebuch, Cologne 1968. – A. Dube-Heynig (ed.): E.L.K. Postkarten und Briefe an E. Heckel, Cologne 1984.
Oeuvre catalogues: Das graphische Werk von E.L.K. [prints], 2 volumes, Berlin 1926 – 1931. – A. and W.D. Dube: E.L.K. Das graphische Werk, 2 volumes, Munich 1967, 2/1980. – D.E. Gordon: E.L.K. Mit einem kritischen Katalog sämtlicher Gemälde, Munich 1968.
Monographs and catalogues: W. Grohmann: K. Zeichnungen, Dresden 1925. – W. Grohmann: Das Werk E.L.K.s, Munich 1926. – H. Fehr: Erinnerungen an E.L.K., Berne 1955. – W. Grohmann: E.L.K., Stuttgart 1958. – A. Dube-Heynig: E.L.K. Graphik, Munich 1961. – E.W. Kornfeld: E.L.K. Nachzeichnung seines Lebens, Berne 1979. – R.N. Ketterer: E.L.K. Zeichnungen und Pastelle, Stuttgart and Zurich 1979. – E.L.K. 1880 – 1938 (Cat.), Nationalgalerie Berlin, Berlin 1979. – A. Henze: E.L.K. Leben und Werk, Stuttgart 1980. – E.L.K. Aquarelle, Zeichnungen und Druckgraphik aus dem Besitz des Städel, Frankfurt 1980. – K. Gabler (ed.): E.L.K. Dokumente, Fotos, Schriften, Briefe (Cat.), Museum der Stadt Aschaffenburg, Aschaffenburg 1980. – E.L.K. Zeichnungen (Cat.), Museen der Stadt Aschaffenburg et al., Aschaffenburg 1980. – E.L.K. Aquarelle, Pastelle, Zeichnungen (Cat.), Museum am Ostwall, Dortmund 1986.

Oskar Kokoschka 1886 Pöchlarn on the Danube – **1980** Villeneuve near Montreux

1905 – 1909 Studies at the School of Applied Art in Vienna. **1907 – 1909** Member of the *Viennese Workshops*. **1910** Moves to Berlin, where he contributes to the *Sturm* magazine. **1911** Returns to Vienna and works as an assistant at the School of Applied Art. Beginning of his relationship with Alma Mahler. **1915** In military hospital. **1917** Moves to Dresden. **1924** Professorship at the Dresden Academy of Art. Numerous trips through Europe, North Africa and the Middle East. **1933** Returns to Vienna. **1934** Moves to Prague. **1937** Branded as "degenerate" by the Nazi authorities. 417 of his works are confiscated. **1938** Emigrates to London. **1947** Takes British citizenship. **1953** Moves to Villeneuve on Lake Geneva, founds the *School of Vision* at the Summer Academy in Salzburg. **1975** Takes Austrian citizenship again.

By Oskar Kokoschka O.K.: Dramen und Bilder, Leipzig 1913. – O.K.: Vier Dramen, Berlin 1919. – O.K.: Schriften 1907 – 1955, Munich 1956. – O.K.: Mein Leben, Munich 1971. – H. Spielmann (ed.): O.K. Das schriftliche Werk, 4 volumes, Hamburg 1973 – 1976. – H. Spielmann and Olda Kokoschka (eds.): O.K. Briefe I (1905 – 1919) and Briefe II (1919 – 1934), Düsseldorf 1984/5.
Oeuvre catalogues: E. Rathenau: O.K. Handzeichnungen [drawings], 5 volumes, Berlin and New York 1935 – 1977. – H.M Wingler: O.K. Das Werk des Malers, Salzburg 1956 [pp.291-343: oeuvre catalogue of paintings, sculptures and other works]. – H.M. Wingler and F. Welz: O.K. Das druckgraphische Werk [prints], 2 volumes, Salzburg 1975 and 1981.
Monographs and catalogues: P. Westheim: O.K., Berlin 1918. – G. Biermann: O.K., Leipzig 1929. – E. Hoffmann: K.: Life and Work, London 1947. H.M. Wingler: O.K.: ein Lebensbild in zeitgenössichen Dokumenten, Munich 1956. – E. Rathenau: Der Zeichner K., New York 1961. – L. Goldscheider: O.K., Cologne 1963. – F. Schmalenbach: O.K., Königstein 1967. – O. Breicha (ed.): O.K.: Vom Erleben im Bild. Schriften und Bilder, Salzburg 1976. – W.J. Schweiger: Der junge K. Leben und Werk 1904 – 1914, Vienna and Munich 1983. – O.K.: Early Drawings and Watercolours (Cat.), London 1985. – O.K. 1886 – 1980 (Cat.), Kunsthaus Zurich et al., Zurich 1986. – F. Whiteford: O.K., A Life, London and New York 1986.

August Macke 1887 Meschede (Sauerland) – **1914** near Perthes-les-Hurlus

1904 – 1906 Studies at the Academy of Art in Düsseldorf as well as the Düsseldorf School of Applied Art. **1905** First trip to Italy. **1906** Trips to Belgium, Holland and England. **1907/8** studies at Corinth's painting school in Berlin. **1908** First trip to Paris, together with Koehler. **1909** Marries Elisabeth Gerhardt. Honeymoon in Paris. They settle down near Lake Tegern. **1910**

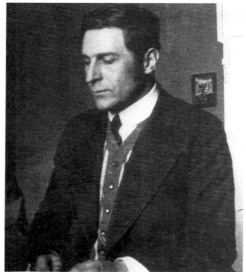

First contacts with the *New Artists' Association of Munich*. Makes friends with Marc. **1911** Contributes to the almanac *Der Blaue Reiter*. Moves to Bonn, **1912** Travels to Paris with Marc and visits Delaunay. **1913** Launches the exhibition *Rhenish Expressionism* in Bonn. Moves to Hilterfingen on Lake Thun. **1914** Trip to Tunis, together with Klee and Moillet.

By August Macke: W. Macke (ed.): A.M. – F. Marc. Briefwechsel, Cologne 1964. Oeuvre catalogues: G. Vriesen: A.M., Stuttgart 1953 [with paintings catalogue]. – A.M. Aquarelle (Cat.), Kunsthalle Bielefeld, Bielefeld 1957 [with oeuvre catalogue of water-colours]. – U. Heiderich: A.M. Die Skizzenbücher, 2 volumes, Stuttgart 1987. Monographs and catalogues: W. Cohen: A.M., Leipzig 1922. – M.T. Engels: A.M., Recklinghausen 1958. - E. Erdmann-Macke: Erinnerung an A.M. Stuttgart 1962. - *Die rheinischen Expressionisten*: A.M. und seine Malerfreunde (Cat.), Städtisches Kunstmuseum et. al., Bonn 1979. – Die Tunisreise (Cat.), Westfälisches Landesmuseum für Kunst und Kulturgeschichte, Münster et al. Münster 1987.

Franz Marc 1880 Munich – **1916** at Verdun

1899 Studies philosophy at Munich University. **1900 – 1902** Studies at the Academy of Fine Art in Munich. **1902** First trips to Paris and Italy. **1907** Second trip to Paris. **1909** Moves to Sindelsdorf. **1911** Member of the *New Artists' Association of Munich*. Together with Kandinsky, starts the editorial team for the Blaue Reiter. **1912** Co-edits the almanac *Der Blaue Reiter*. Takes part in the *Sonderbund* exhibition in Cologne. Member of the *New Secession* in Berlin. Travels to Paris with Macke, where they visit Delaunay. **1913** Trip to the Tyrol. **1914** Moves to Ried in Upper Bavaria. Volunteers for military service. **1916** Memorial exhibition at the *Sturm* gallery in Berlin.

By Franz Marc: W. Kandinsky and F.M. (eds.): Der Blaue Reiter, Munich 1912. – F.M.: Briefe, Aufzeichnungen und Aphorismen, vol. 1, Berlin 1920. – F.M.: Briefe aus dem Feld, Berlin 1940. (New edition: Munich 1982). – F.M.: Aufzeichnungen und Aphorismen, Munich 1946. – W. Macke (ed.): F.M. and A. Macke: Briefwechsel, Cologne 1964. – K. Lankheit (ed.): F.M. Schriften, Cologne 1978. – K. Lankheit (ed.): W.K. – Franz Marc, Briefwechsel, Munich and Zurich 1983. Oeuvre catalogue: K. Lankheit: F.M. Katalog der Werke, Cologne 1970. Monographs and catalogues: A.J. Schardt: F.M., Berlin 1936. – K. Lankheit: F.M., Berlin 1950. – F.M. Unteilbares Sein. Aquarelle und Zeichnungen, Cologne 1959. – K. Lankheit: F.M. im Urteil seiner Zeit, Cologne 1960. – K. Lankheit: F.M. Sein Leben und seine Kunst, Cologne 1976. – F.S. Levine: The Apocalyptic Vision. The Art of F.M. as German Expressionism. New York 1979. – M. Rosenthal (ed.): F.M. 1880 – 1916 (Cat.), University Art Museum, Berkeley 1979. – F.M. 1880 – 1916 (Cat.), Städtische Galerie im Lenbachhaus, Munich 1980.

Ludwig Meidner 1884 Bernstadt (Silesia) **– 1966** Darmstadt

1901/2 Apprenticeship as a bricklayer. **1903 – 1905** Studies at the Royal Academy of Art in Breslau, then moves to Berlin. **1906/7** Studies at the Académie Julian and the Académie Cormon in Paris. Makes friends with Modigliani. **1911** Contributes to the magazine *Die Aktion*. **1912** Founds the group *Die Pathetiker* (The Solemn Ones), together with Janthur and Steinhardt. **1914** Member of the *Free Secession* in Berlin. **1916 – 1918** Military service. **1918 – 1921** Member of the *Co-operative Council for Art* and the *November Group*. **1924/25** Teaches at the Study Studios for Painting and Sculpting in Berlin. **1935** Moves to Cologne. **1937** Branded as "de-

generate" by the Nazis. 84 of his works are confiscated. **1939** Emigrates to England. **1940/41** In internment camp on the Isle of Man. **1952** Returns to Germany.

By Ludwig Meidner: Im Nacken das Sternenmeer, Leipzig 1917. – Septemberschrei. Hymnen, Gebete, Lästerungen, Berlin 1920. – Eine autobiographische Plauderei, Leipzig 1923. – Gang in die Stille, Berlin 1929. – D. Kunz (ed.): L.M.: Dichter, Maler und Cafés, Zurich 1973. Monographs and catalogues: L. Brieger: L.M., Leipzig 1919. – T. Grochowiak: L.M., Recklinghausen 1966. – L.M. Zeichnungen aus dem Nachlaß (Cat.), Kunstverein Darmstadt, Darmstadt 1970. – L.M. 1884 – 1966 (Cat.), Kunstverein Wolfsburg 1985.

Paula Modersohn-Becker 1876 Dresden **– 1907** Worpswede

1892 Spends six months in England. **1893 - 1895** Trains at the Ladies' Teacher Train-

ing College in Bremen. **1896 – 1898** studies at the drawing and painting school of the *Society of Women Artists* in Berlin. **1897** In Worpswede for the first time, where she is taught by Mackensen. **1900** First time in Paris, where she studies at the Académie Cola Rossi and the Ecole des Beaux Arts, and also meets Nolde and the poet Rilke. **1901** Marries Modersohn and moves to Worpswede. **1903** Second trip to Paris, where she visits Rodin at his studio. **1905** Stays in Paris again and studies at the Académie Julian. **1906** February: last trip to Paris. Modersohn follows her in October. **1907** Spring: returns to Worpswede. Birth of her daughter Mathilde on 2 November.

By Paula Modersohn-Becker: S.D. Gallwitz (ed.): P.M.-B. Briefe und Tagebuchblätter, Hanover 1917. – G. Busch and L. von Reinken (ed.): P.M.-B. in Briefen und Tagebüchern, Frankfurt 2/1980.
Oeuvre catalogues: G. Pauli: P.M.-B., Leipzig 1919. – W. Werner (ed.): P.M.-B., Oeuvreverzeichnis der Graphik, Bremen 1972.
Monographs and catalogues: O. Stelzer: P.M.-B., Berlin 1958. – P.M.-B. zum 100. Geburtstag (Cat.), Von der Heydt Museum, Wuppertal 1976. – G. Busch (ed.): P.M.-B. zum hundertsten Geburtstag (Cat.), Kunsthalle Bremen 1976. – E.W. Kornfeld (ed.): P.M.-B. Zeichnungen und Graphik (Cat.), Kunsthaus Zürich, Zurich, 1976. – G. Perry: P.M.-B. Her Life and Work, London 1979. – C. Murken-Altrogge: P.M.-B. Leben und Werk, Cologne 1980. – G. Busch: P.M.-B. Malerin, Zeichnerin, Frankfurt 1981. – P.M.-B. Die Landschaften (Cat.), Kunsthalle Bremen, Bremen 1982. – P.M.-B. Das Frühwerk (Cat.), Kunsthalle Bremen, Bremen 1985. – P.J. Harke: Stilleben von P.M.-B., Worpswede 1985.

Wilhelm Morgner 1891 Soest – **1917** near Langemark (West Flanders)

1908/9 Studies under the Worpswede painter Tappert. Returns to Soest. **1911** Moves to Berlin. Member of *New Secession*. **1912** Takes part in the *Sonderbund* exhibition in Cologne. **1914** Military service.

Oeuvre catalogue: W.M. Das vollständige Holzschnittwerk, Cologne 1970.
Monographs and catalogues: W. Frieg: W.M., Leipzig 1920. – H. Seiler: W.M., Recklinghausen 1958. – W.M. (Cat.), Westfälischer Kunstverein and Westfälisches Landesmuseum für Kunst und Kulturgeschichte, Münster 1967. – E.G. Güse: W.M., Münster 1983.

Otto Mueller 1874 Liebau (Silesia) – **1930** Breslau

1890 – 1894 Apprenticeship as a lithographer in Görlitz. – **1894 – 1896** Studies at the Dresden Academy of Art, then travels to Switzerland and Italy together with the writer Gerhard Hauptmann. **1898/99** Studies at the Munich Academy of Art, under von Stuck. Returns to Dresden. **1908** Moves to Berlin, where he meets the sculptor Lehmbruch and the poet Rilke. **1910** Member of the *Brücke* artists' circle. Cofounder of the *New Secession*. **1912** Takes part in the *Sonderbund exhibition* in Cologne. Travels to Bohemia together with Kirchner. **1916 – 1918** Military service, then returns to Berlin. **1919** Member of the *Co-operative Council for Art*. Professorship at the Breslau Academy of Art. **1924 – 1930** Numerous trips to Dalmatia, Bulgaria, Hungary and Romania. **1937** 357 of his works are confiscated in German museums as part of the Nazi raid on "degenerate" art.

Oeuvre catalogues: L.G. Buchheim: O.M. Leben u. Werk, Feldafing 1963 [with a catalogue of his prints by F. Karsch]. – F. Karsch: O.M. zum 100. Geburtstag: Das graph. Gesamtwerk [prints], Berlin 1974.

Monographs and catalogues: E. Troeger: O.M., Freiburg i.Br. 1949. – H. Jähner: O.M.

Dresden 1974. – O.M. Malerei, Zeichnungen und Druckgraphik (Cat.), Städtisches Museum, Mülheim on the Ruhr 1974.

Gabriele Münter 1877 Berlin – **1962** Murnau

1898 – 1900 Spends two years in the United States, together with her sister. **1902** Studies under Kandinsky at the *Phalanx* school. **1903** Engagement to Kandinsky, who is still married. **1904 – 1908** Joins Kandinsky on his trips to Italy, France, Switzerland, Holland, Tunisia and several times to Russia. **1908** Spends some time in Murnau for the first time. **1909** Buys a house in Murnau. Close friendship with Jawlensky and Marianne von Werefkin. Member of the *New Artists Association of Munich*. **1911** Leaves the Artists' Association out of solidarity with Kandinsky and Marc. **1914** At the beginning of the war, travels to Switzerland with Kandinsky, but returns to Murnau when Kandinsky goes back to Russia. **1915** Last meeting with Kandinsky in Stockholm. **1916** Kandinsky tells her that he wishes to sever all links with her. **1917** Moves to Copenhagen. Due to her separation, she is unable to work as an artist for several years. **1920** Returns to Murnau. **1927** Begins to paint again. Trip to Paris. **1933 – 1945** Withdraws to her home in Murnau, where she works all on her own. **1957** Donates large number of her own works as well as Kandinsky's to the Städtische Galerie im Lenbachhaus, Munich.

Monographs and catalogues: R. Gollek: Das Münter-Haus in Murnau, Munich, undated – J. Eichner: Kandinsky und G.M., Munich 1957. – K. Roethel: G.M., Munich 1957. – G.M. 1877 – 1962 (Cat.), Städtische Galerie im Lenbachhaus, Munich 1977. – R. Gollek (ed.), G.M. Gemälde, Zeichnungen, Hinterglasbilder und Volkskunst aus ihrem Besitz (Cat.), Städtische Galerie im Lenbachhaus, Munich 1980. – G.M. (Cat.), Kunstverein Hamburg et al., Hamburg 1988.

Emil Nolde (Emil Hansen) **1867** Nolde (Schleswig) – **1956** Seebüll (Schleswig-Holstein)

1884 – 1888 After an apprenticeship as a furniture designer and cabinet maker, works in different furniture factories in Munich, Karlsruhe and Berlin. **1889** Teacher at the School of Applied Art in Karlsruhe. **1892 – 1897** Teaches ornamental drawing and modelling at the School of Applied Art in St. Gallen. **1899** Studies at Hölzel's school in Dachau and the Académie Julian in Paris. **1903** Settles on the Isle of Alsen. **1906/7** Member of the *Brücke*. Meets Munch. **1910** Argues with Liebermann and co-founds the *New Secession*. **1913/14** Joins a scientific expedition on a trip to New Guinea, via Russia and China. **1919 – 1921** Member of the *Co-operative Council for Art*. **1926** Moves to Seebüll. **1931** Member of the Prussian Academy of Arts. **1937** 1,057 of his "degenerate" works in German museums are confiscated by the Nazis. **1941** Under Nazi pressure, he is excluded from the Reichskunstkammer (the German Artists' Association) and is forbidden to paint. **1944** His Berlin studio is destroyed during an air raid. **1946** He is made a professor. **1956** The Ada and Emil Nolde Foundation is established in Seebüll.

BY EMIL NOLDE: M. Sauerland (ed.): Briefe aus den Jahren 1894 – 1926, Berlin 1927. – Das eigene Leben (1897 – 1902), Berlin 1931, Cologne 5/1980. – Jahre der Kämpfe (1902 – 1914), Berlin 1931, Cologne 5/1985. – Welt und Heimat (1913 – 1918), Cologne 1965, 2/1971. – Reisen – Ächtung – Befreiung (1919 – 1946), Cologne 1967, 3/1978. – M. Urban (ed.): E.N. Mein Leben (extracts in one volume from the autobiography in four volumes), Cologne 1976, 6/1987. – H. Hesse-Frielinghaus (ed.): Emil und Ada Nolde – Karl Ernst und Gertrud Osthaus. Briefwechsel, Bonn 1985.
OEUVRE CATALOGUES: G. Schiefler: Das graphische Werk Noldes bis 1910 [prints],

Berlin 1911. - G. Schiefler: Das graphische Werk von E.N. 1910 – 1925, Berlin 1925. – G. Schiefler and C. Mosel: E.N. Das graphische Werk. Vol. 1: Die Radierungen [etchings]. Vol. 2: Holzschnitte und Lithographien [woodcuts and lithographs], Cologne 1966f.
MONOGRAPHS AND CATALOGUES: M. Sauerlandt: E.N., Munich 1921. – H. Fehr: E.N. Ein Buch der Freundschaft, Cologne 1957. – W. Haftmann: E.N., Cologne 1958. – W. Haftmann: E.N., Ungemalte Bilder, Cologne 1963, 2/1971. – M. Urban (ed.): E.N. Aquarelle und Handzeichnungen, Seebüll 1967, 5/1981. – E.N. Gemäde, Aquarelle, Zeiczhnungen und Druckgraphik (Cat.), Kunsthalle Köln, Cologne 1973. – E.N. Gemäde, Aquarelle und Druckgraphik (Cat.), Kunstmuseum in Hanover with Sprengel Collection, Hanover 1980. – W.S. Bradley: The Art of E.N., Ann Arbor 1985. – M. Reuther: Das Frühwerk E.N.s Vom Kunstgewerbler zum Künstler, Cologne 1985. – E.N. (Cat.), Württembergischer Kunstverein Stuttgart, Stuttgart 1988.

Max Pechstein 1881 Zwickau – **1955** Berlin

1896 – 1900 Apprenticeship with decorative painter in Zwickau. – **1900 – 1902** Studies at the Dresden School of Applied Art. – **1902 – 1906** Studies at the Academy of Fine Arts in Dresden. **1906** Member of the *Brücke*. He is given the Saxon State Award. **1907** Spends summer in Goppeln with Kirchner. **1908** Moves to Berlin. Member of the Berlin *Secession*. **1910** Co-founder and chairman of the *New Secession*. Trip to the Moritzburg Lakes together with Heckel and Kirchner. **1911** He and Kirchner found the MUIM Institute (Modern Painting Lessons). **1912** Excluded from the *Brücke* because of his participation in the Berlin *Secession* exhibition. **1914** Travels to the Palau Islands. **1915/16** Military service on the Western front. **1918** Co-founder of the *Co-operative Council for Art*. **1922** Member of the Prussian Academy of Arts. **1933** He is forbidden to paint or exhibit by the Nazi

authorities. **1937** Branded as "degenerate" by the Nazis. 326 of his works are confiscated in German museums. **1944** His flat in Berlin and a large number of his works are destroyed. **1945** Professorship at the Academy of Fine Arts in Berlin.

BY MAX PECHSTEIN: H.G. Sellenthin (ed.): M.P. Palau. Zeichnungen und Notizen aus der Südsee, Feldafing 1956. – L. Reidemeister (ed.): M.P.: Erinnerungen, Wiesbaden 1960.
OEUVRE CATALOGUES: P. Fechter: Das graphische Werk M.P.s, Berlin 1921
MONOGRAPHS AND CATALOGUES: W. Heymann: M.P., Munich 1916. – G. Biermann: M.P., Leipzig 1919. – M. Osborn: M.P., Berlin 1922. – K. Lemmer (ed.): M.P. und der Beginn des Expressionismus, Berlin 1949. – Der junge P. (Cat.), Nationalgalerie, Berlin 1959. – M.P. Zeichnungen und Aquarelle. Stationen seines Lebens (Cat.), Brücke Museum, Berlin 1981. – M.P. (Cat.), Ostdeutsche Galerie, Regensburg 1981. – M.P. (Cat.), Kunstverein Braunschweig, 1982. – M.P. Zeichnungen und Aquarelle (Cat.), Kunstverein Wolfsburg, Wolfsburg 1987.

Christian Rohlfs 1849 Niendorf (Holstein) – **1938** Hagen

1863 As a result of a bad leg injury, Rohlfs is bed-ridden for two years. **1870 – 1881** Studies at the Weimar Academy of Art, though he has to interrupt his course several times, due to his illness, until his leg is finally amputated. **1901** Moves to Hagen, where he works in a studio of Osthaus's Folkwang Museum. **1902** He is made a professor in Weimar. **1905/6** Spends two summers in Soest where he meets Nolde. **1910 – 1912** Stays in Munich and the Tyrol. **1911** Member of the *New Secession in Berlin*. **1922** Honorary doctorate at Aachen Polytechnic. **1927 – 1938** Spends most of his time in Ascona, for health reasons. **1929** Foundation of the Christian Rohlfs Museum in Hagen. **1937** 412 of his "degenerate" works in German museums are confiscated by the Nazis.

OEUVRE CATALOGUES: P. Vogt: C.R. Oeuvrekatalog der Druckgraphik [prints], Göttingen 1950. – P. Vogt: C.R. Aquarelle und Zeichnungen [water-colours and drawings], Recklinghausen 1958 [with oeuvre catalogue]. - P. Vogt: C.R. Das graphische Werk, Recklinghausen 1960. C.R., Das Spätwerk (Cat.), Kunstverein Darmstadt 1960. – P. Vogt: C.R. Oeuvrekatalog der Gemälde [paintings], Recklinghausen 1978. – C.R. Das druckgraphische Gesamtwerk (Cat.) [prints], Museum am Ostwall, Dortmund, Dortmund 1987.

MONOGRAPHS AND CATALOGUES: W. Scheidig: C.R., Dresden 1965. – P. Vogt: C.R., Cologne 1967. – C.R. Gemälde zwischen 1877 und 1935 (Cat.), Kunsthalle zu Kiel, Kiel 1979. – H. Froning: C.R., Ramerding 1983. – C.R. Arbeiten auf Papier (Cat.), Folkwang Museum, Essen 1988.

Egon Schiele 1890 Tulln (Lower Austria) – 1918 Vienna

1906-1909 Studies at the Academy of Fine Arts in Vienna. 1907 Meets Klimt. 1911 Member of the *Sema* artists' circle in Munich. 1912 Takes part in the *Blaue Reiter* exhibition. Imprisoned for "disseminating pornographic drawings". 1914 Takes part in the Werkbund exhibition in Cologne. 1915 Conscription for military service. 1918 Dies of Spanish influenza.

BY EGON SCHIELE: A. Roessler (ed.): Briefe und Prosa von E.S., Vienna 1921. – C.M. Nebehay: E.S. Leben, Briefe, Gedichte, Salzburg 1979.
OEUVRE CATALOGUES: O. Kallir: E.S. Oeuvrekatalog der Gemälde [paintings], Vienna 1966. – O. Kallir: E.S. Das druckgraphische Werke, Vienna 1970.
MONOGRAPHS AND CATALOGUES: E.S. Gedächtnisausstellung (Cat.), Österreichische Galerie, Vienna 1968. – R. Leopold: E.S. Gemälde, Aquarelle, Zeichnungen, Salzburg 1972. – A. Comini:

E.S., London 1976. – E. Mitsch: E.S., Salzburg and Vienna 1980. – F. Whitford: E.S., London and New York 1981. – E.S. Vom Schüler zum Meister (Cat.), Hamburger Kunsthalle, Hamburg 1984.

Karl Schmidt-Rottluff (Karl Schmidt) 1884 Rottluff near Chemnitz – 1976 Berlin

1901 Makes friends with Heckel. 1905 Leaves grammar school. Studies at the Saxonian Technical College in Dresden. 7 June: Co-founds the *Brücke* artists' circle, together with Bleyl, Kirchner and Heckel. 1906 The group requests him to ask Nolde to join. He meets Schiefler and Schapire in Hamburg. 1907 – 1912 Summer trips to Dangast. 1911 Trip to Norway. 1912 Moves to Berlin. Makes friends with Feininger. Takes part in the *Sonderbund* exhibition in Cologne. Travels to Italy, Paris and Dalmatia. 1913 Break-up of the the *Brücke*. 1915 – 1918 Military service in Lithuania and Russia. 1918 Marries Emy Frisch. 1918 – 1921 Member of the *Co-operative Council for Art*. Contributes to the magazine *Die Aktion*. 1918 – 1943 Lives in Berlin. Spends each summer on the Baltic coast. 1931 – 1933 Member of the Prussian Academy of Arts. 1937 608 of his "degenerate" works in German museums are confiscated by the Nazis. 1943 Destruction of his Berlin studio in an air raid. He moves to Rottluff. 1946 Returns to Berlin. 1947 – 1954 Professorship at the School of Fine Art in Berlin. 1964 At his suggestion, the Brücke Museum is founded in Berlin.

OEUVRE CATALOGUES: R. Schapire (ed.): K. S.-R.s graphisches Werk bis 1923 [prints], Berlin 1924. – E. Rathenau (ed.): K. S.-R. Das graphische Werk seit 1923, New York and Berlin 1964. – W. Grohmann: K. S.-R. (with oeuvre catalogue of the paintings 1905 – 1954), Stuttgart 1956.
MONOGRAPHS AND CATALOGUES: W.R. Valentiner, K. S.-R., Leipzig 1920. – G. Thiem:

K. S.-R., Munich 1963. - K. S.-R. (Cat.), Folkwang Museum, Essen 1964. – K. Brix: K. S.-R., Vienna and Munich 1971. – G. Wietek: K. S.-R. Graphik, Munich 1971. – K. S.-R. Zum 90. Geburtstag (Cat.), Staatsgalerie, Stuttgart 1974. – K. S.-R. (Cat.), Brücke Museum, Berlin 1984. – G. Wietek: K. S.-R. in Hamburg und Schleswig-Holstein, Neumünster 1984. – L. Reidemeister (ed.): K. S.-R. Der Holzstock als Kunstwerk (Cat.), Berlin 1985.

Marianne von Werefkin 1860 Tula (Russia) – 1938 Ascona

1883 Begins her studies at the Moscow School of Art. – 1886 Her family moves to St. Petersburg, where she becomes a private pupil of Repin. 1888 Shoots her right hand in a hunting accident so that it remains crippled. 1891 Meets Jawlensky. 1896 Moves to Munich with Jawlensky. Gives up

her own artistic work for several years. 1905 Paints again. 1906 Meets Lenbach and von Stuck. 1908 Works together with Kandinsky, Gabriele Münter and Jawlensky in Murnau. 1909 – 1912 Co-founds the *New Artists' Association of Munich*. 1912 Exhibits with the *Blaue Reiter*. 1913 Takes part in the *First German Autumn Salon* in Berlin. 1914 Moves to Switzerland together with Jawlensky. 1919 Moves to Ascona. 1921 Separates from Jawlensky. 1924 Forms the artists' circle *The Great Bear*. 1928 Exhibition of the group together with Schmidt-Rottluff and Rohlfs at the Nierendorf Gallery in Berlin.

BY MARIANNE VON WEREFKIN: C. Weiler (ed.), M.W., Briefe an einen Unbekannten 1901 – 1905, Cologne 1960.
MONOGRAPHS AND CATALOGUES: J. Hahl-Koch: M. v. W. und der russische Symbolismus, Munich 1967. – K. Federer (ed.), M. v. W., Zeugnis und Bild, Zurich 1975. – M. v. W., Gemälde und Skizzen (Cat.), Museum Wiesbaden, Wiesbaden 1980. – B. Fäthke: M. v. W., Leben und Werk, Munich 1988.

The author, the editor and the publisher wish to express their gratitude to the museums, galleries, private collectors, archives, photographers and particularly the estates and families of the artists who supported this book. We would also like to thank the following photographers and photograhic studios: Archiv Alexander Koch, Munich; Artothek, Planegg; André Held, Ecublens; Walther & Walther Verlag, Alling.